Fake?

THE ART OF DECEPTION

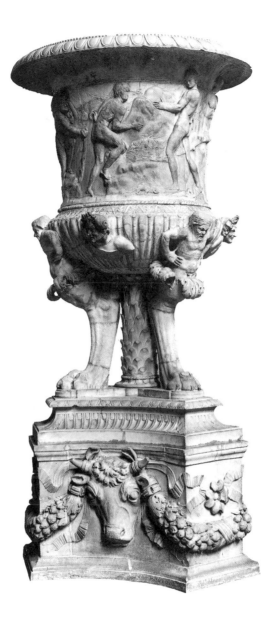

University of California Press
Berkeley and Los Angeles

FAKE?

THE ART OF DECEPTION

EDITED BY MARK JONES

WITH PAUL CRADDOCK AND NICOLAS BARKER

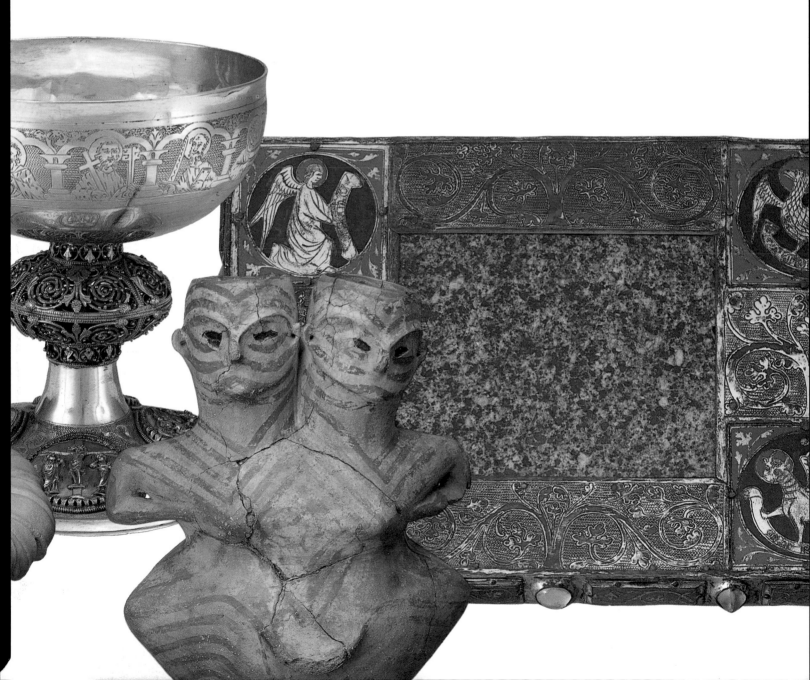

Half-title page The Piranesi Vase (see p. 133)

Title-page Painting after Mori Sosen (122b); 'Clytie' (3); copy of a medieval chalice (21); fake 'Haçilar' ceramic (319b); 'medieval' portable altar by Louis Marcy (198).

This page The Orsini Doorway. This genuine but originally plain Renaissance doorway from the Palazzo Orsini at Ghedi near Brescia was transformed in 1872-9 by the sculptor Pietro Faitini for the dealer Molinari. Faitini copied decoration from pilasters on the church of Santa Maria dei Miracoli at Brescia. The result was so magnificent that the Victoria and Albert Museum was prepared to pay the large sum of £602 for it. An outcry in Italy against its export led the government to refer the case to the Archaeological Commission at Brescia, which uncovered the truth.

© 1990 The Trustees of the British Museum

First U.S. edition published 1990 by
University of California Press
Berkeley and Los Angeles

Library of Congress Catalog Number: 89-52107
ISBN 0-520-07086-0 (cased)
ISBN 0-520-07087-9 (paper)

Designed by Roger Davies

Typeset in Palatino by Roland Phototypesetting Ltd
Bury St Edmunds, Suffolk
and printed in Italy by Arti Grafiche Motta

Contents

Acknowledgements

The British Museum is grateful to the following for their loans to the exhibition:

The Museum of Anthropology and Archaeology, Cambridge 280

The Visitors of the Ashmolean Museum 132a

Nicolas Barker, Esq. 200

The Bienecke Library, Yale University 329

J. S. G. Boggs, Esq. 31

The Booth Museum of Natural History 89

The British Library 36–9, 41–7, 52–4, 57, 59–63, 67, 77, 158–60, 178, 201–4, 225, 240–3

The Trustees of the British Museum (Natural History) 66a, 71, 73, 83–6

The Brotherton Library, University of Leeds 76

The Trustees of the Cecil Higgins Art Gallery 259

The Courtauld Institute of Art 7, 205, 303

The Freud Museum 300

The Geological Society 87

The Worshipful Company of Goldsmiths 291–4

The Hastings Museum and Art Gallery 90, 92, 93

The Horniman Museum 72b, 223, 224

The Hon. Simon Howard 32

The Trustees of the Imperial War Museum 56, 58

Musée du Louvre 4a

Metropolitan Police Museum 260, 264

Museum of London 273

The Trustees of the National Gallery 136, 206, 207, 234, 235

The Trustees of the National Museums on Merseyside 147

The National Museum of Photography, Film and Television 94

The Trustees of the National Museums of Scotland 23d, 75

The Trustees of the National Museums of Wales 171b, c, e, f

News International 53

Parham Park 69

Rijksdienst Beeldende Kunst, The Hague 258

The Society of Antiquaries of London 318

Sotheby's 263

The Trustees of the Tate Gallery 239a

University College, London 202b

The University Museum, Oxford 78

W. Veres, Esq. 183

The Trustees of the Victoria and Albert Museum 19, 22, 28d, 50, 102, 108, 109, 112, 118, 119, 123, 129b, 187, 195, 196, 208, 212–16, 218, 219, 230, 238b, 245–8, 265, 281, 302, 304

Museo Civico, Viterbo 42

The lenders' permission to illustrate their works is also gratefully acknowledged, as is permission to illustrate works not exhibited, from the British Society for the Turin Shroud, the Getty Museum, the Musée de Glozel, and the Staatliche Museen Preussischer Kulturbesitz, Berlin.

The assistance of D. R. Guttery of Wells Krautkammer in the preparation of the radiography display is also gratefully acknowledged.

The exhibition was designed by Simon Muirhead, of the British Museum Design Office, with the assistance of Theresa Bruce. The graphic design is by Nicholas Newberry and the labels and information panels were edited by Jill Hughes.

The British Museum objects illustrated in the book were photographed by Jim Rossiter and other members of the British Museum Photographic Service, including Anthony Milton, David Gowers, Chaz Howson and Simon Tutty.

The text is the work of nearly one hundred contributors, each of whom generously devoted their ill-affordable time to suggesting objects for inclusion, and writing and checking their entries. It was typed by Margaret Massey and read by Andrew Burnett and Antony Griffiths. The massive task of editing it fell to Jenny Chattington of British Museum Publications; it is to her that the major credit for its appearance is due.

Of the many others who have at one time or another been of assistance I should particularly like to mention Carol Hobley, Keith Miller, Elizabeth Adey, Robert Babcock, Christopher Brown, Elizabeth Carmichael, Christopher Chippingdale, Dr L. R. M. Cocks, Brian Coe, John Curtis, Elisabeth Fontan, Sarah Goodwin, Howard Grey, Professor E. T. Hall, Jenny Hall, Philip Harding, Roger Harding, Michael Helston, Raymond Higgs, Richard Hughes, Gregory Irvine, Ian Jenkins, Robert Knox, P. V. A. Johnson, Philip Lancaster, Hannah Lane, Susan La Neice, Fiona Marsden, Malcolm McLeod, Nigel Meeks, Catherine Metzger, Frances Palmer, Janus Paludan, Nicholas Penny, Derek Robinson, Nicholas Reeves, Arthur Searle, Christopher Spring, David Thompson, Eric Turner, W. Wadell, Catherine Walling, Karen Watts, Alwyn Wheeler, Paul Williams, Ian Wilson and Anthea Worsdall. Without the extraordinary kindness and efficiency with which they and their unnamed colleagues dealt with my numerous and time consuming requests for help and information this exhibition would not have been possible.

Abbreviations

BL	British Library
BM	British Museum
V&A	Victoria and Albert Museum

British Museum Departments

CM	Coins and Medals
EA	Egyptian Antiquities
ETH	Ethnography
GR	Greek and Roman Antiquities
JA	Japanese Antiquities
MLA	Medieval and Later Antiquities
OA	Oriental Antiquities
PD	Prints and Drawings
PRB	Prehistoric and Romano-British Antiquities
WAA	Western Asiatic Antiquities

The Contributors

AB Andrew Burnett
BRITISH MUSEUM

AD Aileen Dawson
BRITISH MUSEUM

AF Anne Farrer
BRITISH MUSEUM

AK Artur Kratz
SKULPTURENGALERIE
SMPK, BERLIN

AO Andrew Oddy
BRITISH MUSEUM

AREN Anthony North
VICTORIA AND ALBERT
MUSEUM

AVG Antony Griffiths
BRITISH MUSEUM

BFC B. F. Cook
BRITISH MUSEUM

BJC Barrie Cook
BRITISH MUSEUM

BJM John Mack
BRITISH MUSEUM

BD Brian Durrans
BRITISH MUSEUM

BMCC Barbara McCorkle
YALE UNIVERSITY LIBRARY

CC Craig Clunas
VICTORIA AND ALBERT
MUSEUM

CDWS Christopher Sheppard
BROTHERTON LIBRARY,
LEEDS UNIVERSITY

CJ Catherine Johns
BRITISH MUSEUM

CM Catherine Metzger
MUSÉE DU LOUVRE, PARIS

CNM Carole Mendleson
BRITISH MUSEUM

CRL Christopher Ligota
WARBURG INSTITUTE

CW Clive Wainwright
VICTORIA AND ALBERT
MUSEUM

DB David Buckton
BRITISH MUSEUM

DG David Gaimster
BRITISH MUSEUM

DK Dafydd Kidd
BRITISH MUSEUM

DMB Donald Bailey
BRITISH MUSEUM

DP Devana Pavlik
BRITISH LIBRARY

DCS Dorota Starzecka
BRITISH MUSEUM

DS Doreen Stoneham
ARCHAEOLOGICAL
RESEARCH LABORATORY,
OXFORD

ECD Eryl Davies
SCIENCE MUSEUM

EJD Eamon Dyas
BRITISH LIBRARY

EM Edward Morris
WALKER ART GALLERY,
LIVERPOOL

EMCK Elizabeth McKillop
BRITISH LIBRARY

EVDW Prof. Ernst van der
Wetering
STICHTING FOUNDATION,
REMBRANDT RESEARCH
PROJECT, AMSTERDAM

FC Frances Carey
BRITISH MUSEUM

FP Frances Palmer
HORNIMAN MUSEUM

GB Giulia Bartrum
BRITISH MUSEUM

GNS Geoffrey Swinney
ROYAL MUSEUM OF
SCOTLAND, EDINBURGH

GV Ginette Vagenheim
SCUOLA NORMALE
SUPERIOR, PISA

GRV Gerard Vaughan
WOLFSON COLLEGE, OXFORD

HPP H. P. Powell
UNIVERSITY MUSEUM,
OXFORD

HT Hugh Tait
BRITISH MUSEUM

JAR Judy Rudoe
BRITISH MUSEUM

JB Janet Backhouse
BRITISH LIBRARY

JBG Sir James Graham, Bart.
CECIL HIGGINS ART
GALLERY, BEDFORD

JFMC John Cannon
BRITISH MUSEUM (NATURAL
HISTORY)

JC(MLA) John Cherry
BRITISH MUSEUM

JC(PRB) Jill Cook
BRITISH MUSEUM

JL John Leopold
BRITISH MUSEUM

JM Jim Murrell
VICTORIA AND ALBERT
MUSEUM

JR Jessica Rawson
BRITISH MUSEUM

JT John Taylor
BRITISH MUSEUM

LB Leonard Bourton
BRITISH MUSEUM
PUBLICATIONS

LL Lionel Lambourne
VICTORIA AND ALBERT
MUSEUM

LRHS Lawrence Smith
BRITISH MUSEUM

LS Lindsay Stainton
BRITISH MUSEUM

MA Melanie Aspey
NEWS INTERNATIONAL
RECORD OFFICE,
LONDON

MC Marian Campbell
VICTORIA AND ALBERT
MUSEUM

MF Mirjam Foot
BRITISH LIBRARY

THE CONTRIBUTORS

MHB	Mark Haworth-Booth VICTORIA AND ALBERT MUSEUM	
MJP	Martin Price BRITISH MUSEUM	
MKT	M. Kirby Talley Jr RIJKSDIENST BEELENDE KUNST, THE HAGUE	
MPJ	Mark Jones BRITISH MUSEUM	
MR	Michael Rogers BRITISH MUSEUM	
MRK	Martin Royalton-Kisch BRITISH MUSEUM	
NB	Nicolas Barker BRITISH LIBRARY	
NFB	Nigel Barley BRITISH MUSEUM	
NR	Natalie Rothstein VICTORIA AND ALBERT MUSEUM	
NS	Neil Stratford BRITISH MUSEUM	
NT	Nicholas Turner BRITISH MUSEUM	
OC	Oliver Crimmen BRITISH MUSEUM (NATURAL HISTORY)	
OW	Oliver Watson VICTORIA AND ALBERT MUSEUM	
PB	Peter Bloch SKULPTURENGALERIE SMPK, BERLIN	
PC	Paul Craddock BRITISH MUSEUM	
PG	Philippa Glanville VICTORIA AND ALBERT MUSEUM	
PHJG	Paul Goldman BRITISH MUSEUM	
PM	Patrick Mills BRITISH LIBRARY	
PW	Paul Williamson VICTORIA AND ALBERT MUSEUM	
PY	Peter Young VICTORIA AND ALBERT MUSEUM	
RBG	Robert Bruce-Gardner COURTAULD INSTITUTE, LONDON	
RC	Rosemary Crill VICTORIA AND ALBERT MUSEUM	
RFSW	R. F. Schoolley-West BRITISH LIBRARY	
RK	Rose Kerr VICTORIA AND ALBERT MUSEUM	
RM	Roger Moorey ASHMOLEAN MUSEUM, OXFORD	
RMC	Richard M. Crowe NATIONAL LIBRARY OF WALES, ABERYSTWYTH	
RBNS	Roger Smither IMPERIAL WAR MUSEUM	
RWAS	R. Suddaby IMPERIAL WAR MUSEUM	
RW	Robin Watt NATIONAL MUSEUM OF NEW ZEALAND, WELLINGTON	
SB	Sally Brown BRITISH LIBRARY	
SGEB	Sheridan Bowman BRITISH MUSEUM	
SMCK	Scott McKendrick BRITISH LIBRARY	
SW	Susan Walker BRITISH MUSEUM	
TC	Timothy Clark BRITISH MUSEUM	
TRB	Richard Blurton BRITISH MUSEUM	
TW	Timothy Wilson BRITISH MUSEUM	
VH	Victor Harris BRITISH MUSEUM	
WZ	Wladimir Zwalf BRITISH MUSEUM	

Preface

Unusually, there is a question-mark in the title of this exhibition, for there are as many questions as answers in discussing the subject of fakes and forgeries. To many the main purpose of the forger is to earn money: the forger of a five pound note hopes to make a considerable profit. But this is not entirely true – the wholesale forgery of English fivers by the Germans during the Second World War was undertaken with the intention of undermining the British economy. Michelangelo's forgery of a work by his master Domenico Ghirlandaio was a student prank; but the reason for his forgery of Cupid Asleep, which was sold in 1496 as a classical sculpture, may not have been so innocent. William Smith and Charles Eaton, who produced the famous 'Billies and Charlies' (otherwise known as the Shadwell Dock forgeries) in the middle of the last century, made objects so inept that no true medievalist – one might think – could be taken in by the meaningless inscriptions and jumbled numeration (199). Yet for years these objects were produced at archaeological meetings and pondered on – why? One might easily understand how collectors were taken in by the famous Fonthill Ewer. When this was purchased from the London dealer Edward Baldock in 1819 it was identified as a marriage gift for Caterina Cornaro and the King of Cyprus which had been made by Benvenuto Cellini (1500–71). This object (now in the Metropolitan Museum in New York) is now recognised as a Prague-made vessel of about 1680. But should the experts not have known its date earlier?

Mark Jones, who has splendidly brought this exhibition to fruition, points out that the expert sees what he wants to see; he has tunnel vision. This is a warning to all. Fakes are not always acquired as the result of greed; they are also brought into a collection as the result of preconceived theory or expectation – the Piltdown Skull is a case in point (83). Arrogance in response to demand is a prime mover in the acceptance of fakes, hence the ghastly Van Meegerens (258). Thus the revaluation of fakes is not only satisfying in itself, but also fascinating and salutary. The reaction of the collector or scholar who has been taken in is so varied as to run the whole gamut of human emotion from fury, to hurt pride, to amusement. But the final question is the one that appears to be unanswerable, although psychologists have tried to explain it: why does an object which is declared a fake lose virtue immediately? This question, which concerns the eye and mind of the beholder, should be pondered by all who read this book or visit the exhibition which it records.

There is a horrid fascination about fakes: although we sweep them under the carpet, we tend to discuss them and review them *ad nauseam*; but we review them in an almost shamefaced fashion because we as experts have bumped up against our own fallibility (even if the original mistake was not our own). We are all emotionally involved with fakes; nobody wishes to be associated with them. It is, therefore, with an extraordinary sense of gratitude that I express the thanks of the Museum, its Trustees and staff to all those who have lent fakes to this exhibition. Fortunately, most of the worst errors are our own, the result of nearly two and a half centuries of collecting.

DAVID M. WILSON

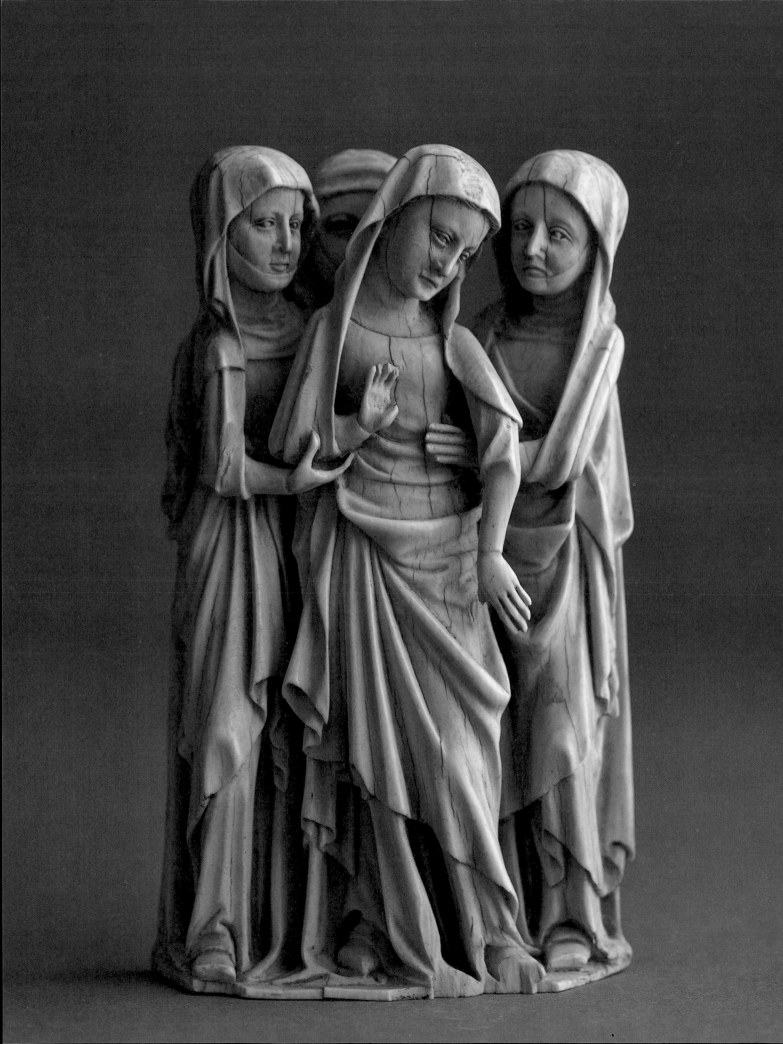

Introduction

Why Fakes?

Mark Jones

Fake? is an exhibition about deception, or rather the material evidence of the myriad deceptions practised by men upon their fellows over three millennia. It is a record of human frailty, of the deceit of those who made fakes and of the gullibility of those who were taken in by them – a curious subject at first sight for exhibition in the British Museum. Yet it can be argued that fakes, scorned or passed over in embarrassed silence by scholar, dealer and collector alike, are unjustly neglected; that they provide unrivalled evidence of the values and perceptions of those who made them, and of those for whom they were made.

Fakes can teach us many things, most obviously perhaps the fallibility of experts. Not a single object has been included here merely because it deceived an untutored layman. Most have been validated thrice over, on initial purchase by an experienced collector, on publication by a leading scholar and on acquisition by a great museum. What is being asserted is not that the less well informed may sometimes make mistakes, though that is evidently true, but that even the most academically and intuitively gifted of individuals, even the most rigorously organised of institutions, can and will occasionally be wrong. And this is not, or not simply, because knowledge and experience can never be complete, but because perception itself is determined by the structure of expectations that underpins it. Present Piltdown Man (83) to a palaeontologist out of the blue and it will be rejected out of hand. Present it to a palaeontologist whose predictions about the 'missing link' have been awaiting just such evidence and it will seem entirely credible. Bring an exceptionally rare Athenian coin to a classical numismatist and he will examine it with careful scepticism. Allow one of the greatest of all classical numismatists, Sir George Hill, a Director of the British Museum, to find such a coin *for himself*, mounted as a jewel around a lady's neck, and he will take its authenticity for granted (177).

This omnipresent fallibility is of wider significance than might be suggested by a misidentified coin or even a misapprehension about the whole course of human evolution. It can affect our conception of reality itself. One whole section of *Fake?* is devoted to the changing boundaries of belief, boundaries that were often marked and sometimes determined by fakes. The fabricators of the Vegetable Lambs of Tartary (71) that grazed on the surrounding grass while joined to mother earth by an umbilical cord, of the 'Sea Bishop' that visited the King of Poland in 1531 (73), or of the numerous mermen (72) that reached Europe from Japan, altered, for a while at least, the mental universe inhabited by those who saw them. And this is not just a question of medieval

credulity. Elsie and Frances Wright's fabricated photographs convinced Conan Doyle, creator of that paradigm of sceptical intelligence Sherlock Holmes, and millions of others, that there really were fairies at the bottom of the garden (76).

Even those resistant to such beliefs may be vitally affected by fakes. Though the disseminator of the 'Zinoviev letter' (54) may have exaggerated when he claimed that it had lost the British Labour Party the 1924 general election and fundamentally altered the balance of power between the main political parties, there is no denying that smear campaigns based on forgeries, most notoriously the *Protocols of the Elders of Zion* (52) have influenced public opinion – and not only public opinion. A rather earlier forgery, the Donation of Constantine, was the legal basis of the medieval Papacy's claim to temporal power in the West and so, among other things, as Nicolas Barker points out, of Pope Adrian iv's grant of Ireland to Henry vi of England (38).

Such forgeries were far from being exceptional aberrations. It has recently been estimated that the great monastic houses of England were so busy forging writs in the century after the Norman Conquest that over half the surviving charters of Edward the Confessor may be spurious (39a). No one can be sure, because their forgeries are so clever that it can still be difficult to detect them today. This illustrates the unrivalled potential of fakes as evidence of the sense of history possessed by their creators. In the fakers' work we can see exactly what it was that they believed to characterise the antiquity of the object faked; exactly what was necessary to meet expectations about such objects and so secure their acceptance.

The sense of history revealed by fakes is sometimes remarkable. As John Taylor notes, the ancient Egyptian forgers of the Shabaka Stone (35), which located the creation of the world in their home town of Memphis, not only claimed that they were copying an ancient, worm-eaten document, but also actually reproduced the layout of just such a document, and introduced archaic spelling and grammatical forms to give it credibility. There could be no better demonstration of the existence of a sophisticated sense of anachronism among the educated élite of Pharaonic Egypt.

Equally surprising is the almost total lack of any such sense demonstrated by some of the fakes surviving from Renaissance Europe. Neither the Constantine and Heraclius medals (137), nor the severed head of Pompey in the Cabinet des Médailles, Paris, nor the coin portraits of ancient worthies by Valerio Belli look remotely classical to the modern eye. There has therefore been a general tendency among art historians to assume that they could not have been intended to deceive. Andrew Burnett, however, has shown that they were (140). The earliest books on numismatics were in fact motivated in part by the existence of such fakes and by a desire to help the collector to avoid them.

Just as the fake itself is evidence of the historical sense of its maker and recipients, so its critical history is a gauge of the development, or decline, of such a sense thereafter. The denunciation of the Constantine and Heraclius medals in the early seventeenth century reflects the emergence of a perception of the stylistic norms of late classical and early Byzantine art, and the realisation that such pieces lay outside

them. In much the same way the gradual exposure of the *Corpus Hermeticum* (63), a highly influential collection of religious texts purporting to prefigure many of the central tenets of Christianity, began with the simple observation, in the late sixteenth century, that a letter from Hermes to Aesculapius could hardly be genuine if it included a reference to the sculptor Phidias (since it would have antedated his birth). It continued with Isaac Casaubon's much more sophisticated demonstration, in the early seventeenth century, that the whole collection was written in the Greek of the first century, not that of Heroditus or Hippocrates, let alone that of the much earlier period to which its composition was ascribed.

The development of a critical tradition has thus been intimately connected, in every field, with the exposure and even the production of fakes. As Christopher Ligota demonstrates, it was in a work purporting to establish the central position of the Etruscans in world history that Annius of Viterbo attacked the unreliability of certain ancient Greek historians and proposed new and highly influential rules for the assessment of historical evidence (42). This is a world in which poachers act simultaneously as gamekeepers, alerted to others' frauds by their own.

Fakes are, however, only secondarily a source of evidence for the outlook of those who made and uncovered them. They are, before all else, a response to demand, an ever changing portrait of human desires. Each society, each generation, fakes the thing it covets most. For the priests of ancient Memphis this was, as we have seen, the promotion of their cult and of their city. For a nineteenth-century nationalist, like Václav Hanka (47), it was a medieval tradition of epic poetry that would fire the heart of the Czech nation and lead it to statehood. For medieval monks it was the relics of saints and martyrs that would perform miracles, attract the faithful and ensure the endowment of their foundation. For Renaissance humanists it was relics of a different kind, of that source of all beauty and enlightenment, the ancient world. Succeeding generations added demand for the work of famous artists, for things associated with famous people and, by the late nineteenth century, for almost anything that spoke to them of the calm certainties of the vanished past.

It may be significant then that the great growth area for faking today is not the creation of religious relics, national epics, or works of art, nor even some specifically modern area like the production of spurious scientific data (though that is on the increase), but the massive counterfeiting of brand-named goods. Wherever there is a market for the perfume of Chanel or Dior, the watches of Rolex or Cartier, shirts by Giorgio Armani, luggage by Louis Vuitton or footware by Adidas, the counterfeiter is at work. Most of the purchasers of their work know that at the price they are paying they cannot be buying the real thing. They are buying an illusion – the illusion of status, of belonging, of success, conferred by the fraudulent reproduction of a famous name.

If fakes provide a unique portrait of the changing focuses of human desires, they also delineate the evolution of taste with unrivalled precision. Where there are fakes it is clear that there was a booming market in the things thus imitated: fakers are above all creatures of the market. Unencumbered by the individualism of a great artist or thinker,

they move quickly to take advantage of the high prices produced by a new fashion before the development of expertise makes their task more difficult or, worse still, their activities undermine the market altogether (as was the case with the market for classical gems in the mid-nineteenth century). If the market concerned is in antiques, however broadly defined, the fakes produced for it will reflect its demands more accurately than the genuine works traded in it. The former mirror the perceived desires of collectors; the latter may pass unchanged through their hands.

Not all genuine objects remain untouched by their owners, however. Some are rendered more acceptable by restoration, a process that provides the same kind of evidence for the history of taste as fakes themselves. The history of restoration is indeed inextricably linked with that of fakes, as the section of *Fake?* devoted to the collection of classical antiquities in the late eighteenth century demonstrates (142–7). At this period the restoration of sculpture was not in itself controversial: no classical figure, however beautiful, was considered worthy of display unless complete. Since classical antiquities were almost always found damaged, restorers were much in demand and their skill lay in the creation of an illusion of completeness, in modifying the old and adding the new in such a way as to create a single unified whole. Faking only came into it when, as was commonly the case, the purchaser was deceived as to the extent of the restoration carried out. In the case of the famous Venus, now at Newby Hall in Yorkshire, the dealer Jenkins created one of the most expensive pieces of classical sculpture ever sold by joining an alien and recut head to a headless body, and selling the result as a complete figure. This is a paradigmatic example of a fake.

Restoration, however, also raises questions of a more complicated kind about the search for authenticity. In the early nineteenth century the crucial decision was taken not to restore the Elgin Marbles. To subsequent generations, reared on the notion that the peak of beauty was to be found in these fragmentary examples of ancient sculpture, previous attitudes to restoration seemed wrong. What had once been seen as returning works of art to their original state, so that they could be seen and appreciated in as near as possible the form that they had had in classical times, was now regarded as deception. So, for example, it was asserted that the restoration of the Aegina marbles by the famous Danish neo-classical sculptor Thorwaldsen amounted to forgery (Schüller, pp. 153–4), and in the 1960s his additions were removed by the Munich Glyptothek, so that the original fragments could once again be seen as they really were. Now a new concept of authenticity is emerging which encourages us to accept that objects have a continuing history, that they are damaged and repaired, cleaned and restored, and that their present state records not only the moment of creation but also a whole subsequent sequence of events. Whether, in the light of this, the pursuit of authenticity requires the restoration of the Thorwaldsen restorations, or whether their removal should be accepted as another significant event in the continuing history of the Aegina marbles, is not yet clear. What is certain is that this controversy has a direct bearing on the treatment of fakes. These have too often been ruthlessly dismantled, victims of a puritanical zeal that would strip away the lie and

reveal the truth behind it, even if the truth is a heap of uninteresting fragments and the fake was a construct of historical and aesthetic value.

If *Fake?* poses questions about authenticity, and the problems posed by the application of different concepts of authenticity by different groups of people to different types of object (see, in particular 28–33), it also, and most painfully, challenges the authenticity of our responses to them. Why, if what we value from a work of art is the aesthetic pleasure to be gained from it, is a successfully deceptive fake inferior to the real thing? Conscious of this problem, some have attempted to deny the importance, to them, of authorship. The great collector and scholar Richard Payne Knight, when attempting to ascertain the truth about the Flora cameo (152), which he had purchased as antique but which the contemporary gem-engraver Benedetto Pistrucci claimed to have made himself, told the dealer who had sold it to him that it did not matter whether it was old or new since its beauty was unaffected by its age. Similarly, the purchasers of the supposedly Renaissance bust of Lucrezia Donati (6) expressed their pleasure, on discovering that it was a fake, that an artist of such talent was still alive. But it would be unwise to rely on museums, dealers or private collectors taking that attitude today.

What most of us suspect, that aesthetic appreciation is not the only motor of the art market, becomes evident when a work of art is revealed as a fake. When a 'Monet' turns out not to be, it may not change its appearance but it loses its value as a relic. It no longer provides a direct link with the hand of a painter of genius, and it ceases to promise either spiritual refreshment to its viewer or status to its owner. And even though the work in question remains physically unaltered our aesthetic response to it is profoundly changed. The great art historian Abraham Bredius wrote of Van Meegeren's 'Vermeer' forgery *Christ at Emmaus*:

> It is a wonderful moment in the life of a lover of árt when he finds himself suddenly confronted with a hitherto unknown painting by a great master, untouched, on the original canvas, and without any restoration, just as it left the painter's studio! And what a picture! Neither the beautiful signature . . . nor the pointillé on the bread which Christ is blessing, is necessary to convince us that what we have here is a – I am inclined to say – *the* masterpiece of Johannes Vermeer of Delft . . . (*Burlington Magazine*, November 1937).

After Van Meegeren's exposure, however, it became apparent that his forgeries were grotesquely ugly and unpleasant paintings, altogether dissimilar to Vermeer's. His success is, retrospectively, literally incredible. M. Kirby Talley Jr concludes his piece on Van Meegeren (258) with the observation 'had Van Meegeren been a better artist . . . he might just have succeeded in producing "Vermeers" which would have fooled more people longer than the ones he created'. Yet as he himself tells us, Van Meegeren was exposed not because he ceased to fool people but because he fooled one art lover too many, Hermann Goering, and was forced to prove himself a forger in order to clear himself of the more serious charge of having sold a national treasure to the enemy.

Van Meegeren's success seems incredible. But what is really extraordinary about it is that the pattern revealed by his case is in fact commonplace. The reaction of Bredius and his numerous distinguished colleagues, far from being exceptionally foolish, was normal; fakes are

very often greeted with rapture by *cognoscenti* and general public alike. It is generally true that fakers are known to us only because they have revealed themselves, overcoming considerable public and scholarly scepticism to prove the works in question theirs only to find that what was so admired as the work of another is now seen as trite and even maladroit (e.g. 209).

From this it is clear that both private and public collections must still contain many works by fakers less boastful, quarrelsome or unlucky than Bastianini, Dossena or Van Meegeren. And they will continue to do so. Some will be exposed by advances in scientific techniques; but many objects cannot be scientifically dated, and even where analysis is appropriate its conclusions must be based on a control group of 'genuine' objects which may itself be contaminated. Others, anchored in their own time, may become 'dated' and expose themselves – as Lord Lee's Botticelli (7) was betrayed by her resemblance to 1920s film stars. But while sensitivity to stylistic anachronism is a powerful tool, it is far from an infallible one. When a group of fakes is accepted into the canon of genuine work all subsequent judgements about the artist or period in question are based on perceptions built in part upon the fakes themselves. Had Bastianini not become enraged by the profits being made from his work we, like Kenneth Clark's art master (see 208), might have a conception of Renaissance art formed around his work.

This, finally, is our complaint against fakes. It is not that they cheat their purchasers of money, reprehensible though that is, but that they loosen our hold on reality, deform and falsify our understanding of the past. What makes them dangerous, however, also makes them valuable. The feelings of anger and shame that they arouse among those who have been deceived are understandable, but the consequent tendency to dispose of or destroy fakes, once identified, is misguided. Even if the errors of the past only provided lessons for the future they would be worthy of retention and study. But fakes do far more than that. As keys to understanding the changing nature of our vision of the past, as motors for the development of scholarly and scientific techniques of analysis, as subverters of aesthetic certainties, they deserve our closer attention, while as the most entertaining of monuments to the wayward talents of generations of gifted rogues they claim our reluctant admiration.

Forging the past
David Lowenthal

A Hampstead Garden Suburb close boasts several 1930s neo-Georgian houses whose open shutters are bolted to the walls. Against Second World War bombing raids, occupants undid the bolts and added hinges so the shutters would shut. After the War the local preservation society insisted the hinges be removed and the shutters bolted back: they were authentically *fake* shutters.

In Vancouver, British Columbia, artefacts by local North American Indians (now Native Americans, correcting Columbus's appellative error) are much esteemed. Recent years have brought Vancouver many migrants from India, and some of them peddle fake Native American artefacts, truthfully labelled, 'hand-made by authentic Indians'.

These tales exemplify the paradoxes inherent in faking. Boundaries between truth and falsehood are hard to fix; what is fraudulent in one context is quintessentially genuine in another. In 1989 American television was censured for simulating the handing-over of a suitcase by a purported spy to a Soviet agent, as 'fakery' that 'insulted viewers, ethics, and journalism'; network executives retorted that old distinctions between truth and fiction were *passé*, since many Americans considered their favourite television characters more 'real' than their friends and neighbours.

Presentations of the past raise peculiarly intractable conundrums of authenticity. Every relic displayed in a museum is a fake in that it has been wrenched out of its original context. Riddled with the inconsistency of compelling yet conflicting preconceptions – the golden glow of nostalgia, the sordid squalor of savagery – all 'olden times' are potentially fraudulent. 'Is that object real?', is a query often heard at historic sites. 'Are you really a weaver? Is this building real? Are you actually doing that work?' Doubt becomes endemic: at Plimoth Plantation, Massachusetts, where impersonators at the reconstructed Pilgrim settlement must profess innocence of anything post-1627, a visitor who sought permission to photograph found himself explaining what a camera was and how it worked; he forgot he was talking to a twentieth-century actor. As a televison presenter of Alex Haley's ludicrously anachronistic *Roots* said: 'There you have it, some of it true, and some of it fiction, but all of it true, in the true meaning of the word'.

Object authenticity is equally problematic. It is a common delusion that works of art are generated by an exclusively creative urge. Like other artefacts, art is mainly fashioned to be appreciated and acquired by others. Prospective viewers and buyers influence the design and production of art objects through artists' needs for subsistence and prestige. And other ulterior motives – to demonstrate or buttress cultural superiority, temporal priority, piety or power – play a major role in fashioning and refashioning art and antiquities. Whether we consider something a fake may depend upon its supposed constituents, its origins, its custodial career, or the erosions and restorations it has undergone. A spurious ownership history may condemn one work as a fraud; authenticating its creator may suffice to make another work genuine. New evidence about motives or technology, age or provenance, may alter the status of objects from 'fake' to 'authentic' or vice versa.

Standards of assessment vary with culture and epoch. To Vasari in the sixteenth century forging an antiquity was a triumph of artistry; for Twain and Leacock in the nineteenth century it was a topic of philistine merriment. In this century forgery has earned Van Meegeren a jail sentence (see 258), and Tom Keating (259) television celebrity. David Sully's 1989 prize-winning painting based on Balthus's 1951 landscape escaped a judge's censure as being not 'a copy, but, consciously or unconsciously, a variation on a theme'.

Changing views about the nature of the past, the significance of history and the symbolic role of relics also impinge on how fakes are assessed. For example, Victorians imagined themselves enlightened transmitters of a glorious and progressive heritage. Their radical renovation of ancient churches and cathedrals reaffirmed ties with a past the

more valued because capable of being improved. To replace early materials and features with modern ones did not falsify medieval buildings; it lent them a higher truth consonant with their hitherto unrealised genius. Victorians improved the past much like Hilda in Nathaniel Hawthorne's *Marble Faun* (1860), who not only restored paintings to pristine glory, but was a 'finer instrument' whose intervention enabled Old Masters at last to achieve their ideals. Only since Ruskin and Morris have we come to consider such restorations destructive and fraudulent.

Religious relics also reflect malleable standards. Early Christian reliquary status depended on the ability to beget miracles. Sacred relics multiplied without losing value; five churches claimed the authentic head of John the Baptist, and the fragments of the True Cross in Jerusalem were believed capable of perpetual regeneration. In the Holy Land that faith endures: at Cana a little girl selling wine jars assured Evelyn Waugh that they were the miraculous relics, but that if he preferred smaller jars she had some; they too were authentic.

Material truth is now usually more strictly construed. We are intensely concerned about authenticity, but extremely ambivalent about how to assess it. 'For fine restoration, there is no substitute for authenticity', runs an advertisement for glass, 'mouth-blown in the same manner since the Middle Ages . . . and for *true* authenticity there is no substitute for Restoration Glass'. Fascination with the truth or falsity of what we see and what we are told is boundless and obsessive. A recent book proclaims fraud 'the growth industry of the eighties'. But modern ambiguity dates back to the nineteenth century, when verbal and visual images in history and fiction, paintings and prints, brought the past to life as never before.

Closely imitating reality, photographs provoked particular stress. Respected figures verbally authenticated daguerreotypes of historic scenes; yet it was well known that photographers contrived their social realism. Verisimilitude made photographs indisputably veracious; to those who saw them, even those who made them, they seemed more real than the actuality. Unlike eye-witnesses' and historians' contradictory verbal reports, a photo gallery of the famous 'would be . . . the best history', asserted Walt Whitman, 'a history from which there could be no appeal'. In filming *The Birth of a Nation* (1915), D. W. Griffiths believed that he was chronicling the Civil War *exactly as it had been*: 'you will see what actually has happened; there will be no opinions expressed, you will merely be present at the making of history . . . The film could not be anything but the truth'.

Several trends combine to give faking and the problem of authenticity their present salience: technical advances; the commodification of culture; the popularisation of art and antiquity; the devaluation of originals and of objective truth; the historicising of values.

Technology has simultaneously promoted the skills of forgery and of its detection, while ever increasing numbers of works of art and antiquity come under scrutiny. The authenticity of virtually every major collection is currently being probed. Improved reproductive techniques also alter attitudes toward fakes. Mass-produced objects detectable as replicas only by scientific analysis invalidate time-honoured reasons for preferring originals and raise doubts about the

very concept of faking. While unmasking forgeries or confirming attributions, technology also casts doubts on the criteria used to assess authenticity and subverts the traditional primacy of artefacts. In recent museum displays interaction blurs the line between original objects and later interpretations. On-the-wall interpretive texts and graphics increasingly dominate actual historical objects.

Much art depends on appearance and decoration. But our culture's scientistic bent denigrates what is on the surface and exalts what is hidden. The façade lies; reality is what is behind it. This bias informed the National Gallery's 1988 *Art in the Making* display of x-ray, infra-red and laser micro-analyses of Rembrandt's paint and brushwork invisible to the naked eye. These weird visions were by implication more authentic than the actual paintings whose inner reality they disclosed. Thus the finished art was devalued as a mere surface expression of hidden chemical and optical structures. The original paintings came to seem almost fraudulent.

By contrast, the commodification of culture – the global tendency to treat art and antiquity as market commodities – augments the value of originals, thereby encouraging their faking. Fame, rarity and uniqueness boost their monetary worth and investment value. Because past masterpieces are a non-renewable resource, the expanding market always needs more originals and seeks new sources in other pasts and cultures. Since ethnic remoteness itself is a cachet of unselfconscious authenticity, previously unregarded artefacts constantly enter the art market. But every intake generates further copies and fakes. Because guidelines for judging these newly appreciated works are rudimentary, faking is easy and widespread. Markets are flooded with ethnic art, tourist art, airport art and instant antiquities.

Linked with commodification is the growing popularity of culture and heritage. Only in our time have antiques diffused through the middle classes, the relics of history and genealogy spread to mass markets, and museums and historic sites become popular haunts rather than élite preserves. Mass clienteles vitally affect what is displayed and how. The press of numbers endangers the safety and vitiates the aura of precious legacies, requiring valuable originals to be screened or, increasingly, replaced by replicas. Less genteel, less educated and less reverential audiences prefer empathy to authenticity. At shrines of the famous the public may demand the real thing, but elsewhere historical truth comes a poor second. As the owner of a rehabilitated 1870s Tennessee house put it: 'I've tried to reproduce the house as authentically as I know how, while keeping it brighter and more cheerful looking'.

Even English Heritage, the statutory guardian of the nation's historic sites, sanctions the re-enactment of events that never occurred, such as Napoleon's attack on Scarborough Castle: inculcating historical lessons at enjoyable locales matters more than 'relatively superficial historical inaccuracies' like who fought whom, when and where. With authenticity so flexible, what could be rejected as fraudulent?

Replacing fragmentary relics with simulated models, and originals with copies, raises similar questions. Fossil dinosaur skeletons are the only 'real' remains, but supposititious 'replicas of living beasts, lunging, roaring and perhaps even sporting the bright courtship markings that

some scientists believe they wore', teach viewers much more about what dinosaurs might have been like. Genuine antique garments disintegrate, while the Museum of the Moving Image pays £10,000 for an 'exact copy' of a dress worn by Gloria Swanson – though not truly exact, since Miss Swanson would have had to shed several stone to wear it.

Modernist revulsion against the burden of the dead past has promoted art forms that elevate ephemeral processes over once-canonical objects. Performance art, auto-destructive art, and earth art renounce claims to purely material value. The jokey paradoxes of Magritte and Dali intentionally erase distinctions between real and fake. The subversion of authenticity is the hallmark of Boggs's drawings of banknotes, which he 'sells' for goods and services, sometimes at face value (see 32). Boggs's meticulous copies are not forgeries – drawn on one side only, they include phrases like 'E=mc2', 'LSD', 'This note is legal tender for artists', and 'Federal Reserve Not'. But categories get confused. 'In exchanging art for money', explained a Boggs precursor, Daniel Spoerri, who sold 'cheques' payable at 10 Deutschmarks for 20, 'we exchange one abstraction for another'. 'What is art? What is money?', muses Lawrence Wechsler. 'What is the one worth, and what the other? What is *worth* worth?'

In shopping for usable pasts post-moderns seek not authenticity but artifice and allusive irony; in Donald Barthelme's phrase, 'all there is is trash, we just have to learn how to dig it'. Yet hand in hand with the deconstruction of history and of object worship goes devotion to frozen and inviolable pasts. The past is accorded sanctity for its own sake; it must not be tampered with. Architectural conservation's 'hands-off anti-scrape' principle extends to all arts and artefacts. Distorting history to make it pay, to make it popular or to make it convincing is deemed blatant fakery.

The authentic early music movement offers an illuminating instance. Until recently most musicians worked within a lengthy living tradition. They treated the past as a continuous corridor leading to the present. Nineteenth-century performers altered Bach to retain the currency of his music. Adapting Bach's clavier works for the modern pianoforte enabled them – like Hawthorne's Hilda – more truly to realise Bach's own aims. By contrast, those who now perform with conscious fidelity to original forms use early music as a storehouse, fashioning repertoires from relics of other times. They demand an historical purity unthinkable when the present was an unbroken extension of the past. The liberties that Liszt took with Bach, the view that 'we understand past geniuses' music better than they did', are now condemned as frauds analogous to the restorations for which Ruskin and Morris condemned Victorian restorers like Giles Gilbert Scott.

Then, as now, retrieval sought to honour past intentions. But while the nineteenth century openly lent the past its help, past intentions now supposedly speak unaided: to improve buildings, artefacts or musical performances is fraudulent. To restore a true past the nineteenth century consciously altered it; today we likewise alter the past, but habitually blind ourselves to our own impact on it.

Authentic revival is either self-delusion or deliberate fakery. Because the re-creation of past music requires modern performance, knowledge

of the present inevitably colours original intentions, original scores, original instruments, original ambiences. Bygone performers were often as responsible as composers for the music played. Many original scores are unavailable, not because they are lost but because they were never produced. Facsimile instruments do not guarantee facsimile sounds; the acoustics of modern concert halls depart from those of earlier locales; background noise, including pervasive broad-band machine-produced sounds, throws up unimaginable differences. *Castrati* are not available to sing what was written specifically for them. And boys' voices today break much earlier than in the past; only less-trained youngsters can now sing the soprano parts intended for musically sophisticated older boys.

Above all, early music retrieval can never achieve fidelity to original performance because we now grow up with other experiences, live in other acoustic worlds. However expert and immersed the modern performer, he can never internalise the music, feel it in his blood and bones like someone of the time when it was created. Nor can the audience shed familiarity with the whole corpus of *subsequent* music. Modern life unavoidably shapes performers' modes of presentation and auditors' expectations.

Do the same strictures apply to the plastic arts and antiquities, where an enduring material object rather than a performance is at issue? The two realms obviously differ. But museum visitors like musical audiences are of our own time; what they make of what they see is similarly shaped by subsequent creations and viewing habits. We may say, 'this is (or is not) the object you think or that it purports to be'; but we can never say 'you are seeing it just as it was seen by its maker' (or original patron or first collector). Anyone who professes to see things with the eyes or mind of the past is misled, fooled, enmeshed in fakery.

Many fabrications are essentially mental rather than material; the fake inscription or manuscript is simply an adjunct to an intended historical deception. Yet their supposed veracity, sanctitude and uniqueness makes fraudulent physical objects seem especially repugnant. From the Renaissance on, scholars aware of textual forgeries and corruptions turned to relics as more reliable past witnesses: the chronicler was venial or *parti pris*, but the antiquarian was above bias. Although it is now evident that artefacts are as easily altered as chronicles, public faith in their veracity endures: what can be seen and touched cannot lie. Material objects attest to the pasts from which they came because they are tangible and presumably durable.

Yet all objects ultimately decay or shatter into unrecognisability. In so doing they lose the identity that formerly made them authentic or fake. These marble fragments may once have been a Hellenistic sculpture, those bits of pigment and wood were perhaps a Quattrocento painting, but they are no longer cohere enough to be assessed as such.

Finally, each object is felt to be a unique exemplar because it occupies a distinct space. Unlike words or music, both infinitely reproducible, material art and antiquities are one of a kind. In their uniqueness inheres their value, which copying – and faking – dissipates.

Fakes connect with the past in a more fundamental fashion. Most fakes are purported antiquities or aim to alter received history. And since past mentalities, motives and modes of production are unlike our

own, we can seldom be confident that any relic is or is not a fake. We never observe the past directly, but only through altered artefacts and subsequent accounts. Some things, we know, cannot have been true; others are highly likely or unlikely to have happened; but much that we surmise about the past can be neither definitively established nor refuted. Hence the truism that nothing is harder to predict than the past. Unlike the present, therefore, the past is also extremely biddable; since few of yesteryear's denizens can answer back, it gives scope for invention denied to today. An apt illustration is E. L. Doctorow's rejoinder to the elderly Texan who challenged his novel *Welcome to Hard Times*, set in nineteenth-century Dakota Territory. '"Young man", she wrote, "when you said that Jenks enjoyed for his dinner the roasted haunch of a prairie dog, I knew you'd never been west of the Hudson. Because the haunch of a prairie dog wouldn't fill a teaspoon". She had me. I'd never seen a prairie dog. So I did the only thing I could. I wrote back and I said, "That's true of prairie dogs today, Madam, but in the 1870s . . .".'

This tale suggests more than delight at the fabricator's cleverness: it reveals the *need* for a fantasy past. We are gluttons for false facts; our craving for fraud rejects all truth but the look of it. We bring to the most improbable past an 'immense assumption of veracities and sanctities, of the general soundness of the legend', notes Henry James; we accept the 'extraneous, preposterous stuffing' of its empty reliquary shell. Glorying in fraud helps to exorcise the ancient terror that a past not perfectly transmitted will revenge itself on us. We need fakes to shield us from too sharp a knowledge. The false past coexists alongside the truth that exposes it, to cushion the erosion of sustaining myth.

Truth is too dangerous to leave naked and unguarded. As we grow older we are continually threatened by the truth about ourselves, as about the world; maturation makes liars of us all. A fake passport cover has been devised for nervous American tourists. Designed to disguise American passports for safety in terrorist action, PASSAFE closely (but deliberately imperfectly) copies the blue Canadian passport (for white Americans) or the green Guyanan one (for black Americans). 'It's not counterfeit', says the entrepreneur; 'the whole point is to create an illusion of authenticity'. Saturated in hyper-reality, to quote Umberto Eco, today's 'imagination demands the real thing and, to attain it, must fabricate the absolute fake'.

Textual forgery

Nicolas Barker

Fake – the word conjures up an image of the cunning craftsman at work, making or marring an object, with intent to deceive the innocent or ignorant viewer. A museum (in the modern sense of the word) is a repository of objects, natural or artificial; objects thus occupy the foreground of the exhibition of which this catalogue is a memorial. But deception is a much more complicated business than the making of an object. It is only the outward manifestation of a web woven of many strands of human aspiration and action, in which the deceived is as

important as the deceiver. A text is textile, something woven. It too is a complex web: if factual, the choice of what goes in and what is omitted involves deception; if fiction ('something made' before 'something feigned'), its success is dependent on some verisimilitude.

The physical form of texts is books and manuscripts, but unlike other objects they cannot be made to display the falsity of texts, whether outright forgery or only fiction. The etymology of the word 'fake' (German *fegen*, 'to furbish' or 'clean up', before all in the deceptive and criminal senses) reveals an ambiguity that underlies everything here: it has a 'good' sense of improvement, as well as a bad sense of betraying or concealing the essential nature of the object faked. While there is not much ambiguity about a forged banknote, other 'documents', whether literal texts or abstract documents, such as a sacred relic or an 'Old Master' painting, involve a tissue, not merely of physical facts, but also of ideas: about goodness or badness, moral or aesthetic; about the passage of time and the change in human expectations that it involves; and about the function and value of such documents. Behind all this is the fact that falsehood, the underlying deception in a 'fake', is an abstraction. It cannot be touched, nor exhibited. Everything here is an image, a hint of something that cannot be seen. Some objects reveal the unseen more clearly than others: put a counterfeit coin against the original, and the nature of the deceit, base for precious metal, is obvious. Others, 'creative forgeries' of things that have no 'original' but answer some more abstract desire or value, defeat such easy comparison.

Of these, the oldest and by far the largest class is that of texts. Much more is involved here than the detection of a false *object*, although the creation of a false document may be an essential part of a fraudulent text. Beyond this, however, lies a false *concept*, literary, political or religious, which may itself be based on a tissue of facts and ideas, some true, others believed to be true but in fact false, others again known to be false but promulgated for reasons which may be 'good' as well as 'bad'. How old this practice is can be seen in the sections on 'Tradition and revival', 'Rewriting history', and 'The limits of belief'. The discernment of truth and the rejection of falsehood is the oldest of human intellectual activities: it is the foundation of criticism. One of the greatest critics, Richard Bentley, put it thus in his exposure of the false *Epistles of Phalaris* (36):

To pass a censure upon all kinds of writings, to shew their several excellencies and defects, and especially to assign them to their proper Authors, was the chief province and the greatest commendation of the Ancient Critics; and it appears from those remains that are left us, that they never wanted employment. For to forge and counterfeit Books, and father them upon great names, has been a practice almost as old as Letters.

Bentley goes on to deal with the motives for forgery: simple gain, 'glory and affectation, as an exercise of style, and an ostentation of wit'. The forgers might confess their deeds, rejoice in their exposure, or prefer 'that silent pride and fraudulent pleasure, though it was to die with them, before an honest commendation from posterity for being good imitators'. 'And', adds Bentley, 'to speak freely, the greatest part of mankind are so easily imposed on in this way, that there is too great an invitation to put the trick on them'.

This robust catalogue of human frailty, in which those who have the trick put on them are as culpable as those who put it, is aimed merely at the forgery or misapplication of texts in the ancient world, but we can recognise in it the framework of deceit that takes in most of the objects included here, and the ideas and incidents that lie behind them. At the same time it begs an important question, that of establishing criminal intent. Bentley makes this a simple matter of black and white, right or wrong, deceit or honesty, and so it sometimes is. But more often it is hard to place a particular work or action on the grey scale, so to speak, of morality. Too often what starts as honest imitation, or even a *jeu d'esprit*, goes underground to emerge later, accepted as that which it pretends to be. It may not be possible to establish at what point it changes from white to black; even if it were, the passage of time may have converted what would have been culpable deceit earlier into honest if ignorant mistake. Worst of all, it may be impossible to put right the edifice of false deduction built up in the interval between invention and disclosure.

It is hard to imagine a text as something independent of the document by which it is disseminated and preserved, but textual forgery predates and is frequently independent of such physical support, and may, indeed, flourish the more without it. Herodotus (fifth century BC) records a pre-documentary forgery, the interpolations made in the text of the Oracles of Musaeus and of Homer made by Onomacritus. Homer suffered again in the Pisistratid recension (sixth century BC), when passages were inserted tending to magnify the Athenian role in the siege of Troy – patriotic fervour is a long-lasting strand in the history of forgery. The book of Ecclesiastes was written by a Jew in the third century BC in the persona of a king of Israel. It was adapted to suit more orthodox tenets by later Jews, and further adapted, translated into Greek and attributed to King Solomon, in Christian interests. A Christian official in the third century AD compiled a manual of practice which he passed off as an Epistle from the Apostles.

The advent of Christianity, and the mass of apocryphal texts that grew up early in its history, merely augmented an already flourishing practice, only complicated by stricter canons of truth and falsehood, specifically addressed by St Augustine in *De mendacia* (AD 393). The Donation of Constantine and the Forged Decretals of Isadore (38) are a remarkable case in point, where the process of forgery lasted for centuries; the same is true of the false charters and chronicle of the Anonymous Continuator of Ingulphus of Croyland. Even more remarkable is the *Liber de tribus impostoribus*, the wickedest of all books, which bracketed Moses, Christ and Mahomet as frauds: already in the thirteenth century Frederick II was accused of its authorship; the philosopher Tommaso Campanella (1568–1639) evaded responsibility for it by creating a false legend of a printed text of 1538. The earliest surviving text appears to be the work of a Dutch *libertin érudit* about 1700. The *Protocols of the Elders of Zion* (52) may end this catalogue of confusion and deceit. There were no Elders, and no Protocols. The Elders were a figment of Slavic anti-Semitism, the 'Protocols' an adaptation of *Dialogue aux enfers* . . . , an imaginary dialogue between Montesquieu and Machiavelli aimed at Louis Napoléon in 1868, made to serve anti-Semitic policy in Russia around 1900. Yet this pernicious

work was recently in print in English in Los Angeles, and may be still.

Beyond these 'deliberate' forgeries lies the still greyer boundary between 'fact' (if false) and fiction. On the one hand, there are the speeches in Thucydides and Sallust, and Samuel Johnson's parliamentary reports, fiction but accepted as fact; on the other hand, there are Elizabeth Barrett Browning's *Sonnets from the Portuguese* (see 243) and Mme de Grafigny's *Lettres d'une Péruvienne*, apparent fact accepted as fiction. Somewhere between the two are Merimée's *Théâtre de Clara Gazul* and Louys' 'translation' of the *Chansons de Bilitis*. *Robinson Crusoe* is canonised as fiction by its imitation, Gulliver's *Travels*, while Defoe's *New Voyage round the World by a Course never sailed before* (1725), pure fiction, records the Bass Strait as fact, years before it appeared on authentic maps.

Increasingly, however, forged texts came to require physical 'support'. The example of Annius of Viterbo (b. *c* 1432) and the inscriptions that he caused to be engraved and then 'discovered' is a cardinal point. Such support was not new. According to an Aristotelian commentator, two early royal collectors of his works had them soaked in cedar oil and dirtied to give them an antique appearance. But Annius represents a humanistic watershed between idea and object: before him the idea is real and the object secondary; after him the idea is secondary to the reality of the object. The *cause célèbre* of the seventeenth century, the rediscovery of the (genuine) *Cena Trimalchionis* of Petronius, was complicated by doubts about the manuscripts (as well as the forgery of a further continuation). It is no coincidence that the first manual of palaeography, Mabillon's *De re diplomatica* (1681), should have appeared at the same time, or that its primary purpose was the detection of forgery.

The eighteenth century saw a further enlargement and refinement of this new preoccupation with the physical form of texts. The manuscripts of Pope, most artful of authors, show his fascination with their visual appearance. The forgeries of Bertram, Macpherson, Chatterton and Ireland (44, 45, 158, 160) show a progressive demand for an original, a manuscript written at the time of the composition of the text, something that could be seen and touched and subjected to new techniques of authentication. It is no coincidence that this trend accompanied the great growth of interest in the relics of the classical past, the unearthing of sculpture, some of which, inevitably, had only recently gone underground.

The final strand in the story of textual forgery is the new demand for the 'autograph', already observable in the tragic farce of William Ireland. *The Cult of the Autograph* by A. N. L. Munby (1962) chronicles the legitimate, but never wholly respectable, growth of this new refinement. The substitution of hand-made signs, by definition none the same, for the hieratic uniformity of seal, *tughra*, paraph, mason's mark or brand was a product of Renaissance humanism. The concept of personality spread from the writing of a name to the individuality expressed in the making of any artefact. We look at a picture, a sculpture, a piece of jewellery, a text, a suitcase, a watch, and ask 'is it genuine?', meaning not merely is it really Charles I, or pure gold, or a reliable way of telling the time, but is it the work of the individual whose name it bears – is it autograph?

The career of the greatest and most pernicious of all nineteenth-century forgers, John Payne Collier (1789–1883), was built on this obsession. His vast output has corrupted, perhaps permanently, the record of the texts of Shakespeare and his contemporaries. His insertions in Philip Henslowe's Diary, his invention of the 'Old Corrector' whose 'contemporary' improvements were written in the margins of a Second Folio (1632) of Shakespeare, the similar emendations to the 1611 Spenser which bore Michael Drayton's 'signature' – all these were products of Collier's agile hand, but still greater command of his authors' sense. The Collier controversy rumbled on throughout his long life, and is not dead. There is no exhibit here, for the watchful skill and enmity of 'the Keeper of Manuscripts', Sir Frederic Madden (1801–73), kept Collier's artefacts out of the British Museum.

There were many other, if lesser, autograph forgers in Britain, but post-Napoleonic France was still more fertile. The spectacular career of Guglielmo Libri, forger as well as thief, was launched there. The 27,000 documents that Vrain-Lucas is alleged to have produced for Michael Chasles are less remarkable as physical objects than as an example of the dominance of an idea: like Dawson, Chasles was possessed by national pride, in his case expressed in the desire to prove the priority of Pascal over Newton as the discoverer of the law of gravity. This led to further and wilder extravagances, including letters (from Marseille) of Mary Magdalene to Lazarus. The Baron Félix Feuillet de Conches was responsible for an appalling number of much more dexterous forgeries of the letters of Marie Antoinette and Henri IV. Eugène-Henri Courtois and Paul Letellier produced a still undetermined number of 'crusader charters' to establish the right of supposedly noble and ancient families to a place in Louis-Philippe's 'Salle des Croisades' at Versailles, opened in 1840. The heady atmosphere in which such artefacts were produced *en masse* is reflected in the ironic recipe for forging an early French text, in this case a type facsimile, written out for a friend by Richard Ford/William Stirling-Maxwell.

Take this book. I gave *ten* francs for it! . . . It was a fancy I had. Unsew the leaves, steep them fearlessly in coffee, dry them. Sprinkle with strong coffee to make blotches. Remove last modern leaf & keep it. Go to Persicotti. Pick up on the floor of his room old filthy parchment of a book he has bound. Also old yellow pages for lining. Have the book bound in *limp* old parchment. If strings of slips of narrow parchment to tie it were affixed it would do well, but it must not look new. You must show him the parchment, not let him do according to his taste. Beware that leaves be not cut – leave them irregular as they are. Show it as a great curiosity – on your table. I have an idea that something good could be made of it. Read the Story.
But take care of it, for I gave ten francs for it.

In all this Bentley's dictum that 'the greatest part of mankind are so easily imposed on' is not to be forgotten. Claudio Bonacini, 'creating' a new sixteenth-century calligrapher or a letter of Galileo, told me how difficult it was to convince people that they were false. Frederic Prokosch, the forger of first editions of Yeats, T. S. Eliot and other modern writers, who died in 1988, found his market's gullibility 'bizarre'. The full story of Hitler's diaries may one day be told, but one feature of it is obvious: the desire of any number of people that they should exist, which overrode the implausibility of the story and the

poor quality of the forgeries as physical objects. Another example, in a quite contrary sense, is the story of the hapless Moses Shapira, who bought fifteen leather strips containing part of the book of Deuteronomy from Arabs who had found them in the Wadi Munjib in Jordan. He brought them to Europe in 1883, where they were universally rejected as forgeries: the text did not fit current theory, the script was illiterate, the finding a plausible tale. Utterly cast down, Shapiro committed suicide. But in 1959, following the discovery of the Dead Sea Scrolls, the question of the authenticity of Shapiro's fragments was reopened. Meanwhile, the fragments themselves have disappeared, and until they are found the mystery will remain.

Forged texts cannot be dismissed as mere pale reflections of their originals. They are, at least, part, and not a negligible part, of the stemma of the text. They can also be deeply revealing witnesses of the 'sociology of the text', a mirror of the society which elicited the forgery. More important yet, as war advances technology so fake texts refine the critical impulse that can expose them. Forgery, like any form of imitation, embodies a creative impulse, and that is reason enough for taking its products seriously.

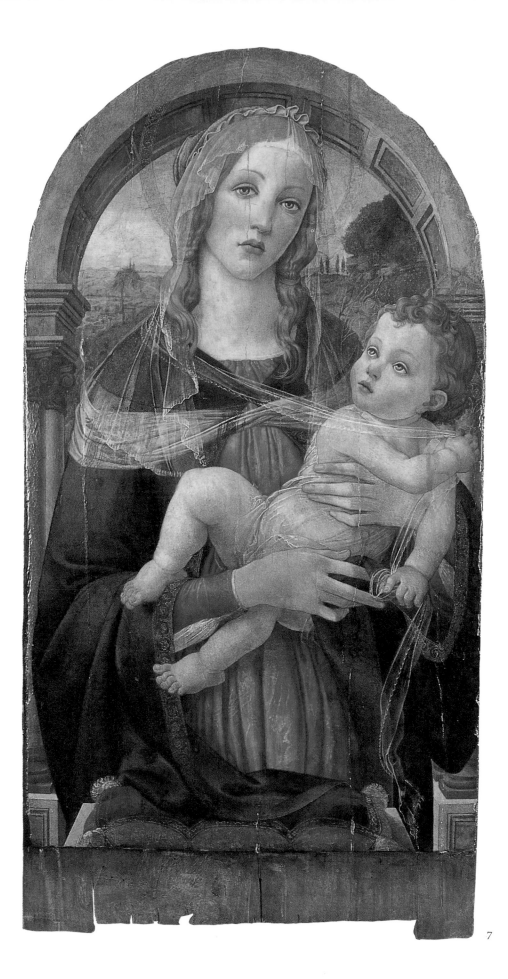

7

1

What is a fake?

The answer to the question, what is a fake?, is not always as obvious as it might seem. The first group of objects shown here includes a number of classic fakes like the 'Etruscan' sarcophagus (1) and the 'Tiara of Saitapharnes' (4), which were made to deceive and succeeded brilliantly, purchased by the world's greatest museums and displayed as ancient treasures. Almost as successful was the 'Botticelli' *Madonna* (7), sold to a wealthy collector and accepted by the art historical establishment as a masterpiece, while Lucrezia Donati (6), though exposed before she was fully launched, demonstrates that even frauds can be beautiful.

Around these undoubted fakes are a number of more problematic pieces. A medieval altarpiece (2), bought for the (fake) ivories on the inside, is now valued for the genuine and important thirteenth-century paintings on the outside. The classical bust known as 'Clytie' (3), though sometimes condemned as an eighteenth-century fake, is in fact ancient, but so reworked to enhance her charms as to have acquired a new personality. Not a fake at all, the brilliantly faithful twentieth-century replica of the seventh-century Japanese Kudara Kannon (8) is nevertheless potentially deceptive, while the jade horse's head (5), once condemned as a 1930s fake, has recently been shown to be the innocent victim of deception and so has re-emerged as a masterpiece of Han sculpture.

Around this group are classes of objects which are sometimes associated with fakes: copies, imitations and replicas. Fakes are sometimes thought of as copies made to deceive and copying itself has come to be regarded as an inherently second-rate and potentially shady activity. Here this assumption is challenged by showing that in many cultures copying has often been the dominant mode of artistic activity (9–13), motivated by a desire to maintain or renew traditional forms and skills, by nostalgia for the past and admiration for its achievements.

Equally powerful is the belief that certain ways of treating religious subjects themselves have religious significance. In the creation of an image of Shiva (14) or a Christian Orthodox icon (15) it is important, not to show originality which would be inappropriate or even blasphemous, but to come as close as possible to an ideal derived from previous likenesses.

Less high-minded, but increasingly common with the growth of a longing for the past, has been the production of close substitutes for the limited supply of genuinely old things: 'antique' furniture, 'Renaissance' jewellery and 'Georgian' houses. In its ultimate form this results in the popularity of replicas, objects which depend for their appeal

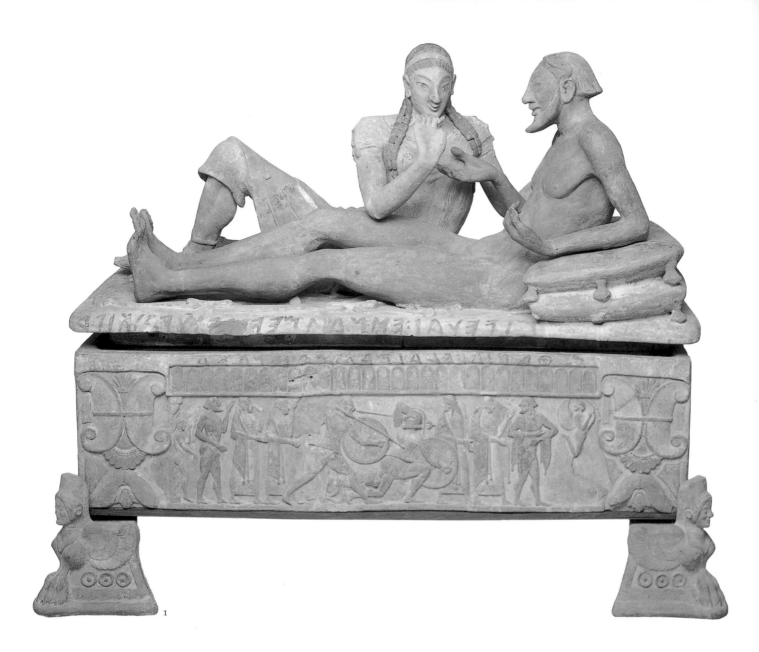

entirely on their ability to evoke some part of the magic of the original (23–27).

It is here that copying comes closest to faking, not only because legitimate copies, as the objects shown here demonstrate (18–22), can come to deceive, but also because the skills used in their manufacture are precisely those called upon by dealers who wish to have damaged objects faked up into something more saleable and new ones forged. When a craftsman makes a table in Louis XVI style (22) and sells it as modern to a dealer, the table is an imitation, not a fake. When the dealer then sells it as an eighteenth-century piece does it become a fake, or is the intention of the maker all important? If so, what should we call the subsequent pieces made by the same craftsman after he has become aware of the dealer's dishonesty?

Questions like these are the subject of the final section of this chapter (28–33), which looks at the difficulties in distinguishing between originals, copies and fakes which result from the widely different conceptions of authenticity reigning in different fields.

1 'Etruscan' terracotta sarcophagus

This splendid *tour de force* came to the British Museum in pieces in 1871, was assembled here and bought two years later, together with a huge collection of classical objects, from the dealer Alessandro Castellani (see 151f, 172, 289). He had himself acquired it from one Pietro Pennelli, who told him that he had excavated it at Cerveteri, the ancient Caere, in Etruria. Within a year of its purchase the inscription on the lid was condemned as a copy from one on a gold brooch in the Louvre. In 1875 Pietro's brother Enrico claimed that he had made the sarcophagus. Pietro denied this fiercely and

threatened legal action against Enrico, who retracted his statement at that time, although he repeated it later. The British Museum preferred to regard the sarcophagus as ancient, although conceding that the inscriptions might be false; but generally outside the Museum its authenticity was doubted. Intended to be an Etruscan work of the sixth century BC, like the Campana sarcophagus also from Cerveteri, now in the Louvre, the pose of the figures on the lid and the nudity of the man are unparalleled, and the dress of the woman, apparently in nineteenth-century underwear, is unlike anything known from antiquity. The reliefs on the chest are based upon Athenian black-figure vase-paintings of a more archaic form than is suggested by the figures on top. The fired-on coloration includes lead, unlike the coloured terracottas of the sixth century BC. It seems very likely that the sarcophagus was modelled and broken up before firing (the firing of such a piece whole would be technically difficult).

It was not until 1935, some sixty years after its acquisition, that the Cerveteri sarcophagus was taken off public exhibition, having in the meantime appeared in countless popular books on the Etruscans and their art. DMB

1300 × 1600 × 900mm
BM GR 1873. 8–20. 643 (Catalogue of Terracottas B630)
LITERATURE A. Andrén, *Deeds and Misdeeds in Classical Art and Antiquities*, Partille 1986, pp. 67–8 with bibliography

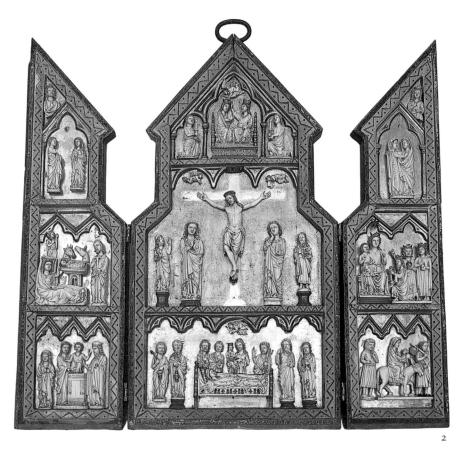

2

2 Medieval triptych with fake ivory figures

Purchased by the British Museum at Christie's in 1858 from the Falcke sale, the triptych had previously been in the collection of Dr Böhm of Vienna, probably by the 1830s, at which time it was furnished with a splendid provenance: it was said to have been presented in the mid-fourteenth century by the Pope to the Emperor and that documents proved it to have been given by an empress to a convent in the fifteenth century; Dr Böhm claimed to have bought it from a superior officer in the army who had acquired it at the suppression of the convent during Joseph II's reign. False royal and papal provenances filled out with local colour have often been attached by collectors and dealers to objects, whether genuine or fake. In this case it is likely that the carver of the ivories sought a commensurately princely sum for his work. He even included a small parcel of relics (probably in themselves 'genuine'; for

relics see 64, 65), housed within the Virgin Mary's bed in the scene of her Dormition.

The British Museum bought the triptych for its ivories; it was judged to be a virtually unique survival of a large-scale Gothic ivory tabernacle with original wooden frame. Ironically, the Museum's purchase turned out well for the wrong reasons. Although the ivories are historicist fakes, the wooden triptych is indeed medieval. On the reverse of the two wings are paintings of four standing saints (Catherine, Nicholas, Margaret and Martin), which were recognised in the 1960s as some of the most important surviving German panel paintings of the mid-thirteenth century (the interior was repainted and gilded when the faker added the ivories).

The intellectual climate of Strasbourg from the time of Goethe's residence there in the 1770s was highly receptive to the neo-Gothic, and this piece may be an exceptionally early Upper Rhenish 'Gothic Revival'

restoration of a medieval object. These ivories are in style unlike the usual 'Paris-style' Gothic ivory fakes (191–3), though a standing figure in the reserves of the Cleveland Museum of Art is by the same hand. Absurdities of costume and eccentric attributes have been introduced, while anachronistic *genre* details abound, but we can still admire the historical knowledge of the carver who adopted the late Romanesque style of Rhenish sculpture, exactly the stylistic phase which corresponds to that of the genuine paintings. He worked in exceptionally large pieces of elephant ivory and his figures had in many places to be cut or adjusted to fit within the original frame, but if we ignore details, the total effect of the altarpiece is now very much as it must have been originally, with applied ivory figures and relief groups against painted backgrounds. NS

H 940mm
BM MLA OA1343 (Ivory catalogue no. 390)
LITERATURE P. Pieper, 'Zwei deutsche Altarflügel des 13. Jahrhunderts im British Museum', *Niederdeutsche Beiträge zur Kunstgeschichte* 3 (1964), pp. 215–28; exhibition catalogue, *Die Zeit der Staufer* I, Württembergisches Landesmuseum, Stuttgart 1977, no. 432

3 Marble portrait bust of 'Clytie'

Purchased in Naples in 1772 from the Principe di Laurenzano, and known as 'Clytie' after the nymph turned into a flower for unrequited love of the sun-god Helios, this bust became Townley's favourite sculpture; it was the only marble he took with him when forced to flee his house during the Gordon Riots of 1780.

The name, if inaccurate, is suitably romantic. It is difficult to reconcile the subject's sensual appearance with its modern identification as the younger Antonia (36 BC–AD 38), daughter of Mark Antony and mother of the Emperor Claudius. Jucker's publication of the bust in 1961, enthusiastically endorsing a Claudian date, was much criticised. Several scholars have since claimed 'Clytie' as an eighteenth-century rococo work.

The marble is probably Parian, and if so it must have been quarried in antiquity, since the underground

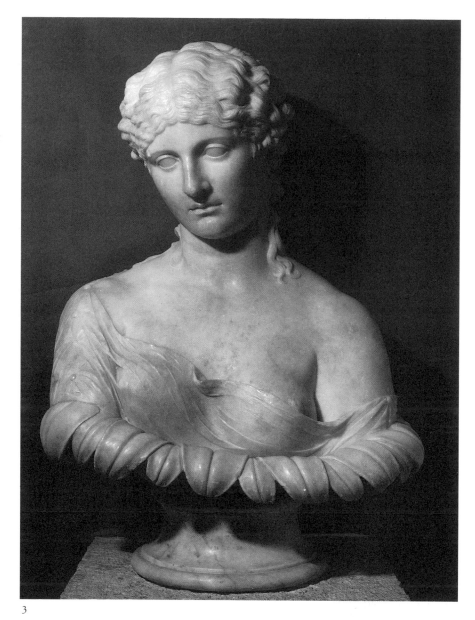

3

quarries were not again worked until the nineteenth century. The finish on the underside of the lotus leaves, which retain traces of encrustation, also speaks for an ancient origin. However, it is likely that much of the surface of the portrait was reworked to enhance its erotic appeal. The model for this transformation of Roman matron to nymph may have been the 'Flora Farnese', a colossal restored figure celebrated from the sixteenth to the late eighteenth centuries for its erotic associations.

Originally the subject may have worn a heavier and less revealing tunic, such as that worn by an

unknown Neronian woman, portrayed in a marble bust now in Sir John Soane's Museum, London. Doubted by those who would have 'Clytie' a forgery, this portrait resembles the more extravagant representations of women at the courts of Caligula, Claudius and Nero.

The extent to which its transformation enhanced 'Clytie's' appeal is demonstrated by its appearance in gems, some of which may have been engraved before 1774 while the portrait was still in Italy, in cameos produced in the 1850s and 1860s, in G. F. Watts's unclothed marble version of 1867, in porcelain

figures made by the firm of Copeland from 1855, and in the popular British Museum replicas on sale today (24b). sw

Greyish medium-grained marble, probably Parian. H 570mm
BM GR 1805. 7–3. 389 (Catalogue of Greek Sculpture 1874)
LITERATURE H. Jucker, *Das Bildnis im Blätterkelch*, Basel 1961, pp. 64–7, no. St. 1; H. Ost, *Falsche Frauen*, Cologne 1984, *passim*; B. F. Cook, *The Townley Marbles*, London 1985, p. 15

4 The 'Tiara of Saitapharnes'

When it was acquired by the Louvre in 1896 this ceremonial cone-shaped helmet, richly decorated with several concentric bands of ornament, was thought to be a head-dress offered to the Scythian King Saitapharnes by the inhabitants of the city of Olbia in the Crimea. There is an inscription to that effect in Greek characters on the castellated wall separating the two figural zones of decoration. The large central band depicts two famous episodes from the *Iliad*. On one side Agamemnon surrenders the captured Briseis to Achilles, seated on a throne. On the other side Achilles pours a libation before the funeral pyre of Patroclus. The lower band shows scenes of hunting, the taming of horses and animal combats.

The appearance of this object on the art market at the very end of the nineteenth century coincided with important discoveries of the previously little-known art of the Scythians, nomadic horsemen and archers who settled in South Russia between the seventh century BC and the first century AD. The establishment of Greek colonies on the Black Sea coast led to the mingling of Greek and Scythian elements in the art of the region, especially in goldsmiths' work, in which significant advances were made in the fourth century BC.

The 'Tiara of Saitapharnes' soon aroused great interest, but many experts had doubts and reservations. The Berlin scholar Adolf Furtwängler was the first to demonstrate that the object was a fake by pointing out that it combined elements from different periods of antiquity. Contemporary periodicals bear witness to the violent

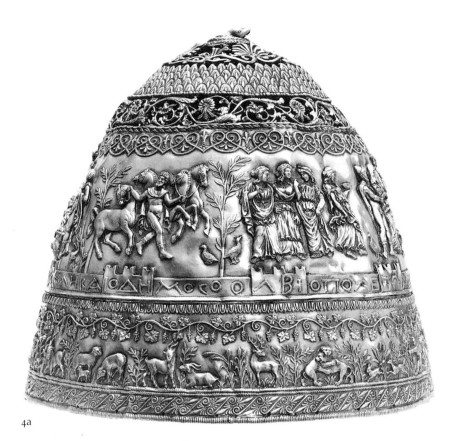

4a

clashes between the tiara's supporters and its opponents; these continued until 1903, when a fraudulent claim to its authorship by an artist from Montmartre elicited a letter to *Le Matin* from a Russian goldsmith living in Paris, who claimed that his good friend Israel Rouchomovsky (a Russian goldsmith working in Odessa) had made the tiara. Rouchomovsky was summoned to Paris and convinced an independent enquiry, conducted by Clermont-Ganneau, professor at the collège de France, that the tiara was his by making part of the object (miniature replicas were made later: see b). It then emerged that Rouchomovsky had made the tiara a few years previously for a dealer of Otschakov named Gokhman (see also pp. 166–7), who had brought him some supposedly ancient fragments as inspiration, together with the books that Rouchomovsky used to invent the decoration of the tiara, viz: N. Kondakof, J. Tolstoi and S. Reinach, *Antiquités de la Russie Méridionale* (Paris 1891, p. 298) and L. Weisser, *Bilderatlas zur Weltgeschichte* (Stuttgart 1884, pls 19 & 20).

Taking advantage of the publicity

surrounding this academic controversy, Rouchomovsky exhibited his 'archaeological-style' objects at the Paris Salon in May 1903 and was awarded a prize medal for them; ironically, they included a rhyton (drinking horn) and pectoral that had appeared as antiques on the Paris art market in 1897–8. CM

4a Gold repoussé sheets, soldered together. H 175mm; w 180mm (max) Musée du Louvre, Paris. MNC 2135.

4b Miniature gold tiara, with repoussé relief decoration. H 40mm
BM MLA 1986, 10–21, 1. Raphael Bequest

LITERATURE M. Collignon, 'Tiare en or offerte par la ville d'Olbia au roi Saïtapharnès', *Monuments Piot* VI (1899), pp. 5–57, with complete preceding bibliography; S. Reinach, 'La tiare dite de Saïtapharnès' *Revue Archéologique* II (1903), pp. 105–12; 'The tiara of Saitapharnes' *Les Arts* (May 1903), pp. v–xi; A. Vayson de Pradenne, *Les Fraudes en Archéologie Préhistorique*, Paris 1932, pp. 519–73

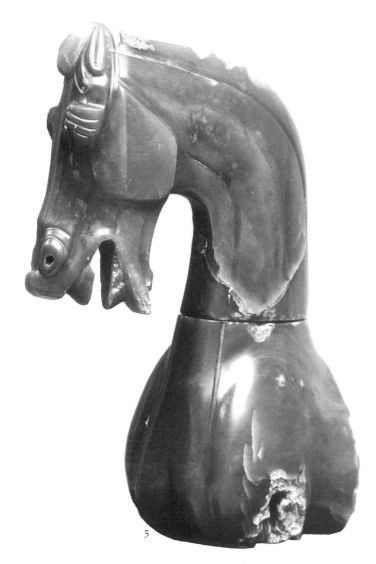

5

was as a forgery of exceptional quality
that the Victoria and Albert Museum
acquired it for £84 (a price comparable
to that paid for genuine Renaissance
pieces) in 1869. MPJ

Marble. H 455mm; W 405mm
V&A 38–1869
LITERATURE A. Foresi, *Tour de Babel*, Paris &
Florence 1868, pp. 43–7; J. Pope-Hennessy,
The study and criticism of Italian sculpture,
New York 1980, pp. 257–8

7 Imitator of Sandro Botticelli, *Madonna of the Veil*

This painting was purchased in 1930,
without an established provenance, by
Lord Lee for $25,000. At the time an
enthusiastic Roger Fry acknowledged
it 'as by the master', and it was
published in 1932 by the Medici
Society, whose directors 'felt that they
could not lose the opportunity of
making this masterpiece available to
all'. It had by then been restored, but
photographs recording the location
and extent of the damage show that it
could have been caused by
mechanically induced fractures, losses
and abrasion. After the Second World
War examination of areas of
undisturbed 'original' paint revealed a
number of inconsistencies in both
materials and technique, pointing to a
late nineteenth- or early twentieth-
century origin. The blue of the
Madonna's robe, which should be a
thickly applied and coarsely ground
mineral – either lapis lazuli or azurite –
was identified as finely ground
prussian blue, a pigment introduced
only in the eighteenth century; the
brown in the background trees has the
appearance of the commonly
discoloured green copper resinate, but
is rendered in an earth pigment, raw
or burnt umber. The features are,
technically, incorrectly painted; for
instance, the dark line of the lips,
which should be in thick pure
transparent madder, is implausibly
rendered in black. The woodworm exit
holes, now filled, were drilled into the
painted surface, causing radiating
stress cracks to develop around them.

The still unidentified forger did not
base his composition on a single
original, but has fused elements from
several pictures to create an acceptably

5 Carving of a horse's head

This jade head was the subject of a
famous dismissal by innuendo in the
autobiography of Orvar Karlbeck
(1880–1967), a Swedish railway
engineer turned archaeological
entrepreneur, who claimed to have
seen it immediately following its
manufacture in Peking in the 1930s.
However, Karlbeck's unpublished
field reports to his Western clients
reveal that the piece had already
entered the London collection of
George Eumorfopoulos (1862–1939)
before his first reference to it in 1931. As
the recent progress of archaeology has
broadened the canon of early Chinese
art it has become increasingly evident
that the head is in fact a rare survival
of Han jade sculpture, about
200 BC–AD 200. CC

H 140mm
V&A A.16–1936. Eumorfopoulos Collection

6 Portrait bust of Lucrezia Donati

From the mid-nineteenth century
early Renaissance sculpture was in
great demand and short supply. The
Florentine dealer Giovanni Freppa
found a solution to this problem in the
sculptor Giovanni Bastianini, who
worked for him turning out low-reliefs
and portrait busts (see also 208a) from
about 1850 to 1867.

Among the most successful of the
latter was this bust of a young woman,
which he presented as a portrait of
Lucrezia Donati, famous as the
mistress of Lorenzo the Magnificent.
The well-known art historian
Cavalcaselle was overwhelmed with
admiration when he saw it. He
recognised in it a masterpiece by Mino
da Fiesole and offered to place it on
exhibition in the Bargello.

Alessandro Foresi, who acquired it
at a high price from Freppa,
discovered that it was a forgery, and it

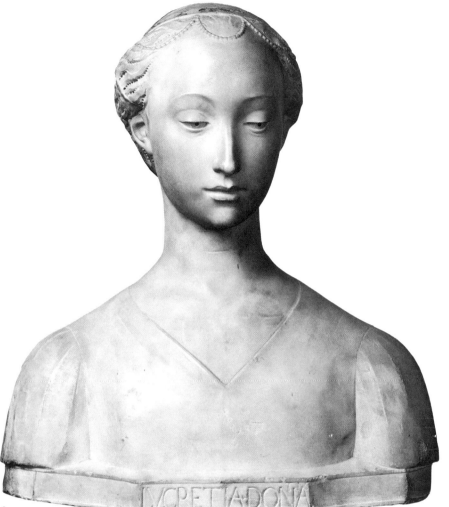

6

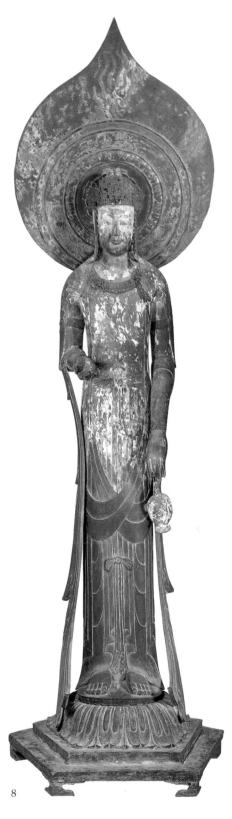

8

typical early 'Botticelli'. Inevitably though, he was unable to suppress the unconscious imprint of his own times; the Madonna can be seen, now even more clearly with the passage of time, to reflect the notions of beauty embodied in the screen goddesses of the 1920s. It is said that it was this observation, made impressively close to that time by the young Kenneth Clark, that first raised doubts about the painting's authenticity. RBG

Tempera on panel. 882 × 458mm
Courtauld Institute of Art, University of London

Illustrated on p. 28

8 Replica of the celebrated Kudara Kannon in the Hōryūji temple, Japan

The custom of replicating objects for religious veneration is very old in Japan. In the Kamakura period (AD 1185–1333) there was a virtual mass-production of certain images. In the Sanjūsangendō hall in Kyoto, for example, one can still see the thousand standing gilt-wood images of the 'Thousand Armed Kannon' Bodhistattva made during the Kamakura period. Exact copies of important statues are being made today with traditional tools and traditional techniques in order to ensure the preservation of the image and for display in the growing numbers of local museums in Japan.

Like the seventh-century original, this wood replica of the Kudara Kannon statue in the Hōryūji temple is, apart from the arms and the draperies hanging from the shoulders, carved from a single huge block of camphor wood. The replica was made in the 1920s by the sculptor Niiro Chūnosuke over a period of two years, so faithfully that only by scientific examination could the copy be distinguished from the original.

The Bodhisattva is known as the Kudara Kannon after the ancient Korean kingdom of Paekche (Japanese Kudara), whence the sculpture was once thought to have originated. However, it differs in several respects from other seventh-century figures in the Hōryūji collection which have a clearly Korean inspiration. The body is altogether more adult and graceful, and the half-smile is more gentle than the 'archaic smile' common to most Asuka period wood and bronze sculptures. The Kudara Kannon is not mentioned in any temple document before the seventeenth century, and its origin is still something of an enigma. VH

Wood with gesso and pigments and gilded bronze fittings. H 3100mm
BM JA Replica OA+8

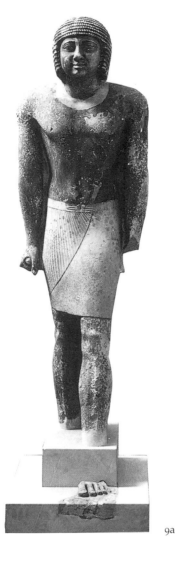

9a

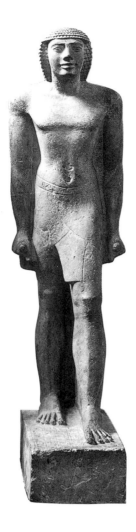

9b

Tradition and revival

9 Archaism in ancient Egypt: statues of Nenkheftka, *c.* 2400 BC, and Tjayasetimu, *c.* 630 BC

The period from about 700 BC to the Roman conquest witnessed a remarkable revival in Egyptian art, seemingly stimulated by the Nubian rulers who gained control of Egypt towards the end of the eighth century BC. One of the most influential factors in this revitalisation of art was the so-called 'archaising tendency', a harking back to the glories of what were regarded as the 'golden ages' of Egypt's past – the Old, Middle and New Kingdoms. The monuments of those periods were studied in detail and those qualities considered to be their finest were imitated in contemporary art, architecture, writing and religion. This was not done with any intention to deceive, but rather out of respect and admiration for the great achievements of the past, and out of a desire to identify the present more closely with those earlier epochs.

Nowhere is this tendency more apparent than in private sculpture. The statue of the priest Tjayasetimu (b), which would have been placed in a temple to enable the owner's spirit to partake of the offerings, is clearly copied from the tomb statues made for private individuals in the Old Kingdom. That of Nenkheftka from Deshasha (a), is an excellent example of such a figure. The sculptor of the late statue has copied both the stiff formal pose, with left foot advanced and arms held rigidly at the sides, and the simple costume, reproducing carefully the short curled wig, fashionable in the Old Kingdom but not usual in the Late Period. Archaising sculptures of the 25th and 26th Dynasties are sometimes such successful imitations of earlier works that dating would be difficult were it not for the inscriptions, which provide essential clues. Since there is no reason to suppose that the texts of the present statue were later additions, the name of the owner, Tjayasetimu – not attested before the Late Period – is a reliable guide, while among his titles is that of Priest of the statues of King Psammetichus I (664–610 BC), demonstrating that the figure cannot be dated earlier than the middle of the seventh century BC. JT

9a Tomb statue of Nenkheftka, 5th Dynasty, *c.* 2400 BC
Limestone. H 1220mm
BM EA 1239

9b Statue of Tjayasetimu, 26th Dynasty, *c.* 630 BC
Limestone. H 1260mm
BM EA 1682

LITERATURE H. Brunner, 'Archaismus', in *Lexikon der Ägyptologie* I, Wiesbaden 1975, cols 386–95

10 Herm of Dionysos, god of wine: a Roman copy of a Greek original

This herm was found with another, also representing Dionysos, by labourers trenching a vineyard at Baiae on the Bay of Naples in 1771. Both sculptures were purchased at their find-spot by a Dr Adair, probably Robert Adair (d. 1790), the subject of the sentimental ballad *Robin Adair*. He brought them to England, and after his death they were acquired by the collector Charles Townley.

Dionysos is here shown as a mature figure with a full beard and long curls bound around the crown by a simple fillet. The lateral branches of the herm were carved separately and are now missing. The chiselwork on the locks of hair and beard was evidently intended to reproduce the effect of engraved bronze. The harshly classicising features are less successfully translated from bronze to marble. The head is nonetheless an excellent Roman copy of classical Greek work. Regarded by the nineteenth-century sculptor Adolf Furtwängler as a copy of a lost work by the Greek sculptor Myron, the head has now been recognised as relating to one of the classical Greek bronze figures recently recovered from the sea near Riace (Calabria). These have been associated with the fifth-century BC Athenian master Phidias and his school.

Herms were dedicated by the Greeks to protect boundaries. At first only the god Hermes, protector of boundaries, was represented in this way, but from the fourth century BC other deities appeared as herms. In the Roman period herms became popular as decorative sculptures, and even for portraits. In this herm of Dionysos Roman appreciation of Greek art is clearly expressed. The sculptor may be associated with a workshop of Roman copyists active in Baiae and the surrounding area in the second century AD, a period of great interest in classical Greek culture. SW

Coarse-grained marble, probably from Thasos. H 2406mm
BM GR 1805. 7–3. 64 (Catalogue of Greek Sculpture 1608)
LITERATURE B. F. Cook, *The Townley Marbles*, London 1985, p. 56 and fig. 53, p. 57; G. Dontas, 'Considerazioni sui bronzi di Riace', in P. Pelagatti (ed.), *Due Bronzi da Riace. Bollettino d'Arte. Serie Speciale* II, Rome 1985, pp. 277–96, esp. 282, figs 6–7; C. Gasparri, 'Una officina di copisti in età medio-imperiale', in S. Walker & A. Cameron (eds) *The Greek Renaissance in the Roman Empire*, forthcoming, London 1989

11 Chinese altar vessel of the 12th to 14th century AD, imitating a ritual vessel of about 1100 BC

Under the Song Emperor Huizong (r. AD 1101–25), ancient bronze ritual vessels were deliberately collected as models for new bronzes to be employed on altars for the Imperial sacrifices to Heaven. Similar copies of ancient bronzes were also used on household altars or in small temples. The older of these two bronze vessels (a) is a sacrificial wine vessel, known as a *hu*, the Shang period (*c.* 1100 BC). The later vessel (b) copies the oval cross-section and s-curved profile accurately and like the original carries two lugs. Although difficult to read, the design on the later bronze includes a monster face around the main part of

10

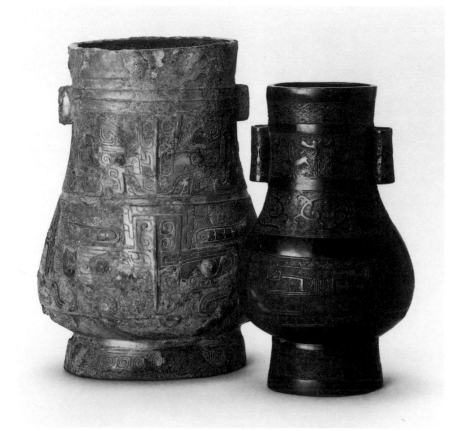

11a,b

13 Ming dynasty bowl and a modern copy

During the 1980s strenuous efforts have been made in China to establish the types of bodies and glazes employed by craftsmen at different periods to make their highly accomplished and elegant ceramics. Much of the impetus behind this endeavour has been the wish to replicate the ancient wares for sale commercially. Copies of blue and white porcelain from Jingdezhen have only slowly been developed and on a small scale (b). They are easily identified, not only from their slightly inferior painting but above all from their very thick and clumsy potting. More successful imitations are currently being made in Taiwan. JR

13a Ming dynasty, 15th century AD
Porcelain. D 195mm
BM OA 1975. 10–28. 18. Addis Bequest

13b Made in Jingdezhen in Jiangxi province, 20th century
Porcelain. D 218mm
BN OA 1983. 2–3. 1

The sacred image

14 Hindu iconography: two bronze figures of the god Shiva

These two representations of Shiva as Nataraja (Lord of the Dance), though separated by eight centuries, show the deity in the same position, carrying the same attributes; further, both dance on a figure symbolising ignorance and are surrounded by fire. In Hindu tradition the effectiveness of icons depends on reproducing the divine image prescribed by writings such as the *agama* texts, which explain how each form of the deity should be depicted. TRB

14a South India, early Chola, *c*. AD 930–40
H 280mm
BM OA 1969. 12–16. 1. Brooke Sewell Fund

14b South India, 18th century AD
H 475mm
BM OA 1880. 445

the body which emulates faces, later known as *taotie*, on ancient pieces. The Shang *hu* type would originally have had a lid. However, later bronze-casters probably did not know this, and none of the surviving copies have lids. The lid was in keeping with the ancient function of this vessel type as a flask for wine in the ceremonies in which food and wine were offered to ancestors. It would have conflicted with the later function of such vessels, which was to hold flowers. JR

11a Shang *hu*, *c*. 1100 BC
Bronze. H 298mm
BM OA 1956. 10–16. 1. Given by P. T. Brooke Sewell

11b Altar vessel, 12th–14th century AD
Bronze. H 280mm
BM OA 1989. 3–9. 1

12 *The Nymph of the Luo River*, late Ming or early Qing dynasty

This is one of several paintings illustrating the theme of the Nymph of the Luo River, the subject of a famous prose poem entitled *Luo shen fu* by Cao Zhi (AD 192–232) in AD 232. The poem describes an encounter between a man of high position and a bewitching river-goddess. The figures are portrayed with the fine even-width linear style that can be traced back to the artist Gu Kaizhi (*c*. AD 344–*c*. 406), to whom other versions of this work are attributed. Most notable among these is a handscroll in the Freer Gallery of Art, which is thought to be a Song dynasty copy of an earlier work. The present painting does not bear any attribution or signature, and it may be regarded as the rendering of an ancient theme in the style of an early master, painted without any intent to deceive. The brush style used in the landscape setting suggests that it may have been painted in the sixteenth or seventeenth century. AF

Handscroll, ink and colours on silk.
536 × 8215mm
BM OA 1930. 10–15. 02
LITERATURE T. Lawton, *Freer Gallery of Art. Fiftieth Anniversary Exhibition: II. Chinese Figure Painting*, Washington 1973

12

13a,b

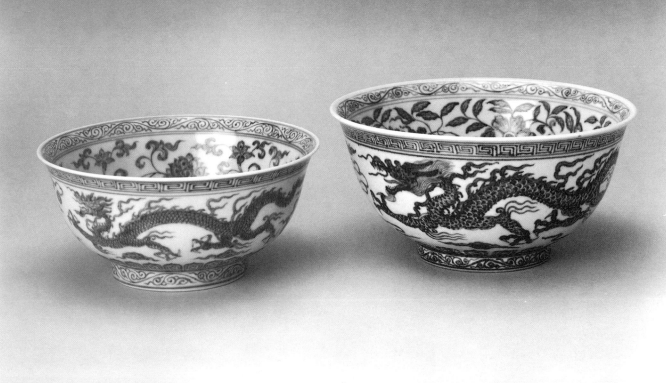

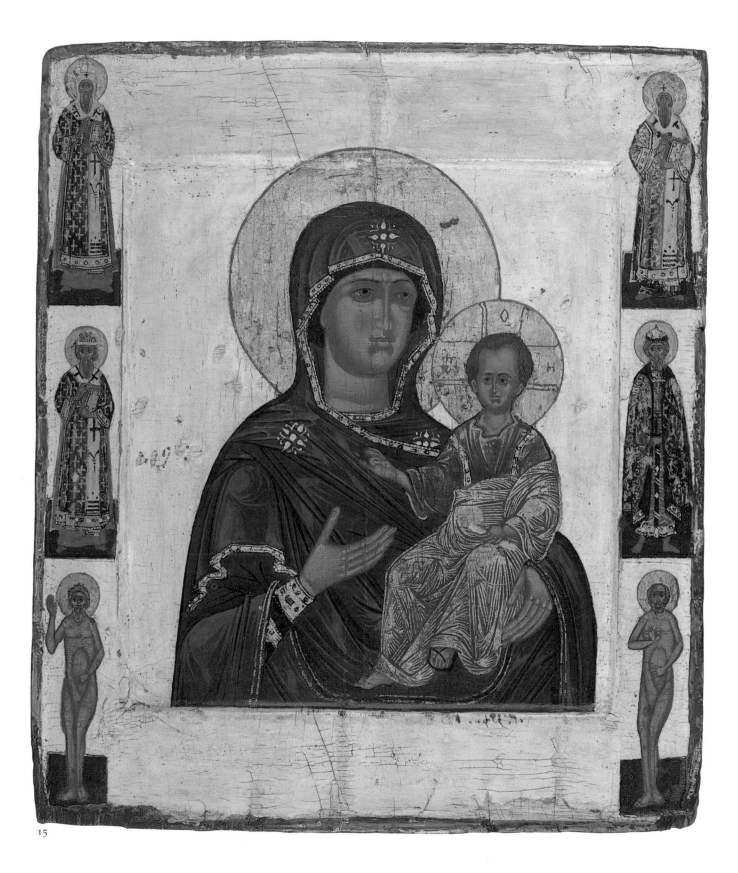

15

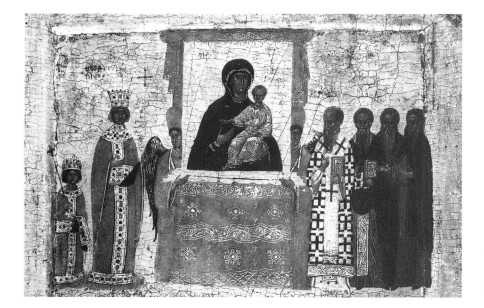

Fig. 1 Icon of the Triumph of Orthodoxy, depicting in its upper register the icon of the Mother of God *Hodeghetria*. See 15
BM MLA 1988, 4–11, 1.

Learning from the master: artists' copies

Copying has always been a fundamental element in the training of painters. From early Renaissance times, when paper became generally available for the first time in Europe, apprentices had to draw copies of a wide range of material. By the sixteenth century this could include prints, drawings, paintings, sculpture and casts.

Pupils were also made to copy works by their masters. Copying was an obvious method of achieving a uniformity of style within a single studio, and masters were in fact permitted to market studio productions as their own work. The guild system established such practices as the norm, and they were continued by the academies of art that supplanted them.

In the field of Old Master drawings early copies of good quality have often been accepted as originals which has resulted in considerable confusion. The problems began at an early date when connoisseurs, including Giorgio Vasari in the sixteenth century, were misled into believing that some copies were autograph drawings by well-known masters. The most deceptive were probably made by pupils who not only worked in the same style, but who would also have had access to the same materials as their more celebrated masters. The attributional problems could be exacerbated by old inscriptions which were thought to be signatures or seemed to provide some reliable indication of authorship. If sometimes fraudulent, speculative or over-optimistic, these annotations were often intended only to preserve the name of the designer of

15 Eastern Orthodox icons: the Mother of God of Smolensk

In the Christian Orthodox world the religious image became almost as sacrosanct as the text of the scriptures, and generation after generation of artists strove to make accurate reproductions of established 'portraits' and compositions. A good illustration of this phenomenon is provided by one of the most popular images of the Mother of God with the infant Christ, which has been faithfully reproduced for countless centuries. The icon of the Mother of God *Hodeghetria* ('She who shows the Way') was believed to have been painted from life by St Luke; according to tradition it was sent from the Holy Land to Constantinople in the mid-fifth century AD. Once there it became the palladium of the city, credited with the defence of the walls on a number of occasions, in particular with the repulse of the Saracens in AD 718. Eventually it acquired its own church, in the Hodegon monastery, built between AD 842 and 867.

From AD 1000 onwards the *Hodeghetria* was often mentioned in chronicles. It was carried in processions, used as a battle-standard, and deeply venerated. After the Crusaders had captured Constantinople in 1204 the icon was removed from a hiding-place in the principal church, Hagia Sophia, and installed in the Venetians' church in the Pantocrator monastery; one of the first acts of the Byzantines on recapturing their city in 1261 was the ceremonial return of the *Hodeghetria* to its proper place. The icon did not survive the fall of Constantinople to the Turks in 1453.

The *Hodeghetria* was evidently very large. An early fifteenth-century description of a weekly procession says that 'the icon works great miracles and heals many sick and exhausts the four men who carry it'. Before its destruction it was depicted in another icon, now in the British Museum; here, mounted on a dais, hung with draperies and supported by two angels, it is the object of veneration by the most illustrious figures of Church and State (fig. 1).

The iconography of the Mother of God *Hodeghetria* was carefully copied throughout eastern Christendom. One of the most notable copies, in the cathedral of Smolensk, was – true to its model – credited with turning back the enemy, this time Napoleon in 1812. The subsequent demand for copies of the Mother of God of Smolensk meant a new wave of popularity for the image said to have been a portrait painted nearly two thousand years ago by St Luke. DB

Russian, early 17th century AD
Egg-tempera and gold leaf on gesso and linen on wood. 314 × 271mm
Mark Gallery, London

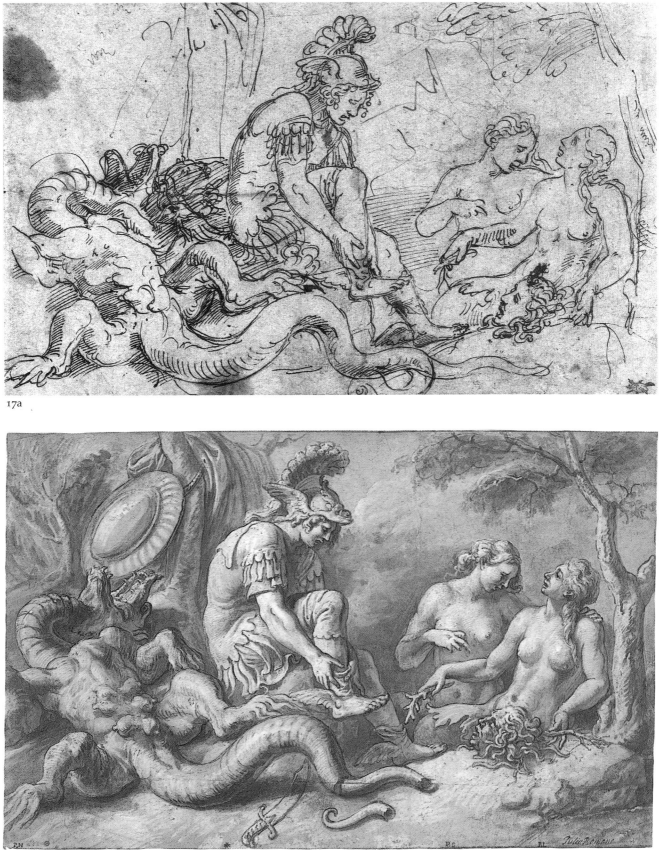

17a

17b

the composition rather than the draughtsman. Until the nineteenth century a lower premium was attached to the autograph quality of the execution; the authenticity of the design or composition was often paramount. Nevertheless, these inscriptions further obscured the issue, and the art market had little incentive to question their validity.

Connoisseurs have also to be alert to the possibility that a drawing has been retouched by another hand. Rembrandt, for example, corrected sketches by his pupils, and sometimes his intervention was extensive. Rubens reworked or improved numerous drawings by earlier masters in his collection (17b). He also restored missing sections, making little or no attempt to disguise his own style. As far as we know, Rubens presents an unusual case, though eighteenth-century artists are known to have elaborated older drawings in order to enhance their market value.

The confusion caused by copies remains a major obstacle to the compilation of catalogues raisonnés of most artists' drawings. The authenticity of many sheets are questioned on the grounds that they may be early copies of good quality. On other occasions the emergence of a superior version of a drawing has led to the demotion of what had been a highly regarded 'original' to the status of copy. MRK

16 After Rembrandt, *Esau selling his Birthright to Jacob*

Attributed to Rembrandt (1606–69) on entering the British Museum, albeit with some doubt, this drawing (a) was recognised in 1906 by C. Hofstede de Groot as a copy of Rembrandt's original, now in the Historisch Museum, Amsterdam (b). A large number of such copies of subject drawings by Rembrandt survive, suggesting that he asked his pupils to copy them. MRK

16a After Rembrandt
Pen and brown ink with brown wash, heightened with white, over light

indications in graphite. 189 × 160mm
BM PD 1873. 5–10. 3544 (H 129). Presented by J. H. Anderson Esq.

16b A photographic facsimile of Rembrandt's original 166 × 157mm
BM PD 1906. 1–11. 15

17 Giulio Romano, *Perseus disarming, and the Origin of Coral* and a copy reworked by Rubens

17b records a composition by Giulio Romano (*c.* 1499–1546), also known through a preparatory study by Giulio himself (a), probably made while he was working on the Camerino dei Cesari in the Palazzo Ducale in Mantua. The copy, to judge from the rather pedestrian outlines in pen and ink, was originally an undistinguished replication of Giulio's work by some unknown follower, but has been transformed in quality by the vigorous and extensive additions made with the brush, which for stylistic reasons have been attributed to Rubens 1577–

1640). Many drawings reworked by Rubens in a similar fashion are known, often, as here, by or after Italian artists whose work he especially admired. Clearly, the authorship of such a drawing can cause confusion; when it entered the British Museum, it was thought to be by Giulio. MRK

17a Giulio
Pen and brown ink, with traces of black chalk, on blue paper. 192 × 316mm
BM PD 1895. 9–15. 645 (P&G 87)
17b After Giulio
Pen and brown ink, reworked by Rubens in brown, yellow and grey washes, with white bodycolour, on faded blue paper. 250 × 393mm
BM PD 1851. 2–8. 322

Collectors' copies

18 Marble portrait head of 'Germanicus'

This head, apparently a portrait of a member of the Julio-Claudian dynasty of the late first century BC or early first

18

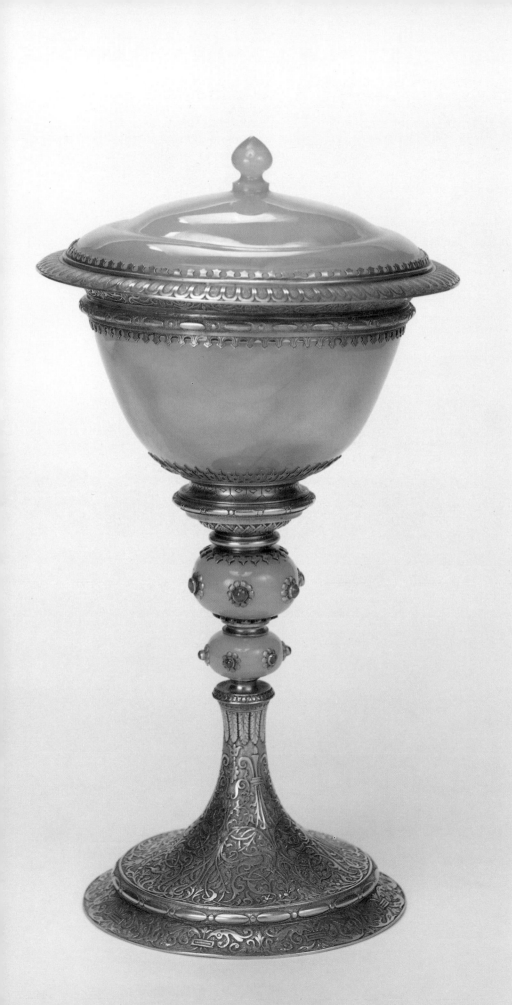

century AD, was said to have been found at Broadbridge in Sussex some time in the mid-nineteenth century, and spent some decades thereafter in a rockery. It was attached to a green marble bust by a twentieth-century owner. The portrait was acquired by the British Museum in 1961 as an import into Britain of the Roman period, a claim strengthened by the proximity of its alleged find-spot to the site of the early Roman palace at Fishbourne. It was published as an ancient portrait of Germanicus in authoritative works on art in Roman Britain, even though doubts about its antiquity had already been expressed. It now seems that it is one of a series of such portrait busts, none of which has a find-spot demonstrating its antiquity beyond doubt and which are probably Italian classicising pieces, perhaps dating from the seventeenth century. Such series, often intended to stand in niches in the library of some wealthy nobleman, were not intended to be deceptive but, as the history of this example shows, time and chance can make them so. CJ

610 × 320mm
BM PRB 1961. 11–3. 1
LITERATURE K. Painter, 'A Roman marble head from Sussex', *Antiquaries Journal* XLV (1965), pp. 178–82; K. Painter, 'Roman sculpture from Hampshire, Somerset, Wiltshire and Sussex', *British Museum Quarterly* XXXVI (1971), p. 36

19 Renaissance Revival cup and cover

This exotic cup and cover was made as part of the furnishings of Fonthill Abbey, the dramatic Gothic Revival mansion which William Beckford (1760–1844) created to house his celebrated collection. Beckford possessed a large number of mounted ceramic and hardstone vessels, some of which were genuinely medieval or Renaissance; others, like this piece, were created – often using ancient carved hardstone or ceramic – to the design of Beckford and his Portuguese companion, Gregorio Franchi. The silver-gilt mounts were made in 1815–16 by James Aldridge, whose mark they bear, but the agate cup and cover are eighteenth century.

 This cup, along with many others,

passed after Beckford's death to his daughter, the Duchess of Hamilton, and was sold in the Hamilton Palace sale of 1882. It was purchased from the sale by the Victoria and Albert Museum for £562. 4s. as a genuine Renaissance object, but soon the true date was discovered and it was taken off display. Once its true importance as an early example of the Renaissance Revival in metalwork was established in 1970 a search lead to its rediscovery in the stores of the Sculpture Department and it was displayed once again. CW

Indian hardstone (agate, chalcedony, ruby) and silver-gilt. H 241mm; W 140mm
V&A 428–1882
LITERATURE *Catalogue of the Pictures. Works of Art and Decorative Objects the property of his Grace the Duke of Hamilton . . . Christie . . . June 17 1882*, lot 2031; C. Wainwright, 'Some objects from William Beckford's Collection now in the Victoria & Albert Museum', *Burlington Magazine* CXIII (1971), pp. 254–64; M. Snodin & M. Baker, 'William Beckford's Silver', *Burlington Magazine* CXXII (1980), nos 932 & 933, 735–48, 820–34

20 Renaissance Revival ring by F-D. Froment-Meurice

This finger-ring was purchased by Lord Londesborough for his wife in Paris in 1852 as a Renaissance work. A year later, however, in the catalogue of Lady Londesborough's collection the ring was described as doubtful. It was later acquired by A. W. Franks, and entered the British Museum in the Franks Bequest in 1897 as 'modern French'. It is only in recent years that it has been recognised as identical to a ring by the celebrated firm of F-D. Froment-Meurice (1802–55), aptly described by Victor Hugo as 'the Cellini of nineteenth century goldsmithing', exhibited along with other 'bijoux renaissances' in Paris in 1844. At the Great Exhibition in London of 1851 Froment-Meurice won a prize medal and his jewels were widely illustrated in both French and English journals. In such circumstances it seems extraordinary that this ring could be passed off as sixteenth century. To a modern eye the modelling of the figures and the form of the bezel, with its armorial bearings, are indisputably nineteenth

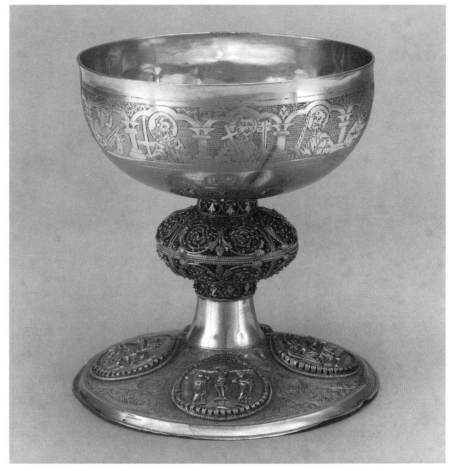

21

century. It is interesting to note that the idea of flanking figures derives from fanciful designs for rings such as those engraved by Pierre Woeriot in the late sixteenth century. Renaissance pattern-books were probably more widely used as inspiration both for revivalist jewellers and forgers than actual surviving pieces. JAR

Oxydised silver, partly gilded. D 30mm
BM MLA AF2578. Franks Bequest
LITERATURE T. Crofton Croker, *Catalogue of a collection of ancient and medieval Rings and Personal Ornaments formed for Lady Londesborough*, privately printed 1853, no. 211; H. Vever, *La Bijouterie Française au XIXe Siècle*, I, Paris 1906, 180; C. Gere in *The Ring from Antiquity to the Twentieth Century*, London 1981, no. 288

21 Copy of the Romanesque chalice in the Holy Apostles' church, Cologne

The gilt-silver chalice in the Holy Apostles' church, Cologne, which

dates from about 1230, was one of the most celebrated of Romanesque liturgical objects. In the 1850s it was published by, and cast for, the scholar Franz Bock of Aachen. By the 1860s it was already a source of inspiration for neo-Romanesque goldsmiths' work, by Martin Vogeno in Aachen, Gabriel Hermeling in Cologne and Franz Xaver Hellner in Kempen, and its influence continued unabated, for instance from the 1870s onwards in the Düsseldorf workshops of C. A. Beumers and H. J. Wilms.

This copy of the Holy Apostles' chalice was bought by A. W. Franks, the first Keeper of British and Medieval Antiquities of the British Museum, as a genuine Romanesque chalice, and he bequeathed it as such to the Museum in 1897. Indeed, it was still considered genuine in the Museum's silver catalogue of 1928. But it is very doubtful whether it was originally

intended to deceive; it is much more likely to be one of the earliest of the numerous German nineteenth-century copies of Romanesque metalwork, such as that published by Franz Bock in his *Die Goldschmiedekunst des Mittelalters* (Cologne 1855, pp. 17–20, no. 4) and *Das heilige Köln* (Leipzig 1858, nr. 92, pl. XXVIII). Unfortunately, we do not know when or where Franks bought his chalice. This would be of particular interest because the original in Cologne had a new stem added above the filigree knop at some unknown date before 1858. In a copy of 1863 at Kleve/Kellen by Hellner of Kempen this added stem is already replicated (K. B. Heppe, in *Kunst des 19. Jahrhunderts im Rheinland*, Düsseldorf 1981, vol. 5 'Kunstgewerbe' p. 37, pl. 6). Since the British Museum copy does not include this added stem, it is tempting to suggest that it was made at the very moment that the unknown goldsmith had the original chalice in his workshop for restoration, before adding the new stem. NS

H 168mm
BM MLA AF3043 (Silver catalogue no. 13).
Franks Bequest
LITERATURE H. Schulte, *Sakrale Goldschmiedekunst des Historismus im Rheinland. Ein Beitrag zur Gestalt und Geschichte retrospektiver Stilphasen im 19. Jahrhundert*, Inaugural-Dissertation zur Erlangung des Doktorgrades der Philosophischen Fakultät der Westfälischen Wilhelms-Universität zu Münster, 1985, pp. 243–9. (The author is grateful to Dr Norbert Jopek for information incorporated in this entry.)

22 Late 19th-century English copy of a French 18th-century table

This table is one of a pair acquired in 1911 by the Victoria and Albert Museum as French, of the 1770s, and displayed as such. In 1921 Thomas Ross informed the Museum that the tables had been made by his father Donald Ross (*c.* 1830–1916), who was in business as a cabinet-maker from 1855; from 1866 to 1886 he operated at 13 Denmark Street, Soho, producing furniture both on his own account and for such well-known dealers as Edwards & Roberts and Duveen.

Numbers of Ross's pieces have passed through the market in recent years and some may still be thought to be eighteenth century. They are often decorated with his 'Ross mosaic', which he copied from the French 'dotted marquetry trellis work' of the 1770s, and, like this table, carry gilded brass mounts made by his special technique. This particular piece is closely based upon a genuine French table by P. Garnier (V&A 1169–1882), acquired as part of the Jones Collection by the Victoria and Albert Museum in 1882. It seems likely that Ross had 'restored' furniture now in the Jones Collection. CW

Mahogany with marquetry of various woods; gilt-brass mounts.
700 × 413 × 366mm
V&A W.47–1911

Replicas and facsimiles

23 Replicas of Greek and Roman objects

From the period of the Grand Tour until the present day there has been a demand by travellers for souvenir copies of antiquities; museums and collectors have also wished to acquire replicas of well-known objects. In the late nineteenth and early twentieth centuries especially foundries and electrotyping firms produced huge numbers of copies, many of which, their origin having been forgotton, appear as antiquities in collections, dealers' stock and museums. Several foundries were based in Naples, including the firms of J. Chiurazzi & Son, S. de Angelis & Son, and G. Sommer & Son. All these issued printed catalogues of their bronze products, which could be purchased in different sizes and different surface finishes; marble copies of certain items could also be acquired. The selection here includes the 1911 catalogue of the combined firms of Chiurazzi and de Angelis (a), with some of their products – a lamp (b) and some surgical instruments (c), the originals of which were found at Pompeii. Other workshops, including perhaps Sommer, made terracotta versions of pottery lamps and vases (f,g); many of these were after the antique, rather than direct copies. An Italian foundry made the splendid tripod table (d), the

23d

original of which was said to be from the Isis temple at Pompeii, but is perhaps from Herculaneum; this copy was acquired by the Royal Scottish Museum in 1870.

Even more ambitious, and catering for interior decorators as much as collectors, is the 1910 catalogue of the Cologne firm of August Gerber (e). From about 1880 this establishment supplied copies in marble, bronze, granite, ivory, and so on, of a vast range of ancient and modern works, from the gable figures of the temple of Aphaia at Aegina, to Lorenzo Ghiberti's door of the Baptistry at Florence (5.5m high), to Canova's Cupid and Psyche, to products of the animaliers.

Very fine electrotype reproductions were made by several firms, including the Württembergische Metallwarenfabrik (h), which made copies of the Hildesheim Treasure and E. Gilliéron's versions of Mycenaean and Minoan objects (i,j).

The British Museum itself formally established a cast service in 1835 and

this was operated between 1857 and 1880 by D. Brucciani: his 1867 cast-list is included here (k). He operated outside the Museum's premises, but after his death the cast service became in-house for long periods, although at other times outside agencies undertook the supply of British Museum casts. DMB

23a Chiurazzi–de Angelis catalogue, 1910
BM GR Library

23b Bronze lamp in the form of a sandalled foot
L 158mm
D. M. Bailey

23c Bronze catheter and a pair of forceps
L 260mm, 195mm
BM GR 1920. 7–17. 5 & 4

23d Bronze Tripod table
920 × 600mm
Royal Scottish Museum

23e Catalogue of the replicas made by the firm of August Gerber, 1910
BM GR Library

23f Terracotta lamp with head of Julius Caesar
L 105mm
BM GR 1983. 7–28. 5

23g Terracotta lamp with a scene of St Peter meeting Christ outside Rome
L 132mm
BM GR 1988. 7–23. 1. Given by Miss J. Schottlander

23h Catalogue of replicas made by the Württembergische Metallwarenfabrik
BM GR Library

23i Mycenaean dagger
Designed by E. Gilliéron of Athens and made by the Württembergische Metallwarenfabrik. Based on a dagger of the mid-16th century BC found at Mycenae in Grave Circle A by H. Schliemann; the handle is an imaginative reconstruction
L 324mm
BM GR 1913. 11–19. 3

23j Fragment of a cup with relief decoration of the siege of a city made by the Württembergische Metallwarenfabrik. The original silver cup fragment with gold details, of the mid-16th century BC, was found in Grave Circle A at Mycenae
H 95mm
BM GR 1908. 12–30. 16. Given by Miss Hutton

23k Catalogue of the plaster casts made by D. Brucciani for the British Museum, 1867.
BM GR Library

24 British Museum replicas

The first British Museum replicas were produced in the early 1960s, when two new materials, silicon rubber and polyester resin, allowed the production of copies much closer in appearance to the original than the plaster casts which the Museum had

23e,j,a (*back row*); g,f,b,h (*middle row*); i (*centre*); c (*front*)

been producing and selling for the previous hundred years. Silicon rubber is used to make extremely accurate and flexible moulds which permit multiple casts to be taken, and to the versatile resin composition can be added powders of marble, limestone, granite, bronze and brass to give the appearance and feel of the object reproduced. The casts are finally given the most careful finishing and skilfully patinated to the required high standard. LB

24a Egyptian cat with 9ct gold ear-rings
The original cat was cast in bronze, with gold ear-rings, and was a votive offering in the form of the animal sacred to the goddess Bastet. It was produced during the Saite Period, about 600 BC.
H 165mm
British Museum Publications

24b 'Clytie' (see 3)
H 695mm
British Museum Publications

24c Aphrodite
The original in bronze dates from the 2nd or 1st century BC, and is an eastern representation of the Greek goddess of love. It was found at Satala, modern Sadagh, in north-east Turkey.
H 425mm
British Museum Publications

25 A colour woodblock print of Toshūsai Sharaku and a modern facsimile

In response to the huge demand for old Japanese prints at the end of the nineteenth century – mainly from European collectors – reproduction editions were issued using the same woodblock printing techniques but cutting new sets of printing blocks. Sometimes these facsimiles were stained with tea and mounted with old brocade covers in an attempt to dupe unsuspecting collectors.

The facsimile (b) of a print (a) by the great mystery artist of the Ukiyo-e (Floating World) school Toshūsai Sharaku (worked 1794–5) was commissioned with no such underhand motive by the Tokyo National Museum from the Adachi Woodblock Printing Institute in 1949. It reproduces an extremely rare print from the original 1794 edition in the Museum's collection which portrays two popular Kabuki actors, Nakamura Tomisaburō I and Ichikawa Komazō II,

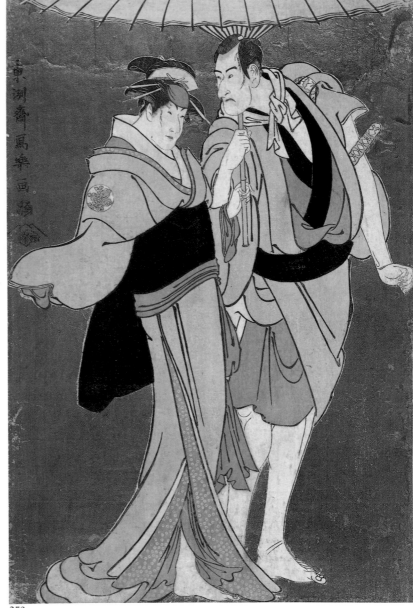

25a

48

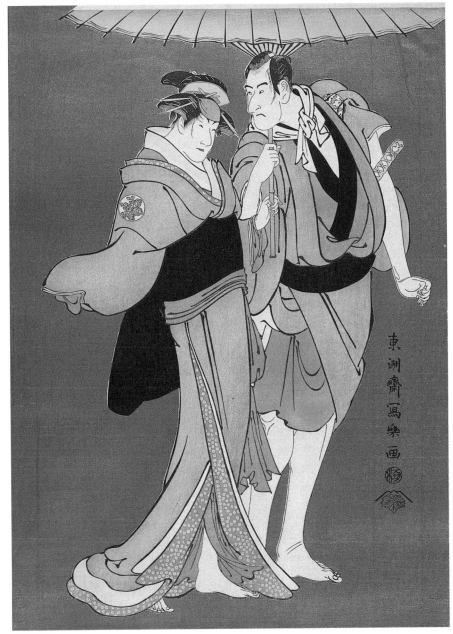

25b

as the lovers Umegawa and Chūbei on their way to commit love suicide together. The facsimile was engraved and printed using traditional techniques with a high degree of reverence and faithfulness to the original; the arrangement of stray hairs around the faces, for example, is identical. Interestingly, the makers of the facsimile chose to match the faded colours of the Tokyo National Museum impression rather than restore the bright blues and purples of the original edition. TC

25a Original
360 × 238mm
BM JA 1909. 6–18. 55

25b Facsimile
387 × 270mm
BM JA OA+056

Collotype and photogravure facsimiles
26–7

In the later nineteenth century newly invented photomechanical processes made it possible to produce facsimiles of prints and drawings of a quality and accuracy that had scarcely been considered possible before. Of these processes the most important were the two represented here (26,27).

Collotype is a curious process developed in France in the 1860s and taken up and used extensively in Britain by the Autotype Company from 1870. It uses a film of reticulated gelatine on a sheet of glass as the actual printing surface. The gelatine is bichromated and as such sensitive to the light which is projected onto it through a photographic negative of the work that is to be reproduced. The gelatine hardens in proportion to the transmitted light, and what remains soft is washed away before printing. Collotype is ideal for reproducing the soft lines of chalk or pencil and watercolour washes, and was therefore very much employed for facsimiles of drawings. In the example here (26b), the main difference from the original (26a) is that the facsimile is in ink of slightly

the wrong shade of red, and the texture of the chalk is flattened.

Photogravure, developed by the Typographic Etching Co. from 1872, also works by exposing a sheet of bichromated gelatine to light transmitted through a photographic negative. This time, however, the gelatine is laid onto a copper plate; the hard parts that remain after the soft gelatine is washed away can be used as an etching ground, the lines of the design being bitten into the plate. The plate can then be inked and printed in exactly the same way that the original had been. This process is ideal for reproducing etchings and engravings, as the result and indeed the method is so close to the original.

Both processes had been fully developed by the later 1870s, and print rooms around the world hastened to publish their chief treasures in this form. This allowed rare works which could not usually be exhibited to become widely accessible to artists and students, and was seen as part of a museum's educational mission. Since the image was the important thing, such reproductions were usually issued in loose sheet form in portfolios with a minimal text. The British Museum produced two series (from which these specimens are taken): that of drawings came in four portfolios published between 1888 and 1894, while that of prints ran to three series with twenty-five parts issued from 1882 to 1913. To avoid any danger of confusion with the originals, each print was stamped on the verso with a special mark *British Museum facsimile* in a cartouche. They are without question the best facsimiles that have ever been published of this collection, even if, as in the case of the early Dutch print, the opportunity was taken to tidy up the very damaged original. AVG

26 Carel Dujardin (1622–78), *Self Portrait*, 1658

304 × 229mm

26a Original, in red chalk
BM PD 1836. 8–11. 325. Sheepshanks Collection

26b Collotype facsimile, from *Reproductions of drawings by old masters in the British Museum*, part III, 1893

27 Master Iam of Zwolle (active late 15th century), *The lamentation over the dead Christ*

258 × 293mm

27a Original engraving
BM PD E1–198

27b Photogravure facsimile, from *Prints in the British Museum reproduced by photogravure*, new series, part II, 1889

Problems of authenticity

The authenticity of a work of art depends on the relation between the work itself and the artist to which it is attributed. A portrait painted entirely by Rubens is more of a Rubens than one in which he painted the face and an assistant the rest, while a portrait produced by others, under his direction and in his studio, is described not as a Rubens but as 'Studio of Rubens'. A copy of a painting by Rubens is just that, but if it is made in order to pass as a Rubens it is a fake. A damaged painting by Rubens that has been deceptively restored so as to lead the buyer to believe it all in Rubens's own hand is also a fake, even though in some areas or beneath the restoration Rubens's own brushwork is still extant. It would be nonsense to talk about a work as a 'Rubens' if it was painted by somebody else. Such an object could at best be an imitation; if it claimed to be a Rubens it would be a fake.

Yet in printmaking and sculpture such claims are made without any such consequence. In printmaking, for example, the artist's role is to create the printing matrix, whether it is a copper plate, a woodblock, or a lithographic stone. But the work of

art is not the printing matrix: it is each and every impression printed from this matrix onto a sheet of paper. An impression, however badly taken, from a plate, however worn and defaced, is still a work by the artist who produced the plate in question. A reproduction, even if far more faithful to the original intention of the artist, is not.

With sculpture the situation is even more complicated. The great majority of carving in stone, at least until the nineteenth century, was not done by the artist, but by his assistants, using a pointing machine (see p. 252) to transfer the model into the marble, which was then finished by hand. The artist frequently played no part in this process but the work was his because it derived from his model and reflected his conception. This does not mean that a marble group by, for example, Rodin is classified as a copy after a model by Rodin (though that is precisely what it is). The marble group is the work of art: the sculptor's model bears the same relation to the finished work as the print engraver's matrix to a print. There is, even so, an element of deceit here, particularly when, as in Rodin's work, the deliberately unfinished chisel marks in the stone promise the viewer the direct insight into the creative process afforded by the deliberately visible brushwork of an Impressionist painting. As Bernard Shaw reported, after sitting for his portrait: 'Rodin told me all modern sculpture is imposture; that neither he nor any of the others can use a chisel'.

Bronzes, which ironically became popular in the late nineteenth century precisely because they translated the sculptor's modelling more directly into the finished work than marbles, present a similar problem. Like prints, bronzes are multiples, but because they are made in a mould taken from the model they do not wear it out in their making. The twentieth in an edition of bronzes need be no

inferior to the first, and a bronze made a century after the artist's death need be no inferior to one made during his lifetime. Yet those who deal with sculpture are less than happy about describing a posthumous cast from a sculptor's model as being by that sculptor (see 28).

The problem presented by J. S. G. Boggs's drawing of a banknote (32) is quite different from that of prints and sculpture. In this case the drawings in question are undoubtedly from the hand of the artist who signed them and so are authentic works of that artist. The problem arises with the artist's subject matter and the fidelity with which he has represented it. An artist who draws a horse is seldom accused of faking a horse, but one who draws a banknote can be charged with a criminal offence.

With the African festival masks (33) the problem is inverted; the authenticity of the object, in the eyes of Western collectors, rests not on its authorship but on its use. In theory at least, two masks made by the same person at the same time can fall into two separate categories – as though a religious painting by Rubens were genuine if placed in a church but not if sold to a secular buyer.

28 Bronze statuette of the Hon. Mrs George Howard by Jules Dalou (1830–1902)

Problems of authenticity affecting sculpture in bronze arise from the fact that artists normally rely on specialist foundries to translate their models into metal. Henry Moore, for example, had many of his larger works cast in Germany. The artist may, but need not, participate in finishing a bronze after it is cast and will usually, but not always, check its quality and patination before it is sited or delivered. The first large cast of Rodin's *Penseur*, taken from a model enlarged threefold from the earlier version by an assistant, was sent

directly to the United States unseen by the artist.

What then is the status of a cast made after the artist's death? One of these two bronzes of Mrs George Howard by Jules Dalou was delivered by the artist to his patron in 1872 and remains in the possession of his successors (a). It is undoubtedly the original and definitive work (which the model of course was not, being only part of the preparatory process which led to its production). There are also a number of other casts, in bronze and terracotta, made for other members of the sitter's family, which are also authentic works by Dalou. The Victoria and Albert Museum possesses yet another cast (b), made by the same founder, Enrico Cantoni, working from the same original plaster as before, with the original patron's permission, but after Dalou's death.

Is this an original bronze by Dalou or not? Would it be less original than one which, in Dalou's lifetime, was delivered direct to the patron unseen by the artist. If not, and if we make more casts now, will they be originals too?

Questions of this kind continually confront dealers in and collectors of bronzes. Numerous unauthorised casts, often from original models, have been made and these when detected are usually denied the status of originals. Many however, the Australian National Gallery among them, accept authorised casts of Rodin's and Dalou's work made as recently as 1970s as originals. Others, like Barbara Hepworth, who left specific instructions that no editions of her work should be completed after her death, take a different view of posthumous work.

Such ambiguities continue to create problems for a market in which buyers are paying not for a realised concept (the market in copies, however, good, is weak) but for a direct link with the hand of the creator. MPJ

H 521mm

28a From the collection of the Hon. Simon Howard, Castle Howard

28b V&A A.1–1985

LITERATURE A. F. Radcliffe in *The Treasure Houses of Britain*, Yale 1985, no. 566

29 Variations on a figure from Giorgione's *Madonna and Saints*

The fortunes of the panel painting *A man in armour* (a) illustrates some of the difficulties in deciding when a copy becomes a fake. The subject is a variant of a figure in Giorgione's *Madonna and Saints* in the Duomo at Castelfranco in Italy, and the painting was indeed once believed to be by Giorgione, perhaps an original study for the Castelfranco altarpiece. It was most recently catalogued, by Cecil Gould, as likely to be a deliberate fake of Giorgione's work, probably dating from the seventeenth century. It is also possible, as he recognised, that the painting is an innocent imitation – in the absence of information about the maker's intentions we can never be sure – but what is clear is that throughout the sixteenth and seventeenth centuries there was a strong demand for Giorgione's work, which was in very limited supply and was consequently extensively imitated and faked.

Most probably the painting had, by the early seventeenth century, found its way to France where, in the 1630s, Cardinal Richelieu commissioned a series of portraits for his 'Gallery of illustrious men'. Philippe de Champaigne, who contributed to this series, was criticised by contemporaries because his portraits were not authentic: he was accused of doing them from imagination rather than from documented likenesses. His portrait of Gaston de Foix, a seventeenth-century print of which is included here (b), may have been a copy of *A man in armour*. If this was a fake, it was so because its claim to be a likeness of Gaston was false. Neither Champaigne nor de Vulson, who published the engraving, mentioned Giorgione, but Michel Lasne, another seventeenth-century French engraver, gave the image added attraction by endowing the male figure with a halo and attributing the composition to Raphael.

By 1816, when 29a was exhibited at the British Institution in London, it belonged to Benjamin West. Again accepted as a Giorgione, it entered the National Gallery in 1855. Shortly afterwards, in 1866, the Victoria and

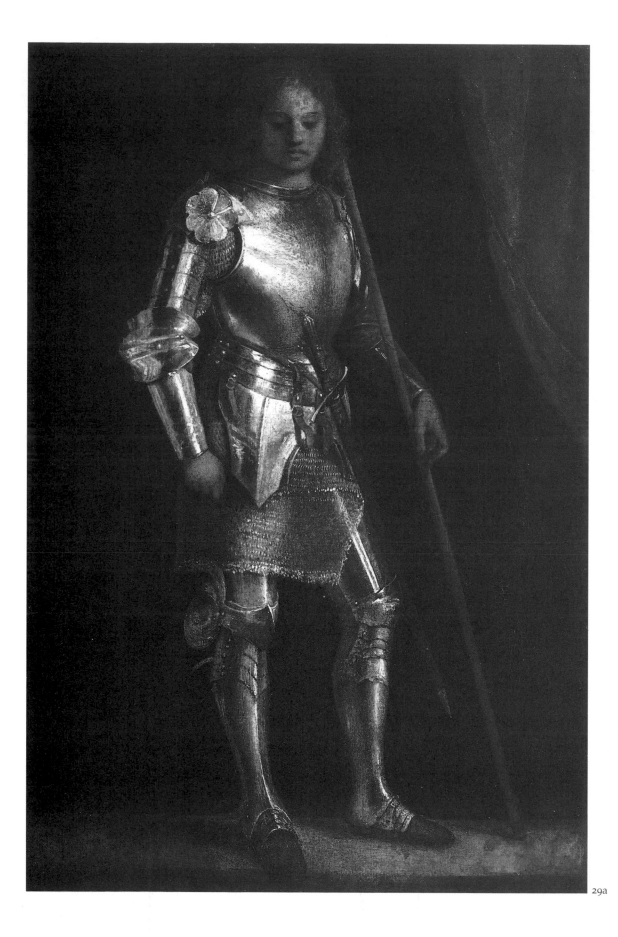

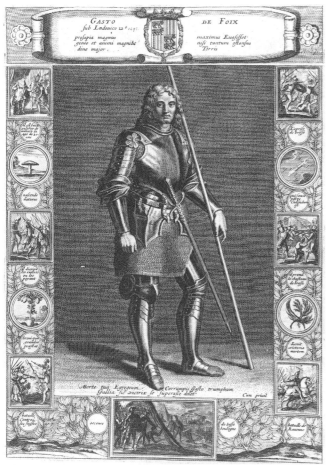

29b

29c

Albert Museum acquired a copy of it (d).

All four versions raise problems about the assessment of authenticity. Since we can never know the intentions of the painter of 29a we will never be sure whether it is a fake or an honestly admiring variation on a theme. What might in the seventeenth century have been regarded as a false portrait of Gaston de Foix (b) would today be thought of as a genuine seventeenth-century engraving. 29c is certainly not a Raphael but it is a perfectly genuine print by Lasne. The four versions also raise questions about what difference such judgements make to the status of the works involved. Even if the National Gallery picture was from the outset a fake it is still a much more influential and historically important work than the honest Victoria and Albert Museum copy. MPJ

29a After Giorgione, *A man in armour*
Panel. 390 × 260mm
National Gallery, 269

29b After Philippe de Champagne, *Gaston de Foix*
Engraving. 410 × 288mm
BM PD 1870. 10–8. 1123

29c Michel Lasne, 'after Raphael', *Saint*
Engraving. 397 × 277mm
BM PD v5–134. Sloane Collection

29d 19th-century copy of 29a
Canvas. 413mm × 282mm
V&A 251–1866

30 Rembrandt *Christ healing the sick*: the 'Hundred Guilder print'

Throughout the eighteenth and much of the nineteenth century this was the most famous of Rembrandt's prints. It gained its familiar soubriquet from a story, which can be traced back to the early eighteenth century, that Rembrandt himself had paid this very high price in order to buy back an impression. The popularity of the print was to lead to a very unusual history for the plate.

30a is a fine early impression printed from the copper plate soon after Rembrandt had finished working on it. The 'burr' caused by the drypoint work can be clearly seen: the ridges of copper thrown up by the artist's sharp point hold much ink which prints as a rich smudge. By the time the later impression (b) was printed, perhaps in the early eighteenth century – long

after Rembrandt's death – the burr had completely disappeared, flattened by the pressure of the printing press, and many of the drypoint lines had been worn away by repeated wiping of the plate. The result is a ghost compared with early impressions, and as such much less interesting to collectors. In consequence many of these late impressions were faked up to look like early ones (c): the composition was 'refreshed' in brush and ink.

By the second half of the eighteenth century the plate was so worn that there was little to be gained by printing it any longer. At this point it fell into the hands of Captain William Baillie (1723–1810), an Englishman who as an amateur printmaker had made a large number of plates in many different techniques. He set himself the task of reworking the original plate with his own etching and drypoint tools, and bringing it back to the state in which it had been left by Rembrandt in 1649. His success can be judged in 30d. Although the result looks slightly more like a Rembrandt than 30b, contemporaries had no difficulty in deciding that the result was a Baillie rather than a Rembrandt, and the plate ended its days ignominiously cut into pieces which were then printed separately.

Other admirers of Rembrandt confined their efforts to making straightforward copies on other copper plates. One such is 30e, which is so poor that it can readily be distinguished from an original. Other copies of simpler plates can be very deceptive indeed, and have often passed for originals; some of these were certainly made with intent to deceive, others simply as *tours de force* of skill on the part of the copyist.

The invention of photography in the nineteenth century introduced a new factor. The process of photogravure (f) allowed a new plate to be made by photographic means from a negative taken from a fine original impression. This plate was then printed by hand in exactly the same way that Rembrandt had printed his plate in the 1640s.

A history as complicated as this produces considerable problems for the concept of originality: 30b is unquestionably an original, and the

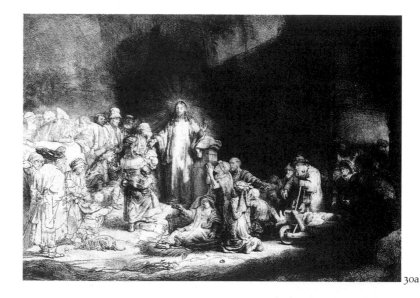

30a

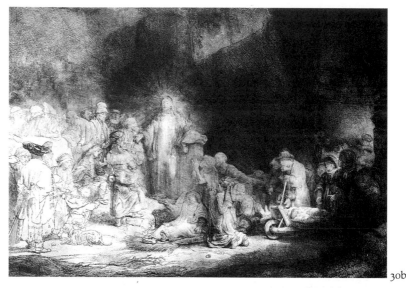

30b

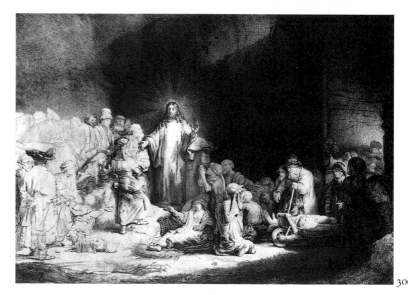

30c

the Bank of England nevertheless went ahead with a private criminal prosecution that came to court at the Old Bailey in November 1987.

There Boggs's lawyer argued that 'not even a moron in a hurry' could mistake these drawings for the real thing since *inter alia* they were quite obviously drawings, were one sided and were signed J. S. G. Boggs. Three leading figures in the art world Michael Compton (ex Tate Gallery), René Gimpel (gallery owner) and Sandy Nairne (Director of Visual Arts at the Arts Council) testified that it would be quite incorrect to describe an artists' drawing of an object as a reproduction of it.

The jury seems to have agreed: Boggs was acquitted. But that the Bank of England's view of his drawings, which presumably rests on the belief that they are sufficiently close to being fakes to represent some sort of threat to the public interest, is shared elsewhere is indicated by the fact that in 1989 Boggs was once again threatened with prosecution, this time in Australia. MPJ

77 × 146mm
Private Collection
LITERATURE L. Weschler, 'Onward and upward with the arts', *New Yorker* (18 and 25 January 1988)

33 Three versions of an African ritual mask

For ethnographers the authenticity of an object depends not on the identity of its maker but on the intention with which it was made and the use to which it was put. *Chi wara* masks are traditionally made by the Bambara people of Mali in West Africa for ceremonial use, but here only 33a has the pegs which would have attached it to a basketwork cap enabling it to be worn; 33b lacks them, and so must have been made for sale to tourists. Even if the two masks had been made at about the same time, in the same place and by the same artist, this would mean, for the Westerner, that one was authentic, the other not.

The third object (c), a carving made for tourists in Torajaland, Indonesia, is clearly based on a *chi wara* figure,

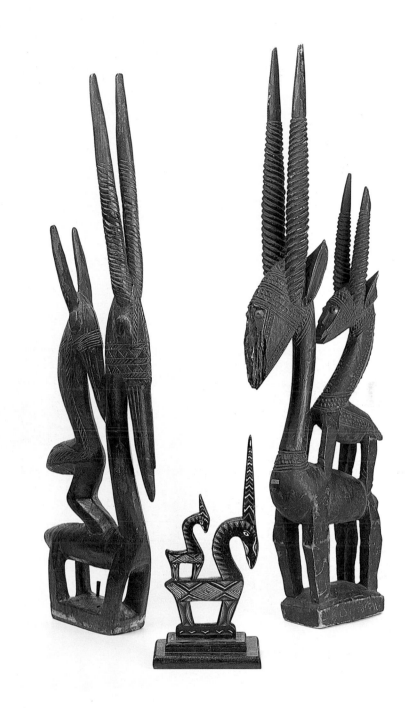

33a,c,b

presumably from a book illustration, reinterpreted in the two dimensional polychromatic style typical of Toraja art. The authenticity of this piece is guaranteed to a tourist buyer by the label on its base which informs the purchaser that it is a registered design and that unauthorised copying constitutes a breach of copyright. NFB

33a *Chi wara* ritual mask
H 750mm; W 210mm
BM ETH 1956. Af27. 8. Donated by Mrs Webster Plass

33b *Chi wara* mask made for sale
H 795mm; W 260mm
BM ETH 1984. Af11. 9

33c Toraja version of *chi wara* mask
H 280mm; W 130mm
M. McLeod Esq.

Late Blighters Final

Evening Standard

Black-out To-night

Black-out To-morrow

No. 35,941 LONDON, SATURDAY, 17. FEBRUARY 1940 ONE PENNY

The Massacre of the R.A.F.
Secret session of Parliament demanded

Premier perturbed – one out of ten planes only return. Another Cabinet reshuffle in sight

Despite the Hush-Hush tactics on the part of our defence chiefs the true facts of the air war situation are gradually leaking out. At the Air Ministry a secret report has been prepared which contains the true balance of the war in the air.

Our airforce has not only lost a perturbing number of its most up-to-date bombers and fighters, but a far higher percentage of its crack flyers than has been admitted. The policy of publishing a weekly casualty list containing between two or three score names of the dead and missing will be overhauled completely. It has misled even people of high rank into a far too optimistic attitude as regards Britains true position.

Everybody of course is aware of the fact that the German claim of having shot down 36 out of a total of 44 British bombers in that famous air battle over the Bight of Heligoland is perfectly correct.

But it now transpires that the German airforce does not publish all the losses of its British adversaries. If a flight of British machines is destroyed without trace, no report is given. The underlying idea of this policy is to overawe the British people with concealed terror. The only source of information for people on this side are rumours.

People ask what has happened to pilot officer so and so, and nobody knows anything at all. He is missing, that is all. *The whole matter is to be the principal question for the next secret session of the House of Commons.*

M. P.s who were at first inclined to disbelieve these hair-raising stories have meanwhile come round to regard the present state of affairs as highly disquieting.

In Whitehall there reigns an atmosphere of gloom. Mr. Kingsley Wood, who *is conducting a sort of personal investigation,* feels that he has been misled by certain subordinate quarters. The Prime Minister is said to be rather uneasy.

Apart from the losses of the R. A. F. in action, the numbers of machines and men "destroyed" in accidents has been very high. Whereas the normal losses in training were expected not to exceed a certain figure per week, it is now reported that this estimate has been at least trebled.

His last Trip to the Front

Mr. Hore-Belisha enjoying Paris

Some of the not very distant relations of Mrs. Oliver Stanley, Lady Wood and Lady Primrose, are seen here discussing the more intimate aspects of the war. You see them both worried. They realise that the dismissal of Mr. Hore-Belisha brings the more delicate issues connected with Jewish influence in Britain to the fore. They represent, so to say, the hidden hand in Downing Street, and, as we say, "Some" hand too.

Is Britain at war with Denmark?

The by now famous exploit of the R. A. F. against the German Northsea coast has been a colossal geographical error. The planes purported to have attacked the island of Sylt and to have damaged the Hindenburg Damm have in reality attacked the Danish island of Roem. Although the Danish Government has treated the incident with commendable reserve, because the damage done to Danish property was comparatively slight, it may be pertinently asked „Are we at war with Denmark? And if so, why?"

Britain no longer secure
Government prepares flight to Canada

As the „Evening Standard" is able to reveal, the British Government are preparing to go to Canada when the grim phase of the war, as predicted by the Prime Minister in his Mansion House speech, is about to begin. The Majority in the Cabinet consider Britain as no longer secure. They have come to the conclusion that a real aerial attack on the British Isles, even if it were strictly limited to military objectives, would create such general disorganisation and chaos, that it would be better to establish a political nerve centre outside of Britain.

The Royal Family would, of course, have to leave the country too. The Royal Tour undertaken last year is regarded as a full dress rehearsal for what will happen in the not too distant future. The Royal Party and the Government would on this occasion be found on men of war. The only ship available is the Battle Cruiser Renown. The Hood and Repulse are undergoing what is politely described as their annual overhaul. They are in Dry Dock, extensive repairs have been necessary after the devastating hits by German bombs and torpedoes.

Meanwhile Mr. Chamberlain is busy forming a shadow Government for the Home country. Obviously the Chiefs of the Fighting Departments would not be sent away. They have to stay behind. Mr. Hore-Belisha has offered his services to act as Liaison Minister in Montreal. He would keep in contact with the fighting services. But all the members of the Inner War Cabinet are certain to leave.

I hear that March 14th has been chosen as a provisional date for the Governmental exodus: it is the day when Hitler seized Czecho-Slovakia. Nothing of the sort is, of course, expected in Downing Street, but the Prime Minister refuses to take any risks.

For the Rich **Rationing in Britain** **For the Poor**

2

Rewriting history

More ancient, more potent and more pervasive than the faking of objects is the use of documents to misrepresent reality itself. This chapter deals with such deceptions, beginning in ancient Babylonia (34) and finishing in the propaganda warfare of the twentieth century.

The perpetrators of such frauds were often priests, partly because it was they who had the learning and skills needed for the forgery of ancient documents and partly because religious foundations, being well endowed, needed to protect their endowment. Their motives were sometimes worthy: knowing that a property belonged to his monastery, but not having the documentation to prove it, a monk might feel it his duty to provide what was lacking (39). They might be playful, as with the invention of eye witnesses to the Trojan War (37), or of a benign character for the notorious tyrant of Tarentum (36), but they could be far from insignificant in their effect. The Donation of Constantine (38) was the documentary foundation of the temporal power of the Papacy, while Geoffrey of Monmouth's twelfth-century *History of Britain* (41) underlay the national self-image of the British until well into the twentieth century.

The power of the past to shape perceptions of the present was fully appreciated by the emerging nationalist movements of the late eighteenth and early nineteenth centuries, as it had been by Annius of Viterbo (42) five centuries and by the priests of Memphis (35) twenty-five centuries earlier. If people could be persuaded that the world had been created in Memphis, that Viterbo was the cradle of a proto-Etruscan civilisation, that Wales or Czechoslovakia (46, 47) had a rich medieval poetic heritage, then Memphis, Viterbo, Wales and Czechoslovakia might once again be great.

Another kind of document purports to provide physical evidence of past events. So the 'torture chair' (51) was popular with northern Protestants as concrete evidence for, and a permanent reminder of, the horrors of the Spanish Inquisition.

The growing importance of political forgery and state propaganda has recently added a further dimension. The course of Anglo-Irish history may well have been altered by the forged letter (53) that convinced many of Parnell's support for the Phoenix Park murders. Similarly, the 'Zinoviev letter' (54) contributed not only to the fall of the 1924 Labour Government but also to the isolation of Soviet Russia from the West in the 1920s and 1930s.

Goebbels regarded Lord Northcliffe as the inventor of modern propaganda warfare. Included here is the *Great Anti-Northcliffe Mail* (60), an unintended compliment to the success of the Northcliffe's campaign; it focused on Allied newspapers' use of the simple but effective technique of altering and recaptioning photographs so that they completely

changed their meaning, becoming evidence for events which never occurred. These photographs provide a neat summary of the central lesson of this section, that it is and has always been surprisingly easy to influence the present by altering the past. If this is in part because it can often be difficult to check the veracity of any account of a past that is, by its nature, essentially inaccessible, it is also and more disquietingly because lies are often more acceptable, more attractive, even more coherent than the truth.

Forgery in the ancient world

34 Old Babylonian forged inscription

This stone cruciform monument from Sippar, southern Mesopotamia (Iraq), is an ancient forgery, most likely created during the Old Babylonian period (first half of the second millennium BC) but purporting to be of the reign of Manishtushu, King of Akkad (c. 2276–2261 BC).

It was discovered in 1881 during excavations on behalf of the British Museum at the site of ancient Sippar in a neo-Babylonian context (seventh to sixth century BC). All twelve sides of the monument are covered with an inscription, the bulk of which deals with the renovation of the temple of Shamash and the very substantial increases in revenue that the temple received from the king. It ends: 'this is not a lie, it is indeed the truth . . . He who will damage this document let Enki fill up his canals with slime . . .'

The monument comes into the category known as a *fraus pia*, or 'pious fraud'. It was probably produced by the temple priests in order to establish the great antiquity of the privileges and revenues of their temple, thus strengthening the temple's claim to them. CNM

H 213mm; W 110mm
BM WAA 91022
LITERATURE I. Gelbe, *Journal of Near Eastern Studies* (1949), pp. 346ff; E. Sollberger, 'The Cruciform Monument', *Jaarbericht ex oriente lux* xx (1968)

35 The Shabaka Stone

The black basalt slab known as the Shabaka Stone preserves the only surviving copy of an important Egyptian religious text usually referred to as the Memphite Theology of Creation. In the earliest tradition surviving from Egypt the creation of the world was ascribed to the god Atum of Heliopolis, but the theology of Memphis sought to give a prior claim to Ptah, patron god of that city, by crediting him with the creation of the other gods and thereby, indirectly, with the creation of the world.

The inscription, much damaged on account of the slab's having been reused as a millstone, dates from the reign of the Nubian Pharaoh Shabaka, of the 25th Dynasty (c. 716–702 BC), and it was originally set up in the temple of Ptah at Memphis. It purports to be a copy of an ancient worm-eaten document which the pharaoh ordered to be transcribed for posterity, and the compiler of the text has reproduced the layout of early documents and introduced a number of archaic spellings and grammatical usages to lend the piece an air of antiquity. In fact, it is now generally accepted that the text in its present form was composed in Shabaka's own time, and that the story of the rescue of the papyrus is an example of a rhetorical device well known in Egyptian royal inscriptions and should not be accepted as a piece of genuine history. However, it is still a matter for dispute whether the content of the text embodies a genuinely ancient religious tradition or whether the document is purely a work of the 25th Dynasty, both in wording and subject matter. On the strength of the latter dating it has been postulated that the stone was intended as a piece of propaganda, aimed at securing the allegiance of an influential section of the Egyptian populace. Shabaka

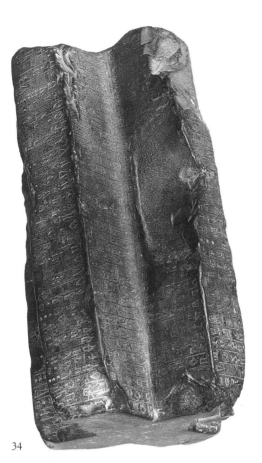

34

reigned at a period when Nubian rulers were trying to establish firm control over the whole of Egypt; Memphis, the first capital and one of the most important cities in the land, had been a focal point for opposition to the Nubians and had only recently been conquered. By erecting an inscription which gave new prestige to the city's patron deity, Shabaka was probably seeking to pacify and conciliate the inhabitants and gain the support of the powerful Memphite priesthood. JT

L 1375mm; W 920mm
BM EA 498
LITERATURE H. Altenmüller, 'Denkmal memphitischer Theologie', in *Lexikon der Ägyptologie* I, Wiesbaden 1975, cols 1065–9; F. Junge, 'Zur Fehldatierung des sog. Denkmals memphitischer Theologie oder Der Beitrag der ägyptischen Theologie zur Geistesgeschichte der Spätzeit', *Mitteilungen des Deutschen Archäologischen Instituts Abteilung Kairo* 29 (1973), pp. 195–204; M. Lichtheim, *Ancient Egyptian Literature: A Book of Readings* I, University of California 1973, pp. 51–7; H. A. Schlögl, *Der Gott Tatenen*, Freiburg 1980, pp. 110–17

36 The *Epistles of Phalaris*, tyrant of Tarentum

This Alexandrian text of about the third century BC purports to be the letters of Phalaris, the cruel tyrant of Tarentum (Taranto in Italy) who, according to Pindar, had a bronze bull made in which he had criminals roasted, eventually suffering the same fate when his subjects revolted about 554 BC. Why he should have been chosen for rehabilitation in Hellenistic Alexandria is not known, but the letters – to his wife and son, to the philosopher Hegesippus and the inhabitants of Himera in Sicily – reveal a kind husband and father, a reluctant tyrant, imbued with a keen interest in literature and a detached view of the world and its opinions. Perhaps no historical fraud was intended, other than to place such a figure some way from Alexandria under Ptolemaic rule. If pastiche was the original intent, it was lost when the text was recovered in the Renaissance and fitted to the image of contemporary 'humanistic' Italian rulers (a).

The text became extremely popular, its matter rather than its historicity being valued, and it was natural for Charles Boyle (1676–1731) to produce an elegant and not uncritical edition of the *Epistles* in 1695 (b). He can scarcely have reckoned on the ferocity with which Richard Bentley (1662–1742), newly appointed King's Librarian, would attack its historicity (with complete justification) and its literary quality (with less). Newtonian chronology and textual sensibility alike were offended by the *Epistles of Phalaris*, and the resulting explosion has become a legendary text in the exposure of forgery.

The copy of Bentley's *Dissertation* (c) that was once in his charge in the Royal Library has not survived to pass to the British Library, which has so many of his own books (acquired from his grandson in 1807), but his annotated copy of Charles Boyle's edition shows the vigour of his hand as well as his mind. NB

36a *Epistles of Phalaris of Tarentum*
Italian manuscript, 1470
BL Arundel MS 525

36b Charles Boyle's edition of the *Epistles*, with Bentley's annotations
BL 682. b.7

36c R. D. Bentley, *Dissertation upon Phalaris*
BL 11312. e.7

37 An account of the Trojan War by 'Dares' and 'Dictys'

For a history of the Trojan War, what could be better than the memoirs of a participant in that event? So it appeared to two Greek authors of first century AD, who exercised their rhetorical skills in composing the eye-witness accounts of 'Dares of Phrygia', a Trojan ally, and 'Dictys of Crete', a Greek ally. So also it appeared to numerous medieval authors, readers, artists and patrons, to whom Vergil's verses presented a less accessible and authoritative text and for whom Homer was generally only a name.

Most medieval literary and artistic versions of the story of Troy, including the illuminated manuscript here, would never have been created had not these Greek texts been translated into Latin in the fourth and sixth centuries AD and had not their status been greatly enhanced by the addition of prefatory letters giving the precise circumstances of the discovery of the original manuscripts. According to the purported letter from Cornelius Nepos to his fellow historian Sallust, Dares' text was found by him at Athens. Dictys' text, according to one Septiminus, was translated by him from a Greek manuscript in Phoenician characters which he had brought to Nero after its discovery at Knossos in Crete inside the very tomb of Dictys.

This manuscript includes, as part of a history of the world from the Creation to the time of Julius Caesar, a French prose adaptation of the twelfth-century *Roman de Troie* of Benoît de Sainte Maure, whose verses formed the most influential medieval texts to derive from those of Dares and Dictys. Among its many richly illuminated miniatures are those on ff. 140ᵛ–141, which portray the Greeks and Trojans as described in the text above, fighting the fourteenth and fifteenth battles. SMCK

Neapolitan manuscript, *c.* 1330–40
BL Royal MS, 20 D I, ff. 140ᵛ–141
LITERATURE F. Avril, 'Trois manuscrits napolitains des collections de Charles V et de Jean de Berry', *Bibliothèque de l'Ecole des chartes* 127 (1969), pp. 300–14; H. Buchthal, *Historia Troiana*, Studies of the Warburg Institute, 32, Leiden/London 1971, pp. 1–8

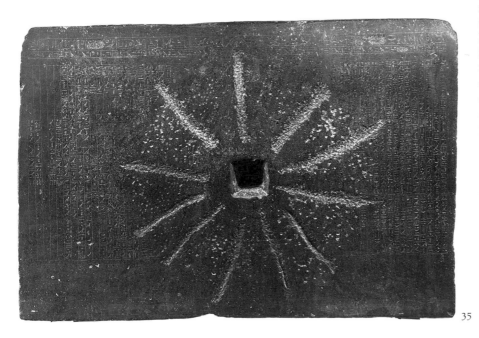

35

37

Monkish forgeries

38 The Donation of Constantine, one of the 'Forged Dectretals of Isidore'

The 'Forged Decretals of Isidore' are documents of greater or lesser antiquity, some genuine, some false, which were assembled in the ninth century with the object of enhancing the temporal power of the Church.

The most famous document in it was the 'Donation of Constantine', the letter from the first Christian emperor to Pope Silvester I, giving him terrestrial power over the West (or was it only Italy?), while he retreated to his new Eastern capital. The words (*Romanae et omnes Italiae seu occidentalium regionum provincias . . . nostro Silvestro universali papae concedimus*) were precise yet not unambiguous: did the words after *seu*

define or expand 'Italy' to include all Western Europe? Gallican bishops preferred the former, papalists the latter definition. One thing was certain: the composition of the Donation predated the Forged Decretals, since it was quoted by Hadrian I in 777.

The credit for disentangling the complex web of deception surrounding the Decretals belongs to Lorenzo Valla (*c.* 1407–57). By applying a mind critically tuned not only to the chronology of historical fact but also to the use of language (much improved by the recovery of classical texts in the previous half-century), he was able to show which documents were genuine and which were later 'pious' fictions. His conclusions (reinforced independently by Cardinal Nicolas of Cusa) appeared in 1440. Valla's critical methods, as refined and improved (in terms of the physical structure of old documents) by Angelo Poliziano, remained the model and admiration of later scholars. The reformers, however, found grist for their mill in the tissue of papal lies and aggrandisement (as they saw it) that Valla had destroyed. Thomas Cromwell was not slow to seize these possibilities, and the translation into English of Valla's text and its publication in 1536 was part of his carefully orchestrated propaganda campaign against the papacy in Henry VIII's interest, based on other historic documents as well as this, notably the *Defensor pacis*.

This was not the only appearance of the forged Decretals in English history. The English Pope Adrian IV's claim to Ireland (and bestowal of it in 1155 on Henry II, at the instance of John of Salisbury) was based on the Donation of Constantine. NB

A treatyse of the donation . . . gyven . . . by Constantyne, Emperor of Rhome . . . a declaration of Laurence Valla . . . against the forsayd privilege, as being forged, London [1534]
BL c.37. h.7

39 Medieval forgeries of royal writs

The possession of royal writs constituting written evidence of the conferment of favourable rights and

immunities was of such importance to great early monastic foundations like Westminster and Battle Abbey that they sometimes produced spurious ones where the genuine article was lacking.

In the case of the writ purported to be of Edward the Confessor (a), the intention of the monks of Westminster seems to have been to equip themselves with documentary support for a claim to the estate of Ickworth (Suffolk). They set out to achieve this aim by adapting or manipulating an authentic writ some time in the second half of the eleventh century and appending to it a copy of Edward's seal, possibly once part of another document.

The monks of Battle Abbey seem to have been similarly motivated. Wishing to defend what they considered their rights against possible episcopal threats, they decided in the twelfth century to produce additional evidence of royal privileges granted in the previous century (b). SMCK

39a Spurious Writ of Edward the Confessor, Westminster, (?) 2nd half of 11th century
BL Sloane Charter xxxiv. 1

39b Spurious Writ of William the Conqueror, Battle Abbey, 12th century
BL Add. Ch. 70980

LITERATURE F. E. Harmer, *Anglo-Saxon Writs*, Manchester 1952, pp. 316–18, 504–5; B. Schofield, 'The Lane Bequest', *British Museum Quarterly* xi (1936–7), pp. 73–5

40 Fake seal matrix of Henry II (1154–89)

Royal charters were sealed or authenticated by a two-sided seal, the obverse of which showed the seated king and the reverse the king on horseback. This lead circular matrix is a contemporary forgery of the second Great Seal of Henry II. The original matrix would have been of silver and the design of the forgery differs from genuine examples in significant details, such as the misspelling of 'Aquitannorum' with two NS. Forged charters and real charters with forged seals were quite common in the twelfth century, but the survival of matrices to produce forged seals is far less common. It is curious that a forged obverse of the same Great Seal of Henry II was found in Ireland in the early nineteenth century. The different sizes of the two do not suggest that they were made as a pair. Christopher Brooke has commented that: 'In England the high watermark of the forger was the period between the new chaos of the Norman Conquest and the establishment of order or growing legal precision in the reign of Henry II'. The defence of monastic property, or the defence of monasteries which claimed exemption from episcopal control, or the right of primacy of one see over another could all lead to forgery. It could however also happen for less grand motives. According to Thomas Walsingham, a chronicler of St Albans, Abbot Ralph (1146–51), deposed his Prior because he discovered that he was employing the King of Denmark's goldsmith to counterfeit his seal. And of the seals used by Christ Church, Canterbury, Archdeacon Simon Langton wrote to Gregory IX in 1238: 'Holy Father, there is not a single sort of forgery that is not perpetrated in the church of Canterbury. For they have forged in gold, in lead, in wax, and in every kind of metal'. JC(MLA)

Lead, with the legend + HENRI//VS : DUX : NORMANNOR : ET : AQUITANNOR : ET : COMES : ANDEGAVOR. D 97mm
BM MLA 1854, 7–19, 1. Found on Barmby Moor Common, Yorkshire. Given by the Hon. Capt. Duncomb
LITERATURE W. de Gray Birch, 'On the seals of King Henry the Second, and of his son the so called Henry the Third', *Transactions of the Royal Society of Literature*, 2nd series, XI (1878), pp. 331–3; W. de Gray Birch, *Catalogue of Seals in the Department of Manuscripts in the British Museum* I, London 1887, no. 56; A. B. Tonnochy, *Catalogue of British Seal Dies in the British Museum*, London 1952, no. 4; C. N. L. Brooke, 'Approaches to Medieval Forgery' in C. L. Brooke (ed.), *Medieval church and society*, London 1971, pp. 100–1

41 Geoffrey of Monmouth, *Historia Regum Britanniae*

Geoffrey of Monmouth was born about the year 1100, brought up at Monmouth, and later went to Oxford, where he met the Archdeacon Walter. From him Geoffrey obtained the foundation of his work, a 'vetustissimus liber' (a very ancient book), *Britannici sermonis* (in Welsh). He set to work and at least part of the *Historia* was in existence by about 1135, when other chroniclers and writers began to make use of it.

His story begins with the arrival, after the sack of Troy, of Brutus, the eponymous Brut of Brittany 'at the time when Eli was high priest' (c. 1170 BC); Brut was supposed to have founded London, and the line of Kings that included Bladud, founder of Bath, and Lear. With Cassivelaunus and King Coel of Colchester we enter historic time; the story of Vortigern leads to the prophecies of Merlin and the great history of Arthur. The line, and Geoffrey's history, ends with Cadwallader's exile to Brittany, his sons refugees in Wales.

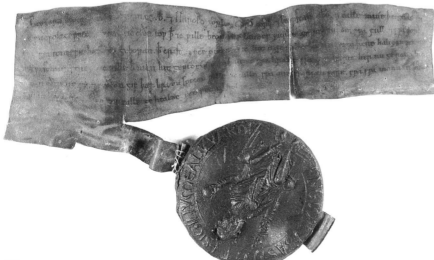

39a

Argument has gone on for centuries about Geoffrey's work and the extent to which it was derived from real sources. Needless to say, the 'ancient book' has disappeared, and we shall never know what it was, if it ever existed – a book of legends of Brut and Arthur of Breton origin, perhaps. It cannot even have been of great antiquity since Bede (c. 673–735) was clearly unaware of the tradition.

The significance of the *Historia Regum Britanniae* lies, however, not in its sources but in its subsequent influence; transformed by Malory in *Morte d'Arthur*, it became 'the Matter of Britain', and dominated British historiography right up to *Our Island Story* (1905), the standard children's history, still in print. It was itself the origin of the 'Grail' romances in all the European languages, as well as the long-lasting mythistory of England. NB

BL Cotton Titus C.XVII

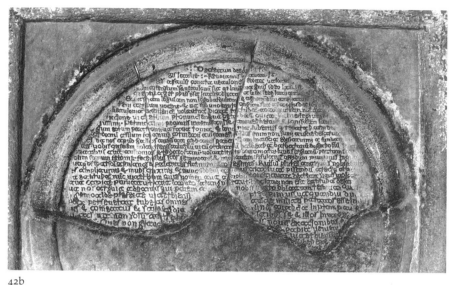

42b

Pride in family, place and nation

42 Annius of Viterbo's fake texts and inscriptions

Giovanni Nanni was born in Viterbo in 1432 (or 1437) and died in Rome in 1502. He was a Dominican, a trained theologian who taught, preached and published mainly in Genoa and in Viterbo. Towards the end of his life he was raised to high office at the Papal Court by Pope Alexander VI.

His fame rests on his forgeries. Latinising Nanni to Annius to suggest descent from the Roman *gens Annia*, he made up a number of ancient historical texts and inscriptions, and wrote commentaries on them. The motive seems to have been a desire to glorify his native Viterbo as the metropolis of a primeval, golden-age Etruria.

He began by composing a local history of Viterbo, apparently lost except for an *Epitoma*, recently published. The side products of this were counterfeit inscriptions (b) in subrudimentary Etruscan (some letters correct; sense invented), doubtful Greek (purporting in one

instance to be partly a transliteration of Aramaic), and more or less imaginary Egyptian hieroglyphic; also in Latin, where the script gives him away. He had them buried for imminent discovery, and when they *were* discovered wrote a commentary on a selection of six, which he addressed to the magistrates of Viterbo. As Roberto Weiss has pointed out, though devoted entirely to fakes, it is in fact the earliest Renaissance epigraphic treatise extant.

Having 'roused the history of Viterbo from its slumbers', and attached its beginnings to the 'theogony of heroes' who first settled Italy (chief among them Janus, an alias of Noah), Annius moved on to his *magnum opus*, an attempt to establish the central position of Etruria within the framework of universal history. Published in 1498, the *Commentaria super opera diversorum auctorum de antiquitatibus loquentium* (a) combines chronology, topography and onomastics (mainly place-names) in an exegesis of ancient texts which, with one exception – Propertius' poem on the Romanised Etruscan god Vertumnus – are all forgeries, ascribed, again with one exception – the 'Persian' Metasthenes, no doubt a (punning?) transposition of the Greek Megasthenes, presented by Annius as a confusion rectified – to real authors: the Chaldaean Berosus, the Egyptian Manetho, Archilochus, Xenophon,

Myrsilus of Lesbos, Fabius Pictor, Sempronius (Caius Sempronius Tuditanus, author of a work on Roman magistrates, rather than the historian Sempronius Asellio?), the Elder Cato, Philo of Alexandria, the Emperor Antoninus Pius. Citing and commenting, Annius establishes the anteriority of Etruscan to both Greek and Latin, deriving as it does from Aramaic, the language of Noah, if not of Adam.

But Annius is not merely telling a story and showing it to be true. He is, if anything, more concerned with method than with narrative, with demonstrating what constitutes history as opposed to fable, mainly Greek fable. His Metasthenes is given over to methodological postulates which are invoked throughout the *Commentaria*. Taking his cue from Josephus' attack on Greek historiography in the *Contra Apionem* (a debt he acknowledges), Annius opposes the fabulations of Greek historians – they were private individuals with no recognised status; they had no access to official records; their material was hearsay and opinion; they often contradict each other – to the veracity of Assyrian and Persian annals. These are based exclusively on official documents and put together by public scribes who have priestly status. Annius calls them 'public notaries of events and times'. His Berosus is the very model of such

a functionary: he was a priest and he excerpted official records to compose a précis of the entire period of the Assyrian monarchy (this, again, based on Josephus). Annius does not share the humanist fascination with the classical historical text, Greek or Latin. Its literariness is suspect to him. The Roman authors he 'produces' – Fabius Pictor, Sempronius, the Elder Cato – are to him antiquarians rather than historians (Antoninus Pius is brought in on account of his *Itinerary* – nothing could be less literary or more official). The irony of a treatise on epigraphy concerned exclusively with fakes is compounded by a forged historical text laying down rules of historical evidence.

Though Annius' fraud was seen through quite quickly, it had widespread and long-lasting echoes. His emphasis on chronology, his high valuation of the evidence of inscriptions, and more generally of names, his 'rules of historical evidence', his passion for Etruscan antiquities and his linguistic theories, all had a sequel. He became the prince of forgers with pride of place in the canon of 'learned impostors' and the distinction of an interdict in a decree issued by the Academy of Lisbon in 1721 naming him as an author not to be read. And his stones still stand in the Museo Civico at Viterbo, a not unworthy tribute the city's power to inspire loyalty in its sons. CRL

42a Annius' *Commentaria*
BL IB 19034

42b Two of Annius' fake inscriptions
630 × 630mm (framed)
Museo Civico, Viterbo

LITERATURE R. Weiss, 'Traccia per una biografia di Annio di Viterbo', *Italia medioevale e umanistica* v (1962), pp. 425ff.; R. Weiss, 'An unknown epigraphic tract by Annius of Viterbo', in C. P. Brand, K. Foster & U. Limentani (eds), *Italian studies presented to E. R. Vincent . . .* 1962, pp. 101ff.; E. Tigerstedt, 'Ioannes Annius and *Graecia mendax*', *Classical, Medieval and Renaissance Studies in honour of B. L. Ullman* ii (1964), pp. 293ff.; *Viterbiae Historiae Epitoma: Annio da Viterbo. Documenti e ricerchi*, Contributi alla storia degli studi etruschi ed italici, I (1981); R. Fubini, 'Gli storici nei nascenti stati regionali italiani', *Il ruolo della storia e degli storici nelle civiltà*, Atti del Convegno di Macerata . . . 1979 (1982), pp. 217ff.; R. Weiss, *The Renaissance discovery of classical antiquity*, 2nd edn, 1988

43

43 Genealogy of the House of Croy

This family tree of the wealthy ducal house of Croy, in the Low Countries, was one of the last in a long line of illustrious pedigrees which served to reinforce the prestige of almost every great European family in the Middle Ages and early Renaissance. Compiled about 1612 by Jacques de Bie from a manuscript written by the last duke, the genealogy is unusually complete, taking his ancestry back through Catherine of Croy, sister-in-law of King Andrew III of

Hungary, to Attila, Nimrod, Noah, and finally Adam and Eve.

It is hard to credit that the erudite Duke of Croy believed this amazing genealogical sequence to be literally true, but this was the age in which James Usher, Archbishop of Dublin, compiled his chronology of the world on similar principles, establishing the date of the Creation as 4004 BC. NB

BL 607. m.9

44 Charles Bertram and 'Richard of Cirencester's' map of Roman Britain

Charles Julius Bertram (1723–65), was the son of a silk dyer who migrated to Copenhagen in 1743. In June 1747, a month before he entered Copenhagen University, Bertram wrote to the famous English antiquarian William Stukeley (1687–1765), referring to 'a curious manuscript history of Roman Britain by Richard of Westminster' which he had seen at a friend's house. Stukeley did not pay much attention to this at first, but later asked for a sample of it. The 'careful copy' which Bertram sent impressed him, and he urged Bertram to get hold of the manuscript and transcribe it, and copy the map that it included. Bertram did so in a series of letters to Stukeley, in which he suggested a fifteenth-century date for it; Stukeley rejected this and attributed it to Richard of Cirencester, a monk at Westminster in the fourteenth century and author of an extant chronicle, *Speculum historiale*. The new work was published in 1757, with Stukeley's *Account of Richard of Cirencester*, which included an engraving of the map.

Local antiquaries and other historians fell on a work which much augmented knowledge of Roman Britain, including a whole new province, many new place-names and new details about the early Christian martyrs in England, notably the first, St Alban. Even Gibbon wrote: 'he shows a genuine knowledge of antiquity very extraordinary in a monk of the fourteenth century'. New Roman names appeared on the Ordnance Survey maps including, notably, the Pennines (*Pennines*

44

Montes). There were sceptics, and in 1845 Karl Wex showed that a misquotation of Tacitus stemmed from a misprint in an edition of 1497. But it was not until 1866–7 that the historical inventions were demolished by B. R. Woodward and J. E. B. Mayor, who showed the text to be an ingenious 'mosaic of information collected from Caesar, Tacitus, Solinus, Camden and other authorities', eked out with invention.

No one knows why Bertram did it. Was he bored and isolated in Denmark, anxious to make a mark in England? Stukeley was an unlikely dupe, one of the founders of the Society of Antiquaries, a pioneer field archaeologist and a sceptic of monkish tales. Bertram's first letter came, however, just as Stukeley had taken orders and become a passionate believer in the Druidic origins of Stonehenge. His enthusiasm may have induced Bertram to undertake more than he intended. But the manuscript copy was good enough to mislead David Casley, then Royal Librarian, and Sir Frederic Madden a century later. Bertram's work was to be partially enshrined in *Our Island Story*. NB

An Account of Richard of Cirencester . . . with his Ancient Map of Roman Britain, London 1757
BL 577. h.25(3)

45 James Macpherson and the poetry of 'Ossian'

James Macpherson's collation and creation of 'ancient Celtic' poetry which he attributed to Ossian, son of Fingal, was at once the most obvious and the most subtle of literary frauds of the eighteenth century; beyond any doubt it was the most influential. It was the unlikely product of two very different but overlapping impulses: the antiquarian desire to recover the ancient history and, more especially, the ancient literature of Britain; and the desire of the Highland Scots to mitigate defeat in 1715 and 1745 by the recovery of an heroic Celtic past.

James Macpherson (1736–96) grew up in the shadow of 1745, with his cousin and clan-leader proscribed, in hiding and then in exile. Education at Aberdeen University introduced him to the other impulse, the recovery of the past from its documents. He returned to the Highlands a dissatisfied teacher. The familiar songs and ballads of his youth held a new suggestion for him, and in 1759 he read some Gaelic poems to John Home (1722–1808), author of the successful tragedy *Douglas* (1756), who urged him to publish them.

Fragments of Ancient Poetry collected in the Highlands of Scotland (1760), *Fingal, an ancient epic poem* (1762), his greatest triumph, and *Temora* (1763) followed, and with it an evolving purpose: what started as a collection of chance relics was melded into a poetic but consistent vision of a Celtic past in which Scots, not the already popular Irish, heroes were dominant. In a decade that welcomed Gray's *Odes* (1757; see 159), Capell's *Prolusions* (1760) and Percy's *Reliques of ancient English poetry* (1765), Macpherson found instant success. From the outset sceptics demanded the original, and Macpherson titillated without satisfying them: in *Fingal* he wrote:

there is a design on foot to print the originals, as soon as the translator shall have time to transcribe them for the press; and if this publication shall not take place copies will then be deposited in one of the public libraries, to prevent so ancient a monument of genius from being lost.

Dr Johnson was one of the sceptics, but Goethe and a large public in Britain and abroad admired 'Ossian'. Macpherson, becoming a successful author and MP, was home and dry; he built a castle near his birthplace, where he died; he was buried (at his request) in Westminster Abbey. A careful edition in 1807 based on 'the originals', showed that his 'Ossianic' poems were substantially augmented and changed versions of traditional Gaelic originals. But by now Fingal's Cave had been given its name: Macpherson's fiction achieved topographic reality, and with it immortalisation by Mendelssohn. NB

Fingal, an ancient Epic poem
BL 78. l.12

46 Iolo Morganwg (Edward Williams) and the poetry of Dafydd ap Gwilym

The first printed edition of the work of one of Europe's great medieval poets, Dafydd ap Gwilym, was published in 1789. Edited by Owain Myfyr and William Owen [-Pughe] on behalf of the Gwyneddigion, a patriotic society of London Welshmen, it was the first of an intended series of editions designed to rekindle interest in the Welsh literary tradition. It remained the standard collection of his work until 1914.

Iolo Morganwg (Edward Williams) is acknowledged as giving help in supplying biographical information about Dafydd ap Gwilym and in furnishing the editors with the poems inserted in the Appendix. However, it was not until G. J. Williams published his article in *Y Beirniad* viii (1919) and more fully in his *Iolo Morganwg a Chywyddau'r Ychwanegiad* (1926) that it was discovered that Iolo had forged numbers 70 and 80 of the poems in the main corpus of the work and the majority of the poems included in the Appendix.

Iolo Morganwg's mastery of Dafydd

47

ap Gwilym's style is universally acknowledged, and the fact that he chose to add to the genuine corpus of an established poet is typical of his method. So highly esteemed were the forgeries that they proved even more popular than Dafydd ap Gwilym's own work during the nineteenth century. RMC

BL 11595 c.6

47 Václav Hanka's *Královédvorský* and *Zelenohorský* manuscripts

Rukopis Královédvorský (the *Královédvorský* manuscript) and *Rukopis Zelenohorský* (the *Zelenohorský* manuscript) are the best-known Czech Romantic literary forgeries in the manner of J. Macpherson's 'Ossian' (45). The *Královédvorský* manuscript was 'discovered' in 1817 in a Gothic vault in the town of Dvur Králové in north-eastern Bohemia, while the *Zelenohorský* manuscript was sent anonymously to the newly founded National Museum a year later from the country estate of Zelená Hora.

In Bohemia the end of the eighteenth and the beginning of the nineteenth centuries saw Czech national revival, which began to look back to the country's Slavonic roots and towards Russia as the strongest Slavonic country. The lack of a great national epic in the style of Homer, the *Niebelungenlied* or the Russian epics led a group of patriotic scholars around Václav Hanka (1791–1861) to manufacture these forgeries, fulfilling the desire of Czech revivalists to prove the existence of a truly national pre-medieval Czech literature with no Western influence.

The *Královédvorský* manuscript was presented as a fragment of a third book of a large collection of thirteenth-century Czech texts, and consisted of two strips and twelve parchment leaves containing eight epic and six lyrical compositions. While the epics drew on the sixteenth-century *Czech Chronicle* by V. Hájek, and presented carefully selected and suitably gilded legends from Czech prehistory, the lyrical poems were based on Czech and Russian folk songs, just as those of

48a

'Ossian' were inspired by Scottish and Irish folk songs and legends.

Following his success with the *Královédvorský* manuscript Hanka grew bolder and presented the *Zelenohorský* manuscript as a work originating from the ninth to tenth centuries, i.e. a period from which no written Czech documents or texts have survived. The manuscript consisted of four parchment leaves and contained an epic fragment *The Judgement of Libuše*, which seems to have aimed at proving the high standard of development of the pre-Christian Czech state (the 'judgement' describes an event that allegedly took place in the seventh century and a reference is made to written law). In fact, both manuscripts are full of attributes pointing to a highly developed prehistoric culture,

fitting the needs of the revivalists keen to raise the self-esteem of a nation awakening from a long decline. In the epic poems, the Romantic ideal is represented by a patriotic hero who, inspired by the Ossianic bard, defends the motherland and the mother tongue in battles with foreign invaders, while the lyric songs stress gentleness, relation of man to nature and the sentiments of the human heart.

At first both manuscripts were accepted enthusiastically by the young generation of scholars (F. Palacký, P. J. Šafařík), but the doyen of the Czech national revival, Josef Dobrovský (1753–1829), expressed his doubts about the *Zelenohorský* manuscript. It took forty years for the authenticity of both manuscripts to be questioned

OLIVERIVS MAGNÆ BRITANNIÆ, HIBERNIÆ. ET TOTIVS ANGLICI IMPERII PROTECTOR.
HANC SVMMI ET TOTO TERRARVM ORBE CELEBERRIMI HEROIS
EFFICIEM SVPREMO SVÆ CELSITVDINIS CONSILIO D.D.D.

CAROLVS I. DEI GRATIA
MAGNÆ BRITANNIÆ, FRAN CIÆ ET HIBERNIÆ REX.

48b

48c

Altered portraits

48 Pierre Lombart's 'Headless Horseman'

These three states of a print by Pierre Lombart demonstrate the potentially deceptive nature of certain portraits. In this case it has been argued by G. S. Layard that the print started its life as a portrait of Cromwell, or rather a portrait with Cromwell's head superimposed on Charles I's body, as inspired by Van Dyck's painted equestrian portrait. Lombart then flirted with the idea of turning it into a portrait of Louis XIV (a), before abandoning the plate, which was then turned back into Cromwell (b) by another engraver before being re-engraved as Charles I (c), and then finally re-engraved again as Cromwell. To add confusion, Layard argues that only those states of the print which are not engraved by Lombart bear an inscription (*Lombart sculps*) asserting that he was the engraver. PHJG

Engraving. 541 × 346mm

48a Fourth state: Louis XIV
BM PD 1935. 4–13. 50
48b Fifth state: Cromwell
BM PD 1935. 4–13. 51
48c Sixth state: Charles I
BM PD 1935. 4–13. 52
LITERATURE G. S. Layard, *The Headless Horseman*, London 1922

openly and the controversy lasted for more than a hundred years during which time the vision of a glorious national past, as presented in the manuscripts, kept alive the national spirit and was a constant inspiration to artists. It was only in 1880s that Czech scholarship, led by T. G. Masaryk (1850–1937), undertook a systematic research which resulted in the exposure of the manuscripts as forgeries. Voices defending them could, however, still be heard right up to the beginning of the Second World War. DP

Rukopis Královédvorský, Prague 1861; illustrated by Josef Manés
BL Cup. 409. b.22

50

Historical relics

49 Chastity belt

There is evidence for the existence of chastity belts from the beginning of the fifteenth century onwards. E. J. Dingwall in *The Girdle of Chastity* (London 1931) concludes that they were invented in Italy around 1400 and were in actual use, albeit occasionally, right into the present century. The evidence for their use in the Renaissance period, however, is largely anecdotal or in burlesque fiction. It is probable that the great majority of examples now existing were made in the eighteenth and nineteenth centuries as curiosities for the prurient, or as jokes for the tasteless. This object is of uncertain date but may be an eighteenth- or early nineteenth-century concoction: it was presented to the British Museum before 1846 by Sir Henry Ellis, then Principal Librarian, after it had been sent to the Earl of Aberdeen, President of the Society of Antiquaries. TW

Iron with fittings for padding. D (waist) 23cm
BM MLA M574
LITERATURE J. J. Brunner, *Der Schlüssel im Wandel der Zeit* (Bern & Stuttgart 1988), pp. 214–15

50 Spur 'from the field of Agincourt'

A genuine early fifteenth-century iron rowel spur has here been inserted into the root of a tree (probably spruce), and mounted with a gilt-copper plaque. The plaque is engraved with a legend stating that the spur came from the battlefield of Agincourt (25 October 1415). The root would have been soaked to soften it, and when dry would have shrunk around the spur.

This item came to the Victoria and Albert Museum with the arms and armour collection of Major V. Farquharson FSA and was accepted as genuine for many years. Investigation of the wood in the 1960s established that it was probably spruce, not known to grow in the area of the Pas de Calais. Suspicions were confirmed when a virtually identical spur, also set in a tree root with a similar plaque mentioning another famous English battle, was sold at auction in 1962. These interesting antiquities are likely to have been produced by an antique dealer specialising in arms and armour. In the 1920s spurs were relatively cheap and the dealer came up with an ingenious idea to boost the value of plain spurs. AREN

H 165mm
V&A M.484–1927. Farquharson Bequest

51 'Spanish Inquisition' torture chair

This chair is said to have been found with a variety of other instruments of torture in 'Cell 23 – a dungeon of the Spanish Inquisition' at Cuenca in Spain. It was assembled from a number of separate elements, some genuine, in the nineteenth century for sale as an interesting antiquity. The vertical iron bar forming the back of the chair almost certainly formed part of a Spanish 'garotte', an instrument of execution by strangulation. The iron bridle attached to the top of the bar is inscribed CORUNA and bears a maker's mark. This appears to be a genuine instrument of torture, possibly dating from the late seventeenth century. It is fitted with a series of horrible devices for compressing the head, piercing the ears, extracting the tongue and crushing the nose. It has been skilfully made by a craftsman trained as an engineer. The iron restraining belt also seems to be genuine, and dates from the seventeenth or eighteenth century. Similar iron belts together with manacles were used to restrain prisoners, and could be attached to walls. The lower section of the chair seems to be some form of adjustable workbench dating from the early nineteenth century to which have been attached padlocks and manacles dating from the late seventeenth century. The two accompanying gags are inscribed CABALLERO (probably the maker) ANO DE 1676 SANTO OFFICIO (Holy Office). These are very well made, and are likely to be the work of a Spanish gunmaker. Each is engraved with the badge of the Inquisition.

With the abolition of torture as part of the legal process in the eighteenth century torture instruments were either deliberately destroyed or were consigned to store-rooms in town halls or castles. In the first quarter of the nineteenth century there was a renewal of interest in such antiquities, and with the Gothic Revival no self-respecting castle was complete without its torture chamber suitably decorated with the tormentors' grisly paraphernalia. Most of the genuine wooden instruments had perished, so copies were made. Romantic fiction in the latter part of the nineteenth century painted the activities of the Spanish Inquisition in lurid colours. It is not surprising therefore that antiquities such as this chair were of great interest to antiquaries and collectors. AREN

Wrought iron. 1680 × 68 × 72mm
Horniman Museum
LITERATURE W. M. Schmidt, *Altertümer des Bürgerlichen und Strafrechts Insbesondere Folter- und Strafwerkzeuge des Bayerischen Nationalmuseums*, Munich 1908, no. 122; R. Held, *Strumenti di Tortura dal Medioevo all' Epoca Industriale*, Florence 1983, no. 26, 27

Political forgeries

52 *The Protocols of the Elders of Zion*

In the *musée noir* of literary fraud few works have deserved greater notoriety

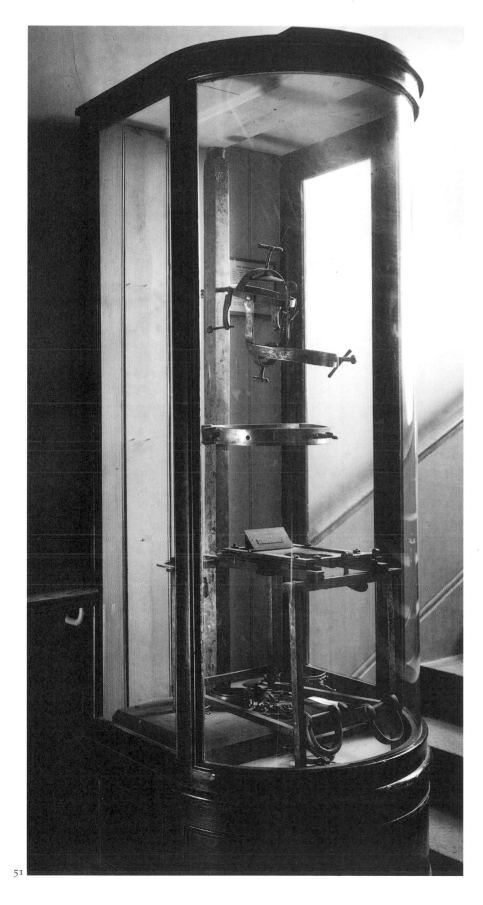

51

than the *Protocols of the Elders of Zion*. The origins of this anti-Semitic tract can be found in two works. The first was a witty onslaught on the Third Empire by a French lawyer, Maurice Joly, published in Brussels under the title *Dialogue aux enfers entre Montesquieu et Machiavel* in 1864. In it Montesquieu presents the case for liberalism, Machiavelli for Napoleon III's despotism, its 'motives and methods stripped of their usual camouflage of humbug'. The second source was the violently anti-Semitic Serb Osman Bey's *Die Eroberung der Welt durch die Juden* (Wiesbaden 1875), which contributed the mythistory of the *Protocols*:

Around 1840, a Jewish parliament was summoned at Cracow. It was a sort of Ecumenical Council, where the most eminent leaders of the Chosen People met to confer. The purpose of summoning them was to determine the most suitable means to ensure that Judaism should spread safely from the North Pole to the South . . .

The blame for uniting these two threads cannot be firmly laid, but the text (slightly abridged) of the *Protocols*, purporting to be a speech made at such an assembly, was published by the anti-Semitic St Petersburg newspaper *Znamya* in 1903. The editor, P. A. Krushevan, described it as 'a translation of a document originally written down in France'; he may have got it from his fellow Bessarabian G. V. Butmi, by whom it was published in 1906. But before that it had been added to the third edition (1905) of Sergei Nilus' *Velikoe v malom* (*The great in the small: Antichrist considered as an imminent political possibility*), under the imprint of the local Red Cross at Tsarskoe Selo, the imperial residence.

Joly's text is manipulated to put the opinions attributed to Machiavelli as the policy of world jewry, directed to destroy the liberalism of Montesquieu. Within each state authority must be enfeebled by excessive taxation and war encouraged by armaments. Industry must be combined in giant monopolies, so that gentile wealth can be destroyed at one blow. Workers will be kept in permanent unrest. Education will be controlled via visual

53b

media, turning gentiles into 'unthinking beasts, waiting for things to be presented before their eyes in order to form an idea of them'. Underground railways will join capital cities, so that the Elders can quell opposition by blowing them sky-high.

This preposterous fiction was printed and reprinted in Russia, spreading abroad after 1917, till it even reached *The Times* (8 May 1920). But *The Times* also published, in August 1921, its decisive demolition, when its Constantinople correspondent, Philip Graves, revealed its real source in Joly's book. But lies are hard to suppress, and the *Protocols* were still being printed recently in Los Angeles by a body called the Christian Nationalist Crusade. NB

BL C.37. e.31
LITERATURE N. Cohn, *Warrant for genocide: the myth of the Jewish world-conspiracy and the 'Protocols of the Elders of Zion'*, London 1967

53 The 'Parnell letter'

This letter purports to be from the Irish leader, Charles Stewart Parnell, written only a few days after the murder of Lord Frederick Cavendish and Thomas Henry Burke in Phoenix Park, and seeming to condone the crime. For *The Times* this was just the evidence it needed to support its series of articles 'Parnellism and Crime', and the letter appeared in facsimile across two columns in the paper of 18 April 1887.

Parnell made no attempt to refute the arguments raised against him by *The Times* until many months after the letter's publication, when the government offered to set up a special commission, in which the paper was forced to substantiate all the claims it had made against him.

The Commission found that the source of this letter and all the others was Charles Pigott, a well-known Irish journalist and forger. In court Pigott was led into reproducing certain spelling errors that had appeared in other letters, and Parnell was completely vindicated. The case cost *The Times* £200,000 in damages, but a steep fall in circulation following the scandal caused it incalculable losses in revenue.

Certainly this was a very clever forgery; the paper on which it was written appeared to be the type supplied exclusively to members of the Dublin Land League, and the signature bore up well to comparison with authenticated examples of Parnell's autograph. MA

53a 'Parnell letter'
Times Archives

53b *The Times*, 18 April 1887
BL Colindale Newspaper Library

54 The 'Zinoviev letter'

The British General Election campaign of 1924 was dominated by the publication of a letter allegedly from Grigori Yevsevich Zinoviev (1883–1936), then President of the Third International, to the British Communist Party calling upon it to pressure the Labour Government into concluding the proposed Anglo-Russian trade treaty and to step up preparations for armed revolution by infiltrating the armed forces.

It subsequently emerged that the letter was a forgery, produced by a small group of White Russian exiles in Berlin and circulated in London with the assistance of the Polish secret service. Thanks to its timing the

THE GREAT SENSATION OF THE ELECTION.

The "Red Letter" Disclosures, which have Proved the Chief Subject of Discussion During the Past Few Days

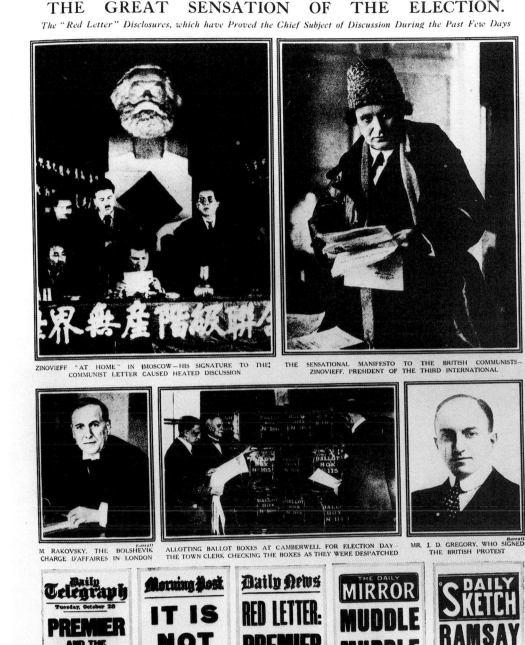

ZINOVIEFF "AT HOME" IN MOSCOW—HIS SIGNATURE TO THE COMMUNIST LETTER CAUSED HEATED DISCUSSION

THE SENSATIONAL MANIFESTO TO THE BRITISH COMMUNISTS—ZINOVIEFF, PRESIDENT OF THE THIRD INTERNATIONAL

M. RAKOVSKY, THE BOLSHEVIK CHARGE D'AFFAIRES IN LONDON

ALLOTTING BALLOT BOXES AT CAMBERWELL FOR ELECTION DAY—THE TOWN CLERK CHECKING THE BOXES AS THEY WERE DESPATCHED

MR. J. D. GREGORY, WHO SIGNED THE BRITISH PROTEST

Daily Telegraph
Tuesday, October 28
PREMIER AND THE "RED" PLOT "ANOTHER MARE'S NEST"

Morning Post
IT IS NOT A FORGERY

Daily News
RED LETTER: PREMIER SPEAKS

THE DAILY MIRROR
MUDDLE MUDDLE MUDDLE

DAILY SKETCH
RAMSAY THE INNOCENT

HOW FIVE OF THE BIG DAILY NEWSPAPERS CALLED THE ATTENTION OF THEIR READERS TO THE "RED LETTER" IN THEIR POSTERS AT THE BEGINNING OF THE PRESENT WEEK

The chief topic of discussion throughout the country during the final stages of the election was undoubtedly the "Zinovieff" letter. This was a "very secret" letter of instruction from Moscow, signed by Zinovieff, the President of the Third Communist International, and addressed to Mr. McManus, in which the writer indicated methods of procedure in seducing the British Army and Navy from their loyalty to the King. The genuineness of this letter (which "found its way" to the Foreign Office) was at first doubted, but the subsequent speeches of Mr. MacDonald leave little room for doubt but that it was taken seriously by him and by the Foreign Office. Great controversy has raged over this document ever since the Foreign Office published details concerning it, almost to the exclusion of other important matters in connection with the election; it would, in fact, be no exaggeration to say that Zinovieff and his letter were the only topics to engage the attention of all parties in the final stages of the great electoral struggle. The pictures we reproduce above illustrate the principal figures in the controversy, as well as a selection of daily newspaper posters commenting on the disclosures.

54b

'Zinoviev letter' was one of the most successful political forgeries of all time. Donald im Thurn, an ex-MI5 officer involved in bringing the letter to official and public attention (it was published by the Foreign Office with a protest note from Ramsay MacDonald to the Soviet Chargé d'Affaires), later claimed that it had vitally affected the outcome of the 1924 election, 'smashed the Communists, split the Labour Party, ruined the Liberals, upset any chance of revolution and made the failure of the general strike a foregone conclusion and established the Conservative Party on a basis of solidity which has never existed before and which is likely to exist for many years to come'.

It also, and perhaps more importantly, put an end to any chance of an improvement in Anglo-Russian relations, contributing to the isolation of the Soviet Union from the West in the late 1920s and 1930s, which provided the context in which Nazi–Soviet co-operation became possible. MPJ

54a *Sunday Pictorial*, 26 October 1924
BL Colindale Newspaper Library
54b *The Sphere*, 1 November 1924
BL Colindale Newspaper Library
LITERATURE L. Chester, S. Fay & H. Young, *The Zinoviev Letter*, London 1967

Propaganda and counterfeiting in wartime

55 The Lusitania medal, 1915

Very large numbers of such medals were sold in Britain and the United States during the first World War accompanied by a label which read:

An exact replica of the medal which was designed in Germany and distributed to commemorate the sinking of the 'Lusitania'.
This indicates the true feeling the Warlords endeavour to stimulate and is proof positive that such crimes are not merely regarded favourably, but given every encouragement in the land of Kultur.
The 'Lusitania' was sunk by a German submarine on May 7th 1915. She had on board at the time 1,951 passengers and crew of whom 1,198 perished.

It was even alleged that the mistaken date on the medal (5 May for 7 May) proved that the Germans had planned to commemorate the event in advance. In fact, the medal proved nothing about the attitude of the German government since it was produced on the private initiative of the satirical medallist Karl Goetz, and was suppressed by the government as soon as it became aware of the medal's existence. Even Goetz himself was not glorying in loss of life but seeking to excuse it on the grounds that the *Lusitania* had been carrying arms (it had) and that the passengers were warned of the danger in advertisements placed in American newspapers. MPJ

Iron. D 56mm
BM CM 1917. 5–3. 1. Presented by Sir George Hill
LITERATURE P. Dutton, 'Notes on some medals inspired by the sinking of the Lusitania', *Imperial War Museum Review* I (1986), pp. 30–42

56 Fake 'over the top' sequence from the film *The Battle of the Somme*

In the late summer and autumn of 1916 the film *The Battle of the Somme* played to packed houses. The climax of the film was a sequence, three stills from which are included here, captioned: 'The attack. At a signal, along the entire 16 mile front, the British troops leaped over the trench parapets and advanced towards the German trenches, under heavy fire of the enemy'. It created a great impression; for example, Frances Stevenson (Lloyd George's secretary) wrote in her diary: 'I am glad I have seen the sort of thing our men have to go through, even to the sortie from the trench and the falling in the barbed wire . . . It reminded me of what Paul's last hours were: I have often tried to imagine to myself what he went through, but now I *know*: and I shall never forget . . .'

A graphic account of the filming of this sequence was provided by the cameraman, G. H. Malins, in his *How I filmed the War* (London 1920), but a panel of experts who viewed the film for the Imperial War Museum in 1922 pronounced the sequence a fake.

Subsequently, another cameraman claimed to have met a soldier who had 'died' for Malins in a trench at a mortar school well behind the lines. That rumours to this effect had circulated even at the time is indicated by the publicity release for the sequel *The Battle of the Ancre and the Advance of the Tanks* (January 1917) which opens 'General Headquarters is responsible for the censorship of films and allows nothing in the nature of a "fake" to be shown. The pictures are authentic and taken on the battlefield'. RBNS

Imperial War Museum
LITERATURE R. Smither, 'A Wonderful Idea of the Fighting: the Question of Fakes in *The Battle of the Somme*', *Imperial War Museum Review* III (1988), pp. 4–16

57 The Hitler 'death's head' and other wartime forgeries of stamps

Both World Wars saw the production of forged stamps by the governments involved in the conflicts, to serve as propaganda, but also to distribute other propaganda.

Two of the 'German' stamps shown here (a) were issued during the First World War by the British Government for use by Belgian soldiers during their occupation of the Rhine and for the distribution of millions of propaganda pamphlets through the post in Germany. For the latter large quantities of stamps would have been required, and their acquisition by the usual means would clearly have aroused suspicion. Apart from these German stamps, three Bavarian

57e

stamps of 1914, two Austrian of 1916 and one of 1917 were also forged.

During the Second World War both the Allies and the Axis powers produced not only forgeries but also deceptive parodies of enemy postage stamps for propaganda purposes (b). The 12pf. stamps with Hitler's head (c) were produced at the instigation of the Americans and are believed to have been printed in Switzerland. The initial attempt was a poor production, which necessitated a second and much improved printing. A 6pf. stamp was also produced at this time, as well as the so-called Hitler 'death's head' stamp. The British authorities also produced forgeries of the Hitler stamps of the 3, 4, 6 and 8pf. denominations, which are of a higher degree of accuracy and, because of the accurate colour matching, are quite deceptive.

It appears that during 1944 the Germans embarked on a propaganda programme to reduce British standing in neutral countries, in part by in producing parodies of British postage stamps (e). The examples here imitate the current definitives of the time; however, closer examination shows that the cross on the crown at the top of the stamp has been changed to the Star of David and the D in the value tablet to a hammer and sickle. The ½d. to 3d. denominations were produced like this, and all of these were also overprinted with *Liquidation of the Empire* and a wide range of British colonies' names.

During the course of the two wars approximately 160 stamps, postcards, stamp booklets and souvenir sheets were produced by both sides for propaganda and espionage purposes. RFSW

57a British forgeries of German stamps, First World War

57b American parody of German 12pf. stamp, 1941

57c American forgery of German 12pf. stamp, 1941

57d Genuine German 12pf. stamp, 1941

57e Anti-British forgeries of ½d., 1d., 1½d. and 3d. stamps, German Propaganda Ministry, 1944

57f Genuine British stamps of 1937–47

R. F. Schoolley-West

58a

58b

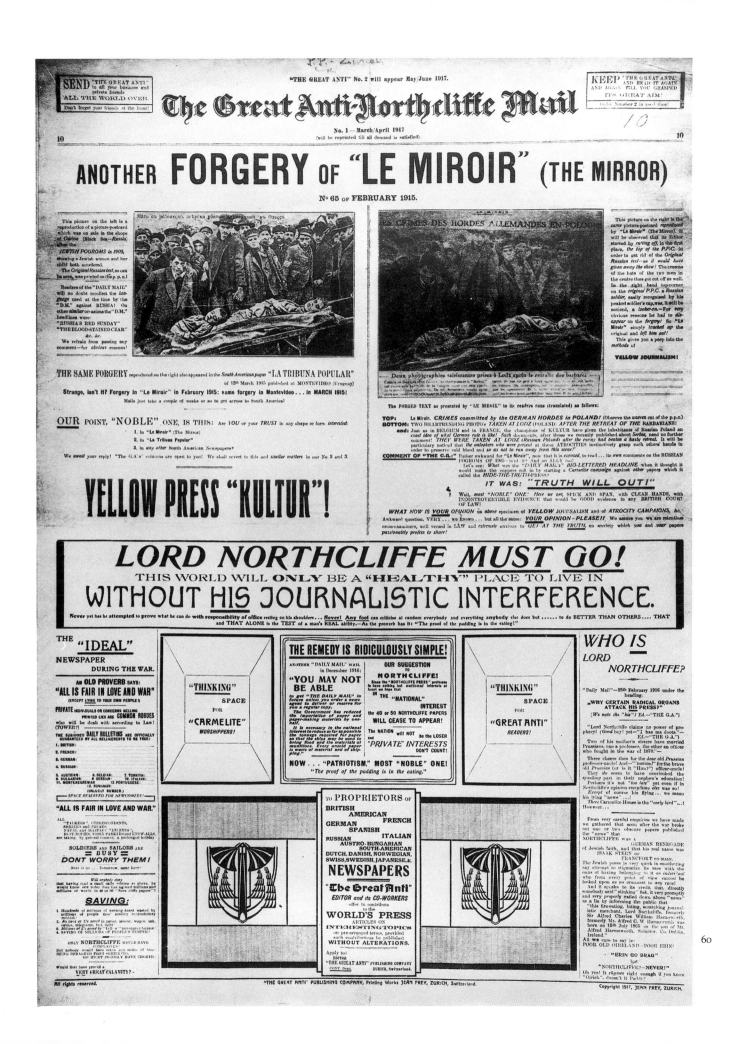

58 Documents used by British servicemen escaping from Colditz

The *Dienstausweis*, service identity card (a), was manufactured in Colditz prisoner-of-war camp and used by Lieutenant-Commander W. L. Stephens RNVR in his successful escape to Switzerland in October 1942. With the aid of this cleverly forged pass and the identity it lent him of a French civilian purportedly working for I. G. Farben in Germany, he managed to cross the four hundred miles from Colditz to the other side of the Swiss border almost without incident.

The copy of a German official stamp (b) was used to create forged documents for escapers. It was carved from linoleum by prisoners of war in Oflag IVC, Colditz, and reads *Polizeipräsidium Leipzig.* RWAS

58a Forged *Dienstausweis*
Lent by the Trustees of the Imperial War Museum with the permission of Lieutenant-Commander W. L. Stephens DSC VRD RNVR

58b Copy of German official stamp
Lent by the Trustees of the Imperial War Museum with the permission of Brigadier W. F. Anderson MBE MC

59 Forged issue of the *Evening Standard*, 17 February 1940, numbered 35, 941

The genuine issue of *The Evening Standard* for 17 February was numbered 36,023. The large discrepancy in the numeration of the forged issue, together with the crude nature of the text, would appear to indicate that this was only a prototype for an ambitious propaganda scheme by the German government. The forgery was undoubtedly intended to be dropped over London as part of a civil demoralisation programme, possibly as part of the Blitz. As things turned out, the first aerial propaganda drop over Britain took place during the Blitz on 1 August 1940. This drop did not include forged newspapers but copies of a speech by Hitler entitled 'A Last Call to Reason'. EJD

BL Colindale Newspaper Library
Illustrated on p. 58

60 *The Great Anti-Northcliffe Mail*, March/April 1917

Among the newspapers owned by Lord Northcliffe in 1917 were *The Evening News, The Times* and, of course, *The Daily Mail.* All through the First World War the German High Command perceived Northcliffe to be a great influence not only on British public opinion but also on opinion amongst the leaders of neutral countries. This perception was later reinforced by his appointment in 1917 as chairman of a government committee to encourage American assistance for the War effort. *The Great Anti-Northcliffe Mail* was published by the Germans in an effort 'to eliminate the Northcliffe Press from the part it is playing in the war'. It was published in Zurich and in size and format was a replica of *The Daily Mail.* This issue was largely devoted to denouncing the Northcliffe press for 'pictorial forgery', for example by demonstrating on page 7 that a photograph that appeared in *The Daily Mirror* (in fact since 1914 no longer owned by Northcliffe) as a German fort destroyed by the Allies had started life as a photograph of a Russian fort destroyed by the Germans. EJD

BL Colindale Newspaper Library

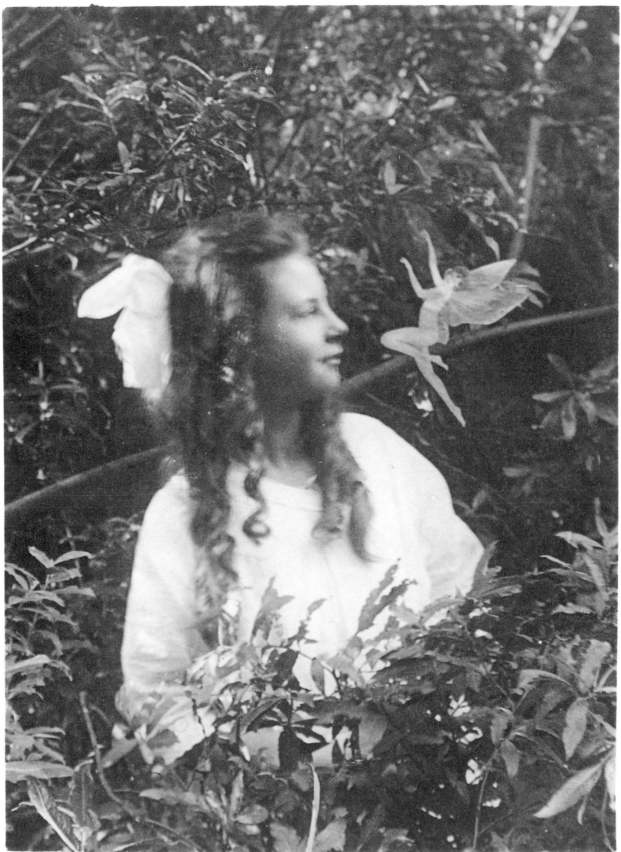

3

The limits of belief: religion, magic, myth and science

The objects in this chapter are the matter of dreams, the material evidence for the imaginary universes inhabited by the human mind. They measure the gap between the world as it was and the world as it is; the changing shape of its boundaries as old wonders are replaced by new ones.

There is evidence here of medieval longing for direct contact with Christ and his saints, met by apocryphal letters (61, 62) and bogus relics (64, 65). There is 'evidence' of the achievement of the alchemists' dream, the transmutation of base metals into gold (66). There is physical evidence for the existence of mythical creatures, unicorns, griffins and mermaids (69–72); and if they are to be taken as indicative of the credulity of the medieval mind what are we to say of the photographs of fairies (76)?

Science is often presented as the polar opposite of the world inhabited by such imaginary creatures. Here it is seen as the natural home of the modern myth. Piltdown Man (83) satisfied a whole generation's expectations of the missing link, just as unicorns' horns satisfied those of the medieval mind, while yet more recent examples of scientific fraud continue to demonstrate how easily fiction can enter a world supposedly devoted entirely to fact.

Apocryphal letters

61 Letter of Christ to Abgar

In the *Ecclesiastical History* of Eusebius (*c.* AD 260–*c.* 340) are found the earliest Greek versions of two letters supposedly exchanged between Christ and Abgar (4 BC–AD 50), King of Edessa. Eusebius claims that the letters were extracted and translated from Syriac originals among the archives of Edessa. In his letter Abgar tells Christ that news of His miraculous cures has led him to believe in His divinity and to request His coming to cure his own affliction. He also offers his city as a refuge from the threats of the Jews. In reply Christ blesses Abgar for his unseeing belief and, although refusing his invitation to his city, promises a life-giving cure through one of His disciples.

In addition to granting material authority to Eusebius' account of Thaddaeus' conversion of Edessa, these texts subsequently acquired a powerful talisman-like quality of their own. For, as is made clear in a text that often, as here, follows the reply of Christ, the owner of the manuscript becomes the recipient of the letter, receiving for himself Christ's blessing and promise of health and life. The letter, therefore, fits very well with the other devotional and liturgical texts found in this early manuscript and with the Anglo-Saxon culture in which the manuscript was produced. SMCK

Mercian manuscript, early 9th century
BL Royal MS 2 A XXX, ff. 12v–13
LITERATURE E. A. Lowe, *Codices Latini Antiquiores*, ii, Oxford 1934–71, no. 215; R. James, *The Apocryphal New Testament*, Oxford 1924, pp. 476–7

62 Letter of Lentulus

This letter, which is said to have been addressed to the Roman Senate by a certain Lentulus, a Roman official in Judea in the time of Tiberius, records the appearance in that province of Christ. In so doing it apparently provides both extra-Biblical evidence of the existence of Christ and the description of his features so lacking in the New Testament. It reads, in part:

a man in stature middling . . . having hair of the hue of an unripe hazel-nut and smooth almost down to his ears, but from the ears in curling locks somewhat darker and more shining, waving over his shoulders; having a parting at the middle of the head according to the fashion of the Nazareans; a brow smooth and very calm, with a face without wrinkle or any blemish, which a moderate colour makes beautiful; with the nose and mouth no fault at all can be found; having a full beard of the colour of his hair, not long, but a little forked at the chin; having an expression simple and mature, the eyes grey.

This description is perhaps one of the sources for the accepted formula for visual representations of Christ.

The letter can be shown to be an Italian humanist's version of an already existing text which is said to have been extracted from the annal-books of the ancient Romans. Moreover, internal evidence points to this text being a late medieval *Latin* translation of a Greek original, similar in many respects to the descriptions of Christ offered by the Greek texts of Nicephorus and John of Damascus.

In this manuscript the letter is found in a sequence of texts relating to Roman history which were copied by an English scribe trained in a humanist culture in Italy. The context is very fitting and contrasts sharply with that of 61. SMCK

English manuscript, early 15th century
BL Harley MS 2472, ff. 37ᵛ–38

61

LITERATURE R. James, *The Apocryphal New Testament*, Oxford 1924, pp. 477–8; exhibition catalogue, *Duke Humfrey and English Humanism in the Fifteenth Century*, Bodleian Library, Oxford 1970, no. 58

63 Isaac Casaubon and the *Corpus Hermeticum*

The idea that the central tenets of Judaeo-Christian religion might have been anticipated, even prophesied, by the sages of the earlier civilisation of Egypt appealed to the syncretistic philosophy of Hellenistic Alexandria, and it attracted a number of writers, both before and after the beginning of the Christian era. Their works, purporting to be translated from 'ancient Egyptian' into Greek, were associated with the Egyptian deity known from the third century AD as Hermes Trisgemistus, and assembled in the collection now referred to as the *Corpus Hermeticum*. It is difficult to know how seriously these texts were meant to be taken when written: something less than deliberate historic fraud, we may suspect, but something

more than intellectual pastiche. At any rate, when recovered in the Renaissance the same texts had a corresponding appeal to neo-Platonists such as Marsilio Ficino, and to syncretistic philosophers and theologians, such as Pico della Mirandola and Jacques Lefevre d'Etaples. Like their Alexandrian predecessors, they were attracted not repelled by the notion that the unique characteristics of Jewish and, still more, Christian faith could have occurred earlier to pious pagans: it confirmed rather than weakened 'the validity of Revelation'.

But some writers suspected the Egyptian antiquity of the texts: in 1575 Matthaeus Beroaldus noted tartly that a letter from Hermes to Aesculapius could not be genuine if it included a reference to the great sculptor Phidias, who lived in the fifth century BC. The attention of Isaac Casaubon was directed to the texts because they were collected in the great Catholic apologist Cardinal Cesare Baronio's *Annales* (1589–1609). Encouraged by James I, Casaubon wrote a comprehensive demolition of the *Annales* in his *De rebus sacris et ecclesiasticis exercitationes* (1614). In the process he acquired a copy of the earlier French scholar-printer Turnèbe's edition of the Hermetic texts, and set to work to read and annotate it. He was deeply versed in Christian Greek, had a sharp eye and ear for factual and linguistic anachronism, and knew the potential sources thoroughly. He summed up his conclusions:

The style of this book could not be farther from the language that the Greek contemporaries of Hermes used. For the old language had many words, phrases, and a general style very different from that of the later Greeks. Here is no trace of antiquity, no crust, none of that patina of age that the best ancient critics found even in Plato, and even more in Hippocrates, Herodotus, and other older writers. On the contrary, there are many words here which do not belong to any Greek earlier than that of the time of Christ's birth.

Casaubon was a skilled detector of literary forgery. In 1603 he had shown the writings attributed to a group of contemporary historians of the reign

of Augustus to be the work of a single later writer. But his destruction of the myth of an Egyptian prefiguration of Christianity was total. Those who defended Baronio did not attempt to dispute this part of *Exercitationes*. Hermes Trismegistus slipped quietly into the underworld of literary curiosity. NB

Mercurii Trismegisti Poemander, seu de potestate ac sapientia divina. Aesculapii definitiones ad Ammonem regem (Paris 1554). BL 491. d.14
LITERATURE W. Scott, *Hermetica* I (1924), p. 14; A. Grafton, 'Protestant versus Prophet. Isaac Casaubon on Hermes Trismegistus', *JWCI* XLVI (1983), pp. 78–93; R. Lane Fox, *Pagans and Christians* (London 1986), pp. 94, 126, 414–16

64

Relics

Relic worship is much older than Christianity and has been inherent in the rites of many cults and societies. The Christian churches have usually (at the very least) tolerated relics, whether of a holy person, or of a place or thing made holy by association with a person or event. In the Middle Ages the supernatural power of relics was seen as an established fact of life, although giving rise to periodic controversy. Relics were bought and sold, swapped, given away as presents and souvenirs, stolen, worshipped and sometimes rejected. Their value could be startling: Louis IX of France paid at least 135,000 *livres* for the Crown of Thorns in 1239 and it was only the most famous of several relics which he housed in his Sainte-Chapelle in Paris; the building itself cost 40,000 *livres* to build. Authenticity was a more complicated matter: for instance, the efficacy of a relic to perform a miracle could 'prove' its authenticity. Again, all manner of seedy merchandising, even the passing off of a manufactured fake, could be justified on the grounds of the relic's subsequent achievement: the monks of Conques openly published their blatant theft of St

Faith's body, because she had later sanctioned the theft by performing so many miracles at Conques. Chaucer's Pardoner with his 'pigges bones' may be a caricature but he stands in the late fourteenth century as part of a long tradition in the trafficking of small parcels of relics. This traffic by no means ceased either with the end of the Middle Ages or with the advent of Protestantism, and indeed many relics are still respected to this day by the Roman Catholic church. But the Middle Ages was the great period of relic worship. Even the most rational of medieval theologians did not seriously question the notion that divine intervention in ordinary daily life was possible through the agency of relics.

There have been virtually no modern scientific analyses of relics for their authenticity. The recent radiocarbon tests on the Turin Shroud are an important exception to this rule, their results proving what medieval historians have long known from a documentary source, that the Shroud was made in the mid-fourteenth century (317). The two reliquaries included here contain a number of obviously fake relics: of the True Cross, of the largely apocryphal Eleven Thousand

Virgins of Cologne, of the milk of the Blessed Virgin Mary, and (probably) of the early Roman martyr St Agnes. They may also contain some genuine relics, in one case of local Scottish saints and of the founder of the Premonstratensian Order, St Norbert of Xanten, who died in 1134, in the other case of St Elisabeth of Thuringia whose canonisation in 1235 is close in date to the mounting of her relic here.

Relics were usually hidden (and locked) within the relic case in the early Middle Ages, and the reliquary often took the outward appearance of the relic within, for instance the form of a head or arm, or represented it visually, as in the reliquary for wood from the True Cross (64). By the twelfth century at least relics were being displayed more publicly, using windows in the relic case, sometimes of crystal or horn (as here in 65), so that the worshipper could actually see the object of veneration. NS

64 Gold and pearl reliquary pendant

The reliquary is shown with its base-plate detached. A series of settings for relics, some of which survive, surround a central setting for

a lost relic of the True Cross. The relics are identified by an inscription, around the cover, as of Jesus Christ, Ninian, Andrew of the Moors, George; (probably) Margaret, Norbert, Fergus and Boniface; and of St Mary. This list includes three Scottish saints, and Norbert, founder of the Order of Regular Canons of Prémontré. The domed rock-crystal cover is locked together with the base-plate by a nut screwed down at the top, to protect the relics from theft. Beneath the crystal a bed of pearls is sewn with gold wire around a gold-mounted wood cross, symbolising the relic of the True Cross within. St Ninian was the apostle of Cumberland and Galloway, and the Cathedral of Galloway at Whithorn was Premonstratensian, so that the pendant could have belonged to a Bishop of Galloway, about 1200. NS

D 50mm
BM MLA 1946, 4–7, 1. Presented by the National Art-Collections Fund
LITERATURE A. B. Tonnochy, 'The Ninian reliquary', *British Museum Quarterly* XV (1952), p. 77; A. C. Ralegh Radford, 'Two reliquaries connected with south-west Scotland', in *Trans. Dumfriesshire and Galloway Natural History and Antiquarian Society for 1953–54*, 3rd series, XXXII (1955), pp. 119–23

65 The gable-end of a 12th-century house-shrine with relics added in the 13th century

The twelfth-century shrine of St Oda at Amay, Belgium, was broken up, probably in the thirteenth century, when a big new shrine for the local saint's bones was made, and its two gable-ends (the second now in Baltimore) were adopted as isolated 'icons' or reliquaries. The frames of the relic windows are post-medieval, but the date when the relics were inserted for display is guaranteed by the parchment 'authentications', written in red ink in a thirteenth-century hand, next to each relic. There are five relics of the Eleven Thousand Virgins, legendary companions of St Ursula of Cologne, whose bones were 'discovered' in 1155, and three relics of St Elisabeth of Thuringia, of the milk of the Blessed Virgin Mary and of St Agnes. Since St Elisabeth was only

canonised in 1235, the adaptation of parts of the old shrine to its new role on the altar at Amay cannot date from much before the 1240s. NS

Oak covered with *repoussé* silver, gilt copper and enamels. H 580mm; W 377mm
BM MLA 1978, 5–2, 7. Wernher Bequest
LITERATURE C. Oman, 'A Mosan reliquary at Luton Hoo', *Burlington Magazine* XCIV (1952), pp. 264–7; R. Forgeur, 'L'ancienne châsse de sainte Ode d'Amay. Sa place dans l'art rhéno-mosan', *Bulletin de la Société royale Le Vieux-Liège*, nos 197–8, tome IX (1977), pp. 163–75; P. Verdier, 'The twelfth-century châsse of St Ode from Amay', *Wallraf-Richartz Jahrbuch* 42 (1981), pp. 7–94

Magic, myths and monsters

66 Alchemical transformations

Alchemists believed that it was possible to transmute base metals into gold. Two examples of 'successful' transmutation are included here. One of them (a) was published by John and Andrew van Rymsdyk in their early description of the collections of the British Museum:

It is said to be an imposition on a gentleman which happened thus: – This pretended Alchymist had two little Knives, one of which had a Gold Point, the other plain, and were made so as to resemble each other as much as possible. The time being fixed on, and the pretended Elixer produced before the Gentleman; the Imposter with legerdemain trick, changing the plain knife, after its dipping, deceived the Eyes by his nimble motion, and brought forth the other with the Gold Blade; then again the Great Elixer being spilt on the ground, and pretended could never be made again . . . [It was] purchased by the late possessor, at a very considerable price.

The other (b), a so-called alchemical bullet, was acquired by the British Museum with a note in an early nineteenth-century hand which reads: 'Gold made by an alchemist from a leaden bullet in the presence of Colonel MacDonald and Doctor Colquhoun at Bapara in the month of October 1814'. That it is indeed pure gold was confirmed by a specific

gravity test carried out by Mr K. Howes in 1971. MPJ

66a Dagger
L 120mm
BM (Natural History)
66b Bullet
Gold. 6 × 5mm
BM CM M2036

67 Oracle bones

Inscriptions on bone and shell of the kind included here represent some of the earliest examples of writing in the world, dating from the late Shang dynasty (*c*. 1500–1000 BC). In ancient China diviners consulted the oracle by observing the patterns left when a hot poker was stuck into a bone or shell. The results of the divination were written on the bone, using a sharp incisor to mark the text. Most oracle-bone writing is between ten and twenty Chinese characters long. The text usually predicts the outcome of battles, harvests, births and other important events, or seeks the meaning of some portent, like unseasonal weather, illness or dreams.

It was early in the twentieth century that Europeans and Americans living in China learned of the discovery of these ancient texts. Samuel Couling, a Baptist missionary working in Shandong province, bought his first bone in 1900, within a year of the discovery by Chinese scholars that the unusual bones known then as 'dragon bones' were in fact the earliest form of Chinese writing. The collection of oracle bones made by Couling with his friend, the Presbyterian missionary Frank Chalfant, between 1903 and 1908 is now in the British Library.

Inevitably, because of the price commanded by genuine ancient inscriptions, some fakes were passed off as genuine: 67a is a good attempt to imitate a text incised in an ox scapula; 67b is an obvious forgery, and may well have been acquired as a curiosity – it is a cross between an archaic *bi* disk and an oracle bone, with dozens of characters crammed onto its tiny surface. EMCK

67a H 140mm; W 120mm
BL Or. 7694, 1545

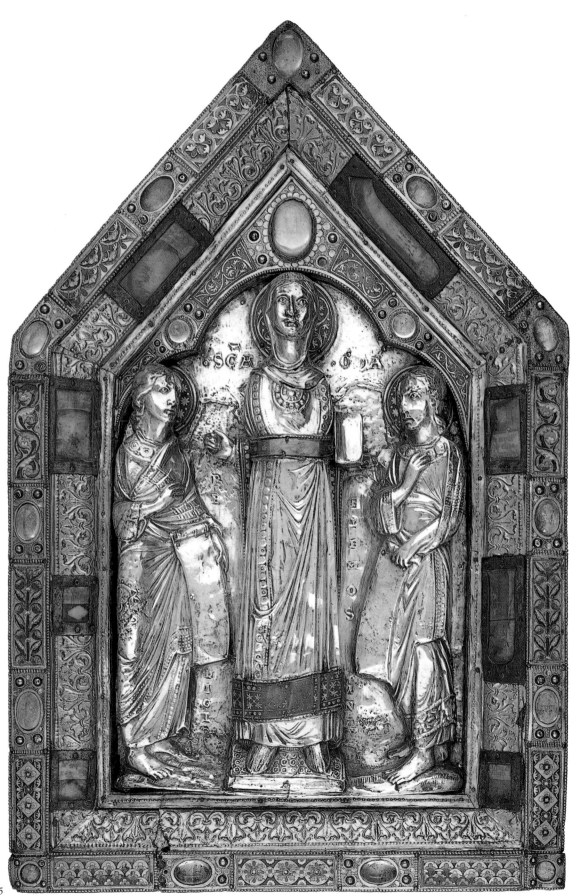

65

From back to front (*left to right*): 73a; 70; 74,67b,67a,73b; 72a,68

67b D 45mm
BL Or. 7694, 2124
LITERATURE S. Allan, X. Li & W. Qi, *Oracle bone collections in Great Britain*, Beijing 1985

68 Witch's wreath

This consists of a leather thong, knotted to form a necklace and strung with twelve amuletic objects: a square piece of wood with a fragment of Holy Writ beneath a sheet of mica; a hollow quill containing a scroll, sealed at each end with beeswax; a horn cross; a piece of animal bone; a thin bone plaque bearing symbols in red sealing wax; a small piece of leather tooled with a six-pointed star; a model of a human heart in beeswax, covered in red wax and transfixed by a large pin;

an eye-shaped piece of horn incised with an iris and pupil; a thin bone plaque with symbols, possibly intended to be signs of the Zodiac, burnt into the surface; a fragment of translucent horn in the shape of a skull with holes burnt out to represent eyes, nose and mouth; a lump of fossilised resin, and a rusty staple of forged iron.

The wreath, purchased for £5 in 1941, came with a document, apparently written by Alice Wornum in Stratton, near Swindon, Wiltshire, on 3 October 1879, which reads:

This Witches wreath was used by Mary Holt a well known wise woman of Stratton who cured my Mother of the Evil eye and our cattle of the plague. This wreath was found in her cottage after she died in 1875.

Suspicions were aroused a year later when it was revealed that no persons of the names mentioned in the document existed. Nor was it possible to trace the wreath back into the nineteenth century. Attention was also drawn to another object associated with witchcraft from Wiltshire – a witch's glove from Wootton Bassett – that had been recently published as a fake and had also been offered to collectors with faked deeds and papers. JAR

L (approx) 360mm
BM MLA 1941, 12–8, 1
LITERATURE 'A Witch Glove from Wootton Bassett', *Wiltshire Archaeological and Natural History magazine* XLIX (1940), p. 242

69 'Unicorn's horn'

In about 398 BC the Greek historian and traveller Ctesias wrote a book about India in which he recorded 'certain wild asses which are as large as horses and larger . . . They have a horn on the forehead which is about a foot and a half long. The dust filed from this horn is administered in a potion as a protection against drugs'.

So the unicorn was born. It was discussed by classical authors, including Pliny, Aelian and Oppian, entered the Latin vulgate as *unicornis*, from the Greek *monoceros* (a mistranslation of the Hebrew *re'em*) and was transformed by medieval bestiaries into a small goat-like creature which could be captured only by a virgin.

Some time in the ninth century 'unicorns' horns' began to circulate in Europe. Elizabeth I had one at Windsor and there was another at Saint Denis (now in the Cluny Museum). It was not until 1638 that the Danish zoologist and antiquarian Ole Wurm gave a public reading of his dissertation on the origin of unicorns' horns that proved that they were really tusks of the narwhal, a type of marine mammal.

This example was first recorded in the will of Margaret, Countess of Bath, who left her daughter-in-law Elizabeth Kytson 'her unicorn's bone' in December 1561. MPJ

Parham Park
L 2006mm
LITERATURE J. Gage, *The History and Antiquities of Hengrave in Suffolk*, London 1822, p. 136; P. Costello, *The Magic Zoo*, London 1979

70 Griffin's claw

The mythical griffin, or gryphon, had the foreparts of an eagle and the hind-parts of a lion. Rhinoceros horns, or the horns of antelopes, bulls or ibexes were preserved as its claws. This example is from an ibex, an Alpine wild goat. Such 'claws' were highly prized treasures and to explain their rarity it was said that only a saint or very holy man could acquire one, and then only if he were able to cure a griffin of some wound or ailment and exact a claw as payment. It is possible

that some such belief lay behind the presence of two griffins' claws and several griffins' (really ostrich) eggs in the shrine of St Cuthbert at Durham, recorded in a list drawn up in 1383. The present band around the mouth of the horn, which probably replaced an earlier fitting in the late sixteenth or early seventeenth century, is engraved with the inscription GRYPHI UNGUIS DIVO CUTHBERTO DUNELMENSI SACER (the claw of a griffin sacred to the blessed Cuthbert of Durham). JC(MLA)

L 711mm
BM MLA OA24
LITERATURE J. Raine, *St Cuthbert* (1828), pp. 120–30 (Translation of *Liber de Reliquiis*); C. H. Read, *Proc. Soc. Ant* IX (1883), p. 250; *Liber de Reliquiis. 1383*, ed. by Canon Fowler, in *Durham Account Rolls*, Surtees Society, vol. 100 (1899), pp. 425–39

71 The Vegetable Lamb of Tartary

The Middle Ages, rightly in many ways, saw the world as a place of many wonders and surprising phenomena. However, the limited communications of the day, coupled with a fervent faith and an uncritical attitude to matters which today we would call science, led to the ready acceptance of many myths that seem truly bizarre to the modern mind. Many people are familiar with the myth which saw the origin of barnacle geese from trees growing somewhere in the north of Europe. A much less well-known but equally fascinating story concerns the Vegetable Lamb of Tartary. This appears to have come to England through Sir John Mandeville, a native of St Albans, who travelled in the realm of the Cham of Tartary and reported that there was in that country a great marvel, through which certain plants gave rise to living lambs, which became independent when mature. This specimen comes from the collections of Sir Hans Sloane, who showed it to the Royal Society in 1698, when he identified it correctly as the scale-covered rhizome and leaf bases of an arborescent fern. It had been sent from India by a Mr Buckley, where it was known as the Tartarian Lamb, but we now know that it must have travelled to India from China, where the fern *Cibotium barometz* actually occurs naturally. Thus it is

apparent that from early times information about this plant, albeit as a garbled collection of half-truths, was finding its way around a large part of Asia. We can safely assume that in many instances the information was accompanied by actual specimens similar to this one. Although the specimen, through the passage of time, now lacks most of its woolly covering, we can readily see how our ancestors would have seen it as clear proof of the story that had come to their ears. JFMC

H 125mm
British Museum (Natural History)

72 Mermen

Prominent in ancient, medieval and modern mythology, mermaids (and, less usually, mermen) were presented as three-dimensional curiosities in European drawing-rooms and popular sideshows from at least the seventeenth century. A significant number of these seem to have originated in East Asia, especially in Japan.

Such 'mermen' consist of the dried parts of monkeys, with fish tails, probably on wood cores. The British Museum example, donated by HRH Princess Arthur of Connaught, was said to have been caught in Japan in the eighteenth century and to have been given to Prince Arthur by one Seijiro Arisuye. BD

72a L 380mm
BM ETH 1942 As1. 1
72b L 502mm
Horniman Museum, WHMM a 17758.
Wellcome Collection

73 Fishy frauds: Jenny Hanivers and 'Sea Bishops'

The term Jenny Haniver is used for the dried bodies of skates and rays (occasionally dogfish) which have been manipulated to produce either anthropomorphic or dragon-like curios. Guillaume Rondelet, though personally sceptical, reported in his *Libri de Piscibus Marinis* (Lyon 1554; English translation by John Gregory 1663–4) that:

in the Year 1531 a Fish was taken in *Polonia*, such a one as wholly

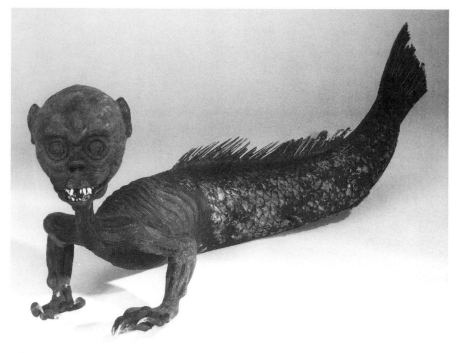

72b

represented the appearance and appointments of a Bishop. This sea-monster was brought to the King, and after a while seemed very much to express to him, that his mind was to return to his own Element again: which the King perceiving commanded that it should be so; and the Bishop was carried back to the Sea, and cast himself into it immediately.

Ulysses Aldrovandi, in his *De Piscibus* (1613), was however well aware how these artefacts were made, and Jenny Hanivers changed from mysterious tokens of superstitious belief to objects of pure amusement. By the mid-nineteenth century they had lost most of their popular appeal, and they are only occasionally made or seen today.

Many species of cartilaginous fish (sharks, skates, rays) have been used for the manufacture of Jenny Hanivers. The snouts of rays often provide the semblance of a bishop's mitre and the pectoral wings have been variously manipulated to give the appearance of an ecclesiastical garment. These features have led to the alternative names, 'sea bishop' and 'sea monk'. Sometimes the male intromittent organs or claspers are fashioned into legs, although the

posterior parts of the pectoral wings have served this purpose in the specimens displayed.

An important feature of most Jenny Hanivers is the face, with prominent 'eyes' and mouth. It is the ventral side of the fish that is viewed, so that while the mouth is that of the fish, the 'eyes' are in fact its exhalent respiratory openings. The true eyes of the ray are in the upper surface of the body and so are here hidden from view.

The origin of the name Jenny Hanivers is obscure. Researchers have often recounted a suggestion that Jeanie Hanvers (a possible earlier name) is a corruption of Anvers, the French name for Antwerp, where they were probably manufactured. OC

H 500mm (a); 370mm (b)
British Museum (Natural History)

74 A simulated shrunken head

The shrunken human heads, or *tsantsas*, of the Upper Amazon have long exercised a ghoulish fascination for collectors, quite divorced from the religious and social importance that attached to them among the Amerindian peoples who produced

them. Demand for them in the world beyond the Amazon has always exceeded the number of genuine examples ever offered for sale, and many of those in both museum and private collections are forgeries.

It is reported that at the end of the nineteenth century corpses were disinterred, or the heads of 'unclaimed dead in city morgues' (Steward 1945) were acquired by town-dwelling traders to provide heads for shrinking by either the Shuar (Jivaro) tribesmen, or people who had learned the techniques from them. Writing in 1938 on the subject of counterfeit *tsantsas*, Matthew W. Stirling gave an account of heads being produced for sale in countries such as Panama, far removed from the areas in Peru and Ecuador where the practice originated.

More recently heads made of goat skin, or sometimes monkeys, have provided a small industry for villagers in Ecuador in the area surrounding Qito. The moistened goat skin is moulded over a clay form. The makers do not, it is said, regard their products as forgeries but as part of the souvenir trade. Some of them are quite convincing in appearance, but features such as the eyebrows can provide an indication that the head is not human. The hair grows in one direction and has to be trimmed and combed into opposite directions to imitate human eyebrows.

For the Shuar the heads of enemies taken in warfare were objects of great spiritual power, and were prepared with elaborate ritual care. The heads of sloths, regarded as ancestral animals by the Shuar, were sometimes prepared in the same way as human heads and were considered to have similar though lesser power.

BM ETH Q89. Am1. 1
LITERATURE J. H. Steward, 'Tribes of the Montaña: An Introduction', *Handbook of South American Indians* 3, Smithsonian Institution, Bureau of American Ethnology, Bulletin 143, Washington 1945, p. 625; M. W. Stirling, *Historical and Ethnographical Material on the Jivaro Indians*, Smithsonian Institution, Bureau of American Ethnology, Bulletin 117, Washington 1938, pp. 76–8

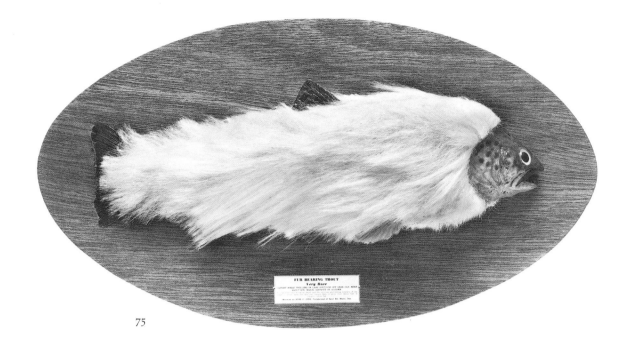

75

75 Furry trout

The belief that the fauna of Canada included furry fish is said to date from the seventeenth century, when a Scotsman, who had written home about the abundance of 'furried animals and fish', was asked to send an example of the latter and obliged. In recent years furry fish have been produced by Ross Jobe, of Sault Ste. Marie, Ontario, using rabbit fur. The accompanying text suggests 'that the great depth and extreme penetrating coldness of the water in which these fish live, has caused them to grow their dense coat of (usually) white fur'.

In the early 1970s an enquirer, believing it to be genuine, brought one of these fish to the Royal Scottish Museum which, recognising it as a hoax, did not retain it. The story had got out, however, and public demand to see the furry fish was so strong that the Museum had to 'recreate' it. This furry fish is, therefore, a fake twice over. GNS

L 270mm
National Museums of Scotland

The Cottingley Fairy Photographs
76

One Sunday in 1917 Elsie Wright, aged fifteen, and her cousin Frances Griffiths, some six years younger, claimed that playing with fairies near their home in the Yorkshire village of Cottingley had delayed their arrival home for tea. To back up this claim the girls borrowed a simple box-camera and duly produced two photographs of themselves with the fairies. Elsie's parents were more irritated than impressed and the episode would have been forgotten had not Edward Gardner, a leading Theosophist of the day, happened to see the fairy photographs.

Gardner was firmly convinced of their authenticity and, more significantly, his conviction was endorsed by Sir Arthur Conan Doyle, creator of that supreme interpreter of physical evidence, Sherlock Holmes. Conan Doyle, deeply interested in spiritualism following the death of his son, showed the photographs to photographic experts. Though suspicious, they were unable to say how the photographs were faked

and Conan Doyle went on to publish them with an account of their origins in *The Strand Magazine* for December 1920. Meanwhile, with Gardner's prompting, the girls produced three more fairy photographs which the delighted Conan Doyle publicised in a further *Strand* article in March 1921.

Thus the Cottingley fairy photograph phenomenon, an obscure domestic affair, became a major 'media event'. The young photographers were caught up in a highly public world of adult enthusiasm and curiosity. There was some fun in it, but by 1926 the strain was such that Elsie emigrated to the USA, where she discovered that the photographs' fame had preceded her. For over fifty years the Cottingley story was retold time and again in the press, on screen and elsewhere, worldwide, either inviting a belief in the supernatural or posing the question 'how was it done?'

That question began to be addressed with unprecedented technical expertise and ingenuity in 1982 by Geoffrey Crawley, editor of the *British Journal of Photography*. Using the available evidence, Crawley's inferences about how the

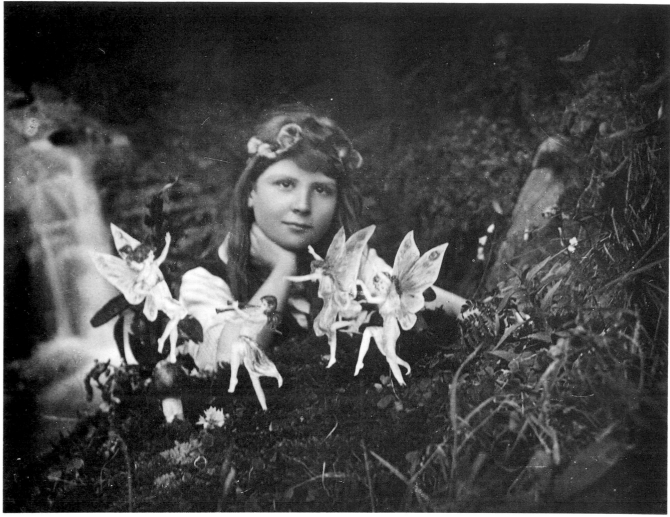

76a

photographs might have been produced came so close to the truth that in 1983 both Elsie and Frances finally decided upon revelation. For most of their lives they had disarmingly and enigmatically deflected questioning; rather than make outrageous claims for their photographs, they preferred to draw attention to the credulous statements of others more eminent and supposedly wiser than they. But by 1983 most of those who could be hurt or embarrassed by admissions were dead.

It now emerged that the photographs were simply but cleverly composed using cut-out fairies kept in position by hat-pins. The enterprise was made possible by Elsie's brief experience of working for a photographer and her growing artistic talent, factors which had hitherto been given far too little weight. Some quiet retouching of the original photographs, outside the girls' control, had later enhanced the published prints.

The Cottingley fairy photographs now stand revealed as an innocent hoax which got hugely out of hand. If their interest for lovers of fairies is diminished, their history continues to fascinate sociologists, folklorists and photographers. CDWS

76a Alice and the fairies

The first and best known of the Cottingley fairy photographs shows Frances Griffiths, her identity temporarily concealed as Alice. The fairy figures were actually based on pictures in *Princess Mary's Gift Book*, published in 1915. The girls forgot to attach wings to the second fairy from the left. CDWS

Brotherton Library, University of Leeds

76b Alice and leaping fairy

This is one of the second group of photographs, taken at Edward Gardner's request. Alice, now rather older, seems to gaze beyond the fairy; in fact she had difficulty in focusing her eyes properly on the narrow edge of the almost two-dimensional fairy cut-out. CDWS

Brotherton Library, University of Leeds
Illustrated on p. 78

76d

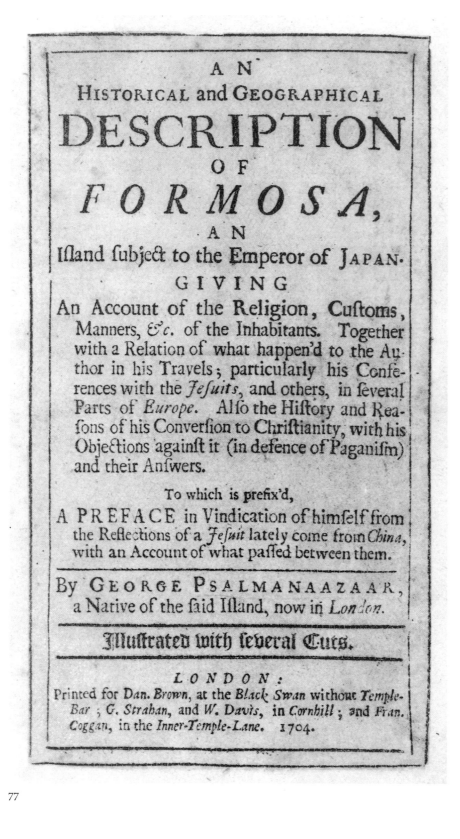

77

76c Fairy sunbath, elves, etc.

The last of the photographs to be taken, the only one not to include a human figure, has an imprecision not seen in the others. Exactly how its particular effect was achieved has not yet been fully revealed. CDWS
Brotherton Library, University of Leeds

76d Painting of fairies by Elsie Wright

Elsie Wright's watercolour of fairies by a stream was painted for Edward Gardner at about the time the photographs were taken. He was unimpressed, but it was natural that he should discount any indication that Elsie might have created the fairies photographed. CDWS
233 × 186mm
Brotherton Library, University of Leeds

76e Autograph letter from Sir Arthur Conan Doyle to Edward L. Gardner, 21 October 1920

Conan Doyle's farewell letter to Gardner comments on the importance of the second set of photographs recently taken and gives his fullest assessment of the significance of the Cottingley events for mankind. CDWS
Brotherton Library, University of Leeds

Science

77 George Psalmanazar, *An Historical and Geographical Description of Formosa*, 1704

George Psalmanazar (his chosen name: his real name is unknown) came to London in 1703, having – as he claimed – left Formosa six years earlier. His ability to subsist on a diet of raw meat and herbs, and his forged Japanese passport designating him a convert to Christianity allowed Psalmanazar to pass as a Formosan despite his obviously unoriental appearance.

His status as a convert was, with his quick wit and desire for publicity, the basis of Psalmanazar's success. The Society for the Propagation of the Gospel, founded in 1698 and

78a

concerned with the translation of the Bible into every possible tongue, was much impressed by his mastery of 'Formosan' (in fact, his own invented language). He crowned his success by writing in Latin an account of his career and country, which was translated into English as *An Historical and Geographical Description of Formosa* (1704), based on published writings as well as his own invention, to which several illustrations added verisimilitude. In 1728 Psalmanazar, ill, read Law's *Serious Call*, saw the light and repented. He spent the rest of his long life as a Grub Street hack. He became genuinely learned in Hebrew, and wrote for Samuel Palmer, the printer, *A General History of Printing*, published under Palmer's name in 1732. He was admired by Dr Johnson, who said 'his piety, penitence and virtue exceeded almost what we read as wonderful in the lives of the Saints'.

Psalmanazar died in 1763 and his (true) memoirs were published in 1764. They were as successful as his forgery sixty years earlier; Horace Walpole said that, as a literary impostor, he possessed a greater genius than Chatterton (see 158). As late as 1808 his imaginary Formosa appeared in G. Bouchard de la Richarderie's *Bibliothèque universal de voyages*. NB

BL 981. a.25

78 J. B. A. Beringer's 'fossils'

These two carved stones once belonged to J. B. A. Beringer, Professor of Medicine at Würzburg University, Bavaria, who accumulated about two thousand such 'fossils', collected in the neighbourhood for him by three local youths. In 1726 he illustrated about two hundred of them in a book, *Lithographiae Wirceburgensis*, in which he set out several different theories concerning the origin of 'formed stones' or fossils.

Before the book had appeared a rumour began to circulate that the 'fossils' were not natural objects and that Beringer was the victim of a hoax. Even when he was informed, Beringer was reluctant to believe that all the specimens were bogus or that his collectors had wilfully deceived him. He sought an inquiry in the Court of the Prince Bishop of Würzburg, and it was shown in evidence that the perpetrators were two of Beringer's colleagues, J. J. Roderich, Professor of Mathematics, and G. von Eckhart, Librarian of the Court and of the University. Their motives were personal dislike and professional jealousy. There is no record of verdict or sentence. Von Eckhart died four years later and Roderich left Würzburg, or was banished.

One of the theories put forward by Beringer to account for the representations in stone could even explain the fragments bearing Hebrew characters. There was an ancient Jewish cemetery close to the place where the specimens were found and since:

Light . . . is a flow of minute solar particles . . . that has the truly marvellous faculty of depicting, portraying and forming the images of the bodies that it falls on in its flow. Could it not also be supposed that it has a certain active and creative power of imprinting on suitable matter the same forms of which it has already taken the impression?

HPP

61 × 75mm (a); 46 × 96mm (b)
University Museum, Oxford
LITERATURE J. M. Edmonds & H. P. Powell, 'Beringer "Lügensteine" at Oxford', *Proceedings of the Geologists' Association* 85 (1974), pp. 549–54, pl. 19

79 Microscope phakomètre/epanaphorascope phlatergometre

This complicated 'instrument' does not perform any useful purpose and was presumably made as a spoof. The use of the word 'phlatergometre' may have an intentional connection with the Dutch or Flemish word *Flater* meaning 'blunder', while phakometre (fakometer) speaks for itself. JL

Possibly Belgian, 19th century
Brass, part silvered, and steel.
H 385mm
BM MLA 1867, 7–16, 3.
Presented by Octavius Morgan
LITERATURE F. A. B. Ward, *A Catalogue of European Scientific Instruments in the Department of Medieval and Later Antiquities of the British Museum*, London 1981, no. 450

80 Handaxes from Moulin Quignon

The production of counterfeit handaxes at the site of Moulin Quignon in northern France was inadvertently stimulated by the customs official turned archaeologist, Jacques Boucher de Perthes. Boucher de Perthes had collected stone implements in the Somme Valley since 1837. His research had convinced both the scientific community and public opinion of the great antiquity of the human race by proving that people had coexisted with extinct species of animals many thousands of years

79

earlier than had previously been supposed. Scientists now wanted to know what sort of people had made the stone implements. To answer this question, Boucher de Perthes needed to find human bones. Offered a reward of 200 francs, the workmen soon came forward with a human jaw-bone and planted the counterfeit handaxes at the site in an attempt to authenticate its antiquity. Initially the 'discoveries' were accepted as genuine, but scepticism among British scientists quickly revealed the hoax. The jaw was recognised as modern and the handaxes were easily distinguished from genuine specimens recovered in the pit because they had been made by metal rather than stone hammers and their fresh condition was not consistent with their discovery in gravel. Furthermore, the superficial iron staining had clearly been applied to the surface and could be washed off. Fortunately, no one involved implicated Boucher de Perthes and the hoax did not discredit his previous research, although it has subsequently

been discovered that he was duped on other occasions. JC(PRB)

80a Genuine handaxe, *c.* 350,000 years old, found at Moulin Quignon near Abbeville in gravels deposited by the River Somme
H 110mm
BM PRB 1939. 3–1.1. Formerly in the collection of the Geological Museum
80b Forgery planted at the same site in 1863
H 104mm
BM PRB 1925. 3–9. 1. E. Ray Lankester Collection

81 Painted pebbles from Mas d'Azil, Ariège, France

In 1891, during his excavations in the cavern of Mas d'Azil in the French Pyrenees, Edouard Piette discovered over two hundred pebbles decorated with simple dot and line motifs applied in paint prepared from the red ochre which occurs naturally at the site. These painted pebbles were found with distinctive stone and bone tools which Piette distinguished with the name Azilian, now dated to between 11,000 and 9,500 years ago. Although painted pebbles had been found at other sites, the discovery of such a large sample at Mas d'Azil excited much attention from scholars trying to decipher the significance of

the motifs. Sadly, their research was completely undermined when in 1929 it was announced that, following Piette's death in 1906, there had been criminal exploitation of the site and many counterfeit painted pebbles had been made and sold along with genuine examples. Museums that had purchased collections of painted pebbles from Mas d'Azil now had a serious problem. The simplicity of the techniques and motifs used to decorate the ancient examples made them easy to copy. The pebbles, and the red ochre with which to reproduce them, could be obtained at the site. With these advantages on the forgers' side, could all the forgeries be detected or only the careless ones? Of the ten specimens purchased by the British Museum in 1929, it is probable that only one is genuine (a). Its paint is dark and dull and the painted border is interrupted by ancient damage. The others can be distinguished as forgeries by the lighter, brighter colouring of the paint or the tell-tale circular streaks left by the use of a modern crayon. However, even after the obvious forgeries have been exposed, there remains a possibility that others may have gone

81a,b

undetected. Unfortunately, this possibility has inhibited research on objects which are really of remarkable interest. JC(PRB)

81a Genuine painted pebble from Mas d'Azil, Ariège, France
H 76mm
BM PRB 1929. 4–13. 3. Purchased from Abbé Henri Breuil

81b Counterfeit pebble coloured with a modern crayon, allegedly from Mas d'Azil
H 62mm
BM PRB 1929. 4–13. 4. Purchased from Abbé Henri Breuil

82 The Himalayan fossil controversy

A recent scientific controversy has centred around the discovery of varieties of ammonoid and conodont in the Himalayas that were previously known only from sources in Morocco and New York.

Some have claimed that these finds cannot be genuine, while others reiterate that they are. Whatever the truth of the matter, the continuing emergence of such cases demonstrates that the scientific world remains vulnerable to falsified data.

Ammonoids of the type supposedly found in the Himalayas
Private Collection
LITERATURE J. A. Talent, 'The case of the peripatetic fossils', *Nature* (20 April 1989), pp. 613–15; V. J. Gupta, 'The peripatetic fossils: part 2', *Nature* (7 September 1989)

Charles Dawson and Piltdown Man
83–93

The announcement, late in 1912, that a new 'Dawn Man' had been discovered at Piltdown caused enormous excitement. It appeared to fulfil the Darwinian prediction of a link between man and apes, as refined and restated in the light of the discovery of Java Man (1891). Equally important, it suggested that the origins of man were to be found not in Java or Germany, as the discovery of an early jaw at Heidelberg (published in 1908) had suggested, but in England.

According to his own account, Charles Dawson, the finder, was presented with the first piece of the Piltdown skull by two workmen in 1908. It was part of what they called a 'coconut' which they had smashed while digging gravel with which to mend a farm road. In 1911 he came across more fragments, a number of associated flint implements (86e, f) and prehistoric animal remains (86a–d); in February 1912 he wrote to Smith Woodward, then Keeper of the Geological Department at the British Museum (Natural History), with news of his find. In June Smith Woodward, Dawson and Teilhard de Chardin, who was then studying at the seminary in Hastings, began a systematic excavation of the site which shortly afterwards resulted in Woodward's discovery of a jaw that appeared to belong with the skull. This was a discovery of the greatest importance, for the skull, though unusually thick, was essentially human in form, while the jaw was ape-like; indeed, only the characteristically human wear of the teeth differentiated it from an ape jaw.

Subsequent discussion centred on this discrepancy and in particular on the kind of canine tooth that such a creature would have possessed. Smith Woodward was quite definite about this; it would have had a canine tooth not unlike that of a chimpanzee but not projecting much above the other teeth and with a human pattern of wear. It was fortunate indeed that a year later, on Saturday 30 August 1913, Teilhard de Chardin found a tooth (84) which was, as Dawson pointed out, 'almost identical in form' to that on Smith Woodward's reconstruction.

Even so, a few obstinate spirits remained unconvinced and it was not until Dawson supposedly discovered fragments of a second skull in 1915, published by Smith Woodward in 1917, that the remaining doubts of, among others, the leading French anthropologist Marcellin Boule, were finally stilled. From this moment Piltdown was accepted by most scientists as one of the most important relics of man's ancestors. A group portrait by John Cooke (87) shows Arthur Keith examining the reconstructed skull, flanked by Underwood, Pycraft and Sir Ray Lankester. Barlow, Elliot Smith, Dawson and Smith Woodward stand behind him. On 10 September 1916 Dawson died. In 1938 a memorial was erected to him and his discovery at Barkham Manor and in 1950 the Nature Conservancy Council cleared the Piltdown site and declared it a national monument.

By this time, however, it had become clear that Piltdown Man was not, after all, the 'missing link'. New finds in China, Java and Africa between the wars showed that he was an aberration; that early man had in fact had an ape-like skull and a man-like jaw, not the other way round. Then in 1949 fluorine dating tests showed that the skull was more probably 50,000 years old than, as had previously been thought, 500,000 years.

This was extremely odd, and it dawned on J. S. Weiner, when reviewing the evidence in 1953, that there was really only one feature distinguishing the jaw from that of a modern ape: the wear of the teeth. When it was discovered on close examination that this had been artificially induced it became immediately apparent that Piltdown Man was a fraud. Subsequent batteries of scientific tests only served to confirm this in every detail; indeed, in one respect they were misleading since they concluded that the skull was ancient and the ape jaw modern, whereas more recent radiocarbon dating has revealed the fact that both are medieval, or later.

Since the 1953 discovery much controversy has surrounded the identity of the forger(s). Numerous individuals have been proposed. Of the two most famous, however, it should be noted that Teilhard de Chardin returned to France before Piltdown II, another deliberate forgery, was discovered, and that

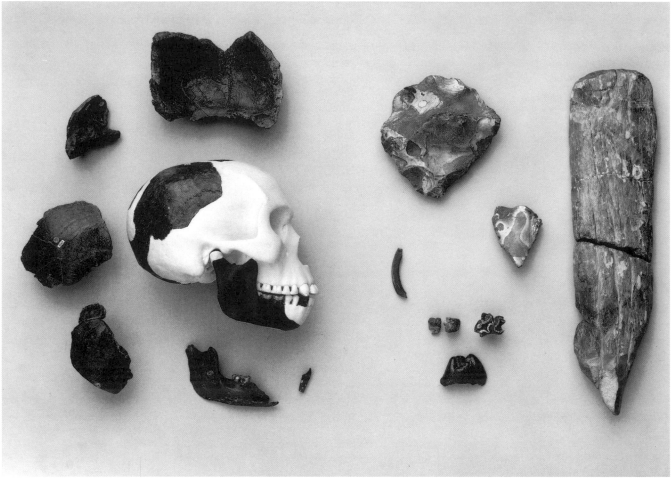

83–6

Smith Woodward was approached by Dawson with the original finds and spent much of his retirement in the 1930s in a fruitless search for further material from Piltdown.

Whether Teilhard de Chardin knew of the fraud is unclear, but it may be significant that the tooth which he so miraculously found was painted rather than stained with iron oxide and a chromium compound in the way characteristic of the rest of the Piltdown material. Whether he hoped to expose the fraud before it went too far by the implausible discovery of exactly the required tooth may never be known. Harry Morris, who knew Dawson and regarded him as a fraud, left a note which read 'Judging from an overheard conversation there is every reason to suppose that the

"canine tooth" *found at P Down was imported from France*'.

However, the key figure in the Piltdown story is undoubtedly Charles Dawson. By profession a solicitor, he had an extraordinary career as a geologist and antiquarian. As early as 1891 Smith Woodward named a new early mammal which retained traces of its reptile ancestry, *Plagiaulax dawsoni*, after its discoverer, who was also responsible for finding three new species of iguanodon. In the 1890s Dawson acquired a statuette (90), which he considered to be the first example of the use of cast iron. Other discoveries included a transitional boat – half-coracle and half-canoe – a Neolithic stone weapon with a wood shaft; a 'Norman prick spur' (92); a

'transitional' horse shoe; a form between *Ptychodus* and *Hybocladus*; a new race of man, possessed of a thirteenth dorsal vertebra; Roman tiles commemorating the refurbishment of sea defences at Pevensey (91), and a stag's horn hammer from the submarine forest at Bulverhythe (93).

Even Dawson's friends found extraordinary things. Henry Willett, for example, who in 1885 presented the British Museum with an ancient Chinese bronze (88) which he had found in the Dane John (donjon) at Canterbury, also presented Brighton Museum, on Dawson's behalf, with the petrified 'toad in the hole' (89), which caused a stir in 1901.

Doubts about many of the strange and marvellous things associated with Dawson have recently

emerged. The Pevensey tile, for example, on examination by thermoluminescence, turned out to be a modern forgery. The cast-iron statuette is now considered to be nineteenth century, the 'prick spur' is no such thing, and the possibility that the ancient Chinese *hu* was buried or abandoned in medieval Canterbury is discounted.

Dawson repeatedly sought the limelight through the discovery of extraordinary objects, many of which were not what they appeared to be. That this forger and fantasist should innocently have found himself at the centre of one of the greatest scientific forgeries of the century is incredible. More likely by far, it was Dawson who (with one or more scientific collaborators) masterminded the whole thing. In March 1909 Dawson wrote to Smith Woodward that he was 'waiting for the big discovery that never seems to come'. He was perhaps motivated in part by a desire to outshine the Germans – 'how's that for Heidelberg', he said when presenting his first finds. MPJ

LITERATURE J. S. Weiner, *The Piltdown Forgery*, London 1955; T. I. Molleson, *The Piltdown Man Hoax*, London 1973; C. Blinderman, *The Piltdown Inquest*, Buffalo/New York 1986

83 The Piltdown skull (five pieces)

BM (Natural History) E590–594

84 Canine tooth, painted with Vandyke brown

BM (Natural History) E611

85 Plaster reconstruction of the Piltdown skull

BM (Natural History) E631

86 Dawson's 'associated' prehistoric finds from the Piltdown site

a Mastodon tooth
BM (Natural History) E622

88

b Stegodon tooth
BM (Natural History) E620

c Beaver tooth
BM (Natural History) E618

d Hippo tooth
BM (Natural History) E598

e Flint implement
BM (Natural History) E606

f Flint implement
BM (Natural History) E607

g Bone implement
In 1953 this was shown to be a piece of fossilised bone whittled and cut with a steel knife
BM (Natural History) E615

87 John Cooke, *A discussion of the Piltdown Skull*, 1915

Back row: F. O. Barlow, Prof G. Elliot Smith, C. Dawson, Dr A. Smith Woodward
Front row: Dr A. S. Underwood, Prof A. Keith, W. P. Pycraft, Sir Ray Lankester.

1830 × 2240mm
Geological Society

88 Chinese ritual vessel (*hu*), 6th–5th century BC

Chinese ritual vessels became known in Europe only after the seventeenth century, when trade with China had brought not only porcelain but textiles and curios of every kind to the West. It is therefore unlikely that this bronze was excavated from the medieval Dane John at Canterbury as Henry Willett claimed. JR

H 260mm
BM OA 1885. 2–18. 1. Given by Henry Willett

89 'Toad in a hole'

The discovery of this 'mummified' toad was communicated by Charles Dawson to the Brighton and Hove Natural History and Philosophical Society in 1901. He reported that a curiously light, lemon-shaped flint nodule had been discovered by two workmen a couple of years earlier which, when they broke it open, proved to contain a toad. Since its presentation to the Museum the toad has shrunk, indicating that it cannot have been very old at the time of discovery.

L 140mm
The Booth Museum of Natural History, Brighton. Presented by Charles Dawson through Henry Willett in 1901

89

90 Cast-iron statuette

Dawson claimed to have acquired this piece in the early 1880s from a workman who had found it together with some Roman coins at Beauport Park, near Hastings, the site of a large Roman iron-working complex and bath-house.

H 87mm
Hastings Museum

91 Stamped brick from Pevensey, Sussex

This fragment of fired-clay brick or tile bearing the stamp HON AVG ANDRIA was published in 1907 by Charles Dawson as a find made during the 1902 excavations at the late Roman fort at Pevensey. Dawson subsequently presented it to the British Museum. The stamp, apparently giving the name of the Emperor Honorius (r. AD 395–423) has been regarded as important evidence for the refurbishing of the walls of the fort towards the end of the fourth century; furthermore, the word 'Andria' was thought to support the view that the Roman name for the site was Anderida. It appears that three, or possibly four, examples of Roman tiles with this stamp came to light at Pevensey; one of these is now in Lewes Museum.

Both the clay fabric of the tile and the lettering of the stamp are unusual for the Roman period, and in 1972 Dr David Peacock of Southampton University carried out further research into the matter. Thermoluminescence analysis at Oxford and in the British Museum Research Laboratory indicated that the tile was made not in the Roman period, but towards the end of the nineteenth or beginning of the twentieth century. TL analysis of the example at Lewes produced a similar result. CJ

H 107mm
BM PRB 1908. 6–13. 1
LITERATURE C. Dawson, 'Some inscribed bricks and tiles from the Roman Castra at Pevensey (Anderida?), Sussex', *Proc. Soc. Ant. Lond.* XXI (1907), pp. 410–13; D. Peacock, 'Forged brick-stamps from Pevensey', *Antiquity* XLVII (1973), pp. 138–40

92 'Norman prick spur'

Iron. L 129mm
Hastings Museum

93 Prehistoric hammer

Made from red deer antler, this 'hammer' was said to have been found in the submarine forest at Bulverhythe, half-way between St Leonards and Bexhill, Sussex.

L 280mm
Hastings Museum
LITERATURE *Victoria County History of Sussex* I, 1905, pp. 327–8

94 A replica of the 'transmitting portion of the original experimental Baird television apparatus'

Between April 1925 and January 1926 John Logie Baird's mechanical scanning television system progressed from displaying crude silhouetted shapes to recognisable human faces.

His work aroused considerable public interest and in October 1926

93 (*back*); 92,90 (*front, left to right*)

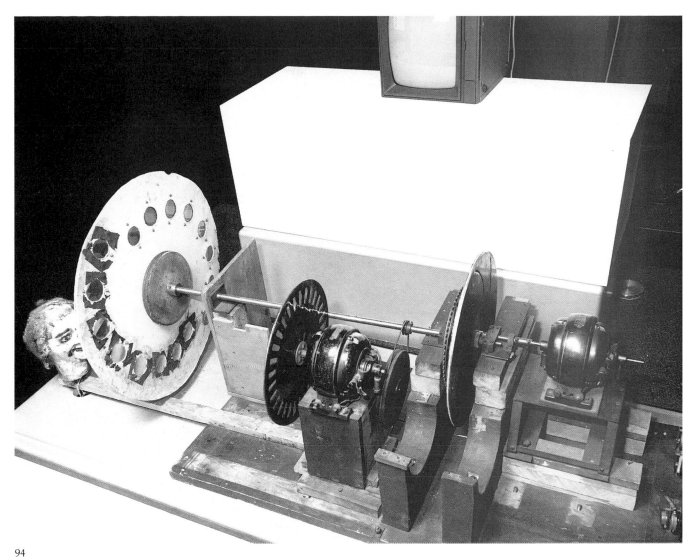

94

Baird presented the 'original apparatus' to the Science Museum which placed it on public display. Recently, however, a close examination has revealed that, even if parts of the assemblage had been used in Baird's work, the machine as presented could never have functioned. What Baird presented to the Museum was not the original apparatus, which had probably no longer existed, but a specially constructed recreation of it, put together as part of the Baird Company's vigorous promotion of its fatally flawed television system.

In July 1929 the authenticity of the display was questioned from another direction by A. A. Campbell Swinton, the pioneer of television as we know it, who wrote to Sir Henry Lyons, then Director of the Science Museum, claiming that the Baird apparatus was of little significance in the evolution of television. ED

National Museum of Photography, Film and Television

奇苍帶露移來玩開向
名園入錦圍 亮先氏書

95a

4

Faking in the East

The first type of faking to be done in China was the fraudulent production of literary texts. Probably even before the third century AD, when twenty-six sections were added to the venerable *Book of Documents* (supposedly eleventh to tenth century BC), attempts were being made to rectify perceived deficiencies in the historical record. This was of much more than scholastic interest, since Confucianism was a system of belief which depended not on divine revelation, but on a true account of how major social and political changes had actually taken place within a cosmic framework. The unmasking of fraud has, for this reason, been one of the highest callings of traditional scholarship, with debates raging over very long periods. The *Book of Documents* forgery was only conclusively proved in the eighteenth century.

The acts of falsifying, replicating and altering artefacts in China are intimately connected with the growth there of what has been called a 'rare art tradition'. This has taken the form of the gradual expansion of the commodity market, in which different groups of artefacts come to be privileged as 'art', acquiring significance as concentrated cultural and economic capital. First to achieve this was calligraphy, for which there was a commercial market from at least the fifth century AD. Painting had reached the same stage by the eighth century. The archaic vessels of the Chinese Bronze Age, although accumulated as numinous treasures under the early empire, did not fully achieve the status of 'collectables' until the eleventh century, when they too began to be studied, exchanged as commodities and forged. But it was the sixteenth and early seventeenth centuries, in the highly commercialised world of the late Ming, which saw the widest expansion in the activities of the Chinese collector, and with it an upsurge in the manufacture of fraudulent antiquities and works of art to feed a market larger than could be satisfied by the limited supply of genuine items.

It is impossible to read the full intention of the maker from a historic artefact. If in the past too much emphasis has been placed on the pure and disinterested reverence for antiquity in China, and on 'archaism' as the dominant mode of aesthetic practice, it would be equally wrong to see every 'archaistic' jade or bronze as the product of commercially motivated forgery. The two strands coexisted, and both were ways of turning the cultural prestige of antiquity into economic value. The period saw a remarkable burst of republication of the key illustrated texts on antiquities, which themselves became important source-books for further new work. Yet the degree of anxiety about fakes and forgeries of all kinds seen in the late Ming literature of connoisseurship (books which are a new type of commodity explaining how to consume appropriately, and themselves the object of several notable literary

forgeries), and the body of evidence for the scale of these activities compel attention. The Chinese word *shangjian*, 'to appreciate, to exercise connoisseurship', is made up of two elements, glossed by one Ming writer as *shang*, 'to discriminate on the grounds of quality', and *jian*, 'to distinguish true from false'. Another contemporary made the gloomy estimate that nine-tenths of the paintings in the growing collections of the newly rich were forgeries. Particularly in Suzhou, the cultural capital of the empire, anything was possible; paintings, archaic jades, bronzes, ceramics and lacquer, in short any type of 'collected' artefact, could be forged. Much of this forgery concerned inscriptions, the tying of an object (particularly painting or calligraphy) to a culturally prestigious name. Here the surrounding apparatus of colophons and seals was at least as much the focus of attention as was the actual pictorial image. Genuine early but unsigned pictures were improved for the market in this way, a practice common from at least the twelfth century. Faked paintings also included traced or freehand copies of genuine originals, as well as genuine paintings dismembered to make two saleable items. In bronze faking, too, it was the inscription which carried much of the value, and more than one Ming writer was at pains to point out that uninscribed bronzes can still be perfectly genuine. Several of the objects here show this attachment to the pretentious inscription, often as in the case of the Bushell Bowl, (102) the means by which the forgery has subsequently been detected.

The scale of art forgery in late Imperial and Republican China was massive. From the eighteenth century the centres were the cities of Suzhou, Kaifeng and Changsha, and it has been calculated that one workshop alone in Changsha was responsible for about 2,000 forged scrolls in the decades 1920–50, most of them significantly attributed to the collections of major political figures. The ambiguity about copying/forging which has always existed in the case of élite artists has been sustained right up to the present, most notably in the person of Zhang Daqian (see 111). As new markets developed, new types of objects came to be replicated, particularly ceramics. In the last century the Western market for Chinese art has exercised its own influence, both by focusing on new types of object already within the art market, like *famille noire* porcelain (118), or by bringing into it new categories altogether, like furniture (123).

In Japan the patterns associated with art collecting came into being later than in China, and were to a certain extent imported from China, along with many actual artefacts of Chinese provenance. The military rulers of the fourteenth to sixteenth centuries were enthusiastic collectors of Chinese painting, again with an emphasis on a small number of famous names. There are also powerful elements within Japanese artistic production, particularly of ceramics, which depend on Chinese prototypes to a greater or lesser degree (114). However, as in China, the growth of a commercial market led to the manufacture of forgeries and copies. In addition to the most obvious field of painting, designs for woodblock prints were pirated in unauthorised editions from the early eighteenth century, and these can be distinguished from the later copies of early prints made to satisfy a Western audience. Sword blades (113), mountings and armour which, though not classed as art, were important trappings of the ruling class, were often provided with

added signatures or certificates of authenticity to improve their prestige.

The explosion of interest in Japanese art in late nineteenth-century Europe and America was answered by the export of great quantities of genuine and fraudulent works of art. The 1890s saw the beginning of the reproduction Japanese print industry, which still flourishes today. Sword fittings, which had not generally circulated in Japan except as part of a mounted blade, quickly became objects of collectors' interest in the West and were similarly reproduced (115b,c). In this century these have been joined by reproductions of the material culture of the Japanese Bronze Age, unknown and untreasured in Japan before the advent of modern archaeology. CC

LITERATURE W. Ho, 'Late Ming Literati: Their Social and Cultural Ambience' in Li and Watt (eds), *The Chinese Scholar's Studio*, New York 1977; J. Rawson, 'The Development of Archaistic Styles in Chinese Ceramics and their Occurrence among Densei Wares', *International Symposium on Chinese Ceramics*, Seattle 1977; Wu Kuanjun & Yang Xin, 'Changsha huo' ('Changsha goods'), *Wenwu* 1981. 3; J. Alsop, *The Rare Art Traditions: The History of Art Collecting and its Linked Phenomena*, New York 1982; R. Kerr, *Later Chinese Bronzes*, Victoria and Albert Museum Far Eastern Series, London 1989

95b

China

95 Woodblock prints of Chinese 17th-century collections

The first print (a) shows a group of copies of ancient Chinese bronzes which includes a *fang ding* similar to 99 below. The flowers depicted with the bronzes suggest a setting in a private house. The jades, bronzes and ceramics placed on the table in the second print (b) might have been part of a scholar's collection. On the right of the print is shown the neck and two tubes of an arrow-vase (compare with 100), but the main part of the body of the vase is missing. These prints illustrate the depth of interest in collecting during the seventeenth century and may have served to attract aspiring collectors. The idea of representing groups of antiquities and other collectors' items in prints dates back to the first half of seventeenth century, when such arrangements of objects are found on decorated colour-printed letter-papers which were produced as books for the collector's shelf. AF

95a Arrangement of antiques and flowers
Woodblock print, ink and colours on paper. 365 × 267mm
BM OA 1906. 11–28. 22 (Sloane 5252)

95b A scholar's collection
Woodblock print, ink and colours on paper. 286 × 294mm
BM OA 1928. 3–23. 036 (Sloane 5293)

96 Ming dynasty mirror

Mirrors, usually round discs of bronze with a flat reflective side and a highly decorated side, are known in China from about 1300 BC, and were used almost without interruption from about the fourth century BC down to the eighteenth or nineteenth century AD. During the Ming (AD 1368–1644) genuine Han (206 BC–AD 220) mirrors or copies of them were popular. It is not clear whether the owners of mirrors like this one recognised that they were copies of mirrors of the third century AD or whether they believed them to be ancient. Such mirrors were not simply prized as antiques but were also buried in tombs. For example, two mirrors, one a Han dynasty type, were found in the

110 (back); 99,101,100 (middle row); 97,96,98 (front row)

Fig. 3 An illustration of an inlaid animal vessel from *Bo Gu Tu Lu*. See 97

'waste pit' of the tomb of Zhu Youmu (d. AD 1634), buried at Nancheng in Jiangsu province (*Wenwu* 1983. 2, pp. 56–64, figs 7&8). JR

16th–17th century AD
Bronze. D 160mm
BM OA 1986. 5–19. 1

97 Ming dynasty vessel in the shape of an animal

Several of these carefully inlaid bronze animal vessels survive, and it seems probable that they were made as fakes to satisfy the demand for antiquities in the Ming period. They are all based upon an illustration in the Song dynasty catalogue, the *Bo Gu Tu Lu*, published in AD 1107–11 and reprinted many times in succeeding centuries (fig. 3). Although the woodblock illustration was revised in succeeding editions, all examples show a creature with hooves, a long head with rounded snout and scalloped ears, as seen in the present example.

This animal form had an ancient

Fig. 2 An inlaid animal vessel of the 4th to 3rd century BC from Shandong Linzi. See 97
From *Kaogu* 4 (1985), pl. 7: 6

pedigree, being employed as early as the fifth century for animals used as supports for vessels and braziers. Four such creatures support a brazier found at Shanxi Lucheng (*Wenwu* 1986. 6, pp. 1–19, pl. 2:1). These creatures were decorated with cast rather than inlaid designs. The illustration in the *Bo Gu Tu Lu* shows, however, an inlaid example similar to a rare inlaid animal vessel of the fourth to third century BC found at Shandong Linzi (fig. 2). The fact that the later bronze animals were generally embellished with inlay and not with cast decoration suggests that only a few genuine examples were in circulation and that the example in the *Bo Gu Tu Lu* was being deliberately copied, probably with intent to deceive. JR

14th–15th century AD
Bronze inlaid with gold, silver and malachite paste. L 260mm
BM OA 1885. 11–8. 1

98 Ming dynsty ewer (*he*)

This inlaid ewer is a careful copy of a fifth-century BC vessel. A comparable example with a similar openwork handle has been excavated at Mizhi in Shanxi province. Inlay of this kind was rarely if ever seen on the vessel type in antiquity and has been added here to give the piece additional prestige, and also probably to make it more attractive. Like the bronze animal (97), the ewer would have been a prized collector's piece, probably thought to be ancient. JR

14th–15th century AD
Bronze inlaid with gold and silver.
H 208mm
BM OA 1981. 6–27. 1

99 Qing dynasty censer in the shape of an ancient *fang ding*

Unlike 97 and 98, this copy of an ancient bronze was not simply a collector's item, but had a distinct function as an incense-burner; it is much less likely to have been made as a fake. Incense-burners stood on household or temple altars flanked by a pair of candle-sticks and a pair of flower vases; the vases, like the incense-burners, often took ancient forms (see 11).

This censer is based on a vessel type known as a *fang ding* (see 308), current in the Shang and early Western Zhou periods (*c.* 1300–950 BC). In such later copies the sloping sides and the widely splayed legs betray dependence on a woodblock illustration which imperfectly conveyed the rigidly rectangular shape of the original, with its legs vertical beneath its body. The frequent use of splayed legs in debased dragon forms suggests that such censers were based on a particular woodblock illustration, possibly in the *Bo Gu Tu Lu*; in antiquity ancient rectangular *ding* with animal- or dragon-shaped legs were very rare. These late pieces are conspicuous in woodblock illustrations of tasteful interiors of the seventeenth and eighteenth centuries (see 95a). JR

17th–18th century AD
Bronze. H 310mm
BM OA 1988. 5–18. 1

100 Arrow-vase

Vases with a tall narrow neck and a short tube either side of the mouth were developed for playing the game of *touhu* (pitch-pot). The vase, known as the *touhu*, was the target at which the two contestants tossed arrows. The antiquity of the game was of particular attraction to the collectors and scholars of the Ming and Qing periods. The earliest mention of the game is found in a historical text, the *Zuo Zhuan*, attributed to the sixth or fifth century BC, and a full description of its rules is found in the ritual text, the *Li Ji*, of the early Han period (second to first century BC). The shape of the pots used at these early times is unknown. The earliest surviving example is a vase in the treasury of the Shōsōin at the Tōdaiji temple in Nara, Japan, probably imported from China in the early eighth century. This vase has a relatively wide and short neck and the two tubes have a scalloped outline to their lower edges. The arrows for the game also survive in the Shōsōin.

The game seems to have become widely known in the Song period, with the conscious revival of ancient traditions. A famous Song historian,

Sima Guang (AD 1019–86), wrote a treatise on the game, and later illustrated editions of his work show vases with tall necks with two tubes at the neck. Song examples of the characteristic shape in bronze are rare, although many small ceramic flasks of the distinctive shape are known. Much more common are large Ming and Qing bronzes, such as this one. Some of them are so heavily encrusted with figures and short tubes that it seems unlikely that they could be used for the game. The august historical associations of the pastime, however, probably made them appropriate for interiors of the aspiring connoisseur. Part of an arrow-vase is illustrated in 95b. JR

17th century AD
Bronze. H 410mm
BM OA +7049
LITERATURE G. Montell, 'T'ou-hu: The Ancient Chinese Pitch-Pot Game', *Ethnos* 5 (1940), pp. 70–83; R. Poor, 'Evolution of a secular vessel type', *Oriental Art* 14, no. 2 (Summer 1968), pp. 98–106

101 Ming dynasty vase, imitating ding ware

While few ceramics were highly esteemed in their day, certain wares were revered by later generations. Ding ware was one of these. Made at northern kilns in Hebei province, ding production flourished from the tenth to thirteenth centuries. A wide variety of shapes were made, but these did not generally include, as far as we know, vessels in the shape of ancient bronzes. In the Ming period, when Song wares – such as guan and ge and ding – were enthusiastically collected and an interest in antiquity was strong, there was a demand for ding wares in shapes known from ancient bronze vessels. There are several Ming dynasty anecdotes about collectors seeking or possessing a ding ware incense-burner in a bronze form, although we know that genuine examples probably never existed. This vase is an attempt to pass off a Ming ceramic as a Song vessel. It has the creamy white colour of true ding ware, but its large size and the features borrowed from bronze design, including the handles and decoration

of pointed blades, are not known in genuine ding ware. JR

16th–17th century AD
Porcelain. H 343mm
BM OA 1936. 10–12. 179. Eumorfopoulos Collection
LITERATURE C. Clunas, 'The cost of ceramics and the cost of collecting', paper presented to the Oriental Ceramic Society of Hong Kong (1988)

102 The Bushell Bowl

This bronze bowl was bought in Beijing in 1870 by S. W. Bushell, physician to the British Legation there and an authority on Chinese art. Bushell had acquired the piece from the collection of the Princes of Yi, collateral relatives of the Qing dynasty (AD 1644–1911) emperors. The dish bears a 538-character inscription taken from a historical work which mentions a date of 590 BC. For some time both inscription and bronze bowl were taken to be of this early date, but between 1904 and 1910 a heated debate on its authenticity raged in the learned journals. Eventually it was concluded that the piece was spurious. Because the inscription was cut and not cast into the metal, the two were not necessarily produced at the same time. The bronze basin itself, cast from a mould made in vertical segments, is difficult to date with any precision, though it was probably made about AD 1550–1750. Because of the long inscription, it is likely that the forgery was prepared for an educated Chinese collector. RK

Bronze, inlaid with gold and silver, with copper rim. H 150mm; W 845mm
V&A 174–1899
LITERATURE R. Kerr, *Later Chinese Bronzes*, Victoria and Albert Museum Far Eastern Series, London 1989

103 Qing dynasty jade tube (*cong*)

Until the last few decades the date and origin of these tall jade tubes were unknown. Square in cross-section and pierced through their entire length with a circular hole, they were known to later scholars as *cong*. They were paired with jade discs, known as *bi* (see 104), and were thought to represent Earth and Heaven respectively. There is no evidence to

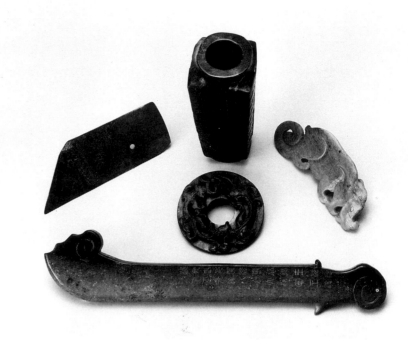

106,103,105 (*back row*); 104 (*centre*); 107 (*front*)

Fig. 4 An illustration of a section of a jade blade from the catalogue of the scholar Wu Dacheng (1835–1902). See 106

support this supposition. Early *cong* and *bi* have now been discovered in profusion in Neolithic tombs of the Liangzhu culture (*c*. 2500 BC) in south-east China. In rich burials large numbers of *cong*, *bi* and axes were arranged on the bodies of the dead.

Because many *cong* were used in a single burial, if just one such burial had been found it would have supplied numerous examples for collectors. For this reason a relatively obscure Neolithic jade type was a much sought-after item. This jade is a rather clumsy reworking of the original Neolithic model. It tapers more sharply from top to bottom than ancient pieces and the schematic faces at the corners are rather roughly incised. Such pieces seem likely to have been made to satisfy the demand for antiquities. Plenty of examples were illustrated in books of ancient bronzes and jades to provide models for craftsmen. JR

18th–19th century AD
L 206mm
BM OA +112

104 Qing dynasty jade disc decorated with dragons in relief (*bi*)

Early discs buried in Neolithic tombs with *cong* were undecorated. Later they were often used in pendant sets indicating rank. Known also in texts as precious gifts between ancient noble or official families, such *bi* must have seemed attractive to collectors not just

for their appearance but also for their associations. The present *bi* is loosely based upon jades of the Han period (206 BC–AD 220). However, the dragons lying on the surface are bolder and more clumsy than their Han counterparts, which were either shown in silhouette around the circumference of the discs, or worked in and out of the flat surfaces. The dark colour of the jade was probably achieved artificially by dipping the piece in a solution of carbon. JR

18th–19th century AD
D 118mm
BM OA 1945. 10–17. 107. Raphael Bequest

105 Ming or Qing dynasty pendant in the shape of a tiger

This jade is based upon an illustration of one of the very few jades recorded in the woodblock illustrated catalogue, the *Kao Gu Tu* by Lü Dalin (first published AD 1092). The pendant type of a tiger in silhouette shown in the *Kao Gu Tu* was prevalent in China during the seventh to fifth centuries BC. However, none of the surviving examples, which include pendants from tombs of the Huang State in central Henan (*Kaogu* 1984. 4, pp. 302–32) and pendants from the royal tombs from Jincun near Luoyang (Umehara Sueji, *Rakuyō Kinson komō shūei*, Kyoto 1936), are as large or as thick as the present example. Evidently copying a woodblock illustration and not an actual jade, the craftsmen had no idea how big or how heavy the originals were. JR

17th–18th century AD
L 190mm
BM OA 1947. 7–12. 475. Oppenheim Bequest

106 Qing dynasty blade fragment

This jade purports to be a broken section of a ceremonial blade of the Shang period (*c.* 1200 BC), which would have carried criss-cross patterns on its ends. Such blades were approximately trapezoidal in shape, and if this were an ancient piece, it would be approximately a third of the whole. A similar section is illustrated in the catalogue of a well-known Qing

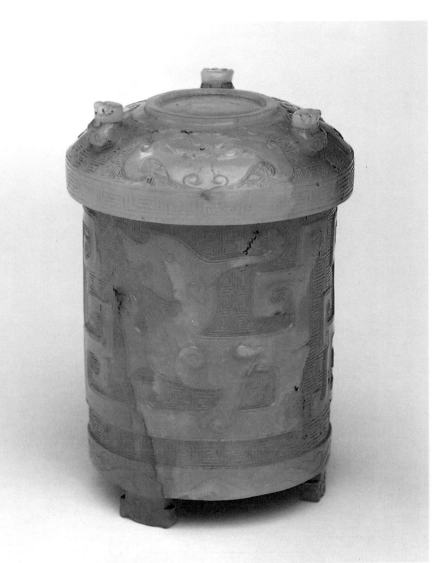

108

scholar, Wu Dacheng (fig. 3). It seems likely that the present jade was made early this century, copying the Wu Dacheng piece, which itself may well have been genuine. The red stain on the jade was produced artificially using iron. JR

19th–20th century AD
L 210mm
BM OA 1948. 7–16. 36. Given by H. G. Beasley

107 Jade sword

This jade bears no resemblance to an ancient piece. Despite its pretentious inscription in a debased form of ancient seal script, which claims that it belonged to King Guang Wu (AD

25–55) of the Han dynasty, it is far removed in type and style from any Han period jade or even bronze weapon. The shape is based upon a late Ming or Qing sword. Similar weapons are illustrated in encyclopaedias, such as the seventeenth-century *San Cai Tu Hui*, and it is possibly from some such source that the shape was derived in error. The jade is very thick and clumsily carved. JR

19th–20th century AD
L 430mm
BM OA 1937. 4–16. 106. Eumorfopoulos Collection

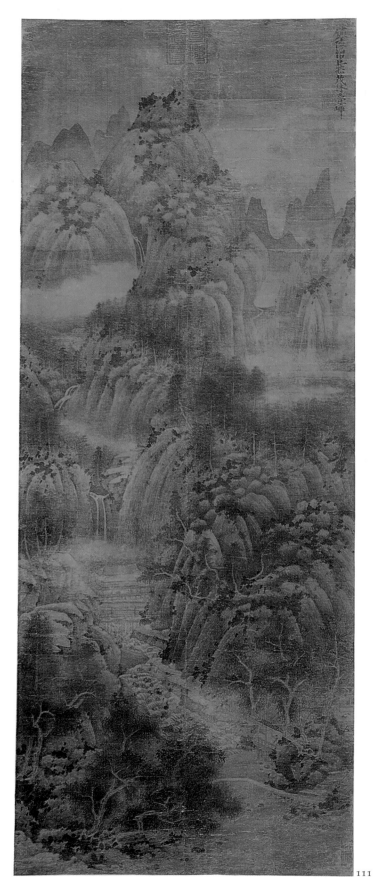

111

108 Jade cup and cover, *c*. AD 1550–1650

A typical example of a group of cups which draw inspiration from the *zhi* drinking vessel of the Han dynasty, both in shape and in low relief decoration. Some bear the signature of Lu Zigang, a jade-worker active in Suzhou about 1560–1600, and hence can never have been intended to circulate as genuine antiquities. However, the considerable degree of anxiety about fake archaic jades evident in late Ming texts suggests that with an unprovenanced piece it is no longer straightforward to distinguish between reverent imitation of the past and commercially driven exploitation of the antiques market. CC

H 89mm
V&A FE. 47&A–1980

109 Imitator of Li Zhaodao, *Landscape*, *c*. AD 1550–1600

This handsome painting is signed by Li Zhaodao (fl. first half of the eighth century AD), and bears seals of the Northern Song imperial collection (eleventh century) and inscriptions by Ma Zhi (fourteenth century), Ke Jiusi (AD 1312–65) and Wen Zhengming (AD 1470–1559). However, it has little or no relation to the style of any of these luminaries, but it is lavishly endowed with attractions for the *nouveau riche* dilettante who is the butt of much sarcasm in Ming art historical literature. Features in the brushwork suggest an origin in the city of Suzhou, the centre of several of the Ming luxury trades, including the copying and faking of artworks. CC

Ink and colours on paper. 1778 × 965mm
V&A E. 422–1953. Sharples Bequest

110 Imitator of Huang Gongwang, *Landscape*

This painting bears the signature of Huang Gongwang (AD 1269–1354), one of the four landscape masters of the Yuan dynasty. Although a similarity to the work of Huang is evident in the piled-up landscape forms, in the long dry strokes texturing the mountains, and in the

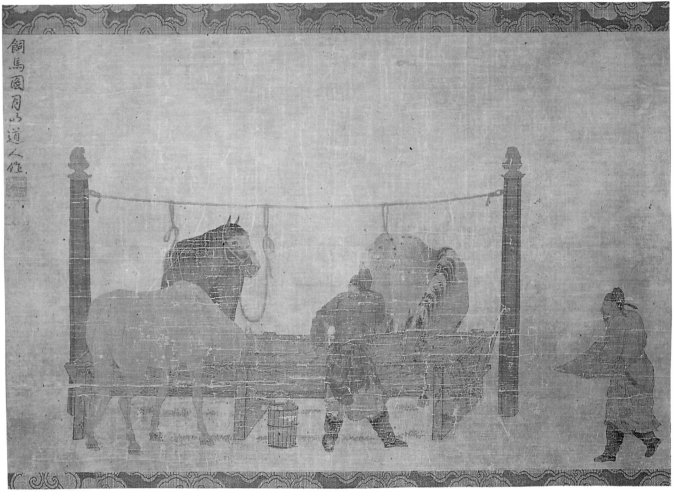

112

naturalism of the trees, the overall stylistic regularity of the painting strongly resembles the idiom of the Orthodox Masters of the early Qing dynasty (AD 1644–1911), whose painting was based on the theories of the late Ming painter and theorist Dong Qichang (AD 1555–1636). It is significant that Huang Gongwang was the foremost of the Yuan masters on whom painters of the Orthodox School based their work. It seems likely, therefore, that this painting was produced by an artist working in this style with the intention of producing a forgery. AF

Hanging scroll, ink and slight colour on paper. 1645 × 475mm
BM OA 1957. 11–9. 01. Given by P. T. Brooke Sewell Esq.
Illustrated on p. 102

111 *Landscape*, probably by Zhang Daqian (1899–1983), attributed to Juran

This landscape bears an attribution to the Buddhist priest Juran (fl. AD 960–80), one of the foremost masters of the Southern School of literati painting, as defined by Dong Qichang. The painting exemplifies the composition and style associated with Juran: the massive mountain is constructed of steep, evenly creviced, smooth slopes which are textured with 'hemp-fibre' brushstrokes and enlivened by ink dots. It closely resembles a late Ming or early Qing dynasty work in the Shanghai Museum also attributed to Juran (Xu Bangda, fig. 11). An inscription on the outside of the present painting suggests that it is by the twentieth-century artist Zhang

Daqian, who is known to have forged many works by Juran as well as by other masters of Chinese painting. AF

Hanging scroll, ink and colours on silk. 1855 × 735mm
BM OA 1961. 12–9. 01
LITERATURE Xu Bangda, 'Connoisseurship in Chinese painting and calligraphy: some copies and forgeries', *Orientations* (March 1988), pp. 54–62

Japan

112 After Ren Renfa, *Feeding Horses*, c. AD 1600–60

This painting is a mirror image of a section of a much longer scroll, *Nine Horses*, by Ren Renfa (AD 1255–1328), now in the Nelson Gallery-Atkins Museum, Kansas City. It almost certainly derives from a *fen ben*, or

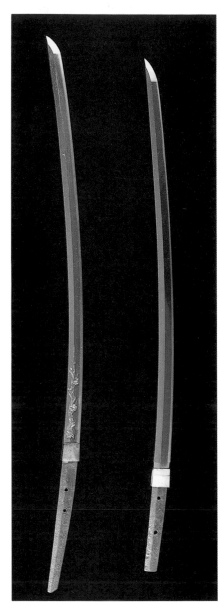

113b,a

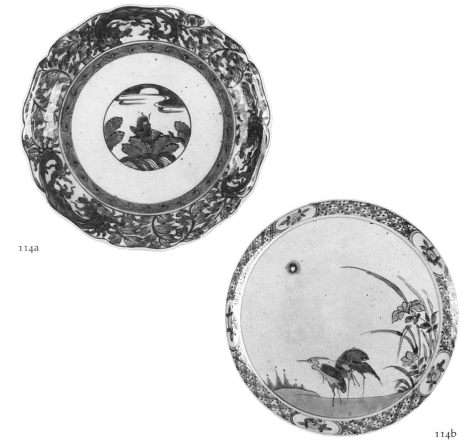

114a

114b

tracing copy of the original. Such a copy is also the source for the woodblock printed version of the picture in *Gu shi hua pu* (Master Gu's Painting Album), published in 1603, attesting to its considerable popularity and wide circulation. The original was transmitted to Japan as a *chūko-watari*, 'later arrival', in the first half of the Tokugawa period, and was copied there in the eighteenth century. This version, now in a Japanese mounting, may have been transmitted at about the same time, or may just possibly itself be a version executed in Japan. CC

Ink and colours on silk. 534 × 755mm
V&A E. 32–1935. Eumorfopoulos Collection

113 'Norinaga' sword blade

Sword blades by famous makers were and are still among the most highly prized of all artefacts in Japan. The genuine fourteenth-century blade included here (a) is attributed to one of the most admired families of sword-makers, the Norinaga of Yamato, active in the fourteenth century; 113b is a probably seventeenth-century imitation.

Several features differentiate the copy from the original. The signature 'Norinaga of Yamato' is stylistically incorrect and is on the wrong side of the tang. The grain of the steel does not flow longitudinally and the crystalline structures along the cutting edge resulting from the original hardening process are not in a typical Yamato style.

The carvings of the plum blossoms

and dragon were added after the blade was shortened and are in the style of the Edo period (AD 1603–1867). VH

113a 14th-century blade
Steel. L 885mm
BM JA 1958. 7–30. 11
113b 17th-century imitation
Steel. L 956mm
BM JA 1958. 7–30. 65

114 Japanese 17th-century porcelain imitating Ming Chinese originals

Porcelain was not made in Japan until the very late sixteenth century, whereas there had been a flourishing industry in China for many centuries. Chinese ware was greatly admired in Japan, and fine pieces were valued for use in the Tea Ceremony. Chinese ceramics and bronzes of the Ming dynasty were copied extensively.

The designs on both these dishes are loosely based on Chinese motifs, particularly the floral and patterned

borders and the central roundel with a fish. However, the porcelain body and the tone of the underglaze blue are recognisably Japanese, as is the freer, more 'folky' composition. VH

114a Porcelain dish with a mark *Dai Min Seika Nen Sei* (Japanese reading for a Chinese mark signifying 'Made in the Chenghua era (AD 1465–87) of the Great Ming Dynasty')
D 215mm
BM JA 1961. 10–25. 1

114b Porcelain dish with a mark *Dai Min* (Japanese reading for the Chinese 'Great Ming Dynasty')
D 206mm
BM JA 1959. 4–18. 15

115 'Shōzui' sword hilt fittings

A pupil of the renowned Toshinaga of Nara, Hamano Shōzui (AD 1696–1739), established one of the major schools of free studio metalworkers in the middle Edo period. His work has been much imitated. Here is shown a genuine mounted hilt fitting showing the Buddhist deity Fudō Myō-Ō which is signed by Shōzui and inscribed 'aged 63 years' (a); alongside are some other 'fuchi/kashira' fittings, also inscribed Shōzui, but dating from the nineteenth century (b, c). VH

115a Iron with black patinated *shakudō* (an alloy of copper with a few percent gold).
L 40mm (fuchi), 35mm (kashira)
BM JA 1958. 7–30. 28

115b Set of 'fuchi/kashira' fittings *Shibuichi* (alloy of copper with about a quarter silver) and gold inlay. L 40mm (fuchi), 35mm (kahsira)
BM JA 1981. 1–30. 234

115c Another version of 115b
Copper alloys with gold, silver and *shakudō*.
L 40mm (fuchi), 35mm (kashira)
BM JA 1939. 6–17. 16

The impact of the West

116 17th-century Persian imitations of Chinese blue and white

Their proximity to the port of Hormuz, the principal Safavid entrepôt in the European trade with India and the Far East from the sixteenth century onwards, gave the south Persian potteries ready access to the European

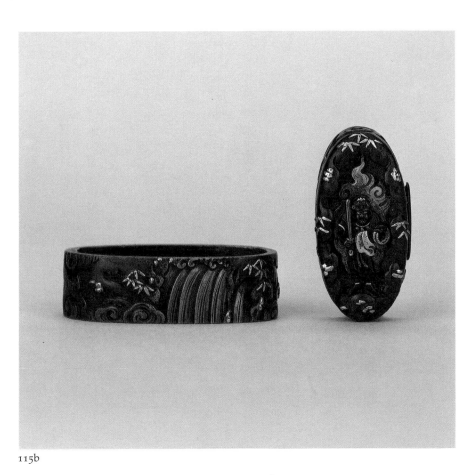

115b

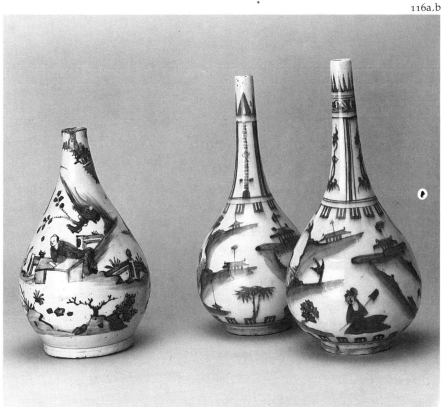

116a,b

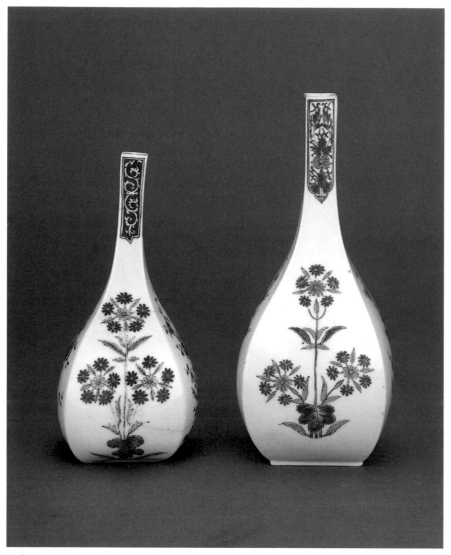

117b,a

squeeze on the south Persian potteries was intolerable, and by 1700 they were in deep decline (Rogers 1989). MR

116a Cut-down porcelain bottle, Chinese (Jingdezhen), mid-17th century
H 256mm
BM OA 1957. 12–16. 4

116b Two frit-ware bottles, Persian, probably from Kirman, later 17th century AD
H 315mm; 297mm
BM OA 1896. 6–26. 4. Gift of Sir A. W. Franks

LITERATURE Ch. Schéfer (ed.), *Estat de la Perse en 1660 par le P. Raphael du Mans supérieur de la Maison de Capucins à Ispahar*, Paris 1890, pp. 335, 354; T. Volker, *Porcelain and the Dutch East India Company. A record of the Dutch registers between 1602 & 1682*, Leiden 1954, *passim*; J. M. Rogers, 'Ceramics', in R. W. Ferrier (ed.), *The Arts of Man*, London & New Haven 1989.

117 English porcelain imitating Japanese originals

The two soft-paste porcelain pieces 117b and 117d were among the many produced to meet the strong demand for porcelain in mid-eighteenth-century England. The colours of the bottle made in Chelsea about 1750–2 (b) closely imitate those on seventeenth-century Japanese porcelain made for export to Europe (a), but the porcelain is white with a transparent glaze. The raised anchor mark on the base identifies its origin.

The Worcester porcelain factory, at which 117d was made in about 1770, was one of a number to produce often quite debased copies of Japanese work (c) for an ever growing market. AD

117a Porcelain Kakiemon-style enamelled bottle with floral motifs, late 17th century
H 222mm
BM JA F1041

117b Chelsea copy, *c*. 1750–2
H 180mm
BM MLA Porcelain Catalogue II, 20. Franks Bequest

117c Porcelain Imari dish, with coloured enamels over a blue underglaze, late 17th or early 18th century
D 290mm
BM JA F496

117d Worcester copy, *c*. 1770
D 220mm
BM MLA 1921, 12–15, 48. Given by Mr and Mrs Frank Lloyd

market. Adapting to the enormous popularity of late Ming Chinese blue and white export wares in that market, the Persian potters turned to the mass-production of highly deceptive imitations, which were often sold to Europe as the real thing. Two pieces are included here (b), along with a Chinese bottle which, to judge from its low technical quality, was probably made for export for Portuguese or Dutch agents (a).

The Persian potters' success can be gauged from the report by Père Raphael du Mans, head of the Capuchins in Isfahan in 1660, that the traditional gifts of Chinese blue and white presented by the Venetian embassy to Shah ᶜAbbas II had been indignantly rejected because they were Persian, not Chinese.

The success of the Persian blue and white industry was not to last. The Persians were at the mercy of changes in European taste for Far Eastern porcelains, which were promptly and more efficiently supplied by the reorganisation of the imperial Chinese kilns at Jingdezhen, by the steadily increasing production of Japanese porcelains under Dutch stimulus from about 1650 onwards (Volker 1954), which undercut the Perisan potters even in their local market, and by the expansion of European blue and white factories like Delft. The double

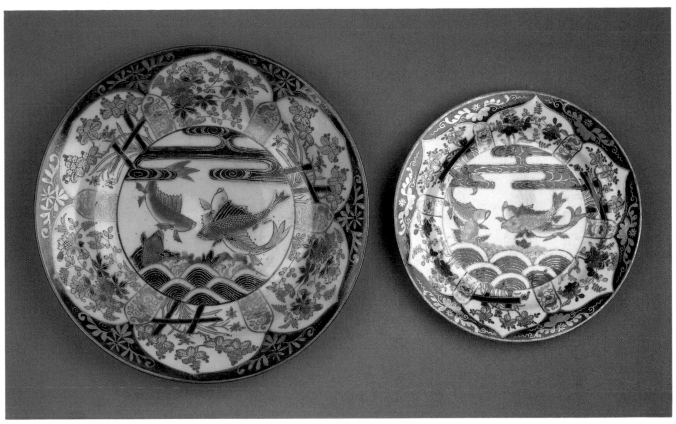

117c,d

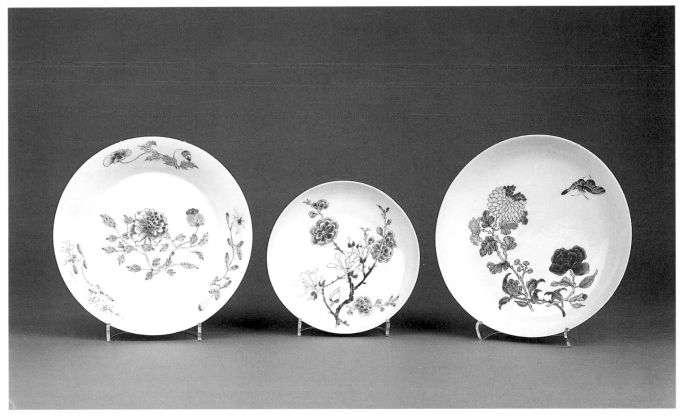

118 *Famille noire* porcelain vase

During the second half of the nineteenth century there was a great vogue in the West for large, brilliantly decorated items of Chinese porcelain. They were used in the sumptuous interior decoration of rich homes. Particularly admired were porcelains decorated with a colour scheme in which black predominated; the name *famille noire* was coined for the group by a French writer called Jacquemart in the mid-nineteenth century. This type of porcelain, originally produced in China during the reign of the Emperor Kangxi (AD 1662–1722), became popular in both Europe and North America. The price paid for *famille noire* increased, reaching a peak just before the First World War. Because there were not enough genuine pieces to supply this lucrative market, many fakes were made in China for export. This vase is an example of fake *famille noire*, dating from the late nineteenth century. RK

H 700mm; D 266mm
V&A C. 1312–1910. Salting Bequest

119 *Famille rose* porcelain dishes

The first of these dishes (a), dating from about 1725–40, is a fine and skilfully painted example of *famille rose*, a style of porcelain popular both in China and Europe in the early eighteenth century. The other two are products of a late-nineteenth-century revival of demand for such pieces.

One is an explicitly revivalist piece (b). It is distinguishable from the original by its light weight, and by the appearance of both the porcelain and the enamel colours. The black outlines are thick, their calligraphy uneven, while little attempt is made to shade enamel colours on flowers and leaves. In comparison with the earlier dish, the overall effect of the decoration is crude.

The other nineteenth-century dish seems likely to have been made to deceive (c). It bears the mark of the Emperor Yongzheng (AD 1723–35), but is betrayed as a late-nineteenth-century piece by its form, style of painting, its palette of light, pastel colours, and by the stiffness in the

arrangement of the decoration, all of which are closer to later factory-marked porcelains than to those of the eighteen century. RK

119a 18th-century *famille rose* dish
D 160mm
V&A 1911C–1885

119b 19th-century imitation
D 198mm
V&A 657–1903. W. H. Cope Bequest

119c 19th-century fake
D 195mm
V&A 589–1907. Julia C. Gulland Gift

LITERATURE R. Kerr, 'Traditional and conservative styles in the ceramic art of China', *Style in the East Asian Tradition, colloquies on Art & Archaeology in Asia No. 14*, School of Oriental and African Studies, University of London 1987, pp. 169–81

120 Sitting figure, believed to be the Arhat Binzuru (Pindola)

This image is an excellent example of the technique known as *yosegi zukuri*, whereby separate pieces are carved and joined together to produce a hollow figure which is then covered in gesso or lacquer and painted.

When this figure was acquired by the British Museum it was thought to date from the Kamakura period (thirteenth century AD), although it was realised that it had been reconstructed to some extent. It was known, for example, that the front portion, including the knees and the hands holding the jewel, were recent additions. This is not unusual with Japanese wood sculpture of great age, and a considerable degree of restoration is accepted. Reconstruction both in antiquity and in recent times was invariably done with traditional tools using traditional materials, and sometimes using old wood acquired from the remains of other pieces of distressed sculpture or from buildings. It is therefore extremely difficult to judge whether or not wood sculpture is genuinely of ancient date. Modern fakers have made sculpture from old wood, smeared honey on the piece, and left it to be suitably ravaged by insects to give the appearance of age.

At first sight the eyes are naturally drawn to the serenely imposing face, and the rest of the figure seems quite in keeping with it. However, by looking not at the face, but at the

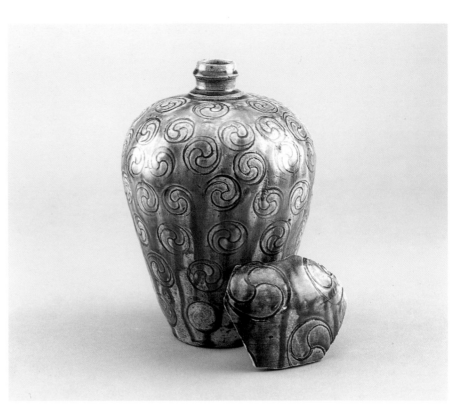

121a,b

123

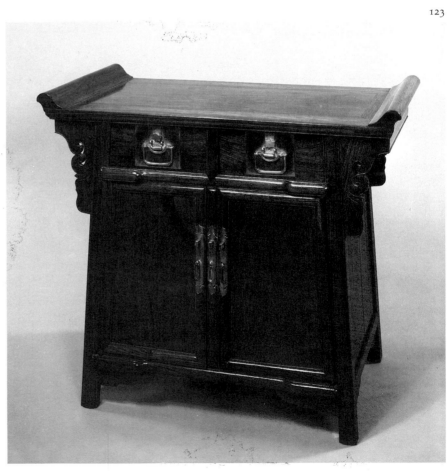

shoulders, neck and back of the head, and then imagining how the face should sit, it becomes evident that the face does not match correctly. Conclusive evidence might be obtained by scientifically dating the various components of the statue, but the likelihood is that the mask which forms the face is an imaginative replacement of much later date, possibly twentieth century.

The Arhats are individuals who have achieved a level of spiritual understanding comparable with that of the Buddha. They occur in Japan in groups of 16, 18, or 5,000, and Binzuru is numbered first in the groups of 16. VH

Wood. H 845mm; W 1000mm
BM JA 1961. 5–17. 1

121 Bottle imitating Seto-ware pottery of the Kamakura period

The rice wine bottle (a) is a twentieth-century fake, imitating ware produced in the thirteenth and fourteenth centuries. Complete and unrepaired pieces of this period are extremely rare, in spite of the very high level of production suggested by the kiln sites. Comparison with a sherd from a genuine Kamakura period rice wine bottle (b) highlights the contrived quality of the decoration on the fake and the unsatisfactory nature of its glaze. VH

121a Fake 'Seto-ware' bottle
H 255mm
BM JA 1956. 3–26. 1
121b Seto-ware sherd. W 104mm
BM JA 1959. 10–22. 4

122 Imitations of Mori Sosen's paintings of monkeys

Mori Sosen (1749–1821) was already celebrated in his lifetime for his great skill in painting animals, and especially those with fur. But his overwhelming reputation is as the faithful and sympathetic recorder of the native apes of Japan.

Following the old distinction between painting on paper and on silk, Sosen had two major styles for his animal subjects. On silk (a) he would brush in every hair with a very fine brush over a coloured wash, using more or less naturalistic colours on the animals themselves, though not necessarily on the rocks and plants which contributed to the pictorial construction. On paper he would employ a broader brush, using ink alone or ink and a few light washes, suggesting the subject's fur through the variations in the brushstrokes, especially where the brush lifted off the paper leaving the finer marks of its individual hairs.

Both of these styles were widely copied by Sosen's pupils, later school and imitators, though silk is the more common. A genuine work should combine all Sosen's virtues, both as observer of apes and as pure artist. The forms of the animals should be undistorted, in proper proportion and full of natural movement. The expressions of the faces should be keen and very sharply painted, and the relationship between the apes, who are social animals, clearly pointed up. In the example here (a) the sympathy between the mother and young is abundantly brought out. Yet, however naturalistically Sosen delineated his main subject, the setting might be much more formalised, following older traditions of combining naturalism with conventionalised forms. The background left largely as unpainted silk is another such convention. Nevertheless, in a genuine Sosen there is never a sense of strain in these juxtapositions, and there is always a good balance in the composition.

Sosen's spiky and calligraphically very undistinguished signature offered an apparently easy task to copyists. In fact, the reverse was the case. Close scrutiny of the genuine signature shows a clear, firm and purposeful line in each individual stroke, which is missing from copies. The seals here, too, are clearly and artistically placed and show little wear. The prominent rising sun in the background of the painting suggests a New Year's work, and this may well be for the Year of the Monkey, occurring at twelve-year intervals. The Monkey Years of 1788 or 1800 seem the most likely, since Sosen used a different character for the 'So' of his name from 1807 onwards.

The first imitation (b) appears to be a serious attempt to reproduce Sosen's smoothest style, and may well be by a member of his school. The signature is a close copy of the master's, but shows some hesitancy in the individual strokes when examined under magnification. The seals are genuine, but in a far more worn state than in Sosen's own lifetime. This suggests that Sosen's own seals were, as often happened, kept by his studio and applied to copies, not necessarily in a spirit of deceit.

These factors apart, the painting itself lacks the softness and sympathy characteristic of Sosen's monkey studies, and scrutiny shows up the clumsiness of the main figure, its disproportionately large head, its awkward position on the stump and the slight clumsiness of its leg. The plum tree is a very contrived element which almost steals the scene from the animals, and does not in any case exist in the wild in Japan. The trunk is done in the 'marbled' technique called *tarashikomi*, which Sosen did indeed use but always with much more subtlety and restraint. The artist adds to this rather harshly angular spots of green representing lichen which in Sosen's genuine work is always used so as not to impose itself on the viewer. Altogether, the composition does not bear close examination. This work was acquired by William Anderson in the 1870s, and there is reason to think it was not new then. It was probably painted in the period between Sosen's death (1821) and about 1850.

The second imitation (c), an attempt to reproduce Sosen's free brushwork on paper, is a complete failure. The monkey is ungainly, its expression lacking animation. The signature is copied with surprising carelessness. The square seal is the one used in (a), but in a very worn state, stamped imprecisely at a slight angle, and using a badly mixed seal-paste which has cast an oily stain round the impression.

The painting might be charitably regarded as very poor work of the late School of Sosen, c. 1850, but it is difficult to imagine an honest process

by which it reached William Anderson in Tokyo as a genuine work. LRHS

122a Mori Sosen, *Monkey and young on a rock with wild berries and the rising sun, c.* AD 1800
Signed *Sosen*, sealed *Sosen* (round seal) and *Mori Shūshō* (square seal).
Hanging scroll in ink and colours on silk.
Painted area: 1050 × 387mm
BM JA 1913. 5–1. 053 (Japanese Painting 2500). From the Arthur Morrison Collection. Given by Sir W. Gwynne-Evans, Bart

122b School of Mori Sosen, *Monkey and young on a flowering plum stump,*
c. AD 1820–50
Signed *Sosen*, sealed with two small seals reading together *Shūshō* (one of Sosen's studio-names)
Hanging scroll in ink and colours on silk.
Painted area: 1052 × 335mm
BM JA 1881. 12–10. 2283 (Japanese Painting 2511). Purchased from the William Anderson Collection

122c Imitator of Mori Sosen, *Monkey searching its fur for fleas under a magnolia,* mid-19th century AD
Signed *Sosen*, and seal *Mori Sosen*
Hanging scroll in ink and light colours on paper. 945 × 270mm
BM JA 1881. 12–10. 2284 (Japanese Painting 2506). Purchased from the William Anderson Collection

123 Coffer, reconstructed

c. 1910–40

The seeming 'modernity' of Chinese hardwood furniture of the sixteenth to eighteenth centuries created a strong market for it among the Western community in inter-war Beijing, a market transmitted to the USA after the War. Not only were outright reproductions manufactured, but original pieces were frequently modified to Western taste, often by reducing large objects to more manageable proportions. Here the disproportionally large timbers used in the top frame and the clear traces of a large circular lockplate point to the creation of a 'drinks cabinet' from some much bigger item of storage furniture. CC

Huali wood. H 785mm; L 975mm; W 497mm
V&A FE.16–1980

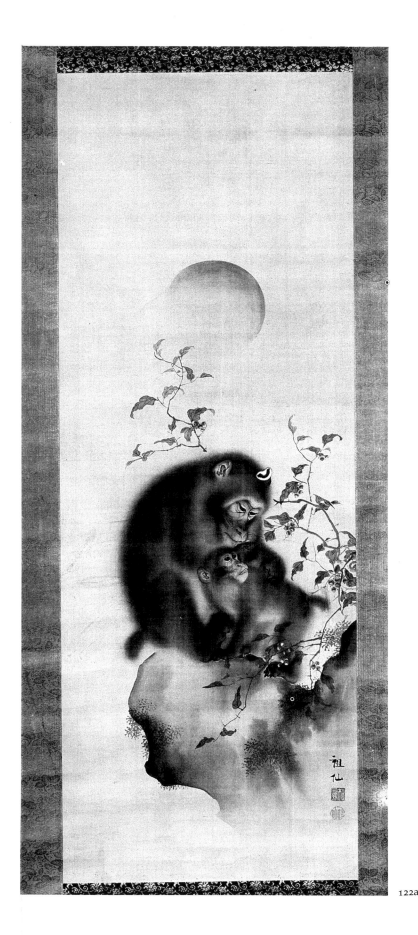

122a

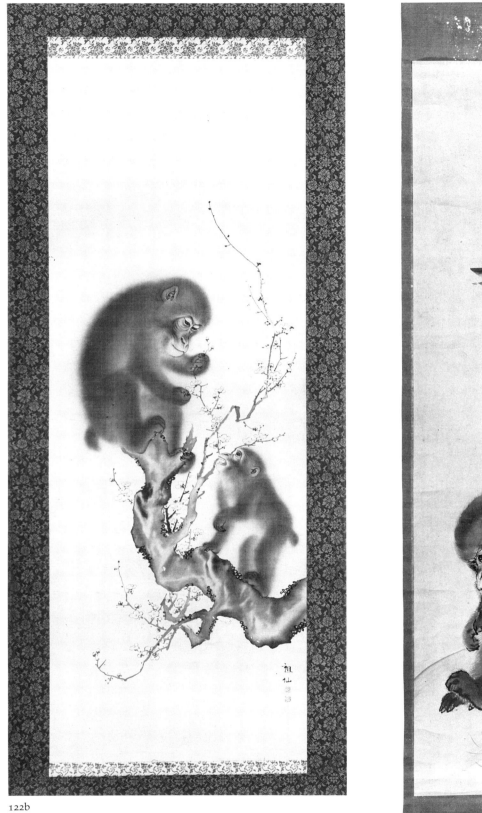

122b

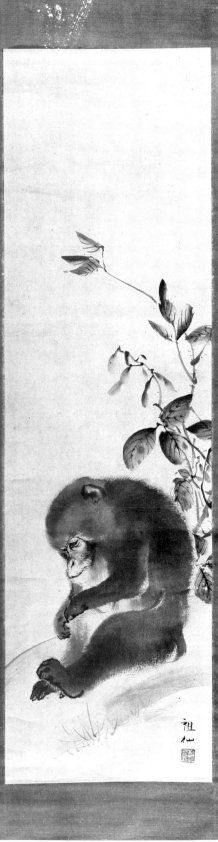

122c

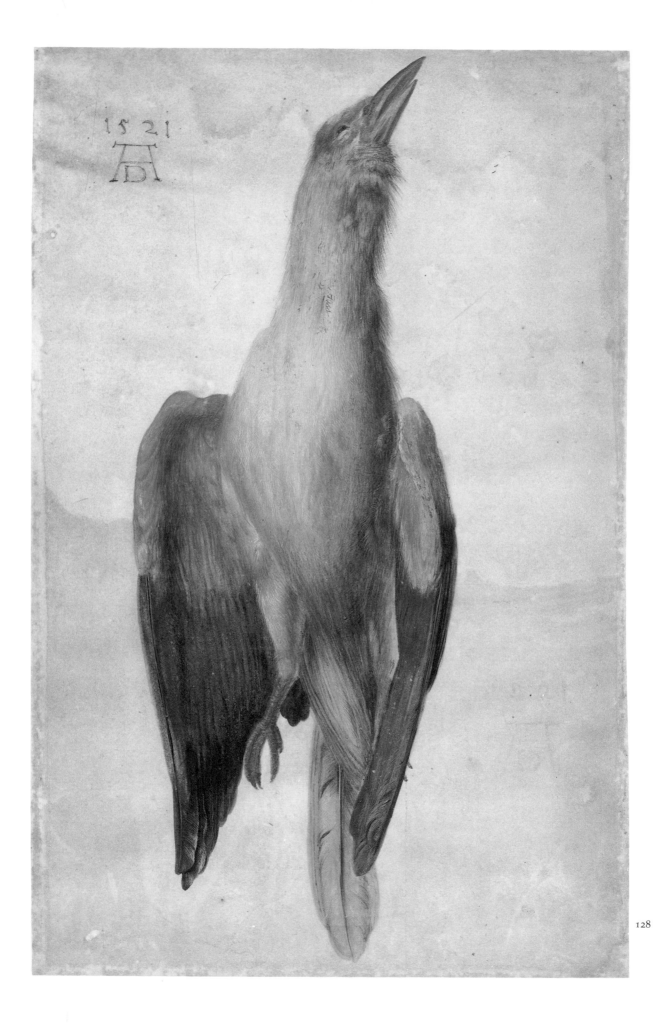

128

5

Faking in Europe from the Renaissance to the 18th century

The faking of art and antiques occurs only in cultures in which old objects and objects associated with a famous individual can command high prices. This is a relatively unusual phenomenon. In most cultures and at most times there has been no special premium on old things; even the most venerated images have been repaired and replaced as necessary, while outstanding artistry or craftsmanship has been appreciated more for its own sake than for any glamour attached to the name of the person responsible for it.

Faking is not, however, found only in modern Western culture. There was a strong demand for Greek sculpture of the golden age in Imperial Rome and some of the surviving Roman copies of such sculpture started life as fakes, perhaps attributed to a great artist like Phidias. Others were simply admiring copies and it is now difficult, if not impossible, to know which are which. In China and Japan too, as we have seen, the development of a market in ancient bronzes, jades and paintings led to the manufacture of fakes. But infinitely the greatest explosion of collecting mania occurred in Europe in the nineteenth century.

The aim of this chapter is to look at the roots of that amazing outburst, or rather the material evidence for its origins provided by the survival of fakes, in three main areas. The cult of the artist and the desire to possess exemplary relics of the ancient world both emerged in the Renaissance and continued unabated thereafter. However, in the eighteenth century a new fascination arose for old things *because they were old*. Not necessarily beautiful, not even necessarily connected with famous historic figures, they were to be acquired and cared for and lived with because they came from and spoke of the past.

The cult of the artist

Albrecht Dürer (1471–1528) and his imitators

124–30

The popularity of Dürer's work within his own lifetime was unprecedented for a northern artist of this period, and it ensured that many copies and fakes of his work were produced from the early sixteenth century onwards. It is probable that as early as 1506 the Italian engraver Marcantonio Raimondi suffered some sort of legal action against him for producing engraved copies of Dürer's woodcut series of the *Life of the Virgin* of 1504–5 (126b). Giorgio Vasari reported in his biography of the Italian artist (1568) that Dürer's second trip to Venice in 1506 was expressly made in order to take out a lawsuit against Marcantonio for the sale of fakes of his works, but he only achieved an agreement that the latter should not reproduce Dürer's name or monogram. Evidence to support this is provided by the fact that Marcantonio's copy of one of the series *Glorification of the Virgin* shows his own monogram with that of Dürer, and in his copies of the *Small Passion* series of 1511 he omitted the Dürer ciphers altogether. The problem must still have existed in 1511, since Dürer added a threatening note in Latin to the tailpieces of his bound editions of the *Life of the Virgin* and the *Small Passion* series: 'Beware all thieves and imitators of other peoples' labour and talents, of laying your audacious hands upon our work!' Further evidence of the circulation of fraudulent reproductions of prints by Dürer is provided by an edict of the Nuremberg City Council of 3 January 1512, which ruled that prints containing Dürer's monogram would be confiscated unless his cipher was removed and the anonymous vendor discontinued sale.

Dürer's concern here seems to

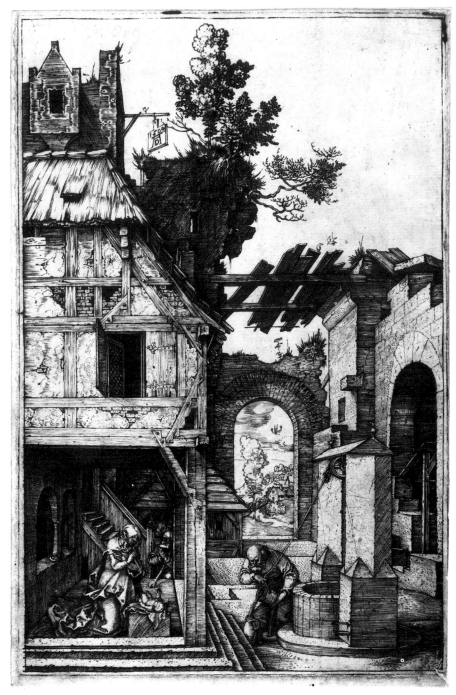

125a

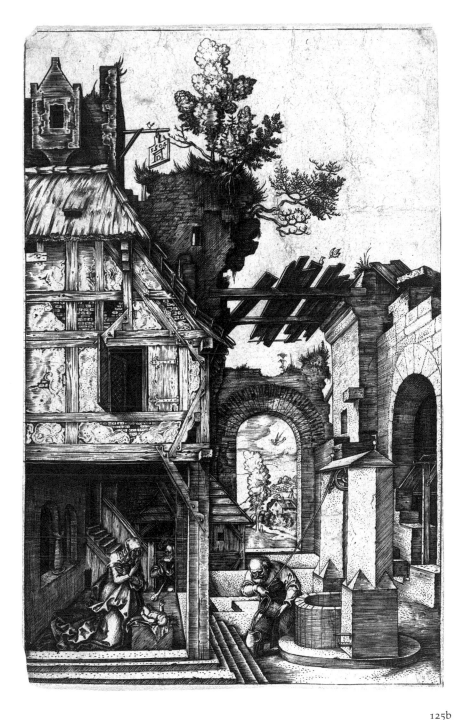

125b

have been primarily with the appearance of his monogram on the copies, rather than with the fraudulent reproduction of his designs, although the value of the designs of prints produced by important artists could also be considerable. A letter of 1475 from an engraver, Simone di Ardizoni, to the Duke of Mantua, Lodovico Gonzaga, attests to this: Ardizoni complains of harassment from the painter Andrea Mantegna, to the point of being attacked, accused of sodomy, and finally forced to flee Mantua for Verona to complete his work, because he was apparently involved in the production of prints after Mantegna's designs without the latter's consent.

The production of skilful copies of Dürer's prints during the sixteenth century – and in later periods, since his popularity with collectors never seriously declined – would therefore have been a lucrative business. The great seventeenth-century collector Archduke Leopold Wilhelm acquired fifteen 'Dürers' for high prices, almost all of which were paintings by followers like Kulmbach or imitators like Hans Hoffmann, whose work had been promoted by the application of the famous monogram.

Many copies of Dürer's prints were also produced for instructive purposes, without any fraudulent intent, although they often fell at a later date into the hands of dealers and collectors who had an eye to deception. The same attention was also applied to his drawings, numerous copies of which have survived. The appearance of spurious Dürer monograms on his own drawings as well as on a large quantity of drawings produced by members of his workshop, followers and contemporaries has confused critics for many years, and the authorship of the monograms has also been the subject of much debate. The addition of a monogram can indicate an intention to deceive, but it may also be a perfectly

genuine attempt to attribute a drawing. It seems that contemporary monograms were also added to indicate a debt to Dürer in the form of a copied composition, or to acknowledge a looser type of connection with one of his designs, the precise nature of which may now be difficult to determine, but not necessarily to imply that the drawing was made by Dürer himself. Furthermore, monograms were often added at later dates by enthusiastic collectors, such as the Strasbourg chronicler Sebald Büheler (1529–95), who inherited the estate of Dürer's assistant, Hans Baldung, and attributed much of his collection of drawings, not always correctly, in this manner. Such inscriptions were, of course, open to fraudulent misinterpretation.

The most notorious sales of works fraudulently attributed to Dürer are referred to by Hans Hieronymus Imhoff, the impoverished descendant of Dürer's friend and patron Willibald Pirckheimer, who recorded the sale of various pictures to an art dealer in 1634 with comments like: 'My father [Willibald; see 128] of blessed memory caused Dürer's signature to be put under this piece, but there were not sufficient grounds to believe that Dürer had painted it' and: 'A fine lion on parchment; though A. Dürer's sign appears on this sheet, it is generally believed that it had been painted by Hans Hoffmann'. It is clear from other entries in his diary that he did not share his doubts with intending purchasers. GB

LITERATURE A. von Bartsch, *Le Peintre-Graveur*, 21 vols, Vienna 1803–22; C. Koch, *Die Zeichnungen Hans Baldung Griens*, Berlin 1941, p. 41; O. Kurz, *Fakes*, London 1948, pp. 33–5; L. Oehler, 'Das "geschleuderte" Dürer Monogramm', *Marburger Jahrbuch* (1959), pp. 57ff.; L. Oehler, 'Das Dürermonogramm auf Werken der Dürerschule', *Städel-Jahrbuch*, NF, iii (1971), pp. 79ff. and NF, iv (1973), pp. 37ff.; exhibition catalogue, *Dürer through other eyes. His graphic work mirrored in copies and forgeries of three centuries*, Williamstown MA 1975

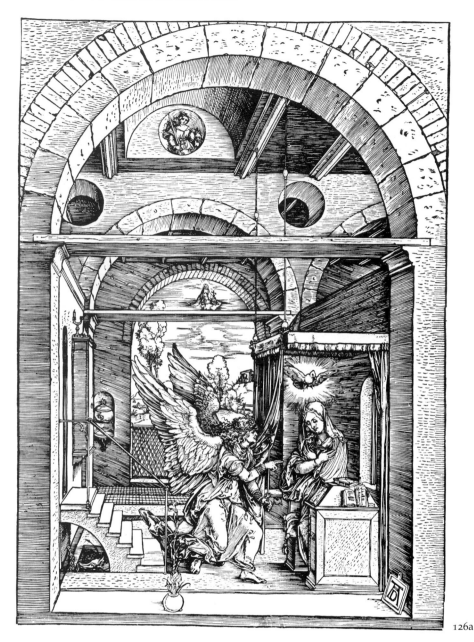

126a

124 Dürer, *Virgin and Child with a Monkey*, c. 1498–9, and a copy by Jan Wierix

Jan Wierix (1549–after 1615) was one of three brothers, all engravers of great technical ability, who worked in Antwerp. The fifty or so engravings by them after Dürer in existence are among the most competently executed copies known. They are always either signed or dated, and many were executed in the engravers' youth. It may be reasonably concluded that they regarded Dürer's work as an important instructive tool, and not as a means of commercial enterprise. There is an impression of the print here (b) in Vienna, however, in which the Wierix monogram has been effaced, most probably by an early owner in an attempt to pass the engraving off as an original Dürer. GB

124a Dürer
Engraving. 191 × 123mm
BM PD E. 4–68 (Bartsch 42)

124b Wierix: signed *IH. W. AE. 17*
Engraving. 188 × 121mm (edge of image)
BM PD E. 4–67

LITERATURE M. Mauquoy-Hendrickx, *Les Estampes des Wierix* I, Brussels 1978, no. 751

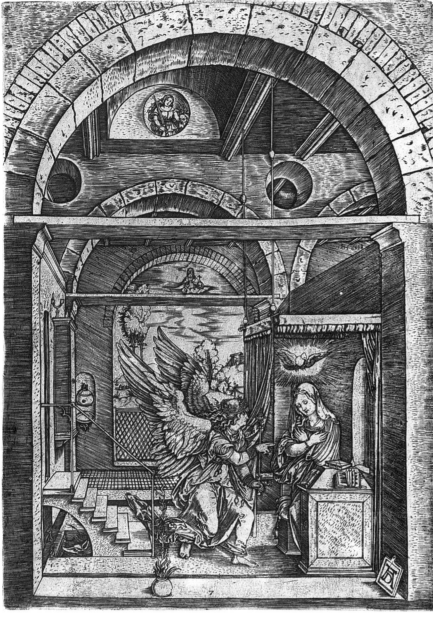

126b

Marcantonio Raimondi (1475–before 1534) made engraved copies of seventeen of them and was, as Vasari reports, selling them as originals in Venice in 1506. Marcantonio's admiration for Dürer was based on more than purely commercial considerations, but had a formative influence on his career as an engraver. Some seventy-four of his prints were copied from Dürer and he frequently borrowed landscape motifs in his early compositions. GB

126a Dürer
Woodcut. 297 × 211mm
BM PD 1895. 1–22. 628 (Bartsch 83).
Presented by W. Mitchell Esq.

126b Marcantonio
Engraving. 297 × 214mm
BM PD 1973. U. 156 (Bartsch 627)

127 Hans von Kulmbach (c. 1480–1522), *St Catherine and St Barbara*

This drawing is inscribed on the upper edge by an early hand with Dürer's monogram and, to the right of St Catherine's wheel – by a different but also early hand – with Dürer's monogram and the date 1514.

Kulmbach was a member of Dürer's workshop in Nuremberg and was one of the master's most successful pupils. The false Dürer monograms, which appear on his work quite regularly, would account for an attribution of this drawing to Dürer in the last century. It is, in fact, a study by Kulmbach for his altarpiece of the *Virgin and Child with Saints*, signed and dated 1513, in the church of St Sebald, Nuremberg. Related drawings by Dürer have also survived which make it quite clear that he played a formative part in the design of Kulmbach's composition, and throw further light on the appearance of the false monograms on the present sheet. GB

Charcoal. 282 × 197mm
BM PD 1895. 9–15. 955
LITERATURE J. Rowlands, *The Age of Dürer and Holbein*, exhibition catalogue, British Museum, London 1988, p. 131, no. 99

125 Dürer, *Adoration of the Christ Child*, 1504, and anonymous copy

The copy (b) of Dürer's print is remarkably deceptive, and was probably made by a contemporary who endeavoured to follow as closely as possible the sloping lines and cross-hatching of the original. On close inspection, the more uniform appearance of the dots in the foreground and around the well reveal a studied approach which lacks the spontaneity seen in the original. The plate was later acquired by the publisher Adrian Huybrechts of Antwerp, who reissued it inscribed with his monogram, an elaborate dedication and the date 1584. GB

125a Dürer
Engraving. 190 × 122mm (edge of sheet)
BM PD 1895. 9–15. 300 (Bartsch 2)
125b Anon, early 16th century
Engraving. 184 × 119mm (trimmed edge of sheet)
BM PD E. 4–35

126 Dürer, *The Annunciation*, and a copy by Marcantonio Raimondi

Dürer's woodcut (a) is one of twenty in his series *Life of the Virgin* of 1504–5.

128 Hans Hoffmann (1530–91/2), *Study of a dead roller*

This is a fairly close copy of a drawing

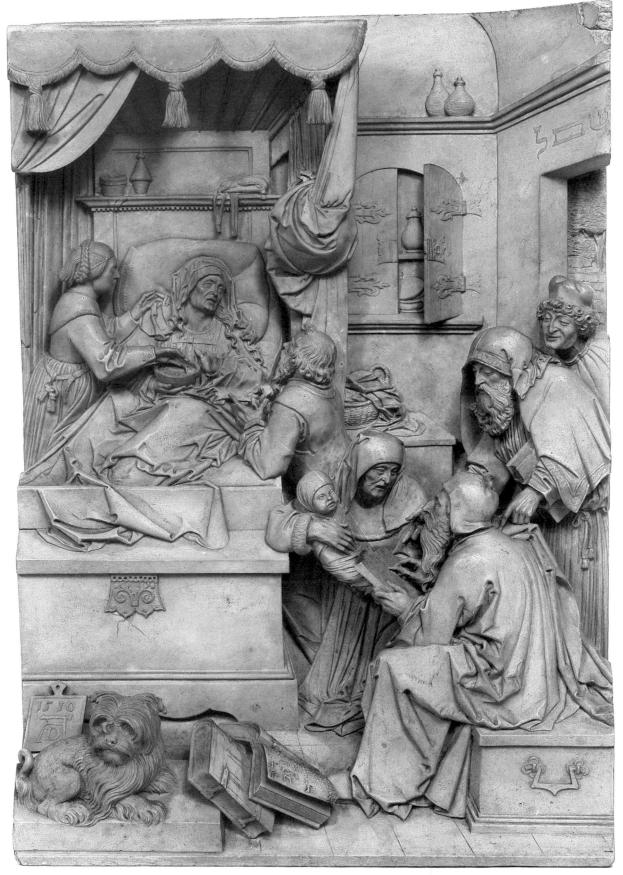

by Dürer, inscribed upper left, by a later hand, with Dürer's monogram and the date 1521. Traces of a similar inscription in the lower right of the sheet are now barely visible.

Hoffmann worked for Rudolf II at the Imperial Court in Prague, and was one of the most important exponents of the so-called Dürer Renaissance, which flourished during the late sixteenth and early seventeenth centuries in Nuremberg, Munich and Prague. He was employed by Willibald Imhoff to make copies of Dürer drawings in the Imhoff Collection; this family were the heirs of Dürer's closest friend, Willibald Pirckheimer, who had collected many of the artist's drawings. The model for the present sheet, which is signed and dated 1512 by Dürer, is in the Albertina, Vienna. Hoffmann's drawing, which until recently was thought to be by a member of Dürer's school, is one of four known versions by him, two of which are signed with his monogram and dated 1583. One of these is also in the British Museum (PD 1890. 5–12. 156). GB

Watercolour and bodycolour on vellum.
282 × 180mm
BM PD G.g. 2–220. C. M. Cracherode Bequest, 1799
Illustrated on p. 118

129 Georg Schweigger, *The naming of John the Baptist*, 1642

Signed with Dürer's AD monogram and dated 1510 on the front of a small detachable panel, the carved stone plaque (a) was considered by R. Payne Knight to be an outstanding work by Dürer, and was for many years displayed in the British Museum as such. It was copied (b) in 1845 by Richard Cockle Lucas (1800–83), a talented sculptor and wax modeller, later said by his son Albert Durer Lucas to have made the Berlin Flora (335). The recent discovery of a signature hidden on the back of the AD cartouche proved the panel to be the work of virtuoso Dürer revivalist Georg Schweigger of Nuremberg, based on Dürer's 1510 woodcut *The Death of the Virgin* (c). TW

129c

129a Schweigger, *The naming of John the Baptist*
Solnhofen stone ('honestone').
192 × 138mm
BM MLA 1824, 4–29, 85. Payne Knight Bequest

129b Lucas, copy of 129a
Ivory. 199 × 133mm
V&A 191–1865. Given by R. C. Lucas

129c Dürer, *The Death of the Virgin*
Woodcut. 287 × 205mm
BM PD E. 2–188 (Bartsch 93)

LITERATURE G. F. Waagen, *Art and Artists in England* I, London 1838, p. 133; E. J. Pyke, *A Biographical Dictionary of Wax Modellers*, Oxford 1973, p. 84; exhibition catalogue, *Dürers Verwandlung in der Skulptur zwischen Renaissance und Barock*, Liebieghaus, Frankfurt am Main 1981, no. 215; M. Baker, *Burlington Magazine* 124 (1982), pp. 271–2; C. Theuerkauff, 'Von Dürer zu Lucas?', *Kunst und Antiquitäten* 4 (1988), pp. 68–73

130 'Dürer's' medals

These three uniface portrait medals, traditionally identified as of Michael Wolgemut, Lucretia or Agnes Dürer, and Dürer's father, all bear Dürer's monogram, and have frequently been published as Dürer's own work. More recently it has been shown that they

131

The Virgin and Child (a) was evidently based on a drawing, now lost, of Raphael's Florentine period. The forger has gone to much trouble to repeat the various changes of mind in Raphael's original drawing; the heads of both the Virgin and the Child are rendered in two positions, and there are other alterations in the position of the Child's right hand and leg. These *pentimenti* are characteristic of Raphael's working method. *The Bacchanalian Procession* (b) is a facsimile copy of a Raphaelesque composition known from an engraving by Agostino Veneziano. The drawing was previously attributed to Titian. NT

132a *Virgin and Child*
Pen and brown ink and red chalk.
204 × 175mm
Ashmolean Museum, Oxford, KTP II, 631

132b *Bacchanalian Procession*
Pen and brown ink with traces of squaring in black chalk. 280 × 429mm
BM PD 1946. 7–13. 502 (P&G 62)

are relatively early examples of the posthumous Dürer revival. MPJ

130a Michael Wolgemut. Signed AD and dated 1508
Lead. D 53mm
BM CM 1923. 6–11. 96

130b Lucretia or Agnes Dürer. Signed AD and dated 1508
Brass. D 62mm
BM CM M8997

130c Dürer's father. Signed AD and dated 1514
Brass. D 72mm
BM CM 1915. 10–3. 1a

LITERATURE Exhibition catalogue, *Dürers Verwandlung in der Skulptur Zwischen Renaissance und Barock*, Liebighaus, Frankfurt 1981, nos 57, 81

131 'Hieronymus Bosch', *Big fish eat little fish*

This engraving was published by Hieronymus Cock in Antwerp in 1557 as after Hieronymus Bosch, and is inscribed *Hieronymus. Bos. inventor*. In fact, the engraver Pieter van der Heyden (*c.* 1530–72 or later) took the design from a drawing by Pieter Bruegel, dated 1556, now in the Albertina in Vienna. This was perhaps based in turn on a now lost design by Bosch, with whose style the composition more closely accords.

This is by no means a unique instance of confusion caused by inscriptions on prints. Cock also published a set of landscape engravings and credited the designs to Cornelis Cort, but the plates were reissued early in the seventeenth century by the Dutch publisher C. J. Visscher as being after Pieter Bruegel. Today the designer is referred to as the 'Master of the Small Landscapes', a nomenclature that rejects both published attributions. MRK

Engraving. 230 × 296mm (trimmed impression)
BM PD 1875. 7–10. 2651 (Bast. 139; H 46; R 40)

132 Drawings by the 'Calligraphic Forger'

These are typical examples of the work of the 'Calligraphic Forger', who was active probably in the late seventeenth century and who made facsimile copies of drawings by Raphael (1483–1520). His hand was first named and described by the Raphael specialist Oskar Fischel in 1913. Earlier collectors frequently confused his drawings with those of Raphael himself, though it is doubtful whether the drawings were really intended as fakes.

133 Marcantonio Raimondi, engraving after Raphael, and a contemporary fake

Raphael's *Judgement of Paris* (*c.* 1512) is one of the most famous engravings of the Italian Renaissance, and marks a high point in the collaboration between Raphael, who designed the composition, and his 'official' engraver Marcantonio Raimondi (see also 126b). Raphael (1483–1520) had moved to Rome to work for Pope Julius II in 1508, and had determined to follow the example of Dürer and others who had gained an international reputation by distributing their designs in printed form. Marcantonio, now also in Rome, was his chosen vehicle. Raphael first trained him to engrave in the style he desired, and then supplied a large number of drawings for him to work on. He also set up his factotum, a man called Il Baviera, to act as their publisher; although there is no evidence, one can assume that the profits were split three ways between the parties.

The success of this operation soon attracted a number of other engravers, most notably Marco da Ravenna and

Agostino Veneziano, who tried to get some of the business for themselves. It seems that it was one of them who engraved the very close copy (b). There is no doubt that it was made by a contemporary, and very little likelihood that it was made by Marcantonio himself. Since it carefully preserves Marcantonio's monogram (MAF, *Marcantonio fecit*), the only possible conclusion is that it was deliberately intended to deceive, as it succeeded in doing for centuries. Those who noticed the relative hardness of the modelling of the copy put it down to later retouching of the original plate, and it was not until the end of the eighteenth century that Bartsch firmly settled the matter by recognising that two distinct plates were involved. AVG

133a Marcantonio, after Raphael
Engraving. 290 × 432mm
BM PD 1973. U. 9. Cracherode Collection

133b Copy of 133a
Engraving. 290 × 432mm
BM PD H 2–26. Cracherode Collection

LITERATURE A. Bartsch, *Le Peintre-Graveur*, XIV, Vienna 1813, p. 197, nos 245 and 246; H. Zerner, 'Apropos de faux Marcantoine', *Bibliothèque d'Humanisme et Renaissance* XXIII (1961) pp. 477–81. I am also grateful to David Landau for allowing me to consult the chapter 'From collaboration to reproduction' in a book he is writing with Peter Parshall on early printmaking; the entry above is based on his work.

134 Giorgio Ghisi, *The Dream of Raphael*, 1561

This is one of the most impressive and mysterious Italian engravings. No one has yet managed to explain fully its symbolism, but it seems clear that it portrays the dangerous path (across the sea in a leaky craft, with rocks and wild beasts in wait) lying before the wise man (on the left) in his quest to reach wisdom (or whatever the female on the right may represent). The two lines of verse at their feet are taken from Virgil's *Aeneid*, book VI, verses 617 and 95.

The major paradox presented by the print is in the text in Latin at the bottom left: 'The invention of Raphael of Urbino. Filippo Dati ordered it to be made in gratitude'. In the sixteenth century this would have been understood to mean that Raphael designed ('invented') the composition, which had then been engraved by Ghisi, a Mantuan engraver who usually worked after the designs of others. But, as commentators have long recognised, the composition could not possibly have been designed by Raphael, who died in 1520. It is very much later in style, and the only link with him is in the pose of the man, which derives from one of the philosophers in the 'School of Athens'.

It remains utterly unclear why Ghisi should have put on his print an inscription which he must have known was misleading, not to say false. Was it to deceive collectors, or is there a more esoteric or private joke behind it on the part of Dati, the man who commissioned it? Answering this

132b

133a

133b

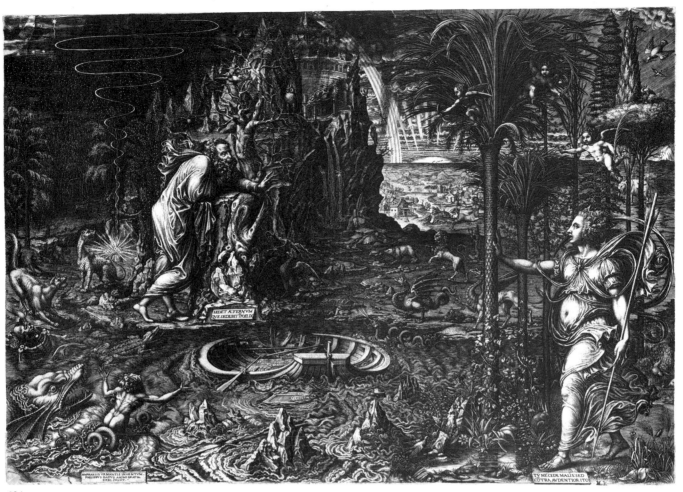

134

question is complicated by the fact that no one has yet managed to find out who Dati was. AVG

Engraving. 383 × 546mm
BM PD V. 5–161
LITERATURE M. & R. E. Lewis & S. Boorsch, *The Engravings of Giorgio Ghisi*, New York 1985, pp. 114–20

135 Forgeries of drawings by Guercino

The identity of the artist who produced these drawings, probably in Bologna in the late eighteenth century, is unknown. He specialised exclusively in the drawings of Guercino (1591–1666), especially the landscapes which were very popular with collectors of the period, concocting them from motifs taken from prints of the genuine drawings varied with passages of his own invention. The characteristic *brio* with which they are drawn approximates to the lively touch of Guercino's own pen drawings, but has quite a different character on closer acquaintance.

The forger's activity must have been lucrative, judging from the numerous examples that survive in collections in Europe and America. Although first identified in 1930 by the Hungarian scholar Edith Hoffman, his work continued, on occasion, to sell as Guercino's work until the 1970s. NT

135a Landscape with a building and a bridge on the left
Pen and brown ink. 272 × 415mm
BM PD 1986. 6–21. 8

135b Landscape with couples on the bank of a river
Pen and brown ink with brown wash.
281 × 423mm
BM PD 1875. 7–10. 2624

135c Landscape with a couple in the foreground
Pen and brown ink with brown wash.
280 × 413mm
BM PD 1875. 7–10. 2625

135d Landscape with figures, and a fortified building in the middle distance
Pen and brown ink with brown wash.
278 × 414mm
BM PD 1875. 7–10. 2626

LITERATURE P. Bagni, *Guercino e il suo falsario*, Bologna 1985

136 Imitator of Rembrandt, *An elderly man in a cap*

There is probably no case which demonstrates so clearly the wide range of variables between the authentic and the downright forged as with the Dutch painter Rembrandt. The constant discussion on the authenticity of his works, particularly in the last decade, shows how confusing this topic is.

135b

Large numbers of paintings are associated with Rembrandt's name: the New York Customs, for example, have listed in their files the import into the United States between 1909 and 1951 of the stupendous number of 9,428 works by Rembrandt. Much of the confusion is due to the activities of Rembrandt's workshops in which works were produced by Rembrandt's pupils but, according to several artists' biographies published by Arnold Houbraken in 1718–21, were sold as works by the master soon after they were painted. As we have seen elsewhere, before the nineteenth century workshop products were not signed by the pupils or assistants with their own names, but incorporated into the master's oeuvre.

The abundance of contemporary 'non-Rembrandts' seems to be a likely explanation of why there are not many faked Rembrandts around. Paintings imitating Rembrandt after the seventeenth century seem to have been done not with intent to deceive but as admiring imitations produced by followers of Rembrandt in what they saw as his style. In the eighteenth century Rembrandt was considered to be an artist with a singular and rather vulgar taste which clashed with the current classicistic norms, and the painters working in his style were rather obscure artists.

An eighteenth-century English painter, Thomas Worlidge, produced etchings in Rembrandt's style, and was considered by the art historian H. Gerson as the possible creator of some of the Rembrandt imitations. He attributed to Worlidge the very unconvincing *Head of an officer* in the store-rooms of the Wallace Collection. Dendrochronological dating of the panel, however, produced a felling date in the early seventeenth century, and this makes an attribution to Rembrandt's period much more likely.

Bona fide eighteenth-century Rembrandt imitations and copies are usually easily recognisable because they were either not made to deceive or, if they were, often lack the rich differentiation in the handling of paint and the subtleties that are characteristic of Rembrandt. We know some eighteenth-century Rembrandt forgeries painted on top of perfectly genuine paintings from the seventeenth century. These supports were no doubt chosen as they lent the forgeries the appearance of age.

The subject of fakes from the nineteenth or early twentieth centuries was determined by the growing interest in Rembrandt's biography and the members of his family. The Metropolitan Museum of Art in New York, for instance, owns a faked portrait of Rembrandt's son Titus. But such cases are exceptional.

The painting here, *An elderly man in a cap*, is a most interesting example of a

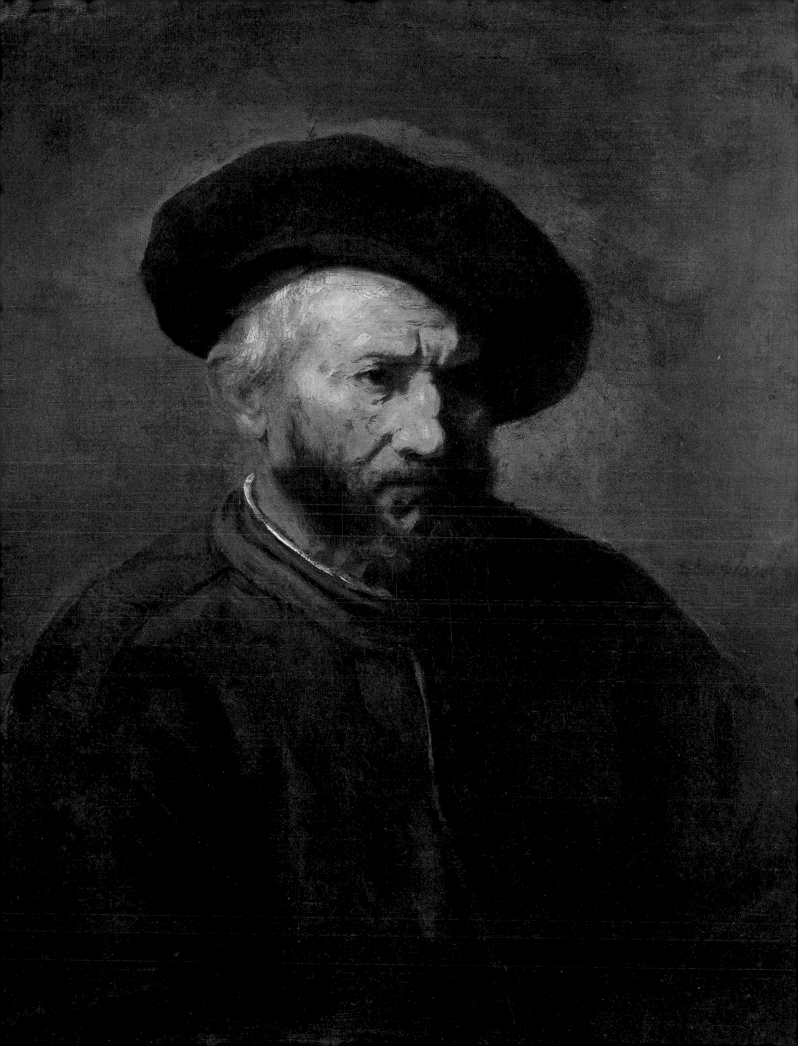

'non-Rembrandt' which has been generally considered to be by a later imitator. On stylistic grounds the painting was described in the National Gallery's catalogue as 'an imitation of Rembrandt, possibly an eighteenth-century one'; the signature it bears, *Rembrandt. f/ 164(8?)*, is characterised as being false. The results of recent scientific investigations by the National Gallery's Scientific Department make it much more likely that it is in fact a seventeenth-century painting. The composition of the grey ground is identical with that in the late self-portrait in the National Gallery. This grey ground appears to have been left uncovered in certain shadow parts of the face, a technical detail quite familiar from other Rembrandts. On closer inspection the composition of those greys turns out to be different from those of the grey ground, and this has also been observed in other genuine Rembrandts.

In fact, analysis of the painting material has given no grounds whatsoever to argue against an attribution to Rembrandt. Even more puzzling is the fact that the paint of the signature is connected intimately to the paint of the background. False signatures were often added later, painted on top of a varnish layer, and these can be detected in the cross-section of a paint sample. The signature was probably by the same hand that executed the painting, as the paint is of the same mixture as the dark tones in the man's cloak.

The most natural conclusion of this would be that the painting is not an imitation but a genuine Rembrandt. But no connoisseur of Rembrandt's work would be convinced by these scientific arguments. Any dispute about the painting's authenticity has long been exhausted. In style and quality it has only a superficial relation to the generally accepted works by the master himself.

The new scientific data force us to reject any idea that this painting is an eighteenth-century imitation. It can now be suggested that it may be a contemporary imitation done either in Rembrandt's studio or very close to it. The signature would have been executed by the counterfeiter himself. This would not be the first example where scientific examination proves that such a counterfeit was produced in Rembrandt's immediate circle and signed with Rembrandt's signature.

So here we may have a case that supports Houbraken's account that Rembrandt was faked by painters from his own circle. This case is, however, certainly not closed, and only meticulous study of large numbers of such pseudo-Rembrandts may bring out patterns to help us understand in more detail what went on in and around his studio. EVDW

670 × 530mm
National Gallery, 2539

The passion for the antique

In the late twentieth century it is sometimes difficult to comprehend the passion with which the public of the eighteenth and early nineteenth centuries regarded the art of Greek and Roman antiquity. This obsession with the antique, which had its origin in the Renaissance (137–41), was by no means limited to scholars and wealthy collectors, but spread outwards and downwards to embrace all levels of society. Anyone with any claim to education and taste would have been able to demonstrate a familiarity with the masterpieces of ancient art, and for the most part this meant antique sculpture.

For the thousands of young Englishmen – and rather fewer Englishwomen – who made the Grand Tour a first-hand knowledge of the art and architecture of ancient Rome (and from the mid-eighteenth century of the new discoveries at Herculaneum and Pompeii, near Naples) was regarded as most fully completing the educational process. Placed in the hands of professional *ciceroni*, or scholar-guides, these tourists undertook courses of varying lengths and intensity.

Fired with enthusiasm for the antique, and marvelling at the great sculpture collections to be seen in the papal museums and in the palaces and villas of the Roman nobility, many visitors quite naturally sought to form their own collections. To facilitate this many of the *ciceroni* operated as dealers themselves, or worked in concert with professional art dealers on a commission basis. In the eighteenth century British collectors – with considerably more spending power than their foreign contemporaries – dominated the market, and the principal dealers operating in Rome in the second half of the eighteenth century were also British. Two stand out above all others: Thomas Jenkins (1724–98), who successfully combined the roles of art dealer and banker, and Gavin Hamilton (1730–97), the Scottish neo-classical painter who supplemented his precarious income with the proceeds of his excavating and dealing activities. There were, of course, many others.

Needless to say, the conduct of the art market in Rome in the eighteenth and early nineteenth centuries was constantly open to trickery and deceit, and forgeries abounded. Those inexperienced in the art of connoisseurship could easily be sold spurious antiquities, either totally fake or so restored and reconstituted that the original antique component was negligible. In the journal of his Grand Tour of 1765 Tobias Smollett warned young visitors to keep their distance from the dealers, and in particular to beware being 'bubbled by a knavish antiquarian'; in the following year the painter James Barry addressed to Burke a withering denunciation of the activities of the dealers in antiquities: 'fragments of all the gods are jumbled together, legs and heads of the fairies and the graces'.

The modern observer must be cautious, however, in seeing the process of restoration and of the making-up of antiquities as deceit *per se*. Throughout the eighteenth

Fig. 5 The Piranesi Vase. This monument, newly restored and reconstructed by the British Museum, is an outstanding example of Piranesi's highly imaginative 'restoration' of antique classical sculpture. Piranesi sold it to the English collector Sir John Boyd (1718–1800) before 1778, and it was purchased by the British Museum from A. Johnston in 1868.

The engraver, architect and antiquarian G-B. Piranesi began to operate in Rome from 1767/8 as a dealer in antiquities and marble decorative work, supplying a principally British clientele. He was closely involved with Gavin Hamilton's new excavation at the Pantanello lake at Hadrian's Villa near Tivoli in 1769, acquiring from the site 'A great number of Fragments of Vases, Animals of different sorts, and some elegant ornaments' (Smith 1901, p. 310). From these Piranesi constructed his fanciful inventions, using surviving antique fragments as inspiration for what were essentially modern neo-classical sculptures of considerable merit.

Piranesi is reputed to have been less than frank about the high degree of modern infill. When he published splendid engravings of the British Museum's vase in volume II of his *Vasi*, his elaborate description of the quality of the marble carving and the monument's elegant proportions paid little or no attention to the fact that some 70 per cent of the work is modern, and that there can be no certainty that the base, support and vase ever belonged together in that configuration in antiquity. On the massive base, for example, two of the three bull's heads represent the only original antique component. The whole of the upper rim of the vase is modern, as is a substantial part of the relief. While it is perhaps inappropriate to describe the vase as a forgery, its status as an antiquity must remain ambiguous. GRV

Carrara marble. H 2718mm
BM GR Catalogue of Sculpture 2502
LITERATURE G-B. Piranesi, *Vasi, Candelabri, Cippi . . . ed Ornamenti Antichi* II, Rome 1778, pls 58–9; A. H. Smith, 'Gavin Hamilton's Letters to Charles Townley', *Journal of Hellenic Studies* XXI (1901), p. 310; A. H. Smith, *A Catalogue of Sculpture in the Department of Greek and Roman Antiquities, British Museum* III, London 1904, pp. 395–7

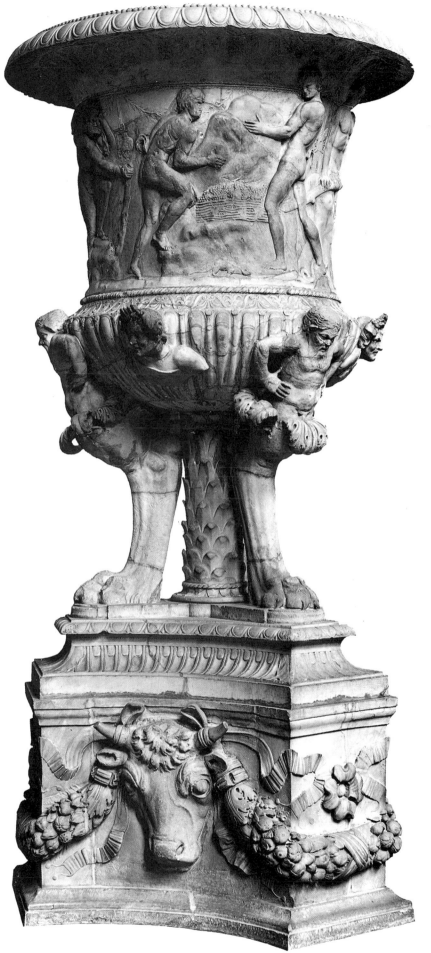

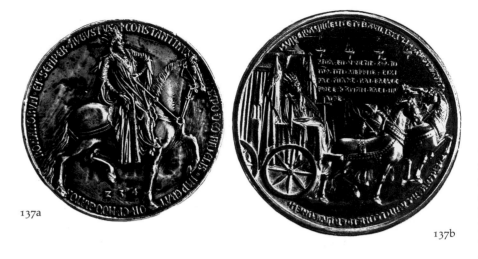

137a

137b

century the principle of restoration was universally accepted, and it was almost unthinkable that a headless or armless torso should not have its missing parts replaced. So long as the restoration of antiquities was undertaken with good taste and skill – whenever possible using similar examples as models – the procedure was welcomed. Eighteenth-century collectors expected their antique marbles to be restored, and if talented Roman sculptor-restorers (such as Cavaceppi, Pacilli, Pacetti, Angelini, Albacini or, indeed, Piranesi) succeeded in disguising modern additions so as not to detract from the overall visual effect, then so much the better.

The problem, of course, was one of degree. While a learned scholar-collector like Charles Townley (1737–1805) might insist on works of high quality in an excellent state of preservation, and was capable of immediately recognising modern additions, other less experienced purchasers could easily be misled; it is also clear from comments made by Townley about his friends that in many cases the collectors themselves were indifferent to the issue of authenticity. The letters of Jenkins and Hamilton prove that they applied different standards to different collectors, and that in most cases they were less than fastidious

in describing the degree of restoration.

The marbles from the collection of Charles Townley included here (142–6) demonstrate various degrees of restoration and the problems associated with them. The bas-relief of a Centaur abducting a woman (143) was extensively restored, almost certainly by Cavaceppi, but there is no evidence that his additions were ever passed off as original. As time went on Townley became less tolerant about such alterations. G-B. Piranesi, the engraver turned art dealer and restorer of antiquities, produced in the decade after 1768 a series of decorative and visually impressive vases and candelabra constructed by combining original antique fragments secured from a variety of sources with modern infill. Piranesi was sometimes reticent in distinguishing for his clients ancient from modern work, and we find Thomas Jenkins in his letters to Townley denouncing Piranesi's claims, calling his antiquities *pastici*, sending him up as *il cavaliere composito* and accusing him of trickery and deceit. On his first Grand Tour Townley had purchased a large vase from Piranesi (similar to fig. 5), but he afterwards disposed of it, presumably because he had by then come to recognise that it consisted largely of modern work.

The taste for restored and visually impressive marbles often led to regrettable tampering. In efforts to minimise ostensible damage and to maximise the impression of white, all-over perfection, restorers and dealers often smoothed down the surface of marbles (see for example 145), and we have it from Townley that Francesco Cavaceppi ('an ignorant sculptor') had tried to remove with acid the traces of original red paint still visible on the bust of Jupiter Serapis (142). We know from his letters that Townley was extremely unhappy with the patched up heads of the two figures of Victory sacrificing a bull (146), attributable to Cavaceppi, and that he considered returning the group to Gavin Hamilton.

From around 1800, however, attitudes began to change, and for the first time informed critics like James Dallaway and J. T. Smith began to question the assumptions underlying the tradition of restoration. In his later writings Dallaway identified Thomas Jenkins as being particularly culpable and denounced him for practising deceptions (such as Jenkins's provision of new heads for the Venus and Minerva at Newby Hall in Yorkshire), but some of these criticisms were unfair, and it can be proved that the details of the restoration of the Newby Venus, for example, were publicly discussed in Rome at the time of its purchase in 1765.

Nevertheless, these criticisms represent the first stirrings of a shift in attitudes which resulted in the important decision, in 1816, that the Elgin Marbles should not be restored. After this date, though fake antiquities continued to be produced in substantial numbers, the eighteenth-century problem of the restored 'partial' fake began to lose its relevance. GRV

LITERATURE J. Dallaway, *Anecdotes of the Arts in England*, London 1800; S. Howard, *Bartolomeo Cavaceppi, eighteenth-century restorer*, PhD thesis 1958, Chicago 1980; F. Haskell & N. Penny, *Taste and the*

138b

139

Antique: the lure of classical sculpture 1500–1900, New Haven & London 1981; C. Picon, *Bartolomeo Cavaceppi: Eighteenth-Century Restorations of Ancient Marble Sculpture from English Private Collection*, exhibition catalogue, Clarendon Gallery, London 1983; J. T. Smith, *Nollekens and his Times*, London 1986, facsimile of 1st edition of 1828

137 The duc de Berry's medals of Constantine the Great and Heraclius

At the beginning of the fifteenth century the duc de Berry, one of the greatest collectors of his or any age, bought a jewelled gold medal of Constantine the Great from an Italian merchant, Antonio Mancini. In all probability he believed that this medal and its companion piece, of the Emperor Heraclius, to be ancient. Certainly, he paid a high price for them and had them copied in gold. In fact, they were new, probably made for sale to the duc, who was known to be interested in acquiring portraits of the great figures in the history of Christianity.

Published as ancient in the sixteenth century by humanist scholars like Jacopo da Strada and Hubert Goltz, the medals were denounced as forgeries in the seventeenth century. In the nineteenth, however, they were hailed as masterpieces of late medieval art, and though frequently discussed in print were never again described as fakes. MPJ

137a Constantine the Great
Silver. D 89mm
BM CM M0267

137b Heraclius
Bronze. D 98mm
BM CM M0268

138 Drawings of fake inscriptions by Pirro Ligorio (1513–83)

Pirro Ligorio worked as an artist, architect and antiquarian for Cardinal Ippolito II d'Este and Popes Paul IV and Pius IV, for a time as architect of St Peter's, before ending his life as antiquarian to the Duke of Ferrara.

His work as an antiquarian consisted in part of making detailed drawings of antique coins, inscriptions and sculpture. In accordance with the custom of the time, he tended to complete fragmentary inscriptions and sculptures, not to mislead or deceive, but to restore his representations of antiquity to their original or ideal form.

In the seventeenth century, however, scholars like Ezechiel Spanheim and Cardinal Noris denounced him as a fraud and his reputation has never recovered. More recent work has, however, tended to support Muratori's more favourable eighteenth-century judgement that 'they [Spanheim, etc.] were rash to damn and proscribe him indiscriminately. For the fact that a scholar's work contains some spurious or fictitious matter is no reason to condemn everything else he wrote as false'.

The two examples of Ligorio's

inscriptions shown here are copies drawn for the seventeenth-century collector and scholar Cassiano dal Pozzo from the original manuscript, now in Naples. Both illustrate the considerable difficulties in distinguishing the true from the false in Ligorio's work. The first (a) represents the tomb of a freedman of the *gens Iulia* from a columbarium discovered on the Via Appia. Where other witnesses record the inscription as reading simply C. IULIUS DIVI. AUG. L/DIONYSIUS/C. IULIUS/STYRAX, Ligorio has added the words AB. EPIST (ulis). LAT(inis).

The other inscription (b), though published as false in the past, is in fact authentic, as has been shown by examination of the original marble in the Museo Kircherano. It did, however, serve Ligorio as the basis for another, false inscription published alongside it in the *Corpus Inscriptionum Latinorum* (CIL 930*b). GV

138a BM GR Franks II, f. 12 (CIL VI 864*)
138b BM GR Franks II, f. 25 (CIL VI 930* a)
LITERATURE E. Mandowsky & C. Mitchell, *Pirro Ligorio's Roman Antiquities*, London 1963

139 The Barberini 'clock'

These two drawings, like 138 from the collection of Cassiano dal Pozzo, represent an object, identified as a clock or *scaphio* from the collection of Cardinal Barberini (early seventeenth century). Ostensibly an equinoctial bowl sundial, it is entirely non-functional and may well have been a sixteenth-century concoction.

Pen, ink and brown wash. 173 × 245mm and 172 × 245mm
BM GR

Renaissance forgeries of ancient coins
140

The problem of forgeries arose in the Renaissance as soon as antiquities, and in particular coins, began to be collected. A discussion of the problems of forgery was one of the common themes of, and motives for, the various handbooks on coins produced in the sixteenth and seventeenth centuries. The work of Marco Baldanza (unpublished, c. 1640) was written 'to help the understanding of those who like the subject and to teach them how to recognise the ancient from the modern, and to show what is more and what is less rare'. The earliest such handbook, the *Discorsi . . . sopra le medaglie degli antichi* of Enea Vico, first published in 1555, devotes an entire section to the problem. In his chapter 'On the frauds which are perpetrated on modern coins to make them look antique' Vico tells us that there were three principal ways of making forgeries, which he called the 'completely ancient', the 'partly ancient' and the 'completely modern'.

Completely ancient forgeries could be made by 'the false joining together of the two sides of coins of different emperors', using solder and filing the edge to conceal the join, or by re-engraving a genuine coin with an engraving tool or jeweller's wheel.

Partly ancient forgeries were made by 'striking one corroded side of a coin with a new die' or 'striking a genuine coin which was of little value because it was worn or had a common type with new dies on both sides'. The unnatural sharpness of the resulting designs could then be disguised by abrading the coin or rubbing it in ash.

Completely modern forgeries could be made by striking coins from modern dies; in this way 'the forger with a new die like an ancient one would make a rare coin'. A second method was casting. 'An ancient coin would be moulded in the marrow of a cuttle fish or in the dust from burnt bones, or in some other substance reduced to dust; the hot and liquified metal would be poured into the mould, and produce a coin similar in appearance and size [to the original]'.

Vico goes on to discuss the various methods of detecting such forgeries; basically there were (as is still the case today) two approaches, historical plausibility and the examination of the details of the specimens. For instance, one might reject a coin because the titles it gives an emperor are known to be impossible. Or, again, one might be able to detect a thin line where the join between two halves has been made, or observe anomalies in the letter forms in the legend.

One is slightly surprised to read Vico's comment that 'ogni mediocre antiquario' could easily recognise forgeries struck from newly cut dies, as, generally speaking, these have historically been the hardest to detect. Interestingly, Vico goes on to give a list of 'the imitators' who 'have been the best at making new iron dies in my time'. These are Vettor Gambello (Camelio), Giovanni da Cavino of Padua and his young son, Benvenuto Cellini, Alessandro Greco (Cesati), Leone Aretino (Leone Leoni), Jacopo da Trezzo, Federico Bonzagna of Parma and Giovan-Iacopo, Federico's brother, whom he describes as surpassing all others.

This list is both interesting and frustrating. It is frustrating because we know almost nothing of the ancient coins produced by these famous sculptors, gem-engravers and medallists. Some pieces, such as those of Alexander the Great or Mithradates VI (140 e, g), can be attributed to Cesati. Of works by Cellini, Leoni, da Trezzo or the Bonzagna brothers we have no knowledge. The fullest information available concerns Cavino, because his dies have survived and we can be sure of what his products looked like. Compared with ancient pieces, they are most impressive. There are some small technical differences in the thickness of the coins, the lettering (made by punches, not engraved) and the style (compare the ancient emphasis on the female breasts with the Renaissance emphasis on their stomachs), but Cavino's works are excellent copies. This is less true of the pieces

140a,b,c

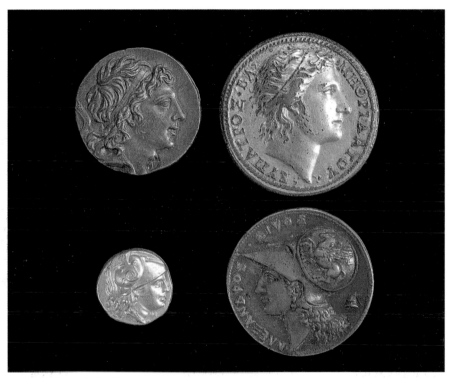

140f,g (*top*); d,e (*bottom*)

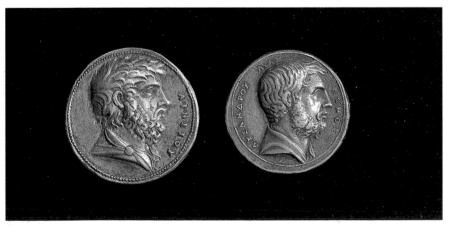

140i,h

attributable to Cesati; other contemporary pieces, by Valerio Belli (h, i), are even less like the originals.

Yet there seems little doubt that these pieces were intended to pass as ancient, and that they probably did so. There is no contemporary evidence to support the modern notion that such pieces were self-declared copies made to fill gaps in people's collections but not intended to deceive: the handbooks all talk of such pieces as forms of forgery or deceit. It is presumably no accident that we cannot ascribe any 'antique' pieces to the medallists named by Vico; the fact that they never added their signatures, as they did on their other works, is a clear indication of their intentions. AB

140a Cavino: self-portrait with Bassiano

Bronze. D 36mm
BM CM Geo. III Ill.Men 189

140b Sestertius of Caligula (AD 37–41) showing his three sisters

Bronze. D 34mm
BM CM *BMC* Caligula 37

140c Cavino: copy of 140b

Bronze. D 35mm
BM CM Geo. III. R11242

140d Gold stater of Alexander the Great (336–323 BC)

D 18mm
BM CM *BMC* Alexander 1568

140e Cesati: bronze copy of 140d

D 32mm
BM CM 1906. 11–3. 1002

140f Silver tetradrachm of Mithradates VI (120–63 BC)

D 29mm
BM CM 1896. 6–1. 56

140g Cesati: gilt copy of 140f

D 32mm
BM CM M0147

140h Belli: Lysander

Silver. D 27mm
BM CM 1906. 11–3. 996

140i Belli: Aeneas

Silver. D 31mm
BM CM 1978. 12–17. 1

140j Julius Caesar, 16th century AD

Bronze. D 31mm
BM CM R11240

140k Reverse of 140j, with elephant quadriga

Bronze. D 32mm
BM CM R11241

The faking of classical gems in the Renaissance

141

Engraved gems were highly prized in antiquity and from the fifteenth century were passionately collected by the great humanists of the Italian Renaissance, the most celebrated collection being that of the Medici of Florence, especially Lorenzo de' Medici (1449–92). Collectors were prepared to pay huge sums for them: Pope Paul II (r. 1464–71), learning that the city of Toulouse owned an ancient cameo of outstanding beauty, offered, besides a large sum and some privileges for their basilica of St Saturnin, to build them a bridge in exchange for it (Weiss 1969).

This interest in ancient gems gave the art of gem-engraving, centred in Italy, a renewed stimulus; the engravers modelled their work on classical sources, but these were as likely to be ancient coins or sculpture as the gems of antiquity themselves. These gems, cut *all'antica*, were admired and collected in their own right, but in the absence of contemporary information it is impossible to know whether they were also passed off as ancient at the time they were made. However, the artists who cut the

dies for forged coins were usually gem-engravers: Domenico Compagni of Rome made deliberate imitations of Greek coins, and though they may never have been intended to deceive, once in circulation they inevitably did. That a similar situation obtained with regard to engraved gems is an unavoidable conclusion. As a gem-engraver, Compagni was admired for his mastery of ancient techniques; he is known to have supplied his own work to Francesco de' Medici in the 1570s. Some of his gems were cut in imitation of ancient coins, but in a letter to Francesco in 1578 he openly acknowledged his debt to the gem-engravers of antiquity; in discussing the Roman style, he wrote: 'I tried to observe all the skill practised by the ancients by leaving a narrow border, cutting in low relief, and by avoiding crudeness in the colour and other matters' (McCrory 1987). The cameo of Mercury (141c) is carved in precisely this way.

The only way of distinguishing ancient from Renaissance gems is on the grounds of style, and some of the characteristics which are usually thought to be significant in forming a judgement are mentioned in the entries below; but, as with any stylistic analysis, the final conclusion remains a matter of opinion. JAR

LITERATURE R. Weiss, *The Renaissance Discovery of Classical Antiquity*, Oxford 1969, pp. 187–8; M. McCrory, 'Domenico Compagni: Roman Medallist and Antiquities dealer of the Cinquecento', in *Italian Medals*, Washington 1987, pp. 118–19

141a Cameo of Meleager offering the Calydonian boar to Atalanta

This cameo was published in 1724 by Baron Philip von Stosch as ancient, but catalogued by Dalton as sixteenth century. The stone is carved in very high relief, and the projecting undercut limbs and vigorous modelling suggest a sixteenth-century date. However, the signature in Greek characters of Sostratus, a

gem-engraver of the Roman Imperial period, is most likely to have been added in the early eighteenth century, when collectors began to pay a premium for a signed gem.

The signature was already regarded as problematic in Stosch's 1724 publication of this gem, then owned by Cardinal Ottoboni in Rome. Stosch noted the misspelling of the name Sostratus, without the second 's', and concluded that since a Greek engraver would not have misspelt his own name, the gem must be by another hand. JAR

Onyx, in a gilded metal mount. H 28mm
BM GR 1890, 6–1, 25 (Dalton Gem Catalogue no. 189). Carlisle Collection
LITERATURE P. Stosch, *Gemmae Antiquae Caelatae*, Amsterdam 1724, pl. LXVII; J. Winckelmann, *Description des Pierres Gravées du feu Baron Stosch*, Florence 1760, p. 185, no. 1087 (the gem never belonged to Stosch, but is mentioned here as one of a group signed Sostratus); S. Reinach, *Pierres Gravées des Collections Marlborough etc.* 1895, pl. 137, no. 67 (a discussion of Stosch's 1724 publication)

141b Cameo of a satyr and a maenad

Acquired by Townley as ancient, this gem was catalogued by Dalton as sixteenth century. The gem is carved in high relief – the maenad's right elbow and the satyr's knee project forward – whereas in antiquity the overall surface tends to be flatter. In this case the depth of cutting and the vigorous modelling can be compared with known Renaissance gems of similarly high quality.

As with 141a above, the signature in Greek characters for Sostratus is most likely to have been added in the eighteenth century. The engraving of the signature, in which the letters are formed by short lines with pronounced dots at the ends, is intended to imitate the way in which signatures were cut in antiquity. JAR

Onyx, in a plain gold ring of the late 18th or early 19th century. H 27mm
BM MLA Dalton Gem Catalogue no. 133. Townley Collection, no. 138

141c Cameo of Mercury

This cameo was acquired by Payne Knight as Roman, but catalogued by

Dalton as sixteenth century. The use of a stone with three thin layers producing a flat low-relief effect and the raised border cleverly imitate Roman gem-engraving of the first to second centuries AD, but the detailed and sensitive modelling of the figure suggests a Renaissance hand. The skill required to exploit wafer-thin layers of different colour in the stone for particular features such as, in this instance, the drapery folds, was considerable. JAR

Onyx, set in a gilded metal mount. H 39mm
BM MLA Dalton Gem Catalogue no. 80 (Payne Knight MS, Gems, no. 67). Payne Knight Bequest

141d Cameo of Apollo

This cameo was acquired by Payne Knight as ancient, but catalogued by Dalton as sixteenth century. The mannered pose of the figure, combined with the rounded modelling, suggests a Renaissance date. In his manuscript catalogue Payne Knight notes the unusual translucent stratum over the black ground, which gives a misty effect. JAR

Onyx, set in a plain gold ring of the early 19th century. H 22mm
BM MLA Dalton Gem Catalogue no. 77 (Payne Knight MS, Gems, no. 5). Payne Knight Bequest

142 Bust of Jupiter Serapis

Jupiter Serapis is identified by the corn-measure (modius) on the head, as worn in Greek religious processions; in the eighteenth century it was interpreted by Townley and his circle as a mystic symbol representing the seed-vessel of the lotus, thereby alluding to the reproductive power of nature. It would appear that Gavin Hamilton acquired the bust through the trade in Rome, and we have it from Townley himself (see his manuscript catalogue in the Department of Greek and Roman Antiquities, British Museum) that 'Francesco' Cavaceppi was responsible for its restoration. S. Howard regards the reference to 'Francesco' rather than to 'Bartolomeo' as merely an error on Townley's part.

141a (*top*); d,b (*centre*); c (*bottom*)

The bust is notable for the traces of original red paint still discernible on it. Townley wrote that when first found the whole face was stained a deep red colour, but that 'Francesco' Cavaceppi '. . . an ignorant Sculptor, used every means to expunge the red colour by the spirit of salt and acquafortis'. It can be presumed that he was also responsible for the restoration of the base and bust, which are deliberately pitted, better to match the weathered surface of the antique head. There can be no suggestion that an astute collector like Townley was unaware of the modern component, and this would appear to be a straightforward case of a restorer 'faking' for the sake of visual homogeneity. It is ironic that in attempting to render the bust acceptable to modern taste – which above all admired the whiteness of antique marble – the restorer attempted to remove the very quality which guaranteed its authenticity. (On colouring the face of Jupiter see Pliny *Hist. Nat.*, XXXIII, 7,36.) GRV

Marble. H 583mm
BM GR 1805. 7–3. 51 (Catalogue of Sculpture 1525). Townley Collection
LITERATURE A. H. Smith, *A Catalogue of Sculpture in the Department of Greek and Roman Antiquities. British Museum* III,

Fig. 6 Illustration of 141a from the catalogue of Baron von Stosch of 1724, showing reconstructed heads on the two figures, clearly indicated by a line at the base of the neck. The heads were presumably added in the early 18th century.

London 1904, p. 4; S. Howard, *Bartolomeo Cavaceppi, eighteenth-century restorer*. PhD Thesis 1958, Chicago 1980, p. 74; B. Cook, *The Townley Marbles*, London, 1958, pp. 22, 24

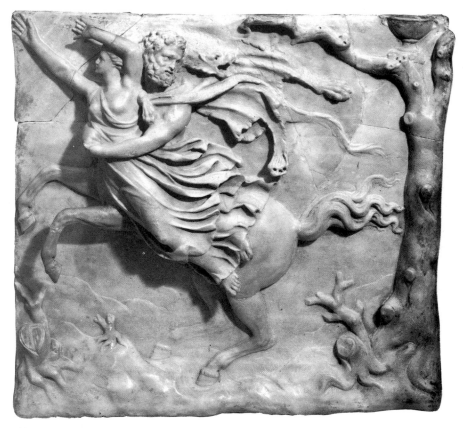

143

143 Relief of a Centaur abducting a woman

This relief was thought in the eighteenth century to represent the story of the attempted abduction of Deianeira, wife of Hercules, by the ferryman Nessos. It was purchased for £40 in Rome in 1768 by Charles Townley, having come from the collection of the Palazzo Verospi in Rome via the dealer Thomas Jenkins. It is of particular interest because it is a documented restoration by Bartolomeo Cavaceppi (1716–99), having been published in 1772 in Cavaceppi's *Raccolta*, the collection of engravings of his principal works.

We know that Charles Townley was fully aware of Cavaceppi's intervention, so there is no question of deceit. Nevertheless, the piece shows Cavaceppi's imitation of antique style, suggesting a broken relief carefully reassembled. It is particularly interesting to note that the marble from which the new sections were carved was itself ancient; when the

relief was recently dismantled it was discovered that these sections were carved from the underside of a Roman funerary inscription (CIL VI 14667) which had been published in the seventeenth century, but thereafter presumed lost. It is instructive to compare this documented restoration by Cavaceppi to 147, an outright forgery attributed to him. GRV

Carrara marble. H 565mm
BM GR 1805. 7–3. 122 (Catalogue of Sculpture 2201). Townley Collection
LITERATURE B. Cavaceppi, *Raccolta d'antiche statue, busti, bassirilievi ed altre sculture restaurate da B. Cavaceppi* III, Rome 1772, pl. 29; A. H. Smith, *A Catalogue of Sculpture in the Department of Greek and Roman Antiquities. British Museum* III, London 1904, pp. 263–4; S. Howard, *Bartolomeo Cavaceppi, eighteenth-century restorer*, PhD Thesis 1958, Chicago 1980, p. 264; B. Cook, *The Townley Marbles*, London 1985, pp. 50–1

144 The Townley Discobolus

The Townley Discobolus, a Graeco-Roman copy of a fifth-century BC bronze statue, was excavated at

Hadrian's Villa at Tivoli near Rome in 1791, and purchased by the dealer Thomas Jenkins the following year. After restoration by Carlo Albacini it was offered for sale in England and purchased by Charles Townley for the considerable sum of £400.

Jenkins assured Townley that in form and quality the Discobolus was comparable to the famous version owned by the Massimo family, which had been discovered ten years before and which the antiquarian Carlo Fea had since identified as a copy of the famous statue by the Greek sculptor Myron. Although the head of Townley's statue had been broken off, Jenkins claimed that it had been discovered lying beside the torso on the site, writing to Townley on 27 September 1794: 'The Head of Your Statue was not only found with it, but I believe You will See it is Precisely the Same Vein of Marble, that in Rome, there never was the slightest doubt of its authenticity'.

Townley remained worried, however, on several points, and upon its arrival in London in 1794 he wrote to Jenkins, asking why the head of his statue faced outwards, and was not turned back to observe the discus, as in the Massimo version. Jenkins consulted the papal antiquary Visconti, who produced an elaborate theory, arguing that the posture of the Massimo Discobolus was 'forced, & *Certainly* disgusting to the Sight', and that the artist of Townley's statue had simply improved Myron's defective pose.

Soon afterwards another headless torso of a discobolus was excavated at the same site and was acquired by Visconti for the papal collection at the Vatican; when a moden head was provided for it Visconti chose to base the restoration on the Townley forgery, rather than on the authentic statue in the Massimo collection.

It seems clear that the head of the Discobolus is not original to the torso. Nevertheless, it is unquestionably antique and has been matched with consummate skill. The head is of the same Carrara statuary marble and does, indeed, have the same veining as the torso, although it is obviously reworked; it is probable that the two

statues which provided the head and torso originated from the same quarry at Carrara.

This is an interesting example of a forgery being given legitimacy by academic experts, and itself becoming an admired prototype; although Richard Payne Knight published the head as a foreign addition in 1809, the British Museum itself attempted to deny the fact as late as 1861. GRV

Marble. H 1720mm
BM GR 1814. 7–4. 43 (Catalogue of Sculpture 250). Townley Collection
LITERATURE R. Payne Knight, *Specimens of Ancient Sculpture*, London 1809, pl. XXIX; A. H. Smith, *A Catalogue of Sculpture in the Department of Greek and Roman Antiquities. British Museum* I, London 1890, pp. 90–1; S. Howard, 'Some Eighteenth-Century Restorations of Myron's "Discobolus",' *Journal of the Warburg and Courtauld Institutes* 25 (1962), pp. 330–4; F. Haskell & N. Penny, *Taste and the Antique: the lure of classical sculpture 1500–1900*, New Haven & London 1981, pp. 199–202; J. Raeder, *Die statuarische Ausstattung der Villa Hadriana bei Tivoli*, Frankfurt 1983, p. 38; B. Cook, *The Townley Marbles*, London 1985, pp. 43–5

145 Statue of Endymion sleeping on Mt Latmos

Charles Townley's acquisition of this statue, which was variously described at the time as Mercury or Adonis, involved considerable disagreement on the question of quality and restoration. It had been excavated by Gavin Hamilton in the summer of 1774 at a site called Roma Vecchia on the Via Latina near Rome. He informed Townley about it, but advised against acquisition on the grounds of its mediocrity. Some time thereafter it was acquired by Thomas Jenkins, who offered it to Townley in February 1775, describing it in glowing terms as a work of remarkable interest and quality. Jenkins despatched it to London without waiting for Townley's reply. Puzzled by this divergence of opinion on the part of his two principal dealers and presuming that one or the other was improperly imposing upon him, Townley played each off against the other, undermining both and so alarming Jenkins that the asking price was dropped from £500 to £300, which Townley promptly accepted. In fact,

145

he was perfectly happy to acquire the statue (the subject of which interested him) despite the fact that the surface had been extensively rubbed down to give an impression of all-over smoothness and textural and coloristic unity.

This deliberate tampering with its original condition – the statue can be presumed to have been extensively chipped and stained when excavated by Hamilton – is characteristic of late-eighteenth-century taste, which increasingly admired in marble a sense of perfection and white smoothness. Several contemporaries, including Piranesi and Gavin Hamilton, accused

Jenkins of unacceptable interference with antique statues for reasons of visual homogeneity. The restorer, who provided the statue with a new right arm, feet, tip of nose and parts of the left hand, is unrecorded but was almost certainly Carlo Albacini. GRV

Marble. L 1296mm
BM GR 1805. 7–3. 23 (Catalogue of Sculpture 1567). Townley Collection
LITERATURE A. H. Smith, A *Catalogue of Sculpture in the Department of Greek and Roman Antiquities. British Museum* III, London 1904, p. 24; C. Pietrangeli, *Scavi e Scoperte a Roma sotto il Pontificio di Pio Sesto*, Rome 1958, pp. 91–2

THE PASSION FOR THE ANTIQUE

146 Two companion groups of Victory sacrificing a bull

The Townley Victorys represent ideal examples of the rather nebulous distinction between restoration and forgery. Both were excavated by Gavin Hamilton at a site in the Alban Hill near Lanuvium (known in the eighteenth century as Monte Cagnolo). This excavation provided a group of other works which are also in the Townley Collection in the British Museum (including 'Acteon attacked by his hounds', the 'Two Greyhounds', and the famous Townley Vase). The Victorys were excavated at different times; after restoration, the first was en route to London by October 1774, and its relatively finer companion by January 1775. The restoration of both can be confidently attributed to the workshop of Cavaceppi, who restored all of

Hamilton's antiquities at this time. Hamilton warned Townley that the Victorys were not of exceptional quality, but he judged that a collector like Townley could make good decorative use of a matching pair.

When they arrived in England – one had been severely damaged en route and was patched up in London, presumably by Nollekens – Townley was infuriated by the high degree of restoration, referring to them in a letter of protest sent to Hamilton as minor, broken works of inferior quality. A connoisseur collector like Townley found the damaged heads in particular, made up from a series of fragments, totally unacceptable. There is no suggestion that Hamilton attempted to pass these sculptures off as entirely original, so they cannot be described as forgeries. Townley, however, regarded their high degree

of restoration as compromising their authenticity. GRV

Marble. H 637mm, 662mm
BM GR 1805. 7–3. 45 (Catalogue of Sculpture 1699, 1700). Townley Collection
LITERATURE A. H. Smith, *A Catalogue of Sculpture in the Department of Greek and Roman Antiquities. British Museum* III, London 1904, pp. 75–6

147 Marble relief: girl before a round temple

J. J. Winckelmann described this relief as 'one of the most beautiful works surviving from Antiquity'. According to Henry Blundell it was placed by Pope Sixtus V in the Villa Negroni from where it was purchased by Thomas Jenkins in 1786. Described in the sale catalogue of Lord Cawdor's collection as 'justly esteemed the finest specimen of ancient sculpture that has reached our times', it fetched 113

147

guineas when purchased subsequently by Blundell for his collection at Ince.

However, Bernard Ashmole decided, when compiling his *Catalogue of the Ancient Marbles at Ince Blundell Hall* (1929), that it was a work of the late eighteenth-century and, given the presence of deliberate breaks and repairs, probably a deliberate forgery. There is a related drawing in the collection of the Prince of Anhalt Dessau, for whom the sculptor-restorer Bartolomeo Cavaceppi worked and, since the temple seems to be derived from an antique relief of the temple of Vesta which Cavaceppi restored, it seems likely that it is his work. EM/GRV

730 × 680mm
National Museums and Galleries on Merseyside, Walker Art Gallery, no. 6535

148 Marble head of Julius Caesar

Acquired by the British Museum from the well-known collector James Millingen in 1818, this strongly individualised head was for a long period the most famous and widely reproduced portrait of Julius Caesar in Britain. By 1961, however, it had been concluded that it was a forgery and Bernard Ashmole, in a lecture given that year, pointed out that the surface had been artificially weathered, perhaps by pounding with a nail-studded piece of wood, and stained to produce an impression of age. He concluded that it probably was made in Rome about 1800. GRV

H 350mm
BM GR 1818. 1–10. 3 (Catalogue of Sculpture 1870)
LITERATURE B. Ashmole, *Forgeries of Ancient Sculpture in marble: creation and detection*, Oxford 1961

149 Forgeries of ancient coins by Becker and Caprara

Ancient coins were as much admired and as avidly collected in the eighteenth and nineteenth centuries as classical statues and gems. Their collectability was confirmed and enhanced by the publication in 1806 of the first volume of T. E. Mionnet's *Description de médailles antiques grecques*

148

et romaines avec leur degré de rareté et leur estimation which, accompanied by 20,000 sulphur casts, provided the first reliable and comprehensive price guide to ancient coins. This gave an equal impetus to the market for coins and to the career of one of the most talented and scholarly of forgers, Carl Wilhelm Becker (1772–1830). Becker is said to have started forging coins to obtain his revenge on another collector who had sold him a fake and then ridiculed his ignorance when he complained of having been taken in. Becker had the satisfaction of seeing his productions purchased not only by the man who had deceived him but also by many of the major public and private collections in Europe.

Becker was a complicated man who operated at a number of levels. The intimate of Prince Carl von Isenburg, whose Visigothic coins he copied, and the friend of numerous scholars and collectors including Goethe, Count Rasumovsky and Count Wiczay, he claimed to have engraved dies imitating the finest and rarest coins of all periods so that collectors could buy copies of those which would otherwise be beyond their reach. If they were passed off as originals, it was by others less scrupulous than himself, and in 1824 he offered to sell his dies to the Imperial Coin Cabinet in Vienna, in order to provide reference collections of base metal impressions from the dies that would make such fraud impossible. Steinbüchel, director of the Cabinet,

was in favour of buying them, and Becker's work was clearly held in some esteem.

However, the Italian numismatist Sestini, who exposed Becker (along with Caprara, a contemporary forger working in Smyrna and Syros) in his *Sopra i moderni falsificatori di medaglie greche antiche* (On modern fakers of ancient Greek coins), argued that he was a criminal. Becker took trouble to age his coins by packing them in a box filled with iron filings, which he then attached to the axle of his carriage and took for a ride. He had a network of agents, including a couple in London who sold his coins as originals; when he had been exposed by Sestini he took to exporting them to Turkey so that they could re-emerge with an eastern provenance. The potential profits were large and the temptation, for a man frequently in financial trouble, correspondingly great. When sold as copies Becker's 296 coins cost about £140 (in 1820 prices); as originals they would have fetched £2,699.

A brilliant engraver, Becker used no mechanical methods of reproduction, cutting his dies freehand and occasionally inventing new coins to suit his fancy. The obverse of his decadrachm of Akragas (a), a masterpiece of its kind, took him only eighteen hours. His assistant, Zindel, whom he employed from 1826 onwards, was hardly less skilled (see e). Becker's forgeries, like those of his contemporary and imitator Caprara, have proved persistently deceptive, appearing in many scholarly publications, including Ernest Babelon's famous *Traité* and British Museum Catalogues. MPJ

149a Becker: decadrachm of Akragas, showing the eagles of Zeus
Silver. D 38.5mm
BM CM G2038

149b Decadrachm of Akragas in Sicily, 5th century BC
Silver. D 38mm
BM CM 1946. 1–1. 817

149c Becker: decadrachm of Syracuse
Silver. D 35.5mm
BM CM G2039

149d Decadrachm of Syracuse, *c.* 400BC
Silver. D 35mm
BM CM 1896. 6–1. 12

149c

149d

149l

149m

149g

149q

149r

149s

150a,d,f (*back row*); c,e (*front row*)

149e Zindel (under Becker's direction): Antigonus Gonatas
Delivered by Zindel 22 May 1828
Silver. D 31mm
BM CM 1850. 8–2. 2

149f Tetradrachm of Antigonus Gonatas (277–239 BC)
Silver. D 31mm
BM CM 1911. 4–9. 279

149g Caprara: Mithradates VI of Pontus
Caprara's first known forgery, this was published as genuine by Sestini in 1822.
Silver. D 33mm
BM CM G2040

149h Coin of Mithradates VI of Pontus (120–63 BC)
Silver. D 33mm
BM CM 1897. 7–4. 4

149i Caprara: coin of Argos
Overstruck on a genuine Athenian tetradrachm
Silver. D 24mm
BM CM 1878. 10–1. 1

149j Coin of Argos, *c.* 4th century BC
Silver. D 24mm
BM CM *BMC* 41

149k Becker: coin of Sextus Pompey, *c.* 40 BC
Gold. D 20mm
BM CM. Crawford, *Roman Republican Coinage* no. 511/1

149l Becker: aureus of Commodus
Gold. D 20.5mm
BM CM *BMC* Commodus 307

149m Aureus of Commodus (AD 180–92)
Gold. D 20.5mm
BM CM *BMC* Commodus 328

149n Becker: medallion of Postumus (AD 260–9)
No original of this size is known. It is probably an enlarged copy of an aureus.
Gold. D 24.5mm
BM CM 1895. 4–10. 21

149o Becker: aureus of Honoria (*c.* AD 430)
Honoria was the sister of Valentinian III
Gold. D 20.5mm
BM CM R11244

149p Becker: denar of Conrad II (AD 1027–39)
Silver. D 20mm
BM CM 1849. 3–6. 4

149q Becker: 10-ducat piece of Michael, Voivod of Transylvania (AD 1593–1601)
Generally accepted as genuine and published as such in the *Numismatic Chronicle* 1876
Gold. 43 × 44mm
BM CM 1858. 5–18. 67

149r, s Obverse and reverse dies for 149q
These dies were executed by Becker for Gabriel von Fejervary in December 1825, who paid him 20 ducats for them
Steel. 66 × 42mm; 144 × 42mm
BM CM Die 2, Die 155

LITERATURE G. F. Hill, *Becker the counterfeiter*, London 1925; P. Kinns, *The Caprara Forgeries*, London 1984

150 18th-century forgeries of ancient vases, jugs and lamps

The strong demand for interesting objects of antiquity was such that not only were direct copies made but plain ancient objects were enhanced by added decoration to increase their value to collectors. A very fine bronze jug modelled in the form of a human head (a) was bequeathed to the British Museum in 1824; it is, however, a very close copy of a fourth-century BC Etruscan jug found at Gabii in the seventeenth century, now in the Louvre. The column-crater (b) was made in the sixth century BC, but its scene of a warrior in a chariot was painted in the early nineteenth century. The two small black-glazed pots, both made in a Greek city in southern Italy during the fourth century BC, have also been 'improved', one with an added red painted design (c), the other by scratching a figured scene through the glaze (d). The plain or broken top of a pottery lamp (e) was removed and a false fired clay replacement, decorated with an erotic scene, inserted. The approximate date when this was done can be inferred from lottery tickets issued in Naples in 1769 which had been used in the packing below the new top. An interesting example of enhancement is found on a fourth-century AD Roman jug (f): an added Etruscan jug-handle is about eight hundred years earlier in date, and a battle-scene of late seventeenth-century style was engraved on the plain surface of the vessel, probably during the eighteenth century. DMB

150a Bronze jug in the form of a male head
H 280mm
BM GR 1824. 4–89. 87. Payne Knight Bequest

150b Column-crater with a modern scene
of a warrior in a chariot
350 × 360mm
BM GR 1867. 5–8. 955. Blacas Collection

150c Ancient vase with modern painted
decoration
H 80mm
BM GR 1978. 3–23. 3. Probably from the
collection of W. Hamilton

150d Ancient vase with modern incised
decoration
H 106mm
BM GR 1856. 12–26. 212. Sir William Temple
Bequest

150e Lamp with modern relief scene
L 152mm
BM GR 1971. 4–26. 28 (Catalogue of Lamps
Q1231)

150f Bronze jug with modern engraved
scene and alien handle
H 265mm
BM GR 1824. 4–89. 4. Payne Knight Bequest

The faking of classical gems in the 18th and early 19th centuries
151–3

By the 1770s the market in classical
sculptures, bronzes, coins and gems
had come to be dominated by British
dealers resident in Rome. Chief
amongst these were James Byres
and Thomas Jenkins, both of whom
supplied antique gems. Jenkins's
main trade was in highly restored
sculptures; during the 1760s he was
assisted in 'putting antiques
together' by the English sculptor,
Joseph Nollekens, who, some years
later, recalled the method by which
Jenkins met the demand for antique
gems:

as for Jenkins, he followed the trade of
supplying the foreign visitors with
intaglios and cameos made by his own
people, that he kept in a part of the
ruins of the Coliseum [sic], fitted up
for 'em to work in slyly by themselves.
I saw 'em at work though, and Jenkins
gave a whole handful of 'em to me to
say nothing about the matter to
anybody else but myself. Bless your
heart! he sold 'em as fast as they made
'em'.

The taste for gems reached a peak in
the 1780s. Jenkins found dealing in
gems to be so profitable that by the

151e (*left*); b (*top right*); a (*bottom right*)

1790s he had given up dealing in
pictures and marbles.

The engravers who worked for
dealers like Jenkins were often very
talented; both the English gem-
engraver Nathaniel Marchant, who
worked in Rome from 1772 to 1778,
and the Italian engraver Benedetto
Pistrucci (see 152) were known to
have made convincing imitations of
antique gems which were sold as
ancient.

Neo-classical work, however,
tended to follow the conventions of
the time in restrained, well-spaced
and sometimes sentimental
compositions. It also responded to
the specific demands of collectors of
the period. Discussion by authors
like Maffei, von Stosch, Gori, Natter
and Mariette of ancient signatures
stimulated a strong demand for
signed pieces, while Lippert's
Daktiliothek (1767), a catalogue

accompanied by plaster casts, made
collection by subject fashionable. As
a result, neo-classical fake gems
frequently feature subject matter
unknown to the classical repertoire
and bear signatures otherwise
known only from ancient
literature. JAR

LITERATURE P. D. Lippert, *Daktiliothek*,
Leipzig 1767; J. T. Smith, *Nollekens and his
Times*, London 1828; P. & H. Zazoff,
Gemmensammler und Gemmenförscher,
Munich 1983

151a Intaglio of Cupid and Psyche

This gem was purchased as ancient by
Charles Townley, but it belongs to a
large group of neo-classical gems with
false signatures in Greek characters. It
bears the signature of the Imperial
Roman gem-engraver Pamphilus.

Townley paid £100 for the gem, a
large sum at the time, and it was the

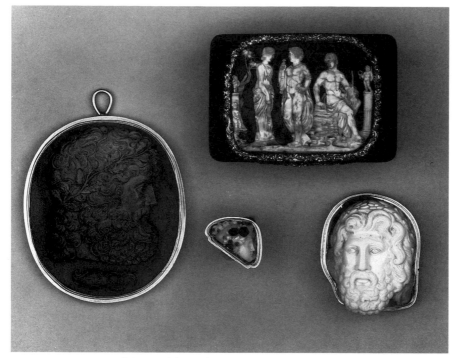

153 (*top*); 151c, 152, 151d (*bottom, left to right*)

most expensive one he ever bought. Other collectors spent more, but Townley was primarily interested in gems as a visual record of classical subjects, and he would buy them twenty or thirty at a time, without recording their prices. JAR/GRV

Sard, set in a gold ring. L 22m
BM MLA Dalton Gem Catalogue no. 663. Townley Collection, no. 102

151b Intaglio of a drunken satyr

This intaglio copies a well-known type of classical antiquity but the subject has been misunderstood and the attitude of the figure is in completely neo-classical style. It was acquired by Payne Knight as ancient, but is typical of the vast output of skilled work that passed for antique.

There are many examples of classical gems with drunken satyrs; all show the figure running or dancing, the head and torso thrown back with outstretched arms, bearing a panther skin in the left arm, a thyrsus (the staff attributed to Bacchus) in the right, and a fallen wine cup on the ground. Here, however, the figure is gracefully upright with head facing forward; the panther skin is slung casually across

the shoulders and there is no thyrsus, nor is there any suggestion of drunkenness, and the wine cup looks almost an afterthought. JAR

Sard, set in a gold ring. H 24mm
BM MLA Dalton Gem Catalogue no. 728 (Payne Knight MS, Gems, no. 41). Payne Knight Bequest

151c Cameo head of Jupiter with thunderbolt

This was acquired by Payne Knight as the work of the Greek gem-engraver Dioscorides, who worked in Rome in the early Roman Imperial period. It was carved in Italy in the late eighteenth or early nineteenth century with a faked signature 'by Dioscorides', and supplied to Payne Knight with a 'certificate of authenticity' in the form of a pen drawing; this stated on the back in an eighteenth-century hand that the gem had been found when digging the foundation of the infirmary in the garden of Santa Trinità de' Monti in Rome in 1576 (see Dalton). Although a fake, this is a neo-classical work of the highest quality. JAR

Brown onyx, set as a pendant in a metal mount. H 95mm (including loop)

BM MLA Dalton Gem Catalogue no. 54 (Payne Knight MS, Gems, no. 108). Payne Knight Bequest

151d Cameo head of Jupiter

Dalton catalogued this cameo as sixteenth century, but Payne Knight, who acquired it as classical, notes in his catalogue that it was discovered when a marsh was drained during the early nineteenth century, and so if not ancient, the cameo is more likely to date from that time. Payne Knight (MS catalogue no. 52) commented on the perfect preservation of the cameo, which was such that the ancient polish could still be seen; this would be surprising for a modern stone found in a marsh, let alone an ancient one.

The bold, almost harsh style of the carving and the arrangement of the curls suggest an early nineteenth-century date. The stone itself is of irregular shape and has been chipped under the beard and on the back, all features which would give an appearance of antiquity to the unwary. The story of its 'discovery' was presumably invented to enhance its value. JAR

White onyx, set in a gilded metal mount. H 50mm
BM MLA Dalton Gem Catalogue no. 53. Payne Knight Bequest

151e Intaglio bust of a warrior

Payne Knight purchased this gem at the posthumous sale of the collection of the lawyer Matthew Duane in June 1785. It was described in the catalogue as 'bust of a young warrior, beautiful sard; and of the best Greek work'. The Duane sale catalogue also states that the gem had previously belonged to the collector and dealer J. P. Mariette. This gem is indeed an astonishingly beautiful piece and the sensitive modelling reflects the variations of colour in the stone. It may have been on account of its beauty that Payne Knight placed it first in his manuscript catalogue. He identified the warrior as Achilles. The style of the engraving, however, especially in the face, suggests that it is neo-classical and it was catalogued by Dalton as eighteenth century. JAR

Cornelian, mounted in a gold swivel
setting. H 34mm (with loop)
BM MLA Dalton Gem Catalogue no. 819.
Payne Knight Bequest

151f Intaglio of a boar

This tiny intaglio, depicting a boar
being attacked by a dog, is engraved
with a false signature in Greek
characters 'by Dioscorides'. The first
three letters are below the boar's head,
the rest below his hind-parts. The gem
was purchased by the British Museum
as ancient in 1865 from Alessandro
Castellani (see also 1, 172, 289).

Castellani had few scruples about
repairing ancient jewellery or putting
together disparate fragments, but it is
impossible to say whether, in this
instance, he had the signature added
to what he thought was an ancient
gem or whether he knowingly sold a
fake of the eighteenth or early
nineteenth century. The collector
Count Tyszkiewicz held that
Castellani's connoisseurship failed
completely over gems, being
frequently deceived by poor modern
fabrications. But even today the
minuteness of this gem makes stylistic
analysis difficult; the opacity of the
stone means that one has to work
almost entirely from a cast. In such
cases the distinction between ancient
gem and modern copy cannot always
be made. JAR

Sard, set in a gilded metal mount. L 16mm
BM MLA 65, 7–12, 212 (Dalton Gem
Catalogue no. 933). Castellani Collection

152 Pistrucci's cameo of Flora

This cameo head of Flora, carved in
high relief from an irregular fragment
of stone, was acquired in London in
about 1812 by Richard Payne Knight
for £100 from the unscrupulous Italian
dealer Angelo Bonelli. Knight believed
it to be ancient, but a few years later
Benedetto Pistrucci (1784–1855)
claimed it as his own work, carved in
Rome as a forgery for Bonelli for less
than £5.

Pistrucci saw the gem at the house
of the botanist Sir Joseph Banks,
whose portrait he was modelling,
when Payne Knight came to show
Banks the cameo. Pistrucci revealed

that his private mark was hidden in a
twist of the hair. Archibald Billing,
who published Pistrucci's
autobiography in 1875, identified this
mark as two small lines converging to
form a hidden Greek letter, but it is
impossible to discern these lines
amongst the engraved lines of the
hair. According to Pistrucci, Payne
Knight was furious and went away
'like a drenched flea'.

In his manuscript catalogue of his
gems (no. 46) Payne Knight
maintained that the gem was an
antique representation of Proserpine,
the goddess of food plants, and
identified the red flowers as
pomegranate blossoms, despite the
opinion of Banks that they were roses.
Bonelli insisted that the gem was
ancient, having come from the
collection of Sir Robert Ainslie,
Ambassador in Constantinople from
1776 to 1792, so that Payne Knight
commissioned Pistrucci to make a
copy in order to judge which story was
correct. When finished, the copy was
the same in form but different in style
and execution. Pistrucci demanded
£50 and a formal acknowledgement
that both gems were of his authorship,
but Payne Knight refused,
maintaining that he was indifferent as
to the authorship of his Flora, since it
remained a uniquely beautiful gem,
whoever made it.

Payne Knight's contest with
Pistrucci was much publicised at the
time and brought Pistrucci several
commissions. Payne Knight certainly
admired Pistrucci's work, if not his
professional conduct; the final gem in
his manuscript catalogue was a head
of Augustus by Pistrucci, which he
praised in the highest terms. JAR

Cornelian breccia, mounted in gold as a
finger-ring. L 27mm (including setting)
BM MLA Dalton Gem Catalogue no. 176.
Payne Knight Bequest
LITERATURE A. Billing, *The Science of Gems,
Jewels, Coins and Medals*, London 1875, pp.
182–90; M. Clarke & N. Penny, *The
Arrogant Connoisseur: Richard Payne Knight
1751–1824*, Manchester 1982, pp. 74–5

153 Box with onyx cameo of a classical scene

This cameo, acquired by Richard
Payne Knight as Greek of the fourth

century BC, illustrates the forger's
cunning in inventing new subjects
that were not to be found in existing
cabinets, and the collector's gullibility
in accepting these subjects as classical.
While individual figures may be
derived from classical prototypes,
there seems to be no source for this
particular grouping and no plausible
identification of the scene has been
made in recent years. Stylistically the
cameo is of the early nineteenth
century, and is set in a contemporary
tortoiseshell box with an ornamental
gold rim.

Payne Knight wrote a whole page in
his manuscript catalogue (no. 95),
explaining his interpretation of the
scene as Theseus bidding farewell to
his mother as he departs for the wars
against the Amazons. According to
Payne Knight, Phorbas (Theseus'
attendant, seated right) holds a
stimulum or goad; the right-hand altar
figure is Cupid holding a sceptre and
flowers, while the left-hand altar
figure is Mars with a sword. Beneath is
another male statue identified as
Hymen, under whose auspices
Theseus is about to marry an
Amazonian virgin, whom he will
capture in the forthcoming battle. JAR

23mm × 79mm × 54mm (box)
BM MLA OA218. Payne Knight Bequest

The Poniatowski gems 154

Prince Stanislas Poniatowski
(1754 1833) inherited the nucleus of
his gem collection from his uncle,
King Stanislas Augustus of Poland
(1732–98). King Stanislas' collection,
acquired from agents in France and
Italy, comprised ancient,
Renaissance and modern gems by
celebrated contemporary engravers:
Guay, Natter, G. Pichler, Cades,
Marchant and Burch. Educated by
his uncle, Prince Stanislas became
by the 1780s a voracious collector of
antiquities, intent on outstripping
his Polish rivals in Rome, where he
settled in 1791 to devote himself to
his collecting.

By the time he died Poniatowski's
gem collection was renowned for its

size and, more particularly, for its inaccessibility: the Prince kept his gems closely guarded and his long-awaited catalogue finally appeared, without an author's name but presumably written by the Prince himself, two years before his death, in 1831. It contained 2,601 gems, of which about twenty were cameos and the rest intaglios, all of remarkably similar large dimensions, and many with elaborately chased gold mounts (see 154b). Another disquieting feature was the number of gems bearing the signatures of ancient engravers, 1,737 in all. In his review the French scholar R. Rochette wrote: 'The collection . . . is full of works by Pyrgoteles, Polyclites, Apollonides, Dioscurides, in greater numbers than there were in antiquity itself',

while the Berlin curator of gems E. Tölken expressed reasonable surprise at the striking resemblance in style between gems signed by Greek engravers and those signed by Roman engravers: 'Pyrogoteles works like Evodus and there are more than 400 years between them'. But the full scandal did not break until after the Prince's death.

Some items were dispersed in the next few years, but the bulk of the collection was eventually sold at Christie's in London on 29 April 1839, where 1,140 gems were purchased for £12,000 by the collector Colonel John Tyrrell. Tyrrell, wishing to publish his newly acquired gems, commissioned the antiquary Nathaniel Ogle to write an introduction. But to Tyrrell's fury Ogle exposed the gems as works of

the late eighteenth and early nineteenth centuries. A newspaper polemic between Tyrrell and Ogle ensued, from which it emerged that Prince Poniatowski had ordered his gems from Italian engravers like Pichler, Giuseppe Girometti and Nicolo Cerbara. The gems were to illustrate episodes from Greek mythology and literature. He then had the false signatures put on by other engravers, Cades and Odelli being among those cited. JAR

LITERATURE S. Reinach, 'Les Pierres Gravées de la collection Poniatowski', *La Chronique des Arts et de la Curiosité*, no. 1 (5 January 1895), pp. 2–3 and no. 2 (12 January 1895), pp. 11–13; J. Prendeville, *Photographic Facsimiles of the Antique Gems formerly possessed by the late Prince Poniatowski*, London 1857 & 1859 (Tyrrell Collection); O. Neverov, 'The Art Collections of the two Poniatowski's', *Muzei* 2 (Moscow 1981), pp. 171–96

154a (*top*); d,c (*centre*); b (*bottom*)

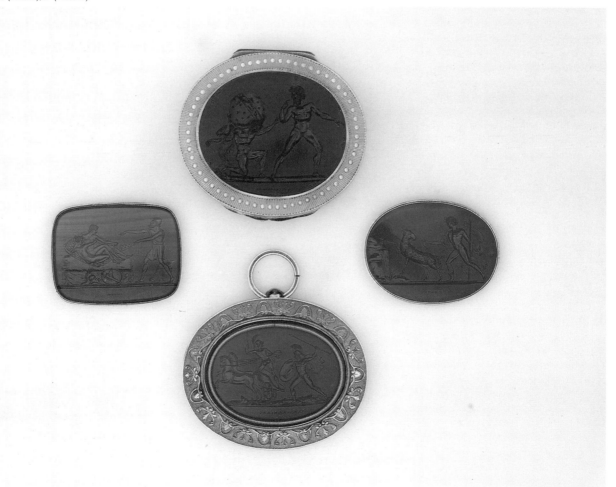

154a Intaglio of Hercules and the globe

This cornelian intaglio was engraved in Italy in the early nineteenth century, and has a false signature in Greek characters 'by Dioscorides'. It was purchased by Tyrrell in 1839 (Prendeville 1859, no. 375), and is set in the base of a contemporary gold box with engine-turned decoration.

w 55mm (box)
BM MLA HG cat. 836. Hull Grundy Gift, 1978

154b Intaglio of Hector and Automedon

In the Christie's sale catalogue (lot 1115) this intaglio is described as follows: 'Hector standing over the dead body of Aretus, is about to attack with his spear Automedon, in order to obtain the horses of Achilles, which Automedon on the chariot is urging on'. Both composition and style are close to Flaxman's designs for the *Iliad* of 1793, especially plates 22 and 32. Engravings after Flaxman's outline drawings were first published in Rome by Thomas Piroli as a set of thirty-four plates. This gem was not among those purchased by Tyrrell. The fake signature is that of Apollonides, an engraver of the Roman Imperial period, who is mentioned by Pliny as second only to Pyrgoteles. JAR

Cornelian. w 55m (including setting)
BM MLA HG cat. 837. Hull Grundy Gift

154c Intaglio of Jupiter and Bacchus

This intaglio is described in the Christie's catalogue (lot 1380) thus: 'Jupiter as a goat leading Bacchus to a fountain in the deserts of Lybia'. The fake signature is that of Gnaios, an undocumented engraver of the Roman Imperial period, some of whose work survives. Purchased by Tyrrell in 1839 (Prendeville 1857, no. 64). JAR

Cornelian. L 40mm
BM MLA 1945, 7–3, 3. Given by Miss F. J. Lefroy

154d Intaglio of Vulcan trapping Mars and Venus in his net

The fake signature is that of Pyrgoteles, the most celebrated engraver of classical antiquity and favourite of Alexander the Great. According to J. Boardman, there are no surviving ancient gems with a genuine signature of this artist. Purchased by Tyrrell in 1839 (Prendeville 1857, no. 105). JAR

Cornelian. L 39mm
BM MLA 1945, 7–3, 2. Given by Miss F. J. Lefroy

155 'Roman' fresco of a flute player, by Richard Evans

During the mid-eighteenth century excavation in the Vesuvian cities revealed for the first time Roman wall-paintings in large numbers and great variety. Hacked from the walls of the houses, such paintings appeared on the art market. However, strict controls on excavations in Pompeii and Herculaneum limited the supply: forgery was inevitable. One of the artists involved in the modern production of ancient wall-paintings was Richard Evans (1784–1871), a portrait painter and copyist and assistant to Sir Thomas Lawrence. Among other forgeries, he painted

155

this large-scale 'mural fragment' depicting a young man holding a pair of musical pipes. This originally entered the British Museum as a genuine antiquity, said by the Rome dealer Capranesi to have been found in a tomb on the Via Appia, although Evans later claimed it as his work. It was sold by Capranesi, along with a painting of Ganymede feeding the eagle, now in the Victoria and Albert Museum, to Sir Matthew White Ridley, who presented them to the respective museums in 1865. DMB

BM GR 1865. 5–20. 1 (Catalogue of Roman Paintings 92). Given by Sir M. W. Ridley

156

Horace Walpole and the Gothic Revival

The character of the collections formed in the second half of the eighteenth century by Horace Walpole (1717–97) and his friends were distinctly different from the majority of his contemporaries. The fashion for collecting classical antiquities which had so dominated collectors in both Europe and England since the Renaissance had begun to give way to a new enthusiasm for medieval objects and works of art suitable for furnishing the Gothic Revival houses being built by the *avant garde* collectors of the 1750s. Strawberry Hill is the best known, thanks largely to the guide book which Walpole himself wrote and published, but other houses like Arbury and Welbeck contained equally interesting collections.

Walpole was well aware of the importance of provenance in collections of ancient objects, and in this area he and his friends were to set higher standards than had been usual before. Such chains of provenance are of course crucial to both private collectors and museum curators in proving the genuineness and date of the objects which they collect. In his *Description of Strawberry Hill* of 1784 Walpole emphasised that his collection '. . .

was made out of the spoils of many renowned cabinets: as Dr Meade's, Lady Elizabeth Germaine's, Lord Oxford's, the Duchess of Portland's and about forty more of celebrity. Such well attested descent is the genealogy of the objects of virtu. . .' He therefore took every opportunity to acquire objects whenever an old-established collection was sold at auction: he bought 'Queen Bertha's' comb (156) in 1786 at the sale of the collection of the Duchess of Portland for eighteen shillings. Before the sale he had established its pedigree back at least 150 years. The

Duchess had inherited it from her father, the celebrated collector Edward Harley, 2nd Earl of Oxford, who had bought it in 1720 at the sale of the remains of the Earl of Arundel's collection. The Arundel provenance was an excellent one, as the collection was made in the 1620s and 1630s before the Earl finally left England in 1641. Walpole accepted that the comb and the inscription were coeval, and, although this is in fact not the case, the inscription was certainly there in 1720 when Harley's librarian recorded it, and it is likely to have been on the comb

when Arundel acquired it.

If works of art or antiquity are purchased for their beauty or superlative craftsmanship, provenance is only relevant in establishing their date of manufacture, and even without a provenance the beauty remains. But if the interest of the object depends on the fact that it had belonged to an important historical figure, then provenance is all. Collectors of Walpole's generation particularly prized objects of the latter type. Arundel, who Walpole tells us 'was the first who professedly began to collect in this country' had of course well appreciated this attitude, though Walpole's generation took the matter several stages further. Arundel's interest in Bertha's comb was not that it was an important example of ancient ivory-carving, but that it had been sent to England by the Pope himself and was thus a tangible part of the history of Christianity in this country.

Such connections with historical figures still add interest to objects for the public and museum curators alike. For example, a 1750s tea-caddy made from Shakespeare's mulberry tree, and one of Elton John's suits have been acquired by the Victoria and Albert Museum in recent years: in both cases the provenance 'makes' the object. CW

LITERATURE C. Wainwright, *The Romantic Interior: The British Collector at Home 1750–1850*, London 1989

156 'Queen Bertha's' comb

The Latin inscription states: 'This comb was sent by Pope Gregory to Queen Bertha'. Bertha was the Queen of Kent whose husband was converted to Christianity by St Augustine in AD 597. When it was acquired by the British Museum in 1916, the inscription was considered to date from around 1800. The provenance recently established for this twelfth-century comb makes it likely that the inscription had been carved upon it by the early seventeenth century (see above). CW

Ivory, H 89mm; W 140mm
BM MLA 1916, 4–3, 1
LITERATURE *Proceedings of the Society of Antiquaries of London* XXVIII (1916), pp. 168–71; C. Wainwright, 'Horace Walpole and his collection', *Horace Walpole and Strawberry Hill*, exhibition catalogue, Orleans House Gallery, Twickenham 1980, p. 16; exhibition catalogue, *English Romanesque Art 1066–1200*, Hayward Gallery, London 1984, p. 366

157a,b

157 Portrait of Elizabeth I as a hag

The gold fragment (a) has no known history prior to 1742, when it was acquired by Horace Walpole at the sale of the Earl of Oxford's collection. Walpole described it as 'a fragment of one of her last broad pieces, representing her horridly old and deformed: An entire coin with this image is not known: It is universally supposed that the die was broken by her command, and that some workman of the mint cut out this morsel, which contains barely the face . . . it has never been engraved'. As knowledge of the piece did not extend beyond Walpole and his circle, the suggestions as to its origin must be Walpole's own, rather than any real general opinion.

It is, of course, highly unlikely that such a piece could have been a genuine product of the late Elizabethan mint. The official policy on the representation of the Queen was both well established and well known. Lawrence included the piece in his list of forgeries in the *British Numismatic Journal*. It has since been demonstrated that it was in origin a genuine currency coin, a sovereign of the mint-mark anchor (1597–1600), but that the obverse had been ruthlessly recut to produce the relatively crude, hag-like features now to be seen.

Subsequent to Walpole's remarks, the forgers went to work and produced a complete coin with the recut design (b), this one intended to be a silver half-crown, mint-mark 2 (1602–3).

The motive behind the original work remains unclear. It is obviously an attack on Elizabeth's alleged vanity, but whether the standpoint was political (republican or aristocratic hostility), religious (Catholic or extreme Protestant reaction to the glorification of Elizabeth's role in the English religious settlement), moralistic, or just mischievous cannot now be ascertained. BJC

157a Gold fragment, purporting to be from a pattern sovereign of Elizabeth I
26 × 15mm
BM CM E3392

157b Damaged silver piece, purporting to be a half-crown of Elizabeth I
D 35mm
BM CM 1899. 2–4. 46. Presented by L. F. Bruun

LITERATURE H. Walpole, *Catalogue of the Royal and Noble Authors of England*, I, 1758, p. 125; L. A. Lawrence, 'Forgery in relation to numismatics, Part II', *British Numismatic Journal* 4 (1907), p. 316, no. 79; J. P. C. Kent, 'Five Tudor Notes', *British Numismatic Journal* 32 (1974), p. 164

158 Chatterton's 'medieval' literary fabrications

Thomas Chatterton (1752–70) began to write poetry while still at school in Bristol; one of his earliest pieces is a satire, *Apostate Will*, composed in 1764. He left school at fourteen and was apprenticed to an attorney. Prodigiously gifted, fascinated with antiquity and perhaps inspired by the success of the 'Ossian' poems (45) and of Horace Walpole's *Castle of Otranto*, he began to fabricate the work of imaginary medieval authors. In 1768 he published in *Felix Farley's Bristol Journey* a piece of pseudo-archaic prose, the original of which he claimed to have discovered in an old chest in St Mary Redcliffe. This attracted the attention of various local antiquaries, for whom he began to provide fake documents and pedigrees. By this time he had already written some of his 'Rowley' poems, purporting to be the work of a fifteenth-century monk,

Thomas Rowley, a friend of the historical Bristol merchant William Canynge. He also fabricated correspondence between the two, as well as other background documents. In March 1769 he sent Horace Walpole a short treatise on painting by Rowley, which Walpole initially accepted as genuine. In the same month he published the first of seven Ossianic pieces in poetic prose. In April 1770, aged eighteen, he went to London, where he continued to write prolifically, but within four months committed suicide by taking arsenic, apparently reduced to despair by poverty. The Rowley poems were first published in 1777 by Thomas Tyrwhitt; controversy over their authenticity raged for decades, until finally put to rest by Walter Skeat's edition of 1871.

Chatterton's brief, brilliant life and tragic death had a powerful effect on the Romantic imagination: Wordsworth wrote of 'the marvellous Boy/ The sleepless Soul that perished in his pride', and Keats dedicated *Endymion* to his memory. The famous painting of his death by Henry Wallis, much admired by Ruskin and now in the Tate Gallery, is not based on any authentic portrait or likeness, for none survived. SB

158a *A Discorse on Brystowe* by 'Thos. Rowleie', with detailed drawings of buildings, monuments and coats of arms, in the hand of Thomas Chatterton
BL Add. MS 24891, ff 3ᵛ–4

158b *The Rolle of Seyncte Bartlemeweis Priorie*. Thomas Chatterton's manuscript 'copy', with his own notes, of a work purportedly by Thomas Rowley
BL Add. MS 5766 C, ff. 6ᵛ–7

158c Letter from Horace Walpole to Thomas Chatterton, dated 28 March 1769, warmly thanking him for his 'very curious and kind' letter offering to send transcripts of medieval manuscripts and expressing an interest in publishing Rowley's poems.
BL Add. MS 40015, f. 11

159 Strawberry Hill Press, *Odes by Mr Gray*

It is ironical, but hardly surprising, that Horace Walpole, who was not above a little historical deception, should have been himself the victim of forgery. He set up his Press at his

158a

'Gothic Villa' at Strawberry Hill in June 1757, and by August his printer had completed his first book, the *Odes* of his friend Thomas Gray (a). In 1765 the printer Thomas Kirgate took charge of the press, printing books and occasional pieces. Walpole died in 1797, but Kirgate remained until the following October. During this period he reprinted, in exact facsimile, a number of the earlier products of the Press, now out of print, which he sold as original.

The credit for exposing these and dating them, by careful analysis of paper, typography and provenance, to the period after Walpole's death is due

to the late A. T. Hazen. Kirgate was clearly fascinated by the Press, and collected items produced by it, annotating them 'with a true collector's or bibliographer's zeal'. When he died in 1810 a large number of Strawberry Hill books appeared in his sale, with multiple copies of those he had 'reprinted'. The fraudulent nature of these 'reprints' might be open to question, although it is clear that they were made to profit from the growing bibliophilic interest in the Press. But he was clearly not above dishonesty: in one instance Kirgate noted, of a copy of *Tonton to Madame la Vicomtesse de Cambis* (1783) now at

Harvard, 'but this and one other were printed', whereas at least six copies are known.

The British Library's Strawberry Hill Press holdings were mostly acquired before 1797, or from sources prior to that date. The great collector Thomas Grenville (1755–1846), who bequeathed his collection to the British Museum, was too young to have bought early Strawberry Hill Press books new. Although he had original editions of several reprinted books, his copy of *Odes by Mr Gray* (b) is from Kirgate's reprint, distinguishable by its thicker paper and the misprint 'Illissus' for 'Ilissus' on page 8. This copy is bound to match a collection of occasional pieces from the Press, into which a copy of the first catalogue of Strawberry Hill books (1810) has been inserted. This suggests that Grenville, like other collectors, acquired his copies direct from Kirgate. NB

159a Original edition of Gray's *Odes*
BL C. 116. C. 2

159b Kirgate's reprint
BL G983

LITERATURE A. T. Hazen, *A Bibliography of the Strawberry Hill Press*, 1942; 2nd edn, Folkestone 1973

160 W. H. Ireland's 'Shakespearean' discoveries

Samuel Ireland was a great admirer of Shakespeare and often read the plays aloud to his family. When his son William Henry (1777–1835) went to work in a law office at the age of seventeen, he amused himself by forging Shakespeare's name to legal papers and then, encouraged by his father's excited response, went boldly on to produce plays and poems. His father was completely convinced by these pieces and held an exhibition of them at his house in Norfolk Street; the literary world flocked to see them, and Boswell was moved to kiss the relics on his knees. A facsimile edition of the 'works' was published in 1795. Strong doubts as to their authenticity began to be expressed, however; Kemble's production of one of the plays, *Vortigern* (c), was loudly jeered, and in 1796 Edmund Malone, the foremost Shakespeare critic of the day, published *An Inquiry into the*

158b

160a

authenticity of certain miscellaneous papers, condemning them as bungling forgeries. Ireland was compelled at last to confess to his deception, and embarked on a more conventional literary career. In 1815 he published *Scribbleomania*, a doggerel collection of entertaining but frequently inaccurate descriptions of his contemporaries. SB

160a Forged letter from William Shakespeare, fulsomely expressing his gratitude to the Earl of Southampton, by William Henry Ireland
BL Add. MS 12051, ff. 39ᵛ–40

160b Forgery of the 'Hystorycaille Playe off Kynge Henrye the Secownde', supposedly a newly discovered work by Shakespeare, by William Henry Ireland
BL Add. MS 12052, ff. 20ᵛ–1

160c *Vortigern. An Historical Tragedy*, 1799
This publication appeared three years after the first and only performance of the play, at the Theatre Royal, Drury Lane, on 2 April 1796
BL 164 i 25

161 The 'Globe Theatre'

This watercolour purports to be a view of the Globe Theatre as it appeared in Shakespeare's day. In fact, it is entirely spurious, based on a section of C. J. Visscher's engraved panoramic view of London (published in 1616), supposedly showing the city as it was in about 1600. Visscher's prospect, however, was highly inaccurate (the Globe, for instance, was mislocated); he never seems to

have visited London and he exercised considerable artistic licence in amalgamating details from earlier maps and views. Nevertheless, Visscher's view was more influential than any other in establishing the accepted (but wrong) image of the Globe as an octagonal building, and the forger of this painting perhaps imagined that its resemblance to the engraving would seem to confirm its authenticity.

On stylistic grounds this work can be dated to the eighteenth century – washes of watercolour are used here in a manner unknown in the early seventeenth century. It belongs to the same type of Shakespearean forgery as the manuscripts fabricated by William Henry Ireland in 1794–6 (160), the very period in which J. C. Crowle (1738–1811) began assembling his extra-illustrated copy of Thomas Pennant's *Some Account of London*, 1793 (3rd edn; 1st edn 1790), to which this seems to have been regarded as a particularly notable addition, being engraved several times in the nineteenth century. It is possible that Ireland was the artist in this case. Crowle's collection, bound in fourteen folio volumes, contains 3,347 drawings and prints of London topography and portrayals of historical events and persons connected with the history of the city; it was bequeathed by him to the British Museum in 1811. LS

Pen and black ink with watercolour on a 'fragment' of paper approximately 297 × 179mm. Inscribed GLOBE SOUTHWARKE
BM PD Crowle-Pennant II, 94
LITERATURE R. A. Foakes, *Illustrations of the English Stage 1580–1642*, London 1985, *passim*; A. Gurr with J. Orrell, *Rebuilding Shakespeare's Globe*, London 1989, *passim*

162 Forged etchings by 'Joseph Sympson Jr,' after Hogarth

In 1794, thirty years after Hogarth's death, the first volume of Samuel Ireland's *Graphic Illustrations of Hogarth* included a group of hitherto unknown etchings purporting to be by Joseph Sympson Jr (d. 1735/6) after designs by Hogarth. Sympson had published two prints after paintings by Hogarth in the early 1730s: these 'new' etchings,

GLOBE . SOUTHWARKE.

" our Theaters are rasd downe
and where they stoode doarse betraied
now ase put forth
by wyrot of comb macht
and midwyet of towers
Davond

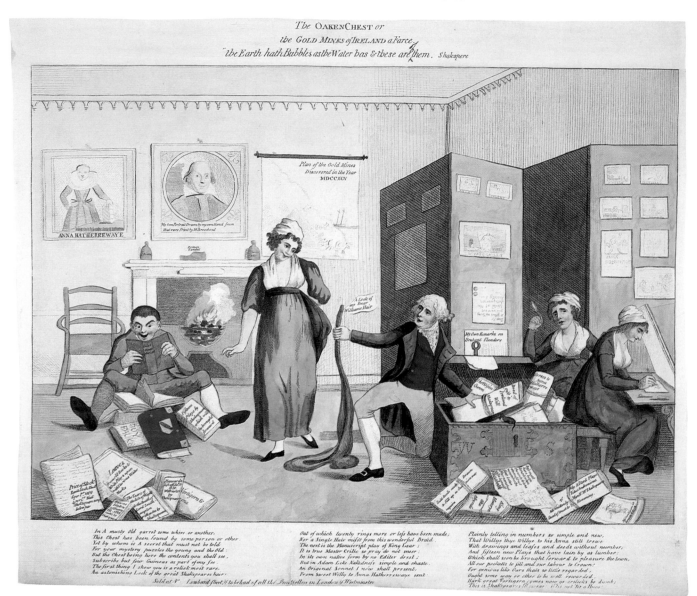

Fig. 7 Entitled *The Oaken Chest or the Gold Mines of Ireland*, *a Farce*, this coloured engraving by John Nixon, published in 1796, shows the Ireland family at home surrounded by the paraphernalia of Shakespearean forgery. William Henry Ireland is the youth seated on the floor.

together with another group that 'emerged' shortly after the publication of Ireland's volume, were thus plausibly associated with a documented, if obscure engraver working in Hogarth's lifetime. A total of seventeen 'Sympson' prints have since the mid-1790s remained in or on the fringes of the Hogarth canon, accepted by some authorities, rejected by others. Paulson has convincingly shown that they are fakes. Some of the prints depict events that took place after Joseph Sympson's death; some purport to be actors' benefit tickets, but none of the dates and occasions match documented benefit

performances, and, most importantly, the etchings are patently crude in design and execution.

An early commentator on and collector of Hogarth's prints, George Steevens (1736–1800), had his suspicions, attributing them to Samuel Ireland's son, William Henry, the Shakespearean forger (see 160). The tickets for *Pasquin* and James Figg (a,d) appeared in Samuel Ireland's 1794 volume, which was published in the same year as his son's first Shakespeare forgeries. As Paulson points out, the forger followed a familiar pattern, choosing in 'Sympson' a plausible historical figure,

whom he connected with people Hogarth certainly knew – James Figg and Henry Fielding, the author of *Pasquin vivetur stultitia* (A Dramatic Satire on the Times; a). He took elements of his designs from the artist's genuine work, on one occasion even producing an etching related to a genuine Hogarth drawing in Samuel Ireland's collection, another indication that the forger may have been William Henry Ireland.

None of these Sympson forgeries were on the grand scale; they are all supposedly minor ephemeral productions of Hogarth's. But as Paulson remarks, Samuel Ireland's enthusiasm for Hogarth, together with his well-known gullibility, may have acted as a challenge to his son's fraudulent talents and as a proving ground for the greater forgeries to come. LS

162a *Pasquin vivetur stultitia*
Etching. 211 × 340mm
BM PD C. c. 1–261

162b Benefit ticket for Joe Miller
Etching. 103 × 141mm
BM PD C. c. 1–260

162c Benefit ticket for John Laguerre
Etching. 119 × 151mm
BM PD C. c. 3–123

162d Benefit ticket for James Figg
Etching. 167 × 125mm
BM PD C. c. 3–129

LITERATURE R. Paulson, *Hogarth's Graphic Works* I, London & New Haven 1965, pp. 309–19; II, pls 334–46

162a

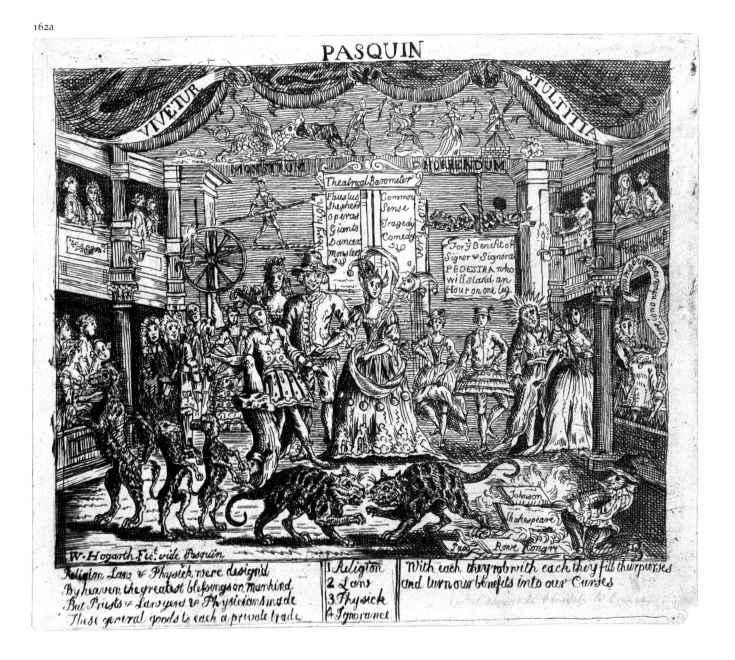

6

The 19th century: the great age of faking

The nineteenth century saw a fundamental shift in the relationship of Western culture to the past. Just as the 'horrid and awful' wilderness of untamed regions like the Lake District and the Alps became first sublime and then idyllic, so the terrifying darkness that surrounded the isolated beacon of antiquity was gradually colonised and tamed. The collecting of relics of the past, previously confined to the acquisition of classical antiquities by a small class of aristocrats and scholars began to spread to other social classes.

Horace Walpole and his circle had discovered the romance of the past even in objects surviving from the period of 'barbarism' between the fall of the Roman Empire and the Renaissance. Their discovery, arriving on the eve of the Industrial Revolution, a period in which spreading affluence was combined with an increasing desire to escape from the present, produced an explosion in collecting. From classical antiquities and Old Master paintings, the mania spread to encompass the chivalric glamour of the Middle Ages, the sculpture and decorative arts of the Renaissance, eighteenth-century ceramics, seventeenth-century metal-work and even, towards the end of the century, the relics of the Dark Ages. And as post-classical European culture itself became exhausted, scholars and collectors searched out new areas of antiquity, coming to value the relics of the Etruscans or even the Sarmatians as once they had valued those of Athens and Rome. An early interest in the art of India extended to central and South-East Asia; America was quarried for relics of the Aztecs and the Maya; eventually the material culture of every people from the Inuit to the Maori began to acquire its own following of scholars, dealers and collectors.

The collecting mania created a paradise for dishonest dealers. As each new craze took off a sudden imbalance between supply and demand created the perfect opportunity for such people to peddle their wares before a pool of expertise had been created. Craftsmen, and some artists, were themselves bemused and sometimes embittered by the fact that the work of their predecessors had so suddenly become many times more valuable than their own. Faking provided not only a living but also an opportunity for revenge on those who showed so unjust a preference for anything old.

The objects in this chapter chart the spread of the collecting mania; indeed, datable fakes can do this more successfully than genuine objects. They also illustrate its nature: the interests of the pioneer collector will be epitomised in the objects made specifically to deceive him. Finally, they demonstrate the effect of faking on the history

of collecting itself. Whole classes of object, like classical gems and medieval ivories, fell from favour because of the uncertainty about what was genuine and what was false.

By the 1930s the great age of faking was over. A new taste for ornament-free design was eliminating whole areas of craftsmanship, while growing expertise, developing scientific techniques and the increasing weight attached to provenance made faking ever more laborious. Attitudes, too, were changing; the almost open gusto with which leading nineteenth-century fakers created and purveyed their wares was gradually eliminated by increasingly stern legal sanctions against them. This is not to say that fakes were no longer produced – the next chapter demonstrates the contrary – but later fakes lack both the exuberance and the quality of those made in the nineteenth century.

New aspects of antiquity

163 Egyptian statuette of Queen Tetisheri

This attractive limestone statuette inscribed with the name of Queen Tetisheri (*c.* 1550 BC) was long regarded as a key piece for the study of Egyptian sculpture of the late 17th to early 18th Dynasties. Over the years it has played a major role in establishing the accepted view of artistic development in this period, and it has served as the basis of numerous critical assessments of other pieces. The suggestion, made in 1984, that the figure is a modern forgery was therefore considerably disconcerting to art historians.

The statuette was acquired in 1890 from the Luxor dealer Mohammed Mohassib and has since become familiar from illustrations in many popular and scholarly publications. Much less well known is another statuette of Tetisheri, of uncertain provenance, of which only the lower half survived. It was published with photographs in 1916, when in the possession of the French Institute in Cairo, but its present whereabouts are unknown. The obvious similarity of this piece to the figure in the British Museum led scholars to conclude that they had originally formed a fair.

Recent scrutiny of the British Museum sculpture, however, and comparison of its inscriptions with those of the 'companion' figure have cast serious doubts on its authenticity.

The inscriptions on the two thrones, though identical in content, are strikingly different in quality and execution. Whereas the texts of the Cairo piece have clearly been carved by a masterful and confident hand, those of the British Museum statue contain numerous elementary errors and omissions which can only be explained as the mistakes of someone unfamiliar with the ancient Egyptian language and with the carving of hieroglyphic texts. Several signs are incomplete, incorrectly formed or absent altogether. Significantly, the sections in which these anomalies occur correspond exactly with areas on the Cairo statue where the texts were damaged or unclear. There can be no doubt that the British Museum texts were copied slavishly from those of the Cairo figure.

While it is possible that the inscriptions on the British Museum's piece have been added to a genuine ancient statue that had been left unfinished, a number of other circumstances suggest that the entire piece is a forgery. Traces of red and blue paint on the figure have been shown under analysis to contain barium sulphate (barytes), widely used by artists in modern times but not employed by the ancient Egyptians in this context. Certain peculiarities of the queen's costume – notably the double shoulder straps of the dress, which leave the breasts bare, and the strikingly unusual wig, which has no exact parallel – cast further doubts on the statue's authenticity. When all these factors are taken into account it becomes

difficult to avoid the conclusion that the renowned statuette of Tetisheri is the work of a modern forger, made at Luxor probably shortly before 1890. JT

H 365mm
BM EA 22558
LITERATURE W. V. Davies, *The Statuette of Queen Tetisheri, a reconsideration*, BM Occasional Papers no. 36, London 1984
Illustrated on p. 160

164 Oyster shell with name of a Ramesside king

Besides examples made of beaten gold (see 306), real oyster shells were commonly worn as objects of personal adornment in the Egyptian Middle Kingdom, at which period they may have served as military decorations. The vast majority of the thirty or more such shells that are known bear the names of 12th Dynasty kings, and it appears that such objects ceased to be used after the Middle Kingdom. This amulet, although made from a genuine shell, displays several peculiarities. It is considerably larger than other examples and is pierced with only one hole, whereas all undoubtedly genuine specimens have two. Most telling of all, the cartouche with which it is decorated appears upside down when the shell is suspended and contains the name of one of the Ramesside pharaohs of the 19th and 20th Dynasties. This obvious anachronism indicates that the inscription on the shell is a relatively recent addition. JT

D 141mm
BM EA 30731
LITERATURE H. E. Winlock, 'Pearl Shells of Sen-Wosret I', *Studies presented to F. Ll. Griffith*, Oxford 1932, pp. 388–91, pls 61–2

165 Egyptian amulets: a faience original and a modern forgery

The false amulet group, made of Nile mud (a), is typical of the crude imitations of ancient Egyptian artefacts produced in large numbers for sale to tourists. The design is based on that of a well-known type of funerary amulet which represents Harpocrates standing between the goddesses Isis and Nephthys. The genuine amulets are normally of

faience and are generally between 20 and 40mm in height. The specimen here (b) dates to the Late Period (664– 305 BC). Besides adopting a larger scale for his piece, the forger has made a number of unwarranted changes in the iconography which betray its recent date. The hieroglyphic signs which the goddesses normally wear on their heads have been replaced by the white crown of Upper Egypt and some other unidentifiable head-dress, and the figures are dressed in pleated skirts instead of the usual close-fitting sheath dresses. The poor modelling of the bodies and the inaccurate proportions reveal a lack of confidence on the part of the maker which is not associated with genuine ancient work. JT

165a Fake amulet group
Nile mud. H 103mm; W 75mm
BM EA

165b Genuine amulet
Faience. H 40mm; W 30mm
BM EA 29970

LITERATURE W. M. F. Petrie, *Amulets*, reprinted with introduction by G. T. Martin, Warminster 1972, p. 35 pl. XXVII (152)

166 Wooden statuette of Meryrehashtef and modern copy

In May 1922 the British Museum acquired two large wooden statues from the Cairo antiquities dealer N. D. Kytikas. The figures purported to be tomb statues of private individuals dating from the Old Kingdom or First Intermediate Period, but are in reality modern forgeries. One of them, a seated figure (EA 55583), was stated to have come from Asyut; the other (a) had no provenance and was uninscribed. Nonetheless, its pedigree is fairly clear, for nude wooden figures of adults were uncommon in ancient Egypt, and this example bears a very strong resemblance to the celebrated ebony statuette of Meryrehashtef (6th Dynasty, *c.* 2200 BC), discovered in an undisturbed tomb shaft in the cemetery of Sedment (b). This statue, excavated by the British School of Archaeology in Egypt during the winter of 1920–1, was published in the latter year and entered the British Museum in January 1923. The pose,

166b,a

attitudes and hair-styles of the two figures are essentially the same, even to the unnaturally rigid posture of the arms and the slightly hunched shoulders. The workmanship of the forgery, however, is vastly inferior to that of its model, and the light-coloured wood used has been plastered and painted dark brown, presumably in an effort to imitate the ebony of which the genuine statue was made.

Since less than two years elapsed between the discovery of the Meryrehashtef statue and the acquisition of the copy by the British Museum, the date of manufacture of the forgery can be fixed between the end of 1920 and the early part of 1922. Because the genuine statue was discovered in a controlled excavation the opportunity for a forger to study the piece would have been limited, and it is perhaps more likely that he worked from photographs. This may account for the discrepancy in size, which is so obvious when the figures are seen side by side. JT

166a False statuette
H 1070mm
BM EA 55584

166b Genuine statuette of Meryrehashtef
H 535mm
BM EA 55722

LITERATURE W. M. F. Petrie, 'Discoveries at Herakleopolis', *Ancient Egypt* (1921), pp. 65–6 and plate; W. M. F. Petrie & G. Brunton, *Sedment* I, London 1924, pp. 2–3, pls VII–VIII

167 Wooden figure of an Egyptian jackal-headed deity

This is one of several wooden statuettes of Egyptian deities discovered by Giovanni Belzoni in the Valley of the Kings, and subsequently sold to the British Museum by Henry Salt, Belzoni's patron. Dating from about 1290 BC, it represents a jackal-headed god, probably Duamutef, and would originally have been entirely covered with black varnish. Such figures, serving a protective purpose, have been found in several of the royal tombs in the Valley; the exact provenance of this one is unknown, although it is very probable that it came from the tomb of

one of the 19th Dynasty pharaohs, Ramesses I or Sety I, discovered in 1817.

Most of the wooden figures from these tombs had been subjected to rough handling by robbers, and many had lost their bases. Before offering them to the British Museum, Salt, or one of his associates (perhaps even Belzoni himself), endeavoured to 'restore' the statues by providing them with pedestals or supports made from fragments of other antiquities. Thus one of the figures (EA 61283) is now mounted on the base of a private funerary statuette dating to the Ptolemaic Period (c. 250 BC), while several others, including the present example, were attached to blocks of wood which had been sawn from a painted coffin of the 26th Dynasty (c. 600 BC). This 'cannibalising' of what were regarded as inferior artefacts to enhance the value of more desirable pieces well illustrates the somewhat cavalier attitude of early nineteenth-century excavators towards their discoveries. JT

H 455mm
BM EA 61111

168 Egyptian 'heart scarabs'

A common item of ancient Egyptian funerary equipment from the New Kingdom onward was the 'heart scarab', a large representation of the dung beetle *Scarabaeus sacer*, often in greenstone or faience, which was placed within the wrappings of the mummy. Its purpose was to prevent the heart (regarded by the Egyptians as the seat of the human intelligence) from disclosing to the gods of the judgement hall any of the dead person's misdemeanours committed while on earth, and the flat base was often inscribed with a text from the *Book of the Dead* to guard against this eventuality.

The forged scarab (b), bought from General Pearse in 1887, purports to be the heart scarab of no less a personage than Tuthmosis III, the 18th Dynasty pharaoh who established Egyptian authority in Syria–Palestine in the fifteenth century BC. That it is a forgery is abundantly clear from the design on the base, which is

unparalleled among genuine heart scarabs and is moreover grossly executed and stylistically inept. Nonetheless, the forger has taken the trouble of attaching pieces of linen to the back of the scarab to convey the impression that it had been torn from the wrappings of the king's mummy. The metal band passing around the edge and across the back is – like the suspension ring – a characteristic feature of better-quality 18th Dynasty heart scarabs, such as the genuine example belonging to the scribe Renseneb (a), but whereas on the genuine specimens these fittings are of gold, those of the 'Tuthmosis III' scarab are made of bronze.

In spite of its unconvincing appearance the scarab was on display until 1900; its withdrawal from public view was prompted by the appearance of a second example, alike in most particulars (even to the spurious 'mummy cloth'), but bearing the cartouches of Ramesses III, a pharaoh who reigned over 250 years later than Tuthmosis III. JT

168a Genuine heart scarab, 18th Dynasty, c. 1450 BC
L 55mm; W 38mm
BM EA 24401
168b Forged heart scarab
L 77mm; W 51mm
BM EA 18190

169 Fake cuneiform inscriptions from the Rich Collection

Claudius James Rich (1786–1821) was a pioneer archaeologist and collector of Mesopotamian antiquities. It was during his period as British Consul at Baghdad between 1808 and 1820 that he formed his collection, before cuneiform had been deciphered. Since Rich did not have these objects copied, as was his usual practice, it is probable that he realised that they were forgeries. They are the earliest known forgeries of their kind and a striking example of the speed with which forgers respond to the creation of a new market.

The clay cylinder (a) is a crude imitation of the small cylinders with royal inscriptions, typical of neo-Babylonian kings, such as Nebuchadnezzar, in the sixth

169b

century BC. The illegible text has been produced by impressing the surface with what was either a real cuneiform tablet or a cast of one, applied hastily, at an angle.

The tablet (b), an imitation of a neo-Babylonian business document, bears impressions evidently produced by real tablets (ie. the cuneiform signs are in negative and cannot be read from the object). CNM

169a Cylinder
L 105mm; D 70mm
BM WAA R60. 9
169b Tablet
L 98mm; W 67mm
BM WAA R60. 0?

170 South Arabian forgeries

In the second half of the nineteenth century Jewish workshops in the Yemen produced a number of good-quality forgeries of bronze plaques with inscriptions in Himyaritic, the language of ancient South Arabia. The fake plaque (b) closely resembles the genuine example (a) but errors in orthography indicate that the forger worked from a copy of an ancient rock inscription transcribed into Hebrew and then put back into South Arabian. As in the genuine plaque, the forger formed the letters with wax, but instead of working

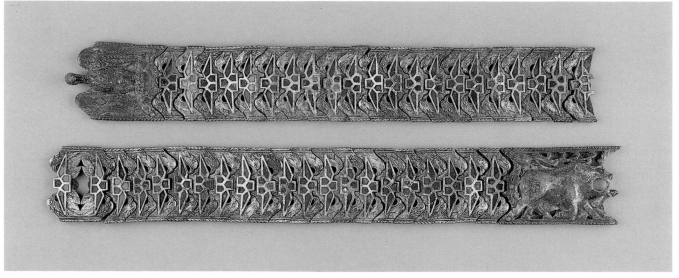

171a

freehand he cast them in a mould so that the same defects appear each time a letter is used.

The statue (c) seems to depict a woman carrying a child and bears something resembling a South Arabian letter 'h', carved in relief. It was acquired by the scholar and explorer E. Glaser in the Yemen in 1885. CNM

170a Genuine bronze plaque from the temple at Amran, near San'a, 1st-3rd century AD
H 226mm; W 122mm
BM WAA 48468

170b 19th-century fake plaque
H 185mm; W 112mm
BM WAA 48484

170c Fake alabaster(?) statue
H 240mm
BM WAA 1887. 6–26. 1

LITERATURE G. Ryckmans, 'Some technical aspects of the inscribed South Arabian bronze inscriptions cast in relief', *Proceedings of the Seminar for Arabian Studies* VIII (1978), pp. 53–65

171 The Sarmatian group of Odessa forgeries

From some time in the 1890s until the 1920s private collectors and museums in Europe and North America were delighted to acquire examples of a class of gold, silver and silver-gilt objects of colonial Greek or 'Sarmatian' style which were said to have been plundered by peasants from burial mounds in the Black Sea region of Russia and adjacent countries. Examples were rapidly absorbed into the literature of the subject and illustrated recurrently in authoritative studies by leading scholars. The true source of these spectacular objects, of which there is still no complete inventory, has only become publicly known since the publication of a paper by A. A. Iessen in 1961.

Iessen convincingly demonstrated that the well-known 'Maikop Belt' in the Hermitage, Leningrad, acquired from 'a private person in 1916', and a very similar belt in the British Museum (a), said to be from Sofia in Bulgaria when acquired in 1910, had both been made in Odessa to the orders of two local antique dealers, the brothers S. and L. Gokhman, in the previous decade or so. The method they used was simple and brilliantly successful. They commissioned extremely skilful local craftsmen to create jewellery and plate, sometimes incorporating suitably damaged parts, based on patterns they had drawn up from the magnificent illustrations of genuine goldwork in N. Kondakof, J. Tolstoi & S. Reinach's *Antiquités de la Russie Méridionale* (Paris 1891) and other finely illustrated archaeological publications. They specialised primarily in recreating two styles: that of the Greek craftsmen who lived in Greek colonies on the Black Sea coast in the late fifth to third centuries BC, catering to the tastes of the rich barbarian chiefs of the hinterland; and that of artisans of the Migration Period, ranging from the last centuries of the first millennium BC to the first few centuries of the next millennium, material now generally termed 'Sarmatian', though sometimes referred to as 'Gothic antiquities' at the time of production. With the wisdom of hindsight, it may be observed that these objects incorporate traits of the Art Nouveau style then fashionable among jewellers, for which there are no parallels in antiquity.

It appears that the Gokhman brothers dealt first in the Greek style, only switching to the later one after the 'Tiara of Saitapharnes' (4), sold to the Louvre in 1896, had finally been withdrawn from display in 1903. By that time other objects in the same style had passed into public and private collections. The Gokhmans' second group of forgeries, in Sarmatian style, was distinguished by a lavish use of inlays incorporating almandines (garnets with a violet tint), many of which may have been obtained from ancient graves.

The workshop or workshops producing these objects ceased operations in Odessa at the time of the Russian Revolution in 1917; but L. Gokhman moved to Berlin with his

stock and German soldiers returning home from the Russian front may have taken other examples westwards with them. It appears that the objects included here from the Howard de Walden Collection (b, c, e, f) were rejected by Berlin Museums as 'Gokhman forgeries' early in the 1920s, before they passed to the English private collection. RM

171a Belt, said to be from Sofia in Bulgaria
Silver, mercury gilded, inlaid with almandines. L 740mm (as extant)
BM MLA 1910, 6–22, 1. Purchased from Miss Anna Lewis (ex Ratner Collection)

171b Belt
Silver, mercury gilded. L 440mm (as extant)
National Museum of Wales, 47.409. From the Howard de Walden Collection

171c Buckle and buckle-plate
Silver, mercury gilded. L 123mm
National Museum of Wales. From the Howard de Walden Collection

171d Roundel, said to be from Sofia in Bulgaria
Silver, mercury gilded, inlaid with almandines. D 60mm
BM MLA 1910, 7–14, 1. Purchased from H. Wienstein

171e Roundel
Silver, mercury gilded. D 65mm
National Museum of Wales. From the Howard de Walden Collection

171f Roundel
Silver, mercury gilded. D 65mm
National Museum of Wales. From the Howard de Walden Collection

LITERATURE O. M. Dalton *The Treasure of the Oxus with other examples of early Oriental Metalwork*, 2nd edn, London 1926; A. A. Iessen, 'The so-called "Maikop Belt"', *Arkheologicheskii Sbornik*[2] (1961), pp. 163–77; P. R. S. Moorey, 'Some Ancient Metal Belts – a cautionary note', *Iran* VIII (1967), p. 155; M. Rostovtzeff, *The Animal Style in South Russia and China*, Princeton 1929

172 Scarab necklace from the Castellani Collection

This necklace was acquired as part of a collection of over 2,000 pieces of ancient jewellery purchased from the dealer, antiquarian and jeweller, Alessandro Castellani in 1872 (see also 151f). In Castellani's privately printed catalogue of his collection it is described as coming from Canino, near Vulci. Its authenticity was doubted by 1911, when it was catalogued as 'about fifth century BC, if genuine' (Marshall no. 2273). Marshall

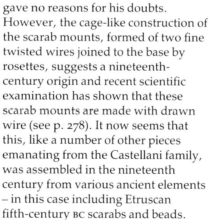

172

gave no reasons for his doubts. However, the cage-like construction of the scarab mounts, formed of two fine twisted wires joined to the base by rosettes, suggests a nineteenth-century origin and recent scientific examination has shown that these scarab mounts are made with drawn wire (see p. 278). It now seems that this, like a number of other pieces emanating from the Castellani family, was assembled in the nineteenth century from various ancient elements – in this case including Etruscan fifth-century BC scarabs and beads.

Many such 'restorations' provided the inspiration for revivalist jewels made by the Castellani firm which made 'archaeological-style' jewellery from the 1850s to the 1930s, thereby reproducing the error time and again. JAR

Gold necklace with 21 cornelian scarabs.
L 281mm
BM GR 1872. 6–4. 649 (Walters Gem Catalogue no. 796). Castellani Collection
LITERATURE J. Rudoe, in *The Art of the Jeweller: A Catalogue of the Hull Grundy Gift to the British Museum*, London 1984, no. 959; exhibition catalogue, *Castellani and Giuliano*, Wartski, London 1984, nos 6 and 7; J. Swaddling & A. Oddy, 'Etruscan gold wire', *Jewellery Studies* 5 (forthcoming)

173 'Etruscan' chariot

In 1911 the British Museum purchased a chariot of decorated bronze sheet, with iron elements, made up on a modern wood framework and with modern iron tyres. It was said to have been found in 1903 near Prodo, between Orvieto and Todi. How much of it is ancient is uncertain, but there is little doubt that the object as a whole is a pastiche, bearing little relation to an ancient vehicle. It was made by Pio Riccardi and his family (who also made the false terracotta Etruscan warriors in the Metropolitan Museum of Art, New York), together with another craftsman named Paplini, apparently for the Orvieto dealer Domenico Fuschini. DMB

1300 × 1500 × 1300mm
BM GR 1911. 4–18. 1

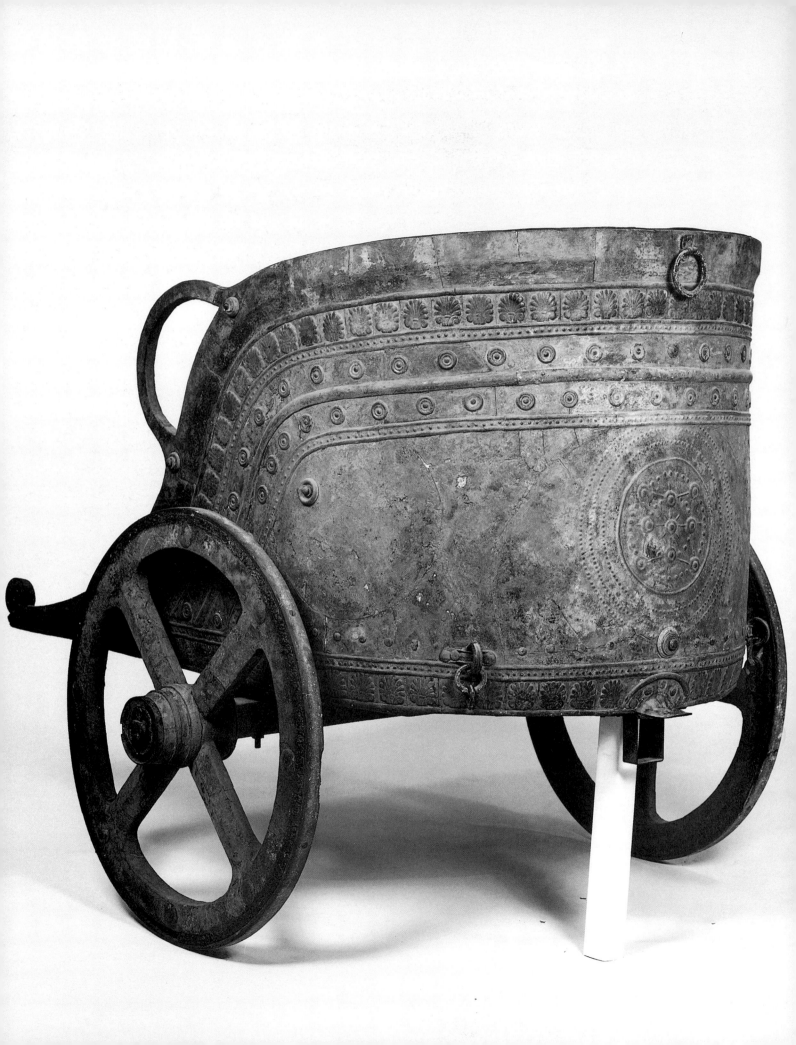

LITERATURE D. von Bothmer & J. V. Noble, *An Inquiry into the Forgery of the Etruscan Terracotta Warriors in the Metropolitan Museum of Art*, New York 1961, p. 15, no. 37; A. Andrén, *Deeds and Misdeeds in Classical Art and Antiquities*, Partille 1986, p. 69

174 The Taormina/Naxos limestone forgeries

In 1867 Dr Savario Cavallari, Director of Antiquities of Sicily, published a group of strange limestone figures of humans and animals, some bearing indecipherable inscriptions in Greek letters. He thought that they were the work of native Siculi, of the eighth century BC. These objects were said by Gaetano Moschella, a farmer, to have been found on a hill called Mastressa, between the ancient cities of Tauromenium and Naxos. George Dennis, British Vice-Consul at Palermo, purchased several of these objects in 1873 and sent them to the British Museum, also believing them to have been made by the Siculi, but in the late fifth or early fourth century. On their arrival in London they were declared to be forgeries. Dennis found this difficult to believe, and, after much correspondence, the objects were left in the Museum, where they were found in a crate in 1969.

Of varying size (the largest in the British Museum's collection is 570mm high), these are typical examples of peasant forgery art, similar but less imaginative examples of which are still being produced in Turkey and Tunisia for sale to tourists. They owe nothing to ancient sculptures, but are the products of a lively mind and a sharp knife. The anatomy of the human figures is rudimentary and often impossible, and the groups are bizarre, but the animals have a certain charm. It seems very likely that the farmer Moschella was their author. DMB

174a Woman and child
H 570mm
BM GR 1969. 10–21. 1

174b Man blowing into an unknown object
170 × 220mm
BM GR 1969. 10–21. 6

174c Bird
L 150mm
BM GR 1969. 10–21. 12

174b,d,a,c

174d Bird
L 100m
BM GR 1876. 11–13. 2. Given by G. J. Chester
LITERATURE D. M. Bailey, in Κωκαλοσ 20 (1974), pp. 172–83

175 Marble relief fragment with the head of a youth

Acquired by the British Museum in 1889, this fragment was believed to be ancient until 1961, when Bernard Ashmole pointed out that it was a copy from slab IV of the North Frieze of the Parthenon. He noted the 'pretended restoration of the end of the nose' and the 'imitation of accidental damage on the forehead, cheek and shoulders: all seemingly done with one instrument and remarkably unconvincing' as evidence that it was a deliberate forgery. Since the slab in question was only uncovered in 1840, this piece must date from the period 1840–89.

H 225mm
BM GR 1889. 10–14. 1 (Catalogue of Sculpture 673)
LITERATURE B. Ashmole, *Forgeries of Ancient Sculpture in marble: creation and detection*, Oxford 1961

176 Tanagra and Asia Minor figures

Ancient cemeteries in Boeotia, particularly at the small ancient city of Tanagra, and in Asia Minor, at Myrina and elsewhere, were plundered during the last quarter of the

175

nineteenth century, and their contents were sold on the antiquities market. Thousands of graves were opened, producing terracotta figures ranging in date from the sixth century BC to the first century AD, but those which appealed most to collectors were the draped women of the third to second centuries BC, which came to be known as 'Tanagras'. The supply becoming exhausted, pastiches made up of ancient but alien fragments were sold as whole pieces. Complete forgeries were also produced. Many of these were based closely on ancient examples, but others were fantasies, often with a mythological content:

both kinds sold extremely well at very high prices.

Fairly typical are the 'conversation piece' (a) and juglet of the Three Graces (b). Though attractive and well modelled, both have applied incrustation and, in the case of the juglet, a 'black glaze' on the rear and mouth of the vessel which was painted on after the piece had been fired. The stylistic differences that distinguished such pieces from the originals, can be seen from a comparison of the false juglet with a genuine example, portraying Eros holding a jug and bowl (c), made at Athens about 350 BC.

Not all such pieces were copied from genuine figurines. The creator of Eos and Cephalos (d), probably working in Athens toward the end of the nineteenth century, produced a three-dimensional version of an engraved composition representing Dionysos and Semele on an Etruscan bronze mirror (G. Dennis, *The Cities and Cemeteries of Etruria*, London 1848, frontispiece).

At their best the forgeries of Tanagra figurines were highly deceptive. It was only in the 1950s that Reynold Higgins condemned a standing figure of a woman (e) that had previously been regarded as an original example of considerable quality. Recent thermoluminescence testing has confirmed his judgement. At about the same time Higgins was able to reinstate a bare-headed figure of a woman (f) that had been withdrawn from exhibition as a forgery in 1934. This is now seen as one of the finest of all ancient terracottas of its period.

More flamboyant than the Tanagra figures were the Asia Minor terracottas, first called Ephesian and then Kymaean, but almost certainly made in Athens, although there were forgery workshops in Smyrna and Constantinople. Some considered them dubious from the first, and their most consistent critic, evoking resentment and abuse from collectors and scholars who had invested large sums of money and academic reputation in acquiring and publishing them, was Salomon Reinach (see also 334). These groups, mainly mythological in content, often having five or six protagonists, are wholly products of their period, well modelled but sentimental and insipid, and ancient only in their references to gods and legend. The clay is distinctive and the drapery a clumsy imitation of genuine terracottas. The example of Eros and a swan (g), is typical of the group. DMB

176a Fake: conversation piece
L 203mm
BM GR 1981. 2–10. 14. From the Salting Collection

176b Fake juglet of the Three Graces
H 196mm
BM GR 1981. 2–10. 11. From the Salting Collection

176a,g,d

176e,f

176c Genuine juglet of Eros, made in Athens, *c.* 350 BC
H 165mm
BM GR 1884. 1–26. 4 (Catalogue of Terracottas 1717)

176d Fake: Eos and Cephalos
H 198mm
BM GR 1981. 2–10. 3. From the Salting Collection

176e Fake figure of a woman
H 203mm
BM GR 1879. 3–10. 1 (Catalogue of Terracottas C258)

176f Genuine figure of a woman
H 197mm
BM GR 1889. 8–8. 4 (Catalogue of Terracottas C303)

176g Fake: Eros and a swan
H 189mm
BM GR 1981. 2–10. 23. From the Salting Collection

LITERATURE S. Reinach, *Classical Review* (1888), pp. 119–23, 153–5; R. Higgins, *Tanagra and the figurines*, London 1986, pp. 162–78

177 'Athenian decadrachm' by Christodoulos

The fake coin (a), supposedly a silver decadrachm of Athens of about 460 BC, was found by Sir George Hill, later Director of the British Museum and

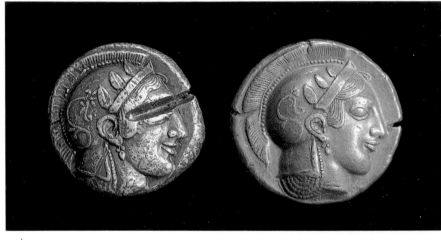

177b,a

one of the most distinguished scholars of his day. He spotted it, it is said, at a social function, nestling on the bosom of an attractive Greek lady. The Museum ultimately purchased the item in 1920, but it later transpired that it was the work of Constantine Christodoulos of Athens, whose products plague museums and collectors even today. In 1914 the Greek authorities seized a thousand dies from his workshop and the discovery that the British Museum had suffered deception came with their publication in 1922. MJP

Silver. D 36mm

177a Fake by Christodoulos
BM CM 1920. 3–18. 1

177b Genuine Athenian decadrachm
BM CM *BMC* Athens 40

LITERATURE G. F. Hill, *Numismatic Chronicle* (1921), pp. 169–71; J. N. Svoronos, *Synopsis de mille coins faux du faussaire C. Christodoulos*, Athens 1922

178 Forged manuscript of Aeschylus' *Persae* by Constantine Simonides

Constantine Simonides, a Greek monk from Mount Athos, came to England in 1853. Soon after his arrival he offered five manuscripts, four of them 'scrolls' or vellum rolls, to Sir Frederic Madden, Keeper of Manuscripts at the British Museum. Madden rejected these as modern, but did purchase other works, mostly fragmentary but all genuine, including a tenth-century chronicle (Add. MS 19390) and an important collection of geographic texts (Add. 19391). Later in the year Simonides sold to Sir Thomas Phillipps, the 'vellomaniac' baronet of Middle Hill, the Hesiod scroll that Madden had rejected, as well as other pieces, and he agreed to copy others (which were 'difficult' to read); next year he offered him an even greater treasure, a vellum roll purporting to be 2,000 years old containing the first three books of Homer's *Iliad*. Phillipps, though by now not unsceptical, bought this too.

From 1854 to 1858 Simonides was in Europe, where he produced numerous other manuscripts, including an ingeniously simulated palimpsest, an early text partially erased and written over later; in this case the later text was genuine, and the 'early' text was added by Simonides. In Leipzig he also produced his most famous text, *Uranius on the Kings of Egypt*, which, if genuine, 'would have revolutionized Egyptian chronology'. At first accepted as genuine by Dindorf and the Egyptologist Karl Lepsius, it was later rejected. Simonides was arrested and charged with forgery, but then released.

By 1858 he was back in England, and in 1860 called on the Liverpool antiquary Joseph Mayer and his friend and curator John Eliot Hodgkin, by whom he was allowed to unroll papyri acquired by him six years earlier in Egypt. They included two genuine hieratic texts relating to tomb robberies, to which were now added 'fragments of a Greek text of the Gospel of St Matthew, purporting to have been written by Nicolaus at the dictation of the Evangelist in the fifteenth year after the Ascension', and other improbably early texts. These were examined and condemned in 1863 by the Royal Society of Literature; C. W. Goodwin pointed to fragments of red blotting-paper, relics of the removal of the hieratic text for which Simonides had substituted Greek.

Meanwhile, in late 1862, Simonides published his claim to have written the *Codex Sinaiticus*, the earliest complete New Testament in Greek. According to letters between himself, another monk, Kallinikos, and the Patriarch Constantius, he had undertaken it at the request of the Tsar. As proof he produced copies of this correspondence, allegedly lithographed by himself as a student in Russia in 1853–5, including one stating that he had seen his work on a visit to Mount Sinai in 1852. In fact, the *Codex* had been discovered at the monastery of St Catherine in the Sinai Peninsula in 1844, and was presented by Tischendorf to the Tsar in 1859. It was bought from the Russian government by the British Museum in 1931.

Simonides left England in 1864 and died of leprosy in Alexandria in 1867. His last forgery, which came to light in Italy in 1871, was a vellum scroll of Aeschylus' *Persae* in uncial script; it was exposed by Friedrich Ritschl the following year and later given to the British Museum by Alfred Spranger. Simonides was not without defenders (or at least sympathisers), among them John Eliot Hodgkin, who preserved the papers, including Simonides' demonstration of how he wrote the *Codex Sinaiticus*; these were given to the British Museum in 1926. NB

BL Add. MS 41478
LITERATURE J. A. Farrer, *Literary Forgeries* (1907), pp. 42–66; A. N. L. Munby, *Phillipps Studies* IV (1956), pp. 114–31; D. Spranger, 'Alfred Spranger', *The Book Collector* 33 (1984), pp. 179–88; M. Gibson & S. Wright, *Joseph Mayer of Liverpool* (1988), pp. 53–4

Fakes of early medieval European jewellery

The familiar characterisation of the period between late classical and medieval Europe as the 'Dark Ages' is belied by its bold and multi-coloured jewellery. Collectors were attracted to it in the late nineteenth and early twentieth centuries, both by its beauty and by a growing fascination with the vigorous peoples who had worn it, the destroyers of the Roman Empire and the ancestors of modern European nations.

By the early twentieth century major collections in Europe and the USA contained fakes from this period, some of which were shown at the Burlington Fine Arts Club in the exhibition *Dark Age Art* (1930). In 1940, however, a number of 'Merovingian' pieces in such prestigious collections as that of Adolphe Stoclet of Brussels, and of J. Pierpont Morgan in New York, were publicly called fakes by W. von Stockar and H. Zeiss. The wealth of such major collectors had acted as a magnet to dealers, and cut-throat competition existed to seek out spectacular pieces. If such were not available, ordinary antiquities could be 'improved'; one such is a genuine seventh-century buckle with a modern bronze overlay depicting what was claimed to be the earliest representation of the Crucifixion (180). Some Continental scholars expressed doubts privately about its authenticity for stylistic reasons after its appearance in 1928, and it soon ceased to be quoted in the literature.

Some fakers simply copied genuine originals. An illustration of a genuine gilt-silver Merovingian bow brooch from Zweibrücken (now in the British Museum), published in 1858, was the source of a series of 'gold' fakes. The size of the reproduction was slightly smaller than the original and the fakes share a number of mistakes in the illustration, as well as a series of inherently unlikely technical features. The fakers of the ensemble of gold 'Lombardic' jewellery (182) followed a similar method. The group was dismissed out of hand by Werner in 1950 when publishing a corpus of genuine contemporary brooches. Indeed, it is such detailed studies of individual types of object that have been crucial in isolating fakes.

One of the known dealers in such fakes was László Mautner of Budapest. As early as 1912 he had handled part of the 'Moigrad Treasure' purporting to be sword fittings from a princely grave of the fifth century; I. Bóna suggests that they had been recently made in Berlin. But Mautner's main period of activity at the centre of a notorious operation in Budapest was between the World Wars, and a number of European museums including the British Museum purchased fakes from him. Nándor Fettich, one of Hungary's leading scientists, recorded Mautner's production of fakes and on several occasions attempted to institute action against him, spurred on by complaints from outraged institutions. But the police responded: 'there is no law preventing the manufacture of art objects and their falsification; if the "objet d'art" doesn't satisfy the museum, let it not buy the piece'.

In Germany, however, action was taken in 1940 against a Munich dealer in fakes, Herbert Marwitz, who was sentenced for fraud. An 'Ostrogothic' brooch in the form of an eagle which he had sold was said, when it was first published in 1937, to have been found at Königsberg in the Sudetenland. This fitted current political ideas about the area's affiliations with the Reich, but in 1940 it was condemned as a fake by von Stockar and Zeiss, causing political as well as legal and scientific controversy. In 1949 the creator of the brooch, the goldsmith Luitpold Pirzl confessed, revealing the true story behind a number of controversial pieces and the role of Marwitz in disposing of them. The fakes produced by this workshop, and the patterns devised for other pieces, covered a remarkable range, and the virtuosity in copying and adapting known finds was formidable.

The court case led to other critical studies in the early 1940s, and a number of fakes were exposed through anachronisms of stylistic detail and construction. H. Kühn analysed a Merovingian gold brooch cited in the Marwitz case and showed how elements had been combined from objects illustrated in his own book of 1935. He also made a study of faked 'eagle' brooches, aided by the recent appearance of a scientific corpus of this type of brooch, and in particular drew attention to a small group of massive cast-bronze 'Visigothic' examples, covered with gold sheet and inlaid with coloured stones or garnets (181). Some had reached American as well as European collections, and in 1941 the faker and Madrid jeweller Amable Pozo was unmasked.

Mixing a variety of general characteristics to create a 'period look' is a regular forgers' practice. The 'Merovingian' group (179), with their garnet inlays, the fish motif, the form of the buckles and rectangular mounts, and the use of a large central cabochon, all bear a resemblance to known artefacts. They have an apparently convincing provenance and history, all false. The height of such forgery is to produce an object which, although credible in terms of known genuine examples, is in itself novel; such 'original' objects were likely to be accepted and are difficult to detect, except perhaps by modern technical methods.

One group of such objects, although admittedly short-lived in scientific esteem, is the 'Lombard Treasure' (183). Consisting of more than thirty pieces and groups, it was said to have been dug up secretly over several years from an unknown

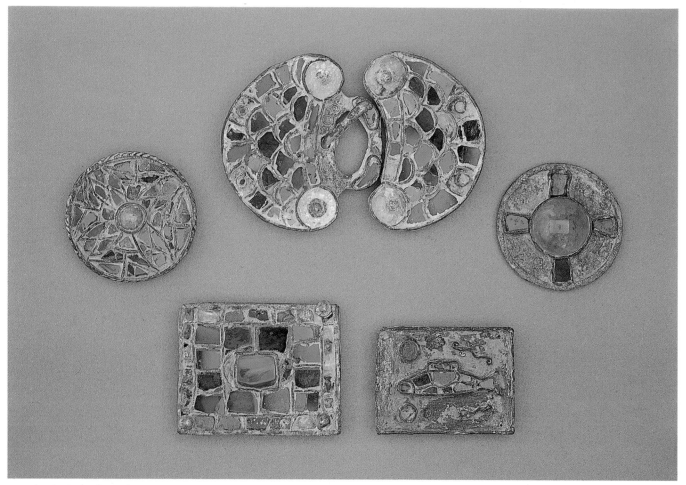

179a,b,c (*top*): d,e (*bottom*)

site in northern Italy around 1929–30; it too drew its inspiration from a variety of well-published sources. While a number of scholars expressed doubts and pointed to the well-known models adopted throughout by the faker, this imaginative assemblage was otherwise accepted uncritically and caused a public sensation. Twenty-one items were exhibited in the Burlington Fine Arts Club exhibition *Dark Age Art* in 1930, when they were confidently ascribed to the tomb of King Agilulf (d. 615). Other pieces associated with his queen, Theodelinda, were added later. Recent study of some pieces, together with analysis of the composition, tooling and inlays, suggests that many of them were made in the same workshop. By

1940 von Stockar and Zeiss had dismissed the 'Treasure' out of hand, commenting caustically on the credulity of some participants. Now the 'Lombard Treasure' can be seen as an attempt, conscious or unconscious, to give a stronger image to the first post-Roman kingdom of Italy at the time when Mussolini was rising to power, playing a similar political role to that of the Königsberg 'find' in Germany. DK

LITERATURE Burlington Fine Arts Club, *Catalogue of the Exhibition of Art in the Dark Ages in Europe c. 400–1000 AD*, privately printed, London 1930, pls 7, 35 and 36; *Lombard Treasure from Royal Tombs*, privately printed, undated; H. Kühn, *Die Vorgeschichtliche Kunst Deutschlands*, Berlin 1935, pls 444 nos 3 and 4, 445 no. 1, 462–3; W. von Stockar & H. Zeiss, 'Die gefälschte Adlerfibel von 1936', *Germania* 24 (1940), pp. 266–77; M. Almagro, 'Algunas

Falsificaciones Visigodas', *Ampurias* 3 (1941), pp. 3–14; H. Kühn, 'Die Grossen Adlerfibeln der Völkerwanderungszeit, *IPEK* vol. 13–14 for 1939–40 (1941); G. Lill, 'Die Adlerfibel von 1936 und andere Fälschungen aus einer Münchener Goldschmiedewerkstatt', *Germania* vol. 28 for 1944–50 (1951), pp. 54–62; N. Fettich, 'La Trouvaille de Tombe Princière Hunnique à Szeged-Nagyzéksós', *Archaeologica Hungarica* 32 (1953). pp. 161–9; I. Bóna, 'Ein Gepidisches Fürstengrab aus dem 6. Jahrhundert in Tiszaszőlős?', *A Veszprém Megyei Musemok Kozlemenyei* vol. 18 for 1986 (1987), pp. 95–113.

179 'Merovingian' gilt-brass jewellery with polychrome inlays

This group was said to have been found in 1913 at Ammenencour, Marne (France).

179a Disc with cloisonné garnets and emerald. D 40mm

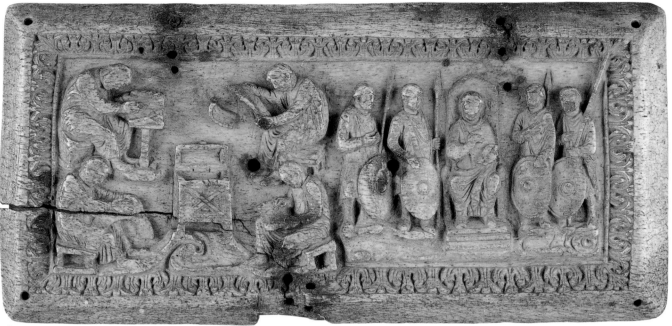

184

The enigmatic iconography is evidently based on that of a ninth-century ivory-carving in the Louvre, where the two groups of figures, arranged vertically, present a single coherent scene: King David, flanked by the royal guard, dictating his Psalms to four scribes seated directly in front of and below his throne. The date MDXV (1515), incised on the book of one of the scribes, was presumably added to bolster the tenuous association with Henry VIII or Wolsey.

Several similar casket-panels have been attributed to Metz, where ancient ivories are known to have been copied in the late 1830s. A plaster cast of the Louvre original may have furnished the immediate model: the Victoria and Albert Museum acquired just such a cast in 1855. DB

H 140; W 293mm
BM MLA 1907, 5–13, 1. Given by the National Art-Collections Fund
LITERATURE J. Romilly Allen, 'A carved bone plaque found at Reading', *The Reliquary and Illustrated Archaeologist*, n.s., 11 (1905), pp. 53–4, frontispiece; O. M. Dalton, *Catalogue of the ivory carvings of the Christian era . . . in the . . . British Museum*, London 1909, no. 50; A. Goldschmidt, *Die Elfenbeinskulpturen aus der Zeit der karolingischen und sächsischen Kaiser, VIII–XXI. Jahrhundert* I, Berlin 1914, no. 143 (no. 141 for the Louvre original)

185 The 'Constantine bowl'

Although he had previously turned it down, this bowl was successfully sold to the collector Count Tyszkiewicz by a Roman dealer who had 'discovered' in its interior a previously unsuspected representation of Christ, together with two busts identified by a Latin inscription as the Roman Emperor Constantine the Great and his second wife, Fausta.

While the bowl itself may be ancient, the engraved decoration of the interior, including the inscription purporting to date from Constantine's second marriage (AD 307–26), cannot belong to the Early Christian period. Both the beard and the cross-halo of Christ are anachronisms (probably copied from an eleventh-century Italo-Byzantine mosaic of the Last Judgement).

Other mistakes include the badly misunderstood costume, the seated pose with no provision for anything to sit on, and the bizarre termination of the figure between knee and ankle. The engraved decoration was probably executed late in the nineteenth-century, just before it was sold to Count Tyszkiewicz. DB

Earthenware. H 49mm; D 129mm
BM MLA 1901, 6–6, 1. Bought with funds provided by 'Friends of the British Museum' or 'Friends of the National Collections'
LITERATURE H. Wallis, *Egyptian ceramic art*, London 1900, pp. 27–37, pl. XII; O. M. Dalton, *Catalogue of the Early Christian antiquities . . . in the . . . British Museum*, London 1901, no. 916; J. Strzygowski, 'Die Konstantin-Schale im British Museum', *Orient oder Rom: Beiträge zur Geschichte der spätantiken und frühchristlichen Kunst* (1901), pp. 61–4; J. Wilpert, 'Die "Konstantin-Schale" des British-Museum', *Römische Quartalschrift für Archäologie und Kirchengeschichte* 21 (1907), pp. 107 16

185: drawing of engraved decoration inside bowl

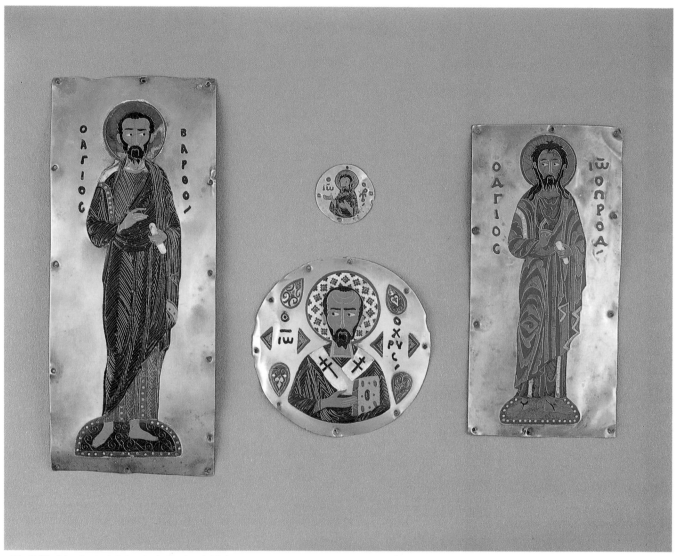

186a (*left*); d (*centre top*); b (*centre bottom*); c (*right*)

186 'Byzantine' enamels from the Botkin Collection

Large numbers of gold cloisonné enamels were acquired between 1892 and 1911 by the St Petersburg collector Mikhail Petrovich Botkin (1839–1914) and catalogued by him as tenth- to twelfth-century Byzantine. Over 150 of them have no known previous history and a suspicious 'family likeness'. None show any sign of ever having been buried and, compared with indisputably medieval Byzantine enamels, they are generally on a larger scale, with cleaner-cut designs and broader expanses of more vibrant colours.

The plaques and medallions are flatter than their slightly domed medieval counterparts, and the gold is thinner. The enamelling techniques used do not conform to standard Byzantine practice. Folds in garments are usually monotonous, generally consisting of unrelieved parallel lines, either in 'nested v-folds' or in square-ended hairpin shapes (see a). Where they do fall in curves, they often form abstract patterns with sensuous shapes redolent of Art Nouveau and *fin-de-siècle* japonaiserie (c).

It is, however, the facial features of a Botkin enamel which give it its unmistakable stamp: smooth,

exaggerated curves at temples and cheeks contrasting with fussy detailing of the hair and beard, elongated eyes with the iris in the extreme corner, and a supercilious double-downward-curving mouth.

The models for Botkin enamels were, for the most part, colour lithographs, published between 1866 and 1892. The figure of St Bartholomew (a) is modelled largely on the St Bartholomew on the reliquary of the True Cross in the cathedral treasury at Limburg an der Lahn, made in Constantinople between AD 963 and 989, although other elements may have been copied from the *Pala d'Oro* in San Marco,

Venice. The bust of St John Chrysostom (b) is taken from the St John reliquary at Limburg, perhaps with elements borrowed from the 'Chalice of the Patriarchs' in the treasury of San Marco. A figure of St John the Baptist (c) is based on representations of Sts Philip, Andrew and Peter on the Limburg reliquary, while a bust on a medallion (d) may have been modelled on the bust of the saint on a much larger gold cloisonné enamel medallion in the Zvenigorodskoi Collection. This collection, now in the Metropolitan Museum of Art, New York, was published with superb colour illustrations in 1892.

It seems likely that the Botkin enamels were made between 1892 and 1911 in St Petersburg, where the Fabergé and other workshops were active in enamelling. Analyses of Botkin enamels in Baltimore, Boston and Washington have detected colorants introduced in the nineteenth century. DB

LITERATURE [M. P. Botkin], *Collection Botkine*, St Petersburg 1911; D. Buckton, 'Bogus Byzantine enamels in Baltimore and Washington D.C.', *Journal of the Walters Art Gallery* 46 (1988), pp. 11–24 (with extensive bibliography); C. Stromberg, 'A technical study of three cloisonné enamels from the Botkin Collection', *Journal of the Walters Art Gallery* 46 (1988), pp. 25–36

186a Plaque with figure of St Bartholomew
194 × 81mm
Axia Art Consultants Ltd, London
LITERATURE *Collection Botkine*, pl. 65; sale catalogue, Sotheby's, London, *Icons, Russian pictures and works of art*, 18 December 1987, lot 306

186b Medallion with bust of St John Chrysostom
D 88mm
Axia Art Consultants Ltd, London
LITERATURE *Collection Botkine*, pl. 84; sale catalogue, Sotheby's, London, *Icons, Russian pictures and works of art*, 18 December 1987, lot 304

186c Plaque with figure of St John the Baptist ('the Forerunner')
151 × 73mm
Axia Art Consultants Ltd, London
LITERATURE *Collection Botkine*, pl. 78; sale catalogue, Sotheby Park Bernet & Co., London, *Robert von Hirsch Collection* II, 22 June 1978, lot 243

186d Medallion with bust of St John the Baptist
D 29mm
BM MLA 1989, 7–8, 1

LITERATURE *Collection Botkine*, pl. 91; sale catalogue, Sotheby's, London, *European works of art and sculpture*, 20 March 1989, lot 3

187 'Hispano-Arabic' ivory casket

The mistakes in the inscription on this casket, referring to the daughter of Abd ar-Rahman III (AD 912–61), Calif of Cordoba, suggest that it might be a nineteenth-century derivation of another similarly inscribed casket, also in the Victoria and Albert Museum. The extraordinarily accomplished quality of the carving seems, however, to set it apart from the best-known maker of such pieces, Francisco Pallás y Puig (1859–1926) of Valencia, and it is still not clear whether or not it is a later imitation. PW

Ivory with silver-gilt mounts enriched with niello. H 85mm; L 130mm; W 85mm
V&A A. 580–1910. Ex Spitzer and Salting Collections
LITERATURE J. Beckwith, *Caskets from Cordoba*, London 1960, p. 34 and figs 32–3; E. Kühnel, *Die islamischen Elfenbeinskulpturen*, Berlin 1971, cat. no. 21, pl. IX

188 Edward Emery's forgeries of medieval British coins

The publication of three editions of John Pinkerton's *Essay on Medals* in the late eighteenth and early nineteenth centuries, with its guides to the rarity and prices of classical and British coins, provided the necessary base for the growth of a widespread market for coins – and forgeries of them – in the British Isles.

Early fakes by people like Singleton (alias Dr James Edwards, fl. 1825–43) were regarded as likely to deceive only the 'unwary and inexperienced coin collector', particularly after the foundation in the late 1830s of the Numismatic Society of London (later

the Royal Numismatic Society), with its journal the *Numismatic Chronicle*, which provided a new forum for the exchange of information; the publication of Edward Hawkins's *Silver Coins of England* (1841) and John Lindsay's *Coinage of Ireland* (1839) and *Coinage of the Heptarchy* (1842) also raised the level of expertise in medieval British coins.

Each advance in the sophistication of the market produces a new advance in the sophistication of forgers. Edward Emery responded to the new climate by producing forgeries infinitely superior to Singleton's. Hand-struck from hand-engraved dies, probably by the talented medallist W. J. Taylor (1802–85), who was also involved with questionable restrikes of rare coins and medals, their production closely mimicked that of the genuine article, and they were frequently overstruck on genuine but commoner coins of a later period.

Their invention also showed a close acquaintance with the coinage and a feeling for the unmet wants of antiquarians and collectors. Emery had a nice eye for the pieces which ought to exist but did not. Coins of King Aethelbald of Wessex were not to be found, so he had dies produced imitating a coin of Aethelbald's father Aethelwulf (a) which, after a few coins had been struck, he altered so that they read Aethelbald; he then struck a few more. Forty years later this coin reappeared, becoming the subject of two learned articles in the *Numismatic Chronicle* which asserted its authenticity and an, admittedly doubtful, entry in the British Museum Catalogue before being denounced as a fake in 1905.

On other occasions Emery's historical imagination ran away with him; many would love to have found a

188a 188b 188d 188e

coin of Richard *Coeur de Lion* struck while on crusade, but it is doubtful that any were taken in for long by Emery's coin of Richard I struck at Ascalon in the Holy Land. His testoon of Francis and Mary Queen of Scots, and his medal of Lady Jane Grey as Queen of England were also too good to be true. The latter had almost as short a career as its subject, being denounced in the *Numismatic Chronicle* and its dies confiscated and defaced as early as 1842. MPJ

188a False penny of Aethelbald (*c.* 857–60)
Silver. D 20mm
BM CM *BMC* Aethelbald 1

188b Genuine penny of Aethelwulf (839–58)
Silver. D 20mm
BM CM *BMC* 76

188c 'Penny of Richard I', struck by 'Ceoric at Ascalon'
Silver. D 19mm
BM CM 1889. 2–4. 23

188d 'Testoon of Francis and Mary Queen of Scots', 1558, based on the genuine ducat of the same year
Silver. D 33mm
BM CM 1899. 2–4. 50

188e 'Medal of Lady Jane Grey', 1553
Silver. D 34mm
BM CM. Bank Coll. Eng. Med. 5

LITERATURE J. Pinkerton, *Essay on Medals*, London 1784, 1789 and 1808; H. E. Pagan, 'Mr Emery's Mint', *British Numismatic Journal* XL (1971) pp. 139–70

189 Luigi Cigoi's forgeries of medieval Italian coins

The work of Edward Emery's contemporary, Luigi Cigoi (1811–75), also demonstrates a response to the growing interest in coinage of the Middle Ages. Cigoi, a tanner of Udine in northern Italy, directed a gang of die-engravers who produced a wide range of forgeries, including ancient, Byzantine, Ostrogothic, Lombardic, Vandal, Renaissance and seventeenth-century Venetian coins. He was, however, most famous for his forgeries of medieval coins of north Italian mints, many of which were new but plausible varieties, invented by Cigoi to satisfy the collector's hunger for rarities. Cigoi's false patinas were as skilfully concocted as his bogus varieties, and he acquired a considerable reputation as a dealer and numismatist before the rejection

of a large quantity of false material which he had sold to the firm of A. Hess led to his exposure by Carlo Kunz, director of the Trieste Museum.

Though Cigoi left his collection, including many of his fakes, to the museum in Udine, they have continued to deceive; these two pieces were both included by Warwick Wroth in his British Museum Catalogue of the *Coins of the Vandals* (1911). MPJ

189a Coin of Matasuntha, wife of Witigis
Silver. D 13mm
BM CM *BMC* Matasuntha 1

189b Coin of Witigis, Ostrogothic King of Italy (AD 536–40)
Silver. D 11mm
BM CM *BMC* Witigis 7

LITERATURE L. Brunetti *Opus Monetale Cigoi* n.p. [Trieste?] 1966

Gothic ivory fakes
190–3

The rich collectors of nineteenth-century Europe sought Gothic ivories more eagerly than any class of medieval object, except perhaps illuminated manuscripts and Limoges enamels. Difficult as it is to compare monetary values, it is tempting to say that they are actually cheaper today than they were in the late nineteenth century, something that could hardly be less true of manuscripts or 'Limoges'. Surviving Gothic ivories are virtually never inscribed or dated. The religious wars and revolutions of the sixteenth to eighteenth centuries led to the breaking-up of ivory objects into single plaques, so that even a post-medieval provenance prior to the nineteenth century is extremely rare. In the nineteenth century vast quantities of elephant ivory were imported into Europe, so the material was cheaply available and the rewards for the faker were high at a time when passion for the Middle Ages was not always matched by historical and aesthetic judgement, hence the present-day collectors' anxiety.

Ivories 'in the Gothic manner' were already carved in the seventeenth and eighteenth

centuries, with no intention to deceive. With the Gothic Revival grew a new admiration for the sentimental narrative elements so easily identifiable in medieval ivories, particularly in secular ones, with their scenes of hawking, Courtly Love, battles with castles and tournaments, Wild Men, games of chess, kings and queens. The first serious Gothic ivory fakers were active by the beginning of the nineteenth century: a group by the forger responsible for 190 belonged to the Cologne collector Baron von Hüpsch, who died in 1805, and one of the same series of fakes was already acquired in 1810 for the Musée de la Ville, Lyon. In 1828 Charles X acquired the collections of the Lyon painter Pierre Révoil, formed throughout the first quarter of the nineteenth century, which already included, unbeknownst to him, several Gothic ivory fakes. By 1856, when the British Museum bought a collection of 170 ivories from William Maskell, a leading authority in his time, the sales and dealers' rooms were flooded with fakes. In fact, collectors and museum curators were with a few notable exceptions unsuspecting until the later years of the nineteenth century. Now they are perhaps too suspicious; aesthetic criteria being by definition subjective, few are prepared to trust their own judgement. Within the next decade or so the newly developed radiocarbon accelerator unit, which can date tiny samples of ivory to within ±60 years, will allow the definitive elimination of fakes from the corpus of thirteenth- to fourteenth-century ivories.

Included here are outstanding examples of the British Museum's collection of Gothic ivory fakes, each reflecting some different aspect of the taste of its time. NS

LITERATURE J. Leeuwenberg, 'Early nineteenth-century Gothic ivories', *Aachener Kunstblätter* 39 (1969), pp. 111–48 (review Danielle Gaborit-Chopin in *Bulletin Monumental* 128, 1970, pp. 127–33); J-F. Garmier, 'Le goût du moyen âge chez les

collectionneurs lyonnais du XIXe siècle', *Revue de l'Art* 47 (1980), pp. 53–64; exhibition catalogue *Le 'Gothique' retrouvé avant Viollet-le-Duc*, Hotel de Sully, Paris 1979–80, nos 218–20, 235–6

190 Ivory group of the Holy Women at the foot of the Cross

The British Museum has several examples of the work of this outstanding early forger of Gothic ivories, called by Leeuwenberg 'the Master of the Agrafe Forgeries', after the large *agrafe* (clasp) with which he decorated many of his male costumes. He based his medieval pastiches on the fourteenth-century alabaster altarpieces of northern France and the Low Countries, but he betrays his true period in his over-elaborate costumes, which sometimes fall into anachronism (e.g. here with the very tight *barbettes*, barbs of a nun's head-dress), and in his rendering of the over-sentimentalised and self-questioning faces. NS

Late 18th or early 19th century
H 121mm
BM MLA 1918, 5–4, 4. Bequeathed by the Rev. E. S. Dewick
LITERATURE Leeuwenberg, fig. 10
Illustrated in colour on p. 10

191 Openwork ivory leaf with scenes of the Infancy of Christ, the Dormition and Coronation of the Virgin

Format and iconography are based on thirteenth-century plaques of the so-called 'Soissons diptych group', but here anachronisms of detail and costume proliferate: the heads are over-characterised, and details of architecture and furniture too elaborate for the thirteenth century. Not only is this forger less accomplished than the carver of 190, but his medieval sources are chronologically earlier. Leeuwenberg called him 'the Master of the Bearded Men Forgeries'. It may be noted that the plaque has never had a function; there are no traces of hinges, and supporting strips of ivory are glued all round the back of the frame, a technique without medieval parallel. NS

First half of the 19th century
H 180mm
BM MLA 1856, 6–23, 44 (Ivory Catalogue no. 313)
LITERATURE Leeuwenberg, p. 142 and n. 78

192 Ivory head of a king

Recorded as in the collection of Sir Samuel Meyrick (1783–1848) of Goodrich Court, Herefordshire, a distinguished medievalist and collector of armour, this ivory was subsequently owned by the great Victorian architect William Burges, who gave his medieval collection, chiefly of arms and armour, to the British Museum. The head is of the highest accomplishment and was even carved with a flat upper surface for the attachment of a separate crown, as with many genuine Gothic ivories. However, as a 'portrait bust' in format, the head and neck emerging from an open collar, it betrays its neo-Gothic inspiration. It is closely based on the famous head of Edward II from his tomb of the 1330s in the choir at Gloucester. It may indeed have been carved as a Victorian image of the murdered English king, without any intention to deceive, although Burges was convinced of its medieval date when he presented it to the Museum in 1874. There are certainly no grounds for believing, as did Leeuwenberg, that this carving is by the forger who executed 190. NS

First half of the 19th century
H 59mm
BM MLA 1874, 7–25, 1 (Ivory Catalogue 249)
LITERATURE Leeuwenberg, fig. 41

193 Ivory mirror-back, with soldiers

First recorded in 1851, this ivory is like an illustrated manual of helmet design of the twelfth to seventeenth centuries (information Mr Claude Blair). Indeed, such a book is probably precisely what this antiquarian forger used. With his exotic view of medieval warfare and his fascination with the details of armour, he was catering to a well-established mid-nineteenth-century collectors' market. Even the breakages to the ivory seem to have

been contrived to create a medieval effect. NS

First half of the 19th century
D 140mm
BM MLA 1902, 4–23, 4 (Ivory Catalogue 380)
LITERATURE A. C. Kirkmann, *Journal British Archaeological Association* VI (1851), pp. 123–4; C. H. Read, *Proceedings Society of Antiquaries*, 2nd series, XIX (1902), p. 44

194 The Hope Goblet

With spectacular technical skill and artistry, the Muslim cities of Aleppo and Damascus were producing between about 1250 and 1360 enamelled and richly gilded glass, the like of which could not be made in any European centre of glassmaking, not even in Venice. The princely courts and wealthy houses of medieval Europe greatly prized them, and often had them protected and enhanced by setting them in gold or silver-gilt mounts or in ornately decorated leather cases. The close copying of these Islamic glasses, especially the mosque-lamps, was not unknown in the second half of the nineteenth century, but with extraordinary and, as yet, unparalleled audacity the faker of the Hope Goblet has used Western European religious figures (the enthroned Madonna and Child, attendant angels and standing figures of St Peter and St Paul) and a Latin pious inscription in a Gothic script, while at the same time retaining to a large extent the general form of an Islamic goblet.

Nevertheless, the base is exceptional within the context of Middle Eastern glass because it lacks the ubiquitous applied foot-rim, which gave stability to this type of tall, flaring goblet. In its present form the goblet is somewhat impractical and unsafe – and yet it is in perfect condition.

Generally known as the Hope Goblet because it first came to light in the collection of Adrian Hope (sold in 1894), it almost immediately became internationally famous, being quoted at first in books and learned articles as one of the rarest and earliest enamelled glasses from Venice – indeed, stylistically attributable to the early Gothic period and therefore pre-dating the first surviving group of

undisputed Venetian enamelled and gilded glasses by more than a century.

Other experts suggested that it was made by a Syrian craftsman, possibly working in Venice, but more probably at one of the Latin Christian courts in Crusader Palestine ('Outremer') before they fell, one by one, to the Muslim forces between 1265 and 1291. Indeed, it was proposed in 1958 that it was probably made in Syria by an Italian craftsman, perhaps a Venetian, during those turbulent decades. Either way, it was mistakenly associated with the enamelled heraldic glass beaker signed by the 'Magister Aldrevandini' (British Museum) and a small group of similar pieces (mainly excavated in Europe in a fragmentary state), which are today thought to have been made between the late thirteenth and mid-fourteenth centuries, probably in Venice.

Although there must have been an exceptionally well-informed 'mastermind' behind the glassblower who made and decorated the Hope Goblet, the authenticity of which was first questioned only in 1968, this clever fake can be faulted on almost every count. Both the metal of the glass and the palette of the enamels, especially the apple-green and the silver, provide the strongest grounds for suspecting a modern date, whilst an analysis of the decoration reveals inconsistencies in style and date which can only result from the faker's eclectic choice of sources. Furthermore, the Latin inscription † DNIA MATER REGIS ALTISSIMI ORA P PA, contains errors and incorrect letter forms and abbreviations, and is, exceptionally, executed in silver (now oxidised) on a yellowish foundation. This technique and the use of white enamel for faces and hands (with outlines in black) argue against the former attribution of the Hope Goblet, to a Syrian craftsman before 1291. Indeed, it may have been made in England in the last quarter of the nineteenth century. HT

194

H 200mm
BM MLA 1894, 8–4, 1
LITERATURE C. J. Lamm, *Oriental glass of medieval date found in Sweden . . .* , Stockholm 1941, pp. 81–2, pl. XXIII, 2; A. Gasparetto, *Il Vetro di Murano*, Venice 1958, p. 33, fig. 15; H. Tait, 'European: Middle Ages to 1862', in *Masterpieces of Glass*, London 1968, p. 152, no. 205, n. 6; H. Tait, *The Golden Age of Venetian Glass*, London 1979, p. 17; H. Tait, 'The "Hope" Glass', in the *Papers of the 'Aldrevandini Glass' Symposium of 1988*, British Museum (forthcoming)

The anarchist and forger Louis Marcy
195–8

Since the publication of a revealing article by Otto von Falke in *Belvedere* (1922), Marcy's name has been associated with the production of numerous objects ingeniously medieval or Renaissance in style. The term 'Marcy fake' is now a byword, yet there is no firm evidence of Marcy's skills as a craftsman, although examples of his accomplishment as a salesman abound.

Marcy was born on 2 April 1860 in Reggio Emilia, northern Italy, his real name being Luigi Francesco Giovanni Parmeggiani. He claimed to have been apprenticed in 1872 to a printer and later to a jeweller in Italy. In 1880 he went to France, probably Paris, visited Brussels in 1888 and moved to London, where he lived between 1888 and 1903, visiting Paris in 1892. In 1894 and 1895 Marcy sold several expensive 'medieval' items to the Victoria and Albert Museum and to the British Museum – in addition to those included here a purse mount, another casket, a crozier (V&A), and a holy water bucket (British Museum). He returned to Paris in 1903, was arrested as an anarchist on 28 June, and ultimately spent five months in prison. Contemporary newspaper accounts of his arrest throw some light on his dealing activities. The house in which he was found was so filled with 'antiquities' – worth an estimated two million francs – that he was assumed either to have stolen them or to be an international fence. One of the three women arrested with him claimed to be the widow of an antique dealer, Victor Marcy, and one of her daughters, Blanche, was Marcy's mistress and the wife of the distinguished historical and *genre* painter Ignacio de Leon y Escosura (1834–1901), a collector of antiques. On release from gaol Marcy remained in Paris, and from 1907 to 1914 edited and largely wrote an art journal *Le Connaisseur: Revue critique des arts et curiosités*, devoted in part to savage attacks upon capitalist art collectors, dealers and art forgers. He left Paris about 1918, later returning to Reggio Emilia, where he bought a house, and in 1932 successfully negotiated the sale of his collection of 'antiquities' to the Municipality, where they may be seen today (correctly attributed).

Though evidently an audacious rogue, Marcy himself was less certainly either a dedicated anarchist, or the principal in the forgery enterprise. It is not clear how the improverished young man ingratiated himself in London with museum authorities and private collectors alike, but it is inconceivable that he did not have a backer. Although proof is lacking, circumstantial evidence points to the respectable and wealthy Leon y Escosura.

Marcy's outstanding success in the English market may partly have resulted from good timing. The allegedly Spanish provenance of many of his wares must have been calculated to tickle the curiosity of anyone who had read Charles Hercules Read's report on the great historical exhibition in Madrid in 1892, where quantities of little-known and unpublished Spanish church treasures were on show. And in 1893 the British Museum had made one of its most brilliant acquisitions, the Royal Gold Cup, which had for centuries been owned by a monastery near Burgos.

Marcy pieces give the impression that they were made for rich or noble patrons – statues of the Virgin and Child, drinking horns and cups, reliquaries and purse mounts. Many are made of metal, ranging from gold to iron, cleverly patinated or covered with well-worn gilding, often enamelled and given spurious historical interest by their embellishment with accurately rendered heraldic decoration. In addition, a fondness for castellated and incomplete or damaged objects characterises most of his products. Much of Marcy's success lies with the skilled craftsmanship of his material, and the inspired eclecticism of his designs, none of them direct imitations, many clever transpositions from one material to another – ivory to metal, manuscripts to enamel. Where a source can be identified, it is often to be found in a public or private collection in Paris, or else in a book, illustrated in colour. Marcy's workshop might have found all it wanted without leaving Paris. MC

LITERATURE This information partly derives from C. Blair's introduction to the *Catalogue of medieval and Renaissance pieces in Reggio Emilia* by John Hayward, edited by Claude Blair and Marian Campbell (forthcoming 1990). Recent literature includes the exhibition catalogue *Fälschung und Forschung*, Essen 1976, pp. 51–4; C. Blair & M. Campbell, 'Le mystère de Monsieur Marcy', *Connaissance des arts* 375 (1983)

195 Marcy reliquary, in German 15th-century style

The architectural extravagance of this piece seems to be based on secular German drinking vessels produced in Nuremberg (J. M. Fritz, *Goldschmiedekunst der Gotik in Mitteleuropa*, Munich 1982, pls 344, 509, 518 etc.), and is unparalleled in a liturgical object, but closely resembles the castellated confections seen on Marcy purse mounts (Victoria and Albert Museum), drinking horns (Metropolitan Museum, and Reggio Emilia) and cups (Museo Lazaro Galdiano, Madrid). No relic is visible beneath the round piece of crystal set at the front, and details of the buildings appear unfinished. MC

Rock-crystal, mounted in silver, set with four small enamelled heraldic shields.
H 250mm
BM MLA 1896, 7–16, 2

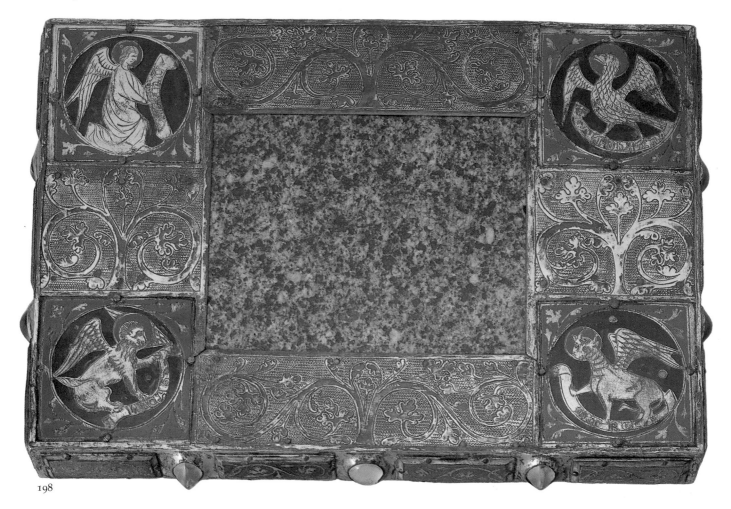

198

196 Marcy chessboard in the style of Limoges/Paris, *c.* 1330

At first glance this is one of Marcy's most convincing pieces. The motifs used include a great variety of grotesque motifs (animals, birds, fish and men) – none identical – which alternate with flower sprays of two basic designs. Close inspection shows the green patina to be paint, the daisy motifs to be over-mechanical, their five-petal regularity more reminiscent of Mary Quant than Limoges, their bright vivid blue unparalleled among medieval enamels. The 'jester-leg' supporting feet are unconvincing, and the designer has forgotten to take into account the practical need to differentiate distinctly between neighbouring squares. Medieval chessboards are exceedingly rare; this appears to be based on an example at Aschaffenburg illustrated in colour by J. von Hefner-Altenek

(*Die Kunstkaminer . . . Carl Anton von Hohenzollern-Sigunaringer* II, Munich 1866, pl. 137). The only other known Marcy chessboard, at Reggio Emilia, is larger, of much cruder manufacture and narrower range of colours (red and blue), though with similar motifs. MC

Badly wormed oak, mounted in gilt copper, set with 64 plaques of champlevé enamel.
H 55mm; L 316mm
V&A 320–1895

197 Marcy chess-players' casket, in the style of Paris, *c.* 1340

One of Marcy's most successful pieces, the casket is powdered with fleurs-de-lys clearly intended as heraldic pointers to the identity of the royal players. The swaying figure style echoes that found in the Parisian enamels on the Jeanne d'Evreux reliquary (in the Louvre, Paris) of 1339, although the scene is based on a

German manuscript illustration showing Otto von Brandenburg and his wife playing chess, which was widely reproduced in the nineteenth century; this was in the Bibliothèque Nationale, Paris, until 1888 (Essen exhibition catalogue, no. 48, no. 2). The hinges are remarkably unworn and the head finial to the hasp unconvincingly romantic. MC

Gilt copper and champlevé enamel.
H 80mm; W 210mm
V&A 432–1895

198 Marcy portable altar, in the style of Limoges, *c.* 1250–1300

Despite the plausibly worn gilding, it is disquieting to find St Luke's symbol, the ox, labelled St Mark, a mistake found also amongst the almost identical enamels decorating a silver lectern in the Reggio Emilia Museum. The over-regular motifs of the

'Limoges' side plaques, with their strangely heavy bevelled edges, closely resemble those on a *vernis brun* portable altar of similar dimensions also in Reggio Emilia. The designs for these may derive from Limoges plaques illustrated in A. Du Sommerard's *Musée de Thermes de l'Hotel de Cluny. Catalogue . . .* (1st edn, Paris 1863), with their telescoped third dimensions. Both altars are probably based on the eleventh-century portable altar now in the Musée de Cluny (ex Spitzer Collection). The style of the side enamels and engraved foliage, of about 1250, is at odds with the somewhat ambiguous drawing style of the Evangelist symbols of about 1320. MC

Marble (?), mounted in sheet copper, and set with crystals and champlevé enamel plaques. L 310mm; W 220mm
BM MLA 1896, 7–16, 1

199 'Billy and Charley's' medieval forgeries

William Smith (Billy) and Charles Eaton (Charley) were mudlarks who searched the foreshore of the Thames for valuable objects. In 1857, deciding that they could make more money by manufacturing 'finds', they started to cast a range of 'medieval' objects, mainly medallions or badges, decorated with figures, animals and garbled inscriptions, in hand-cut plaster moulds.

Taking the precaution of dating many of their products (in arabic numerals), mainly to the eleventh century, they sold them at Shadwell, where a new dock was being excavated. Through William Edwards, an antique dealer whom they had known for some time, many of their wares found their way into the shop of another antique dealer, George Eastwood.

Naturally, the sudden appearance of these peculiar objects aroused suspicion, and in April 1858, in a lecture to the British Archaeological Association, Henry Cumming condemned them as forgeries. His lecture was reported by the *Athenaeum* and sales rapidly declined. George Eastwood, however, decided to sue the *Athenaeum* for libel and at the subsequent trial secured the famous scholar Charles Roach Smith as a witness. Roach Smith considered that, even though the judge decided that Edwards had not been libelled, the trial 'proved the genuineness of the finds'. In his opinion they could not be forgeries because no forger would produce anything so preposterous and no forger could produce so wide a variety of objects. It was not until 1861 that a further article by Roach Smith on the finds, suggesting that they dated from the reign of Queen Mary and that they had been imported to replace devotional items destroyed during the Reformation, provoked

199b,a,e,c,f (*back, left to right*); d (*centre front*)

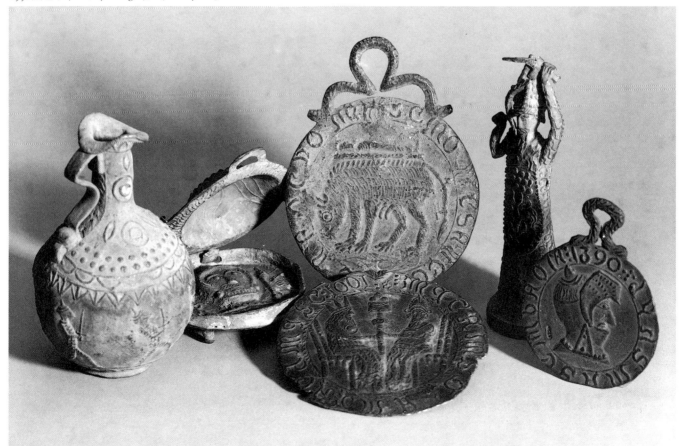

200

Charles Reed into further investigation. This culminated in the theft of some of Billy and Charley's moulds, which were then exhibited at the Society of Antiquaries.

Though their exposure restricted their market, Billy and Charley continued in business, using 'cock metal' (a lead/copper alloy) from 1863, until Charley's death in 1870. They produced several thousand pieces in all, and their work is now quite sought after. As evidence of the extent to which a vision of the Middle Ages had penetrated popular culture, as a concrete realisation of that vision and as enduring proof of the gullibility of even the greatest scholars, they are unrivalled. MPJ

199a Reliquary
Lead. D 72mm
BM MLA OA5291

199b Ampulla with running knights
Lead. H 119mm
BM MLA OA5413

199c Standing figure
Lead. H 138mm
BM MLA OA5288

199d Badge: king and bishop, dated 1001
Lead. D 99mm
BM CM 1916. 1–2. 14

199e Badge: a strange beast, dated 1030
Lead. D 94mm
BM CM M3133

199f Badge: medieval knight, dated 1390
Lead. D 66mm
BM CM 1930. 1–2. 16

LITERATURE R. Halliday, 'The Billy and Charley Forgeries', *Antique Collector* (June 1988), pp. 140–3

Illuminations and bindings

200 Glossed Gospels of the 12th century

This glossed Gospel of St Mark was probably written in southern France early in the second half of the twelfth century, to judge by the paucity of the gloss, which has left large areas of the page unwritten. At some point the manuscript passed from France to Italy; its present binding is Italian half-calf, dating from the second half of the eighteenth century. It bears the book-plates of Louis de Bourbon, King of Etruria (d. 1803), and of Cardinal Oppizoni (d. 1855).

The drawings, which add an improbable but decorative element to the pages with large blank areas, are exceedingly faithful copies from south Italian eleventh- and early twelfth-century manuscripts, notably the Monte Cassino, Benevento, Gaeta and Troia 'Exultet' Rolls, and the great Cassinese illuminated manuscript of Rabanus Maurus, *De universo*. The only occasion when these manuscripts were all together in one place was between 1873 and 1910, when a printing press was set up in the monastery of Monte Cassino, with lithographic equipment, to publish facsimiles of the major treasures of the library there, and of other related manuscripts. The other manuscripts were brought to Monte Cassino then, and the probability is that one of the lithographic draughtsmen copied them into the manuscript, presumably on the market since Cardinal Oppizoni's death.

Whether this was done with fraudulent intent is not clear. The drawings were done from the originals not the facsimiles, since several that are accurately coloured appear in the facsimiles in black and white (on the other hand, a hole at the foot of the paschal candlestick in the Exultet Roll is drawn in as a coloured detail). The book certainly returned to the market in the twentieth century, and was sold to the Swiss collector Martin Bodmer by the Libreria Olschki of Florence in the 1940s in all good faith as genuine. Later, however, it was seen by Bernhard Bischoff, who recognised the drawings as false. Bodmer returned the manuscript to Erwin Rosenthal in 1955, and it was offered for sale as a forgery by his son Bernard M. Rosenthal (Catalogue xv, 1964). The book resumed its travels, reaching the present writer, who recognised the source of the drawings, in 1972. NB

Private Collection

201a

201 The 'Spanish Forger's' 'medieval' miniatures

No details of the career of this talented and prolific artist have yet emerged and his identity remains obstinately obscure. He seems to have been active about 1900 and to have continued to work well into the present century. He may have been living in France, as many of his works were purchased in Paris. He was christened the 'Spanish Forger' in 1930, after one of his panels had been attributed to an artist active in Spain in the fifteenth century. He was responsible for a very large output of panels and of manuscript pages, many of the latter executed on genuine medieval vellum culled from dismembered Italian choirbooks: 201b is one of fifty miniatures painted on vellum taken from a single choirbook. Many of the subjects can be traced to popular illustrated books of the late nineteenth century and in particular to the publications of Paul Lacroix (a). They are presented in a romantic style derived from fifteenth-century painting and deliberately aimed at the idealised view of the Middle Ages held by the less sophisticated art lover. There is no doubt that this work was intended to deceive the would-be collector of its day. Now it commands substantial prices in its own right. Several other miniatures, including 201c, representing complex historical scenes, appear to be by a different

202b

hand, although closely related to the work of the 'Spanish Forger'. The example included here is copied from T. de Bry's *America* (1594); a map appears on the verso of the leaf. It was purchased from a London dealer, as genuine, in 1905. JB

201a The 'Spanish Forger': musicians performing before a king and queen
Miniature on vellum
BL Add. MS 54248

201b The 'Spanish Forger': an angel presenting a book to a saint
Miniature on vellum
BL Add. MS 53783

201c Columbus landing in America
Miniature on vellum
BL Add. MS 37177

LITERATURE W. Voelkle, *The Spanish Forger*, New York, 1978

202 Manuscript illuminations by C. W. Wing

Although he is now best known for the 'medieval' and 'Renaissance' illumination which he produced in quantity about the middle of the nineteenth century, Caleb Wing (d. 1875) is first recorded in 1826 as the artist of a series of lithographed local views distributed by the Royal Marine Library in Brighton. About ten years later he was living in London and painting some rather undistinguished portrait miniatures. His talent as an illuminator eventually emerged, and during the later years of his career he produced several hundred miniatures. The majority were painted for Mr John Boykett Jarman, a collector and dealer in *objets de vertu* with premises off Bond Street, whose selection of illuminated manuscripts was severely damaged by flood in the summer of 1846: water strains can still be seen on some items (c).

Originally employed to restore what could be rescued, Wing soon found himself painting new miniatures and additional decoration for insertion into genuine medieval and Renaissance books. Almost all of his miniatures were direct copies or adaptations from genuine medieval or Renaissance work, and he was adept at choosing subjects appropriate to their intended settings. The subject of The Three Living and The Three Dead (a) was copied from a similar miniature in

202c

203a

203c

another Jarman manuscript (now lost). The surrounding border is inspired by decoration elsewhere in the manuscript. A scene of the Crucifixion in an Italian Book of Hours (b) is adapted from a French manuscript (c); the borders, also by Wing, are based on the work of Attavante. The host manuscript was originally a fairly simple little book, transformed by Wing into a luxury item with a complete series of miniatures and borders.

Whether Wing's additions were deliberately intended to deceive is unclear. He was certainly quite widely known in his day as a professional facsimilist, but his work is of such a high standard that it has quite frequently been regarded as genuine during the past century. JB

202a The Three Living and the Three Dead
A miniature inserted into a Flemish Book of Hours, *c.* 1500
BL Add. MS 35319, ff. 188ᵛ–189. Ex Jarman Collection

202b The Crucifixion
A miniature inserted into an Italian Book of Hours, *c.* 1470–80
University College London, MS Lat. 25

202c The Crucifixion
A miniature in a French Book of Hours, *c.* 1520, which provided the model for 202b
BL. Add. MS 35214, ff. 48ᵛ–49

LITERATURE J. Backhouse, 'A Victorian Connoisseur and his Manuscripts: the Tale of Mr Jarman and Mr Wing,' *British Museum Quarterly* XXXII (1967–8), pp. 76–92; H. Leathlean, 'Henry Noel Humphreys and the Getting-up of Books in the Mid-nineteenth century', *Book Collector* 38, no. 2 (1989)

203 Fakes of Renaissance book-bindings

During the 1870s and 1880s a thriving enterprise of faking bindings, masterminded by Guiseppe Monte and executed by Vittorio Villa, was conducted first in Bologna and then in Milan. They specialised in converting genuine but plain or blind-tooled

sixteenth-century bindings into elaborate pedigree examples: 203a was ostensibly made in Rome for the collector Giovanni Battista Grimaldi; 203b is a genuine example of a Grimaldi binding.

A contemporary of Villa's, Hagué, was a competent binder and restorer who worked in London, Paris and Brussels during the second half of the nineteenth century. In later life he, like Villa, specialised in imitations of sixteenth-century bindings, usually bearing the ownership mark of distinguished collectors (c). MF

203a Late 19th-century binding by Vittorio Villa
M. T. Cicero, *Epistolae*, Venice 1544; bound in olive-brown goatskin, tooled in blind and gold. 320 × 217 × 33mm
BL C. 108. eee. 9

203b 16th-century Roman binding by Marcantonio Guillery for G. B. Grimaldi
Luigi Pulci, *Morgante Maggiore*, Venice 1545; bound in red-brown goatskin, tooled in gold and blind. 225 × 160 × 22mm
BL G. 10835

203c A binding made by Hagué in the 1880s J. Mazzochius, *Epigrammata antiquae urbis*, Rome 1521; bound in brown calf, tooled in gold and decorated with gold, silver and coloured paint, with the arms of Cardinal Granvelle in the centre. 298 × 200 × 34mm BL C. 48. h. 10

LITERATURE For the most recent book on Grimaldi's bindings see A. R. A. Hobson, *Apollo and Pegasus*, Amsterdam 1975; for binding forgeries see H. M. Nixon, 'Binding Forgeries', VIth International congress of Bibliophiles, Vienna 1971

204 A pair of 'tavolette' book covers by I. F. Joni

Icilio Federico Joni, a Sienese painter, gilder and restorer, manufactured during the last two decades of the nineteenth century a number of imitations of the *tavolette di Biccherna*, wooden covers used for the Sienese tax accounts which were produced from the mid-thirteenth century until the end of the seventeenth century. Joni, who had read a pamphlet on the *tavolette*, but who never went to the Archivio di Stato to see the originals, was far from reticent about his activities, which he described in his autobiography (1936).

The gilt and painted wooden covers here purport to be those of the accounts of the Gabella for 1456. MF

384 × 630mm
BL [no press mark]
LITERATURE I. F. Joni, *Affairs of a Painter*, London 1936; M. M. Foot, 'English and Foreign Book bindings', 31 and 35, *The Book Collector* (1984), pp. 486–7; (1985), pp. 488–9

Reviving the Italian Renaissance

205 Triptych attributed to I. F. Joni, *Madonna and Child with Saints*

The image is in the style of a Sienese Quattrocento painting, but x-radiography exposes the work as modern, and a detailed comparative examination of the decorative punch marks in the gilding, using a technique recently developed by M. Frinta, convincingly suggest that it is the work of Joni.

The x-ray shows that the panel on which it is painted was worm-eaten

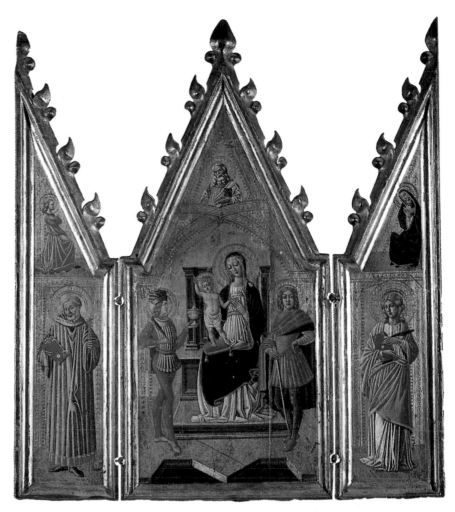

205

205: detail of x-ray

before the ground was applied, as it fills the exposed channels, appearing as a denser white. The nails that can be seen attaching the ornate moulding to the edges of the shaped panels are of modern manufacture and yet are encased within the continuous unbroken surface of the painting, precluding their presence as part of a repair or a later addition. The hinges, however, being part of the external and visible structure, are much older. RBG

Oil and tempera on panel
600 × 500mm
Courtauld Institute of Art, University of London
LITERATURE M. Davies, *The Earlier Italian Schools*, London 1961

206 Federigo da Montefeltro (1422–82) with two of his children

It is characteristic of certain kinds of fake that they 'go off' quite rapidly. The 1986 edition of the National Gallery's illustrated general catalogue states baldly 'this picture is evidently not old', yet it was acquired as a Renaissance painting from Mr J. Hanson Walker Jr in December 1923 and published as School of Melozzo in the 1929 catalogue of the Gallery's paintings.

From the beginning, though, there were suspicions that there was something not quite right about the picture. Sir Charles Holmes wrote, in the *Burlington Magazine* (XLIV, 1924, p. 195).

It has no pedigree, and as it is somewhat unusual it deserves to be described carefully, if only for the benefit of the gentlemen whose motto is *omne ignotum pro falsifico*. It is painted in tempera of an almost flinty substance, covered with a curiously hard brown varnish . . . the ground is a very solid coat of gesso laid upon an ancient worm-eaten panel . . . long ago the panel had split vertically, and the two halves are kept in their place by an old morticed batten . . . worm holes . . . had penetrated the gesso and paint in more than a dozen places, and had to be stopped before the picture was exhibited.
The quality of the workmanship was fine, yet gave no clue at first sight to the origin or authorship of the panel.

In all a classic description of a fake of the period – oven-baked to produce a

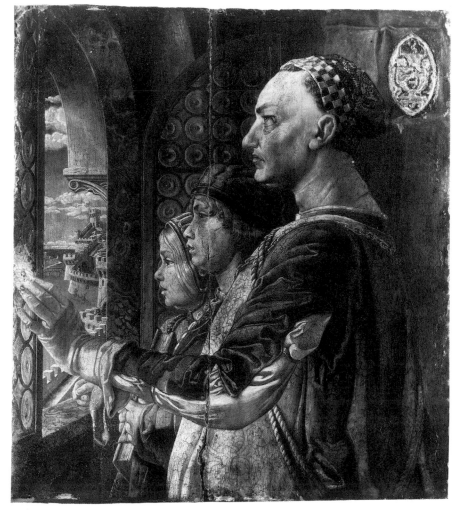

206

flint-hard surface, painted on already worm-eaten panel, and with 'worm holes' drilled through the paint. It was probably painted less than ten years before its purchase, and Martin Davies in his 1961 catalogue records the suggestion that it is by I. Joni. The last statement, however, remains puzzling. It would be difficult now to find admirers for this painting yet it is neither the case that we are more skilled than Sir Charles Holmes and his contemporaries at judging quality of workmanship, nor that such judgements are essentially subjective. What then has changed in the interim? MPJ

Tempera on panel. 406 × 365mm
National Gallery, 3831

207 'Francesco Francia', *The Virgin and Child with an Angel*

Acquired as a work by Francia (*c.* 1450–1517/18) from the Spitöver-Haas Collection in Rome by Ludwig Mond in 1893, this picture retained its attribution until 1955, when a scientific examination revealed that it was probably nineteenth century.

It appears to be a variant of an altarpiece painted for the church of the Misericordia, Bologna. Like the altarpiece, it bore an inscription, now almost completely effaced, reading OPVS FRANCIAE AVR(EFIC)IS/ (M)CCCCLXXXX. The 1955 examination revealed that although the panel is painted right up to the edges it is not likely to have been cut and that the 'cracks' on that part of the Virgin's

207

forehead that is covered by her veil were painted in.

Whether a copy or a fake, it was painted by someone who was relatively familiar with the techniques and pigments used in genuine fifteenth-century Italian paintings and is a good example of the kind of work which was in demand and would pass as genuine in the late nineteenth century. It shows none of the deliberate damage which is a feature of early twentieth-century fakes like 7.

Panel. 585 × 445mm
National Gallery, 3927. Mond Bequest, 1924

208a

208 Fakes of Italian Renaissance sculpture by Bastianini and others

From the middle of the nineteenth century onwards the rising prices for Italian Renaissance sculpture and the ready availability of skilled and talented sculptors trained in the imitation (and often the restoration as well) of original works of the period provided fertile ground for forgery.

The identity of such sculptors, their working methods and the way in which their productions reached the market has, naturally, remained largely obscure. The chance nature of the discovery of the little that is known is illustrated by the extraordinary circumstances which led to the unmasking of the Florentine faker Giovanni Bastianini (1830–68).

In his early years Bastianini, who worked mainly for the Florentine dealer Giovanni Freppa, was content to produce close copies of the work of admired Renaissance sculptors. In the low relief here (a), which must date for the mid-1850s, the Virgin is based on a stucco copy of a lost relief by Antonio Rosselino, while the Child derives from a fragment attributed to Desiderio da Settignano. It was to the former that it was attributed in the first catalogue of the sculpture in the Victoria and Albert Museum (1862).

In the early 1860s, however, Bastianini became more adventurous. He produced a bust of Savonarola, which was coloured and aged by the sculptor Gaiarini before being placed in a villa belonging to the Inghirami

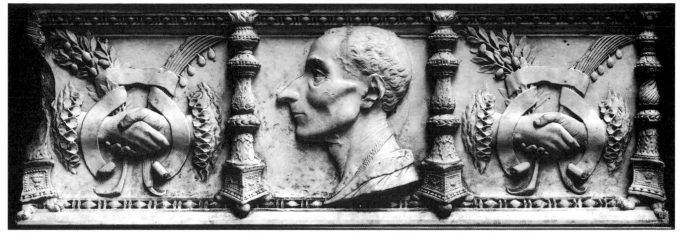

208b

family near Fiesole. There it was discovered by the great Florentine picture dealer Capponi, who bought it for 650 lire and put in on display in his shop. The sensation caused by its appearance was such that shortly afterwards two well-known patriotic artists, Giovanni Costa and Cristiano Banti, bought it for 10,000 lire to prevent its export and placed it on public exhibition.

Much encouraged by this, Freppa commissioned a bust of the poet Girolamo Benivieni from Bastianini for 350 francs (at the time 1 franc = 1 lira). Shortly afterwards he sold it to M. de Nolivos for 700 francs and when it was exhibited in Paris the following year (1865) it was highly praised as a work of the school of Verrocchio. The Louvre then bought the bust at auction for 13,600 francs. It was this that made Bastianini famous. Far from keeping their part in the affair secret, Bastianini and Freppa first rejoiced in the bust's success with their fellow artists and dealers and then, irked by de Nolivos' failure to share the profits and by his refusal to believe that Bastianini had the talent to produce such a work, set out to prove that the Louvre had been taken in. As so often in the history of art forgery, it required laborious efforts on the part of the forger himself to prove that his work was really his own.

Contemporaries were generous to Bastianini. Giovanni Costa, when told that his Savonarola was a fake, expressed himself pleased that so

distinguished an artist was alive, not dead. Alessandro Foresi regarded his Lucrezia Donati (see 6), for which he paid 1,500 francs, as a true masterpiece, and the Victoria and Albert Museum was content to buy it, as a Bastianini, for a price equivalent to that commanded by genuine Renaissance pieces. With time Bastianini's reputation has declined; Pope-Hennessy describes him as 'diligent and uninspired', but the deceptiveness of his work is beyond question. Recently, for example, it has been suggested that the terracotta bust of a lady (V&A A.9–1916), which when acquired was thought to be Bastianini's copy of a bust by Desiderio da Settignano in the Louvre, is really his model for that work.

Of Bastianini's fellow forgers less is known. It has recently emerged, however, that the marble frieze (b), which was still rather doubtfully classed as by Matteo Civitale in the 1960s, is in fact by the sculptor Vincenzo Consani (1815–77), from whom it was acquired by the Victoria and Albert Museum for £33. 6s. 3d. in 1859.

More interesting is the second low relief of the Virgin and Child (c). Acquired by the Victoria and Albert Museum from the Gigli-Campana Collection for £80 in 1861 as a Donatello or Desiderio da Settignano, it was for many years one of the most popular Renaissance works on display in London; many more plaster casts of it were sold than of any other piece in

the Victoria and Albert Museum. For a whole generation it must have represented the first contact with the serene beauty of early Renaissance low-relief carving. At the turn of the century, however, W. von Bode (see 335) demonstrated that it was a fake, and Sir John Pope-Hennessy has suggested that it is to be attributed to the Florentine sculptor Odoardo Fantacchiotti (1809–77).

Such pieces can now be appreciated in their own right as works of art which even so severe a critic as Pope-Hennessy agrees may be 'extremely pretty' (Lucrezia Donati, 6). As a historical phenomenon their significance is twofold. With their sometimes slightly saccharine and sentimental reworking of their Renaissance models, they have falsified generations of art historians' and art lovers' perceptions of the art from which they are derived. However, it was precisely this quality that made them so accessible and popular in the nineteenth century. The forgeries were in part responsible for the growth in appreciation of the real thing. Kenneth Clark recalled:

I was taught drawing at school in a dismal room that contained about a dozen casts, which I was required to draw in pencil. As I drew them every week for four years I got to know them fairly well. Four of them were by Bastianini, one was the British Museum Caesar [148] . . . and one was the bust of a female saint which . . . is undoubtedly nineteenth century. There was not a single cast of an authentic work by Mino da Fiesole,

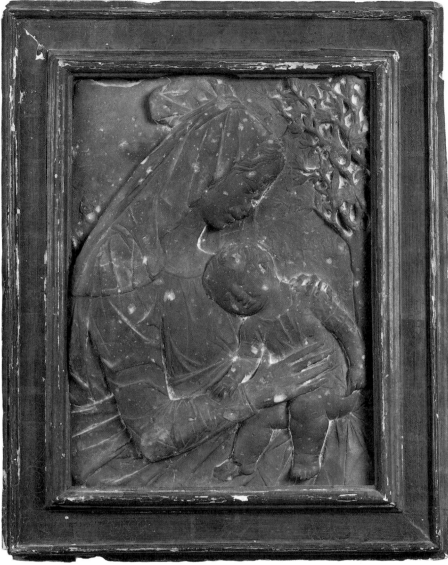

209

Rosselino, still less Donatello, simply because they would all have contained an element of style that would have upset my drawing master. The same, I am sure, was true of art schools all over the country.

MPJ

208a Bastianini: relief of the Virgin and Child, *c.* 1855
Marble. 673 × 448mm
V&A 4233–1857 (Cat. no. 728)

208b Consani: marble frieze
378 × 1076mm
V&A 5899–1859 (Cat. no. 288)

208c Attributed to Fantacchiotti: relief of the Virgin and Child
Grey sandstone. 611 × 378mm
V&A 7582–1861 (Cat. no. 2740)

LITERATURE K. Clark, 'Forgeries', *History Today* (November 1979), pp. 724–33; J. Pope-Hennessy, *The Study and Criticism of Italian Sculpture*, New York 1980

209 Alceo Dossena, relief of the Virgin and Child

One of the most famous forgers of sculpture in the twentieth century, Alceo Dossena (1878–1937) was also one of the most versatile. His numerous successes included a Madonna and Child attributed to Giovanni Pisano and a 'classical' Athena, both bought by the Cleveland Museum, an Annunciation attributed to Simone Martini and bought by Helen Clay Frick for $225,000, and a

tomb attributed to Mino da Fiesole, bought by the Boston Museum of Fine Arts.

When Dossena discovered that for this last piece the dealer Romano Palesi had received 5,975,000 lire, while he personally had been paid 25,000, he laid a complaint before a magistrate. The trial that followed in 1928, and the numerous publications about Dossena that have appeared since, have thrown light on much of his production, but his skill at faking the patina normally imparted to marble by great age was remarkable and a number of his works may still be misattributed.

Briefly famous after his exposure, Dossena saw his work, exhibited under his own name in Naples and Berlin, savaged by the critics. This example, acquired from the exhibition in Berlin, shows why. Removed from dependence on the dealers who set him his subjects and exercised strict quality control, his work had markedly deteriorated. Of interest though is the deliberately inflicted damage, a hallmark of the faker's trade, which Dossena must absentmindedly (or drunkenly) have inflicted on his work before remembering that this example was to reach the world as his own. MPJ

Terracotta. 502 × 375mm
V&A A.92–1930
LITERATURE D. Sox, *Unmasking the Forger: The Dossena Deception*, London 1987

Unfortunately, for conservation reasons it has not been possible to include this item in the exhibition

210 Italian 'Renaissance' maiolica

From the 1830s onwards Italian Renaissance maiolica became increasingly popular with collectors, and prices rose sharply throughout the century, creating a market for fakes. At the same time the spirit of Risorgimento nationalism in Italy brought with it a desire to recreate the glories of Renaissance art. Well into the present century the creation of original maiolica in Renaissance style coexisted with the production of deceptive forgeries, and these two strands are sometimes hard to disentangle.

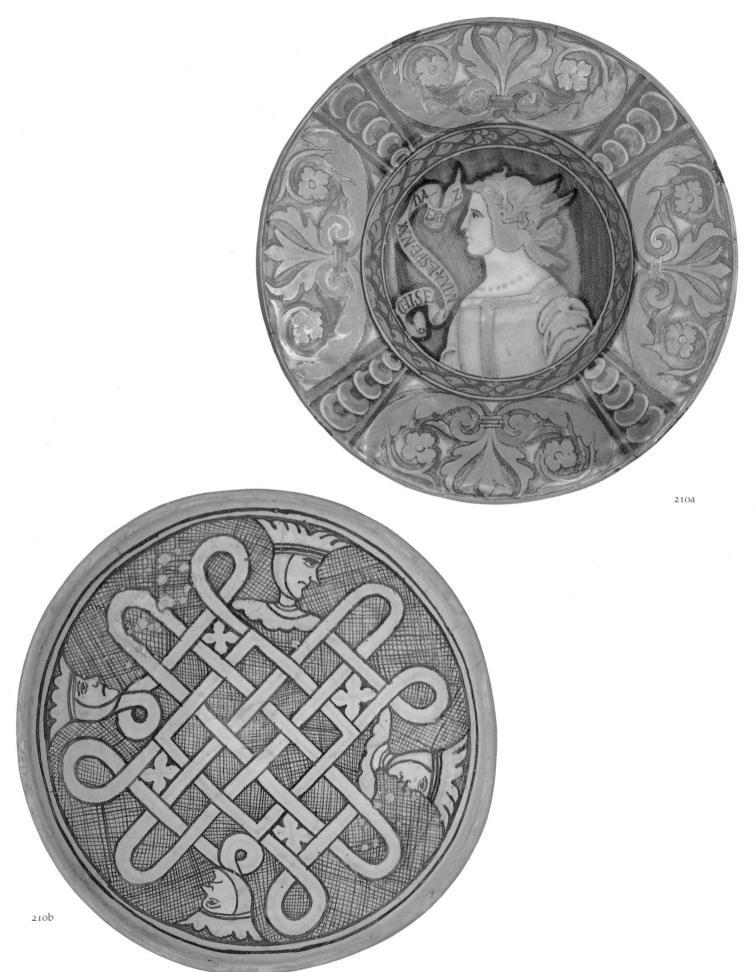

210a

210b

The first of these pieces (a) is decorated with golden and reddish metallic lustre, a technique which was rediscovered in Italy in the 1850s. It is in the style of Deruta lustreware of the early sixteenth century and was probably made in Gubbio or at Gualdo Tadino around 1870.

A bowl (b) acquired by the British Museum in 1913 as an example of medieval maiolica from excavations in Orvieto, north of Rome, is considerably more convincing. A similar piece formerly in Berlin, destroyed in the Second World War, may have been the original from which it was copied or another fake.

Most impressive as a work of art is the plaque (c) by Ferruccio Mengaroni of Pesaro, the most talented of all maiolica painters in the Renaissance Revival style, decorated with scenes from a Venetian *Biblia Pauperum*. Bought for the Victoria and Albert Museum in 1926 at the request of

Bernard Rackham, then Keeper of Ceramics, as an outstanding Faenza object of about 1500, it was revealed as a work of Mengaroni by Gaetano Ballardini of the Museo delle Ceramiche in Faenza two years later. TW

LITERATURE T. H. Wilson, *Ceramic Art of the Italian Renaissance*, London 1987, pp. 175–8, with further references

210a Dish
D 235mm
BM MLA OA9180. Given between 1874 and 1880 by Major K. Henderson as 'modern maiolica for comparison'

210b Bowl
D 335mm
BM MLA 1913, 11–17, 1

210c Ferruccio Mengaroni: plaque
173 × 238mm
V&A C.84–1926. Given by Henry Oppenheimer through the National Art-Collections Fund; previously owned by Bernardo Astorri, Bologna

LITERATURE S. Petri, 'Le fasi delle ceramica faentina in una preziosa raccolta', *Bollettino dell'antiquario* I, no. 2 (April 1920), pp. 7–8;

B. Rackham, 'Recent accessions to the maiolica at South Kensington', *Burlington Magazine* 50 (1927), pp. 258–60; Luigi Serra, 'In memoriam Ferruccio Mengaroni', *Emporium* 61 (1925), pp. 309–10; Gaetano Ballardini, *Maestro Ferruccio Mengaroni*, Collana di studi d'arte ceramica 5, Faenza 1929

Reinhold Vasters and his 'Renaissance' fakes
211–13

The survival – and recent rediscovery in the Victoria and Albert Museum's Print Room in the mid-1970s – of more than a thousand working drawings from the workshop of the Aachen goldsmith Reinhold Vasters (1827–1909) has firmly established this craftsman as one of the more prolific and prosperous perpetrators of gold (or gold-mounted) fakes in the

211c

Renaissance style. Vasters entered his mark as a goldsmith in Aachen at the age of twenty-six, and in the same year, 1853, was appointed, despite his lack of experience, 'restorer' of the great historic treasury of the cathedral of Aachen by Canon Bock. Nothing has yet been discovered about his education or the workshop in which he had been trained, but his lucrative career as a faker seems directly linked with the activities in Aachen and Paris of Frédéric Spitzer (1815–90), a Viennese antiquarian and dealer who settled in Paris in 1852 and whose collection, containing many fakes by Vasters, was dispersed by auction in 1893. Vasters's drawings were sold in 1909 and presented to the Victoria and Albert Museum in 1919, but they had already been sent there in 1912 by the celebrated London dealer Murray Marks for an opinion. Edward Strange, Keeper of the Department of Engraving, Illustration and Design, reported that they were 'designs for goldsmiths' work, many pieces of which, I understand, have been placed on the market as old work'. The drawings included designs for the rock-crystal cup and cover (211) and pendant jewels (212, 213) included here. HT

LITERATURE C. Truman, 'Reinhold Vasters – "the last of the goldsmiths"?', *The Connoisseur* 200 (March 1979), pp. 151–61; Y. Hackenbroch, 'Reinhold Vasters, Goldsmith', *Metropolitan Museum Journal* 19/20 (1986), pp. 163–268

211 Rock-crystal cup and cover

During the period from about 1865 to 1885 Reinhold Vasters was responsible for many highly ambitious pseudo-Renaissance rock-crystals set in enamelled gold and gem-studded mounts. His drawings for this tall, elegant, covered cup (a), which had already been removed from public display in 1964 as spurious (purely on the grounds of style), show a clear division into two separate areas of work. Firstly, there is the design of the rock-crystal components (cover, bowl, stem and foot), *without* any mounts

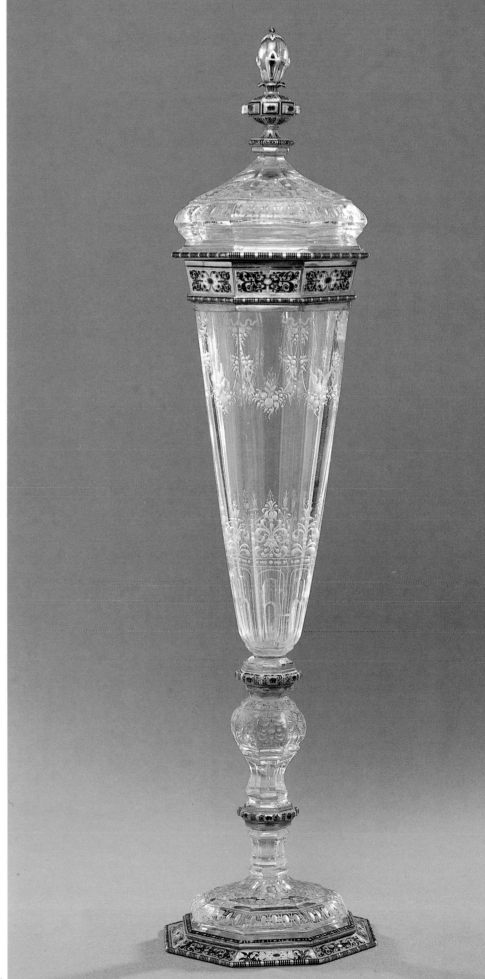

211a

but with such precise indications of the faceting, moulding and wheel-engraved ornament on each section that an engraver-cutter would have had no difficulty in working from it (b). Secondly, there are six coloured designs covering in minute detail every aspect of the gold mounts, the coloured enamel decoration and the gold settings for the table-cut emeralds and for the cabochon sapphire surmounting the finial (c–j).

Curiously, the sheet of ten detailed drawings of the gold finial mounts (c) bears the scribbled heading *Cristalchampagnerglas*. The other annotations are also in German and mainly refer to the enamelling. Indeed, one of them is of unique importance because it proves that these drawings are not just faithful recordings of existing (old) finished objects; it reads (in translation): 'This gold surface is very thin but I think I can enamel this design into it'. This piece was catalogued by Spitzer as 'Italian, 16th century', but by 1953 it had been reattributed to 'Milan or Prague, about 1600'. HT

211a Cup and cover
H 400mm
BM MLA 1953, 2–1, 4. Gift of Lord Lee of Fareham, 1953

211b Design for the rock-crystal elements
Black ink. 358 × 110mm
V&A E.2688–1919

211c Detailed drawings of the gold finial and stem mounts
Bodycolours with gold and white; pencil under-drawing. 121 × 180mm
V&A E.3441–1919

211d Technical drawings of the cover's gold rim mounts
V&A E.3444–1919

211e–g Technical drawing of the bowl's rim mounts and 2 detailed drawings of the alternating panels of enamelled ornament
V&A E.3439–1919, E. 3442/3–1919

211h–j Technical drawing of the foot's gold rim mounts and 2 detailed drawings of the alternating panels of enamelled ornament
V&A E.3446–1919

LITERATURE *La Collection Spitzer* v, Paris 1892, p. 16, no. 12, with ill.; A. B. Tonnochy, 'The Lee of Fareham Gift', *The British Museum Quarterly* XVIII, 3 (1953), pp. 88–90, pl. XXIV; C. Truman, 'Reinhold Vasters – "the last of the goldsmiths"?', *The Connoisseur* 200 (March 1979), p. 158, figs 1–4; H. Tait, *Proceedings of the Silver Society 1982* III, 3 (1982), p. 63, figs 1–3

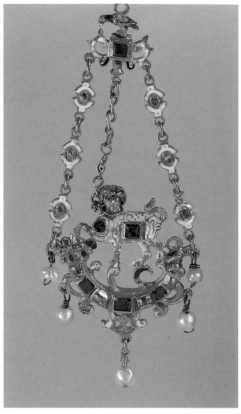

212a

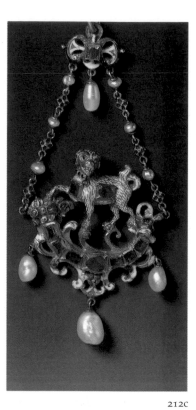

212c

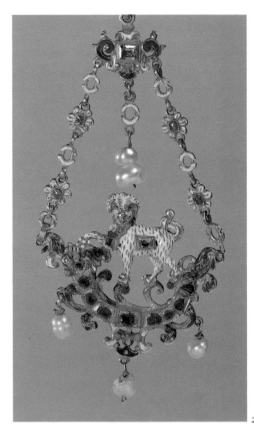

212b

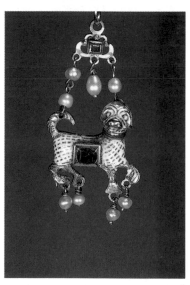

212d

212 The 'dog on cornucopia' jewels

The difficulties of interpreting the evidence of the Vasters drawings is exemplified by the coloured drawing of the 'dog on cornucopia' pendant jewel (e). A number of gold pendants of this general design have survived, of which four are included here (a–d). Are they all fakes produced by Reinhold Vasters in the mid-1860s, or are any of them of sixteenth-century origin? One of them (c) originally belonged to Frédéric Spitzer (lot 1842 in the 1893 sale), subsequently entered the collection of Lord Astor of Hever (sold in 1979), and was lent as a Vasters fake to the 1980 exhibition *Princely Magnificence* by the present owner. A second version in the Spitzer Collection sale in 1893 (lot 1843) has not yet been located, but another similarly spurious example in a private collection is included (d). Although the latter piece was designed without the cornucopia and with the dog facing in the opposite direction, the

212e

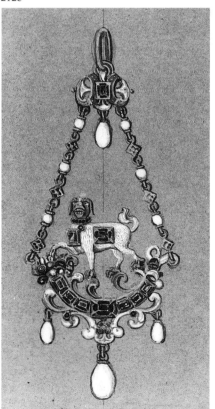

3.

212f

212g

jewel is closely related to the group, and it may be a slightly later variant from Vasters's workshop, dated about 1875–85.

The earliest record of any of these jewels is 1857, when an example in Lord Londesborough's Collection was published (f) and was stated to have been 'obtained in Spain'. This is doubly significant: firstly, Vasters only registered his mark as a goldsmith at Aachen in 1853 and is not thought to have begun faking for Spitzer as early as the mid-1850s; and secondly, a 'dog on cornucopia' jewel was designed in 1603 by a Spanish apprentice, Gabriel Ramon, and his design is preserved in the Barcelona *Llibres de Passanties* (g). Could the Londesborough example (location unknown) be a genuine Spanish pendant of about 1600, or were jewels of this type being copied by modern goldsmiths before 1857?

Three other examples of this jewel were believed to have a Spanish provenance, because they appeared in the 1870 sale of the jewels given to the shrine of Our Lady of the Pillar at Saragossa cathedral in Spain. However, the sale had been entrusted to a leading Madrid dealer, José Miro, who produced a muddle-headed and uninformative catalogue. The auction of 532 lots extended over a period of a fortnight. Two of the three 'dog on cornucopia' pendants were purchased at the sale by the Victoria and Albert Museum (a,b). They are remarkably similar, but in 1980 only 212a was included as genuine in the *Princely Magnificence* exhibition, attributed to Spain and dated about 1603. The other (b) had had doubts cast on it in 1979 by C. Truman and is, perhaps significantly, described as having *diamonds*, rubies and an emerald whereas 212a is 'set with spinels, *crystals* and an emerald'.

Unfortunately, the Saragossa shrine provenance of 1870 offers no guarantee of authenticity for any of the jewels of Our Lady of the Pillar since recent donors could have given (in good faith) jewels that were modern pastiches. A physical comparison of the Londesborough example and of the Saragossa examples might help to determine if any 'dog on cornucopia' jewels are older than the nineteenth century. HT

212a Pendant jewel
Enamelled gold, set with spinels, crystals, and one emerald, and hung with small pearls. H 102mm
V&A 334–1870. Purchased at the 1870 Saragossa shrine auction sale

212b Pendant jewel
Enamelled gold, set with rubies, table-cut diamonds and one emerald, all hung with small pearls. H 102mm
V&A 336–1870. Purchased at the 1870 Saragossa shrine auction sale

212c Pendant jewel, made by Reinhold Vasters, c. 1865
Enamelled gold, set with table-cut rubies and emeralds, all hung with small pearls and suspended by two chains of tiny pearls. H 83mm
Ulf Breede, Munich. Ex Spitzer and Lord Astor of Hever Collections

212d Pendant jewel
Enamelled gold, gemset, suspended by two chains of small pearls; the dog's paws terminate in gold loops hung with small pearls. H 53cm
Private Collection

212e Vasters's design for a pendant jewel and two alternative 'cartouches'.
Bodycolour with gold and white; pencil under-drawing. 100mm × 99mm
V&A E.2843–1919

212f Coloured illustration of the Londesborough enamelled gold jewel, set with six emeralds and a ruby
From F. W. Fairholt, *Miscellanea Graphica*, London 1857, pl. v. 3

212g Photograph of a signed and dated design, brown ink, submitted by Gabriel Ramon in 1603 and preserved in the *Llibres de Passanties* (f. 362).
Barcelona, Instituto Municipal de Historia de la Ciudad.

LITERATURE C. Oman, 'The Jewels of Our Lady of the Pillar at Saragossa', *Apollo* (June 1967), pp. 400–6, pl. II; P. E. Muller, *Jewels in Spain 1500–1800*, New York 1972, p. 96, figs 152–4; C. Truman, 'Reinhold Vasters – "the last of the goldsmiths"?', *The Connoisseur* 200 (March 1979), p. 158, pl. G; exhibition catalogue, *Princely Magnificence*, London 1980, nos 109, H23, and HG7; S. Bury, *Jewellery Gallery Summary Catalogue*, Victoria and Albert Museum, London 1982, p. 154, nos 15 and 17; H. Tait, *Catalogue of The Waddesdon Bequest*, I: *The Jewels*, London 1986, pp. 136–8, fig. 126

213 Pendant jewel of 'Charity'

This gold pendant jewel (a) is undoubtedly one of Vasters's 'Renaissance' deceptions. It was purchased after the sale of the Spitzer Collection in 1893 by Sir George Salting as a genuine sixteenth-century jewel. However, when the Vasters drawings were rediscovered it was realised that at least four of the designs related to this jewel: a view of the front as it is today (b); an alternative front view in which the Charity group has been replaced by a cross of diamonds flanked by St John and Mary (c); a view of the reverse corresponding exactly with the present jewel (d); and, finally, a drawing of the figures of Charity,

Faith and Prudence on the pendant jewel (e). Indeed, because this separate drawing of the three figures had been done, Vasters only drew them in outline in the general front view, not because the figure group was of sixteenth-century origin (as was proposed in 1979). The entire jewel is of one date, about 1870–80, and the figures and gemstones are fastened to the backplate by square nuts. HT

213a 'Charity' jewel
Enamelled gold, set with table-cut rubies and diamonds H 71mm
V&A M. 534–1910. Salting Bequest

213b–e Four designs for 213a
Bodycolours with gold and white; pencil under-drawing

b Front view. 70mm × 40mm
V&A E. 2841–1919

c Alternative front view. 70mm × 40mm
V&A E. 2842–1919

d Reverse. 112 × 75mm
V&A E.2813–1919

e Detail of figures on pendant. 25mm × 70mm
V&A E. 3278–1919

LITERATURE Sale catalogue, *Catalogue of the Collection Spitzer*, Paris, 17 April–16 June 1893, lot 1813; C. Truman, 'Reinhold Vasters – "the last of the goldsmiths"?', *The Connoisseur* 200 (March 1979), p. 158, fig. 10. col. pl. F–G; C. Truman, in *Princely Magnificence*, exhibition catalogue, Victoria and Albert Museum, London 1980, p. 137, no. H 17, ill (p. 44); Y. Hackenbroch, 'Reinhold Vasters, Goldsmith', *Metropolitan Museum Journal* 19/20 (1986), p. 182, figs 30–1

'Renaissance' armour 214–15

Embossed and decorated Renaissance armour in good condition is extremely rare. Much appreciated in the late nineteenth century by collectors like David M. Currie, from whose bequest both of these pieces come, it fetched very high prices.

The breastplate (214), which was accepted as a genuine piece of high quality by many authorities, was illustrated in J. Starkie Gardner's standard work *Foreign Armour in England* (1898), where it was described as 'French sixteenth-

century'. In fact, both breastplate and morion (215) more closely resemble the work produced by the famous Picinino family for princely families in late sixteenth-century Milan. However, the stretching of the metal, which has produced various cracks, the uneven quality of the embossing, the poor quality of the gilding on the breastplate, and the unworn state of even the areas in highest relief on the morion, and artificial darkening of the surface of the metal on the morion by acid all tend to reveal these works as fakes.

The breastplate, which was recognised as a fake when it entered the Victoria and Albert Museum in 1921, may well be by the Florentine restorer Gaetano Guidi, who is known to have made embossed armour in this style for the collector Frederick Stibbert in the 1870s. The morion is an exceptionally skilful forgery, which was not detected until the 1960s. AREN

214 Breastplate

Embossed and gilded steel. 517 × 330mm
V&A M.147–1921

215 Morion

Steel embossed and damascened in gold. 285 × 330mm
V&A M.106–1921

LITERATURE L. G. Boccia, *Il Museo Stibbert* IV, Florence 1976, pl. 65; A. R. E. North, 'Armour and its decoration', *Antique Collector* (November 1988), pp. 105–9

The Renaissance in Northern Europe

216 Elizabethan silver-mounted stoneware pot and agate cup

Books on Elizabethan silver are dominated by mounted objects such as coconut cups, stoneware pots and porcelain. A disproportionately large number have survived, because the vessels made wholly of silver have been melted down and refashioned. However, not all these mounted

214, 215

objects are genuine, as tests of the metal and other materials confirm. The fashion for Gothic or 'Tudorbethan' interiors associated with the Prince Regent in the early nineteenth century demanded decorative plate in an appropriately Old English style. Objects had their mounts enhanced or were altered, like the late Stuart silver andirons converted into sideboard ornaments for George IV. The stoneware pot (a) was presumably made to satisfy this demand for accessories; when a sample from the base was tested by thermoluminescence the ceramic proved to have been fired sometime in the forty years around 1800.

In the mid-nineteenth century collectors became better informed

about English silver through Octavius Morgan's study of hallmarks (1853) and the special 'Loan Exhibition' at the Victoria and Albert Museum (1862). By the 1860s hallmarks were sometimes added to old objects and to newly made copies to make them more saleable. The agate cup (b), acquired by the Victoria and Albert Museum in 1867 and long considered a masterpiece of Elizabethan goldsmiths' work, is now recognised as a confection. The bowl is late eighteenth or early nineteenth century, and the stem is probably Antwerp work (unmarked) of the late sixteenth century. The disc which bears the hallmarks is merely pressed inside the base without solder. The whole is held together by a

machine-made screw and was probably assembled shortly before its purchase. PJG

LITERATURE P. Glanville, 'Tudor or Tudorbethan', *International Silver and Jewellery Fair Hardbook*, 1989, pp. 9–15

216a Stoneware pot with silver-gilt mounts, with hallmark for London 1576–7 and goldsmith's mark WC over a pig or grasshopper (?). H 280mm
V&A 215–1869
LITERATURE P. Glanville, *Silver in Tudor and Early Stuart England*, London 1989, no. 40

216b Agate cup with silver-gilt mounts, with hallmark for London 1567–8 and goldsmith's mark RF (for Roger Flynt) inserted under foot. H 200mm
V&A 38–1867
LITERATURE P. Glanville, no. 10

217 'Charles II' delftware dish

Though previously catalogued as genuine, this dish, with its distorted version of the royal arms, portrait of Charles II and birds imitated from Chinese porcelain, is hard to parallel among seventeenth-century English delftware, and seems likely to be a Victorian fake. TW

D 492mm
BM MLA 1887, 2–10, 138. Bought from Henry Willett
LITERATURE R. L. Hobson, *Catalogue of . . . English Pottery in . . . the British Museum*, London 1903, no. E155

218 French 'Renaissance' cabinet

The splendid collection of French and Italian Renaissance decorative art assembled by the Toulouse lawyer Jules Soulages was brought to England in 1855. It had been purchased for £11,782 by a syndicate of seventy-three aristocrats, architects and craftsmen organised by Henry Cole, Director of the Victoria and Albert Museum. When it was exhibited for seven weeks in London in the following year 48,093 people came to see it. After much lobbying, Cole persuaded the Government to buy the collection for his museum in instalments between 1859 and 1865. It included ceramics, metalwork, bronzes, enamels, textiles, glass and furniture, and was the most important such collection then in Europe.

Many of the objects are still on display but, as is so often the case with ancient furniture, some pieces are either heavily restored or made up from old carvings. Several were, therefore, de-accessioned in the 1950s, one at least of which may have been genuine. So little recent research has been done on furniture of this type that great care needs to be taken before it is declared to be 'fake' and this cabinet is one such piece. The balance of probability, however, is that it was made up in the 1830s from a combination of old (including the carvings) and new material. CW

Walnut inlaid with mother-of-pearl, marble and other woods. H 2375mm; L 1222mm; W 508mm
V&A 8453–1863
LITERATURE J. C. Robinson, *Catalogue of the Soulages Collection . . .* , London 1856,

218

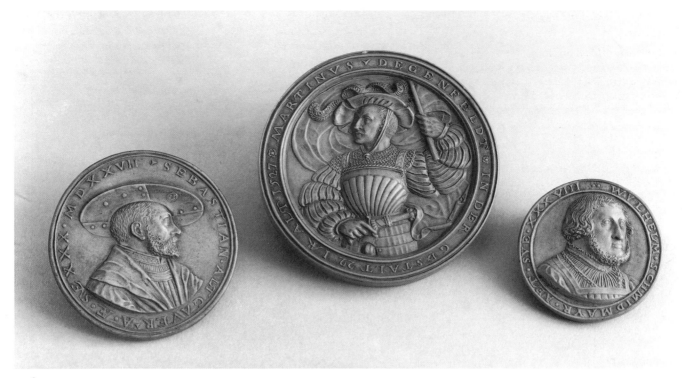

220b,a,c

pp. 182–3; C. Wainwright, 'Models of Inspiration', *Country Life* (June 1988), pp. 266–7

219 '15th-century' Swiss or German coffer

This coffer is one of a group which, along with a number of carved panels of similar character, were until recently considered to date from the fifteenth century. These objects are now known to date from the 1830s, but are closely modelled upon actual medieval Swiss and German examples, particularly one now in the Historisches Museum in Basel.

The present piece is a very plausible fake; it has an impeccable provenance stretching back to the 1840s, when collectors' interest in such pieces was still very new. It was purchased at the sale of the Coutereau Collection in Paris and by 1862 was owned by the celebrated English collector Hollingworth Magniac. It was shown in 1862 at the Victoria and Albert Museum at the special 'Loan Exhibition', and was in the sale of the Magniac Collection in 1892, where it was bought by another famous

collector, George Salting, who bequeathed it to the Victoria and Albert Museum in 1910. CW

Carved boxwood with silver-gilt mounts.
H 635mm; L 130mm; W 82mm
V&A W.119–1910
LITERATURE J. C. Robinson (ed), *Catalogue of the special exhibition of works of art . . . at the South Kensington Museum*, London 1862, p. 64; *Catalogue of the renowned collection of works of art chiefly formed by the late Hollingworth Magniac . . . Christie . . . July 2 1892 . . .* lot 781; Von Horst Appuhn, 'Die schönsten Minnekästen aus Basel Fälschungen aus der Zeit der Romantik', *Zeitschrift für Schweizerische Archäologie und Kunstgeschichte* XLI (1984), 149–59

220 Franz Giessmann's three 'German Renaissance' models for portrait medals, *c.* 1898–9

Franz Giessmann (d. 1925), who worked at Seidnitz near Dresden and elsewhere, was a virtuoso carver of wood and stone, specialising in reliefs in German sixteenth-century style. Many of these were sold as genuine Renaissance objects. A group of his works was given to the British Museum by Max Rosenheim in 1901 in full knowledge of what they were. TW

220a Martinus Degenfeldt, dated 1527
Solnhofen stone ('honestone'). D 80mm
BM MLA 1901, 11–15, 31

220b Sebastian Altcauer, dated 1527
Solnhofen stone ('honestone'). D 63mm
BM MLA 1901, 11–15, 41

220c Wylhelm Schmidmayr, after Peter Flötner
Solnhofen stone ('honestone'). D 47mm
BM MLA 1901, 11–15, 40

LITERATURE *Mitteilungen des Museen-Verbandes* (1910), pp. 6–10, section 61; (1926), p. 59, section 558, nos 53, 54, and 47

221 Iron clock in the Gothic manner

This weight-driven domestic iron clock with hour striking is a complete fake, thought to have been made by Rudolf Albrecht of Rothenburg ob der Tauber. In about 1910 he published a book where a number of such spurious medieval clocks are illustrated (*Die Räder-Uhr*. Rothenburg ob der Tauber s.a.). JL

H 565mm
BM MLA CAI-2055. From the Ilbert Collection

222 'Renaissance' Rhenish stoneware

One of the most important developments in Continental ceramic technology during the later Middle Ages was the discovery of the technique of salt-glazed stoneware in the Rhineland. Potteries at Siegburg, Cologne and Raeren, for instance, exported their hard-fired, non-porous and highly durable wares as far as Britain, the Low Countries and Scandinavia.

The first half of the sixteenth century marked the artistic high point of stoneware manufacture. The applied moulded decoration of heraldic, figural and ornamental motifs were almost certainly copied from models executed by a number of German engravers, such as Peter Flötner, Heinrich Aldegrever, Virgil Solis and Sebald Beham.

By the middle of the nineteenth century there was a growing interest in antique German stoneware, complementing the contemporary historicist fashion for carved oak furniture and *Gründezeit* interiors. Prices for Renaissance German stonewares rose sharply as a result and the market for copies or reproduction stoneware expanded.

Both Peter Löwenich of Siegburg (working 1830–40) and Hubert Schiffer of Raeren (after 1885) attempted to reproduce authentic stonewares using traditional potting techniques. The firm C. W. Fleischmann of Nuremberg produced its own sales catalogue of 1867 (*Originale Nachbildung alter Thongefässen*), which included a wide selection of Rhenish and other categories of German stoneware (Reineking-von Bock 1970).

Such products were seldom intended as fakes but many were later sold as authentic Renaissance and baroque pieces. Both examples here

222b,a

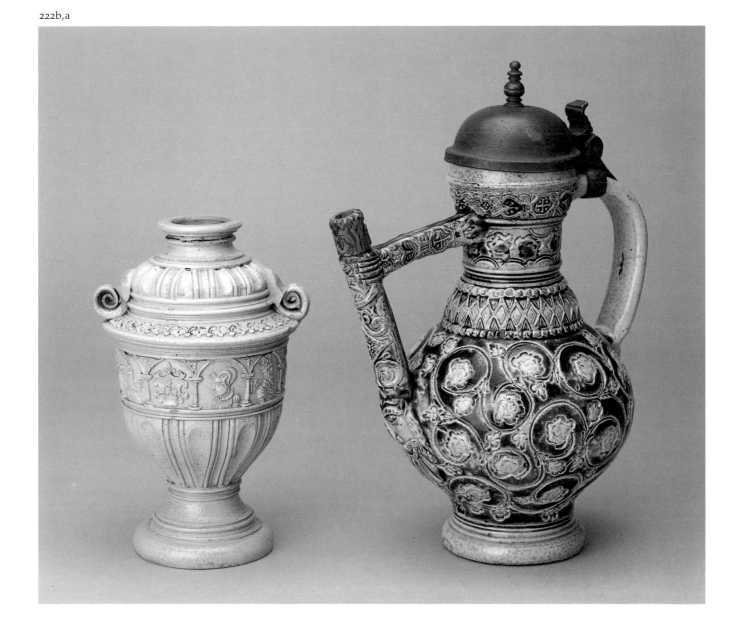

223

probably from a mould made at Frechen, near Cologne, is unknown on Westerwald products of the sixteenth or seventeenth centuries. The Raeren-type urn (b) is decorated with an applied frieze of royal portrait heads and their respective shields, again taken from original mould matrices similar to those discovered at the kiln site at Raeren (Kohnemann 1982). One of the shields contains the merchant's mark of the master potter Jan Emens Mennicken (working 1568–94) and the date [1]587. Despite these elements, the urn does not fit into the range of shapes known to have been produced at Raeren, and relates more closely to the nineteenth-century reproduction vessel forms. DG

222a Jug
H 208mm; D (rim) 58mm
BM MLA 1855, 12–1, 102. Bernal Sale

222b Urn
H 172mm; D (trim) 40mm
BM MLA 1889, 7–2, 5. Lady Charlotte Schreiber Collection

LITERATURE R. Reineking-von Bock, 'Steinzeug-Nachahmung, Nachbildung oder Fälschung?', *Keramos* 49 (1970), pp. 3–66; M. Kohnemann, *Auflagen auf Raerener Steinzeug*, Raeren 1982

223 '16th-century Spanish' archlute

Labelled *Johannes Montoya de Cardona. 1591*, this archlute is a fake built up around the remains of a genuine old instrument. The ribbed back and the lower part of the neck probably formed part of an eighteenth-century lute. The table is made of coniferous wood and has been stained to look old; it has been stamped in six places with what appears to have been a book-binder's tool. The rather coarse decoration consisting of slices of sea-shell(?) set in black mastic may be derived from a folk instrument. The upper neck and the pegs are roughly made. It was almost certainly intended to be collected rather than played. The best-known 'improver' of old instruments was Franciolini, who was active in Florence towards the end of the nineteenth century, but the workmanship in this example is too crude to be from his workshop. FP

were thought to be sixteenth century when acquired by the British Museum. Today there is still great difficulty in differentiating between a sixteenth-century stoneware jug and a nineteenth-century reproduction. As the later versions are almost certainly now over a hundred years old, condition and wear marks offer no reliable guide. Authentic and reproduction stonewares were made from clays from the same source and were fired in the same type of kiln, while the decoration was often taken from surviving sixteenth- and seventeenth-century moulds.

Scientific techniques, such as thermoluminescence dating, have so far proved ineffectual in distinguishing Renaissance period stoneware from modern products, although more refined testing is currently taking place on problem pieces at the British Museum's Research Laboratory.

The cobalt-blue bridge-spouted jug (a) was probably made in the Westerwald during the nineteenth century. The vessel incorporates applied decoration made from an original mould matrix. The grotesque bearded mask at the base of the spout,

H 1800mm; W 460mm
Horniman Museum 15·10·48/49. From the
Bull Collection

224 '16th-century Italian' violin

Though labelled *Gaspard
Duiffopruggar/bononiensis Anno 1517*,
this violin is thought to have been
made about 1850 in the Vosges.
Decorated violins of this type were
first made by J. B. Vuillaume
(1798–1875), but were manufactured
in large quantities in French and
German factories during the second
half of the nineteenth century. Their
production was probably inspired by
antiquarian interest in 'Gothic' art and
in the earliest history of the violin. An
inscription in modern French (À LA
GLOIRE DES ARTISTES-MUSICIENS) is
painted around the ribs, imitating
sixteenth-century practice; the double
purfling and the shape of the f-holes
also reflect features of genuine early
violins. FP

H 600mm; W 230mm
Horniman Museum 15·10·48/28. From the
Bull Collection

225 Fritz Kreisler's musical fakes

This is an example of one of Fritz
Kreisler's salon pieces which he
playfully attributed to various baroque
composers, in this case Louis
Couperin. When in 1935 he eventually
owned up to having composed them
himself, it was clear that he had
effortlessly deceived a number of
music critics over the years who might
have been expected to be a little more
sceptical. Ernest Newman mounted a
ponderous attack in *The Sunday Times*,
while *The Musical Times* even
suggested that he had used the names
of illustrious composers to increase
sales and subsequent royalties. Others
managed to retain a sense of
proportion, and Kreisler himself
remained unruffled, blandly
remarking on the good sportsmanship
of the musical public. PM

Chanson Louis XIII
BL H.1694 no. 5

The 18th century

226 Watches by Thomas Tompion and A. L. Breguet with contemporary forgeries

Famous watchmakers have always
been vulnerable targets for the work of
fakers, even during their lifetimes.

Two of the most celebrated, Thomas
Tompion of London (1639–1713) and
Abraham-Louis Breguet of Paris
(1747–1823), were copied extensively
by forgers with varying degrees of
finesse. The extent of forgery in
Tompion's time is demonstrated by an
entry in the Clockmakers' Company
Court Minutes for 3 July 1704, the year
in which Tompion was Master of the
Company. A number of the leading
London makers, including Tompion,
Daniel Quare and Joseph Windmills,
expressed their annoyance at the work
of the 'Amsterdam forgers', who they
accused of 'setting those Person's
Names on their Worke and selling it
for English Worke'. They ordered the
setting-up of a committee to consider
ways of preventing the trade. A gold
watch by Tompion and Edward
Banger with the arms of the Pettit
family of Denton (Kent) on the back of
the outer case (a), is included, along
with a contemporary fake in silver
with false signatures (b).

Breguet's work was extensively
forged in France (d) and more
especially in Switzerland (e), and
some of the best fakes are very difficult
to distinguish from watches made in
Breguet's own workshops (c). JL

226a,b

226a Gold pair-cased verge watch by Tompion and Banger, hallmarked London 1703, with the casemaker's mark ws.
D 54mm
BM MLA CAI-2351. From the Ilbert Collection

226b Contemporary English forgery, c. 1700. Silver-cased verge watch signed *Tompion London 1721* with wandering-hour dial inscribed *Tompion London*. D 51.5mm
BM MLA CAI-447. From the Ilbert Collection

226c Gold-cased cylinder watch, 1789. Movement signed *Breguet No. 196*.
D 54.2mm
BM MLA CAI-1857. From the Ilbert Collection

226d French fake, c. 1800. Lever watch with movement signed *Breguet A Paris*. D 51mm
BM MLA CAI-940. From the Ilbert Collection

226e Poor-quality contemporary fake, probably Swiss, c. 1800. Silver-cased verge watch signed *Breguet A Paris*. D 53.7mm
BM MLA CAI-860. From the Ilbert Collection

The faking of 18th-century ceramics

227–33

The mania for collecting ceramics took hold in England around the middle of the nineteenth century. The first collectors' handbook, Joseph Marryat's *History of Pottery and Porcelain*, appeared in 1850 with illustrations of prize specimens of both European and English porcelain. In the next decade or so both national and regional exhibitions were held where owners could display publicly their prized possessions. Museums, too, began to collect in a systematic fashion, making their first large purchases at the sale of Ralph Bernal MP held in 1855.

There had, however, been a considerable demand for certain kinds of pottery and porcelain before 1850, notably for the products of the French royal porcelain factory at Sèvres, and demand inevitably exceeded supply. Alexandre Brongniart, director of the Sèvres factory, began selling off soft-paste porcelain from 1804; it was subsequently repainted in England after the original uninteresting decoration had been removed. Imitation French soft-paste was made not only at Nantgarw and Swansea in Wales, but also at

Madeley in Shropshire for several decades. Certain colours such as pink and turquoise (the most costly colour to produce according to the factory's methods) were particularly fashionable (228), and were therefore the most frequently faked. It has been estimated that over half a million pieces were produced in England before 1856 to satisfy this market. 'Jewelled' Sèvres was also much sought after, and therefore widely imitated (229). It is usually detectable by the trained eye or by microscopic examination, as the workmanship is inferior to the eighteenth-century pieces.

In 1937 Wallace Elliot, then a china collector of thirty years' standing, gave a talk tracing the collecting of early eighteenth-century English porcelain up to the early 1860s. He quotes the interesting comment by Montague Guest, son of Lady Charlotte Schreiber, that in 1860, when he began to collect, there was 'an enormous supply, and very little demand, and in consequence the "fake" hardly existed'. Fakes and copies of Bow and Chelsea (230) were being made towards the end of the nineteenth century, notably by Samson of Paris, established in 1854. Many pieces bearing Samson's mark, which often took in the unwary as it resembled that used at Sèvres, are now collectors' items in their own right. Reproductions of Lowestoft porcelain (232) were seen by Elliot at least as early as the 1920s, and Longton Hall, Derby and Worcester fakes were all in circulation by this time. The most recent known faker of English eighteenth-century porcelain (a husband-and-wife team) operated in Torquay from the early 1960s (see 263). AD

LITERATURE R. Savill, *The Wallace Collection Catalogue of Sèvres Porcelain* III (References, Appendices, Index), London 1988, pp. 1167–71; W. Elliot, 'Reproductions and Fakes of English Eighteenth-Century Ceramics', *Transactions of the English Ceramic Circle*, II, no. 7 (1939), pp. 67–82; W. B. Honey, *European Ceramic Art*, London 1952, 'Forgeries'

227 'Meissen' elephant

This elephant and its stand came to the British Museum as part of the Franks Bequest. Franks believed the figure to be Meissen, but it is now known that this model was never manufactured there; Kaendler's genuine 'Sultan on an elephant' of 1741 is quite different.

The origin of this and a similar piece in the Museum of Fine Arts, Boston, is not known; a French origin is suggested. AD

Hard-paste porcelain with a celadon glaze; on an ormolu stand. H 340mm
BM MLA Franks 119
LITERATURE Sir A. W. Franks, *Catalogue of a Collection of Continental Porcelain*, London 1896, p. 75, no. 119; E. Mew, *Dresden China*, New York 1900, pl. 12; W. B. Honey, *Dresden China*, London 1934 (new edn 1954), p. 182 no. 60; C. Albiker, *Die Meissner Porzellantiere im 18. Jahrhundert*, Berlin 1959, p. 27, no. 254; H. Tait, *Porcelain*, London 1962, pl. XXII, (rev. edn 1972), pp. 35–6, pl. 22; H. Tait, 'Ormolu-mounted "Celadon" Elephants of Early Meissen Porcelain', *Ars Ceramica* 6 (1981), pp. 50–3, figs 1–7

228 'Sèvres' bowl, cover and stand

From the second third of the nineteenth century Sèvres soft-paste porcelain was much prized by wealthy collectors. Most prized of all were pieces with the famous pink ground, popularly called 'rose Pompadour' or 'rose Dubarry' after Louis XV's mistresses, and there are probably more fakes of this type than genuine pieces. The pink on this bowl is of an unpleasant, rather bluish tone, and the over-elaborate gilding outlined in dark red shows signs of having been refired. Both stand and bowl are blackened on the foot, and both have small scars, pinholes and inclusions which would have prevented them from being sold as first-quality products of the Sèvres factory, although they were doubtless made there. Many 'seconds' were disposed of in the early nineteenth century and decorated subsequently, in both France and England. The painting is distantly related to similar scenes on Sèvres decorated by André-Vincent Vieillard, but does not reach his standard of technical accomplishment.

228, 229

The flower sprays underneath the landscape scenes are particularly unconvincing. AD

L (stand) 198mm; H (bowl and cover) 106mm
BM MLA 1948, 12–3, 21. Bequeathed by Sir Bernard Eckstein, Bart

229 Redecorated Sèvres milk jug

This jug purports to be one of a small number of 'jewelled' pieces, decorated with gold foil in a technique perfected by J-P. Le Guay and P. Coteau at the Sèvres factory in about 1780. It even bears the mark 2000 used by the gilder Henry-François Vincent *le jeune*, but this is a fake, and, though the jug itself was made at Sèvres, the decoration was applied elsewhere. A large number of such 'jewelled' fakes exist, many of which are still accepted as genuine. They are to be distinguished

from the originals mainly by poor workmanship. AD

H 200mm
BM MLA 1938, 4–14, 1. Given by William King

230 'Bow' and 'Chelsea' shepherds and shepherdesses

Seen alongside the originals (a,b,e,f) which they imitate are pairs of fake Bow (c,d) and Chelsea (g,h) shepherds and shepherdesses. Probably made in the late nineteenth or early twentieth century, perhaps by Samson of Paris, such fakes are skilful and superficially deceptive but differ from originals in a number of significant respects. They are made in moulds taken from originals, and as clay shrinks in firing they are smaller than the pieces they imitate. They are made of hard-paste rather than soft-paste porcelain, and

analysis of the 'Bow' group has shown that, unlike the originals, it does not contain bone ash and has an unleaded glaze.

The colours used on the copies are relatively harsh, in the main because the soft, melting colours of the originals cannot be achieved on hard-paste porcelain. The pale pink used for the 'Bow' shepherdess's jacket, for example, differs markedly from the original. Finally, the marks on the (suspiciously clean) bases, though intended to deceive, are often inappropriate. The fake 'Bow' figures, for example, bear the red anchor mark used at Chelsea (*c.* 1752–8), even though this model was never made there. AD

230a, b Shepherd and shepherdess, Bow, *c.* 1760
H 270mm, 265mm
V&A C.144–1931, C.143–1931. Given by W. A. Floersheim

230e,f,g,h

231a,b,c

232a,b

heavier and has numerous black specks and pinholes, inside and out. Considered dubious in the past, this example has recently been shown to have the same composition as (a) and is probably genuine, if badly made. The incised triangle mark on the base, however, which was added after the piece had been fired, may well be spurious. The third item (c) is heavy to the touch and, particularly where the tree's leaves, flowers and the goat's hair are concerned, crudely modelled. The bee, the handle and the oak leaves near it are too large and placed differently from the preceding examples: it is likely that this is a later copy. AD

231a Genuine
Soft-paste porcelain. H 104mm
BM MLA Porcelain Catalogue II, 16

231b Probably genuine
Soft-paste porcelain. H 108mm
BM MLA OA10577

231c Fake
Soft-paste porcelain. H 108mm
BM MLA OA10578

LITERATURE W. Elliot, 'Reproductions and Fakes of English Eighteenth-Century Ceramics', *Transactions of the English Ceramic Circle* II, no. 7 (1939), pp. 70–1

232 Genuine and fake Abraham Moore Lowestoft mugs

Both of these mugs have an inscription on the base giving Abraham Moore's name and the date 1765. The fake (b) is given away by its blurred decoration, crazed, ill-fitting and lumpy glaze and generally coarse appearance.

The existence of such fakes (there are two other examples in the Victoria and Albert Museum) has been known since at least 1924, but their origin remains uncertain. AD

232a Genuine
H 85mm
BM MLA Porcelain Catalogue XI.7. Franks Bequest, 1897

232b Fake
H 118mm
BM MLA 1957, 4–3, 1. Presented as a study item by H. E. Marshall

LITERATURE W. Elliot, 'Reproductions and Fakes of English Eighteenth-Century Ceramics', *Transactions of the English Ceramic Circle* II, no. 7 (1939), pl. XXI

230c,d Copies of 230a & b
H 235mm, 224mm
V&A c.181–1938, c.181A–1938. Given by the executors of the late Wallace Elliot

230e,f Shepherd and shepherdess, Chelsea, *c.* 1760
H 285mm, 300mm
V&A c.141–1931, c.142–1931

230g,h Copies of 230e & f
H 270mm (both)
V&A c.182–1938, c.182A–1938. Given by the executors of the late Wallace Elliot

231 Three versions of the 18th-century Chelsea 'goat and bee' jug

These three versions of the same model illustrate some of the problems in distinguishing between genuine and fake. The first (a) is particularly finely made and is incised *Chelsea 1745*; its authenticity is beyond question. The second jug (b) is somewhat

233

233 Redecorated Worcester mug

The decoration of this piece, with its extensive area left white and especially the initial E, is highly unusual. It has appeared in at least one publication as an important example from the Worcester porcelain factory, supposedly as part of the Hope Edwards Service. However, the surface has been abraded, an effect visible to the naked eye on close inspection, indicating that the original decoration has been removed, probably using hydrofluoric acid, and replaced with a more desirable scheme.

For well over a century there has been a collectors' market for Worcester porcelains. The existence of a large number of redecorated pieces is acknowledged. As this mug entered the British Museum in 1921, it was probably 'improved' in the late nineteenth or early twentieth century. AD

H 140mm
BM MLA 1921, 12–15, 46. Given by Mr and Mrs Frank Lloyd
LITERATURE R. L. Hobson, *Worcester Porcelain*, London 1910, p. 90, pl. LIX, 5; R. L. Hobson, *Catalogue of the Frank Lloyd Collection of Worcester Porcelain*, London 1923, no. 166

235

French 18th-century paintings
234–5

Ceramics were not by any means the only French eighteenth-century artefacts that became highly sought after in the second half of the nineteenth century. French furniture was much admired (see 22), and the work of painters like Watteau, Fragonard and Chardin became increasingly fashionable. It is likely that the two copies included here were promoted to the status of original works at this period.

234 Imitator of Chardin, *Still life*

Until the publication of Martin Davies's catalogue of the French School in 1946, this was accepted as a painting by Chardin. Davies, however, pointed out that neither the style nor the handling were Chardin's and suggested that it might be by a nineteenth-century imitator of his work.

The false signature and date (*Chardin 1754*) were presumably added before the painting first appeared at a sale in Paris (16 April 1869), and certainly before it was acquired by Lord Savile, who presented the painting to the National Gallery in 1888.

Oil on canvas. 380 × 450mm
National Gallery, 1258
LITERATURE M. Davies, *French School*, London 1946

235 Imitator of Watteau, *L'accord parfait*

From a print by Baron after the original, this painting was acquired in Paris by Sir Richard Wallace, creator of the Wallace Collection, and bequeathed by him to Sir John Murray Scott, who left it to the National Gallery as a Watteau in 1914.

Oil on canvas. 270 × 230mm
National Gallery, 2962
LITERATURE M. Davies, *French School*, London 1946

Antiquarian and literary fakes
Peter Thompson's antiquarian fakes
236–7

Peter Thompson (*c.* 1800–74) was an ingenious though dubious character, who described himself variously as 'carpenter and builder', 'bookseller' and, more curiously, 'colonial architect'. Insofar as he is known today it is as an antiquarian forger. Born in Norwich, Thompson was established in London as a carpenter and builder by 1828. His ambitions were beyond those of an ordinary craftsman; in 1835 he submitted an unsuccessful set of designs for the new Houses of Parliament, and in the 1840s he turned his attention to the erection of partially prefabricated temporary buildings, some of which were exported to the colonies. The introduction of stringent new regulations by the Metropolitan Buildings Office seems to have forced him to give up this business venture.

In March 1852 a group of drawings was exhibited to the Archaeological Association showing the fortifications erected around London by the Parliamentarians at the beginning of the Civil War (237). These were said to have been drawn by Captain John Eyre and were the property of Mr Peter Thompson, who intended to publish them by subscription. The members of the Association found them 'extremely interesting' and Thompson received a number of orders for etchings of them at £2.12s.6d. per set. Captain Eyre was in fact invented by Thompson, who also provided an appropriate genealogy (236) and biography. This, together with a 'self-portrait', was published as the introduction to *Eyre's Fortifications of London, 1643* in 1852. Supposedly a descendant of a genuine Simon Eyre, a fifteenth-century Lord Mayor of London, John Eyre was

'born' in 1604, educated at Oxford 'and afterwards attended Prince Charles [Charles I] in his travels', became a Captain in the 'Red Regiment of the Train Bands of London' and a student at Gray's Inn. A Royalist supporter until John Hampden's trial, 'when the defence . . . of that great man completely opened his eyes, and caused him to alter his opinions', Eyre became a staunch Parliamentarian, entering 'Cromwell's Regiment'. His end came when he was fatally wounded at Marston Moor, and he died on 23 July 1644. Thompson gives further biographical details: Eyre was an excellent linguist, and proficient in music and drawing. According to a conveniently preserved common-place book, from 1639 until going on active service he apparently saw much of Wenceslaus Hollar (who, incidentally, was a Loyalist supporter in the Civil War!), 'sketching with him the tombs and monuments of the various churches of London'. It is thus not surprising that 'Eyre's' drawing style bears a superficial similarity to Hollar's. An album in the British Museum includes a number of drawings 'signed' by Hollar, as well as all the drawings supposedly by Eyre 'recording' the fortifications erected around London in 1642–3. In fact, the forts actually erected during the Civil War bore no resemblance to these elaborate ramparts, but were hastily constructed earthworks. Thompson derived most of his details from readily available sources: George Vertue's 1738 plan of the forts, published in Maitland's *History of London* (1739), while the houses and streets in the drawings were taken directly from Hollar's London views.

Thompson sustained Eyre's existence until 1853, when he claimed that he had in his possession a number of drawings by Hollar made for Eyre, showing the house in which Shakespeare had lived in Southwark. However,

13 A Bulwark and half on the Hill at the end of Gravel Lane

237

doubts had already been cast in certain quarters and Thompson had to return to more orthodox ways of making a living. He issued a number of pamphlets on working-class housing, and became enthusiastic about the use of concrete, which being both fire- and vermin-proof could be used to build 'moral houses'. Poverty-stricken, Thompson died in 1874. LS

LITERATURE I. Darlington, 'Thompson Fecit', *Architectural Review* CXXIV (July–December 1958), pp. 187–8

236 'The family of Eyre'
Thompson's fake genealogy of 'Captain John Eyre'
BM PD 1890. 5–21. 8 (1 . . . 19)

237 *Eyre's fortifications of London, 1643*: 'A Bulwark and half on the hill at the end of gravel line'

Pen and brown ink. 208 × 337mm
BM PD 1909. 6–28. 56. Presented by Lady Tyler

238 James Gillray (1757–1816), *Connoisseurs examining a collection of George Morland's*

Gillray's print (a) has a particularly apposite place in any exhibition concerned with forgery, for it both comments on the work of a much-forged genius, and provides us with a striking likeness of a renowned copyist of the Old Masters: George Morland. To understand it we must retrace the career of Morland, an artist who urgently needs the reassessment of a major exhibition. He studied with his father Henry Morland, a portrait painter, and at the Royal Academy Schools, and first exhibited sketches at the Royal Academy in 1773 when he was ten. By the age of seventeen he enjoyed a considerable reputation as a landscape, *genre* and animal painter, but during the 1790s the expense of his alcoholism led to him becoming the victim of unscrupulous dealers. He produced a vast number of canvases in his last decade which were taken from him before they were dry (sometimes even before they were finished), touched up by others and sold. Estimates of his total output range as high as 4,000 paintings before his death in October 1804, and the market became glutted with his later slapdash efforts. This is the background to the print which shows, from right to left, Mr Mortimer, Mr Baker, Mr Caleb Whitefoord, Mr Mitchell and Captain William Baillie.

Mr Mortimer was a well-known picture dealer; Mr Baker a friend and patron of Sandby, Herne and other watercolour painters; Mr Whitefoord was a wit, wine merchant and patron of Wilkie; Mr Mitchell was the twenty-four-stone friend of Rowlandson; and Captain William Baillie (1723–1810), a retired Civil Servant and 'copyist'. Baillie, an Irishman who had fought at Culloden, enjoyed a reputation for his copies of Old Master drawings in private collections, and is the subject of one of the impressive preparatory drawings for the print. It shows him peering through his inverted spectacles and is

CONNOISSEURS *examining a collection of* GEORGE MORLAND'S.

238a

footsteps. The caricature relates to the 'working relationship' between Whistler's studio assistant and mistress, Rosa Corder, and Charles Augustus Howell, the entrepreneur, dealer and somewhat shady 'fixer' of the movement, who is remembered for arranging the disinterment of Elizabeth Siddal's coffin and the removal from it of Rossetti's poems. Between them Corder and Howell were well able to cope when the demand for Rossetti drawings exceeded supply.

Rosa Corder is also reputed to have forged a number of pornographic drawings by Henry Fuseli (1741–1825). Fuseli was left-handed, and thus shaded his drawings from left to right. However, the drawing of the *Procuress and Lover* (b) is shaded from right to left, and it may have been done by Corder, who was right-handed. As with most forgeries, it is difficult with hindsight to believe that the flabby drawing of the procuress's hair could ever be confused with the Medusa-like elaborations and precision of a real Fuseli drawing. The secrecy surrounding erotic works of this description has only been dispersed in very recent times to permit real study; for example, when Ruthven Todd first published an examination into genuine and fake Fuseli erotic drawings (*Footprints in the Snow* 1947), he was only able to reproduce small postage stamp details, which curiously created an even more titillating result than the reproduction of the whole sheet. Inevitably, such furtiveness has affected attributions in this area.

The present drawing appropriately came from a group of erotic drawings including a genuine Fuseli and a fake Theodore van Holst, owned by Michael Sadleir, the author of the novel *Fanny by Gaslight* (published 1940), a brilliant historical pastiche purporting to be an autobiography of a Victorian courtesan. LL

239a Max Beerbohm
Watercolour. 318 × 387mm
Tate Gallery, A 01039

239b Rosa Corder (?) after Fuseli, *Procuress and lovers*
Pencil. 333 × 230mm
V&A E.106–1952

labelled *A Connoisseur of the Dutch School contemplating a Rembrandt effect.* This is a reference to Baillie's etchings after Rembrandt, and in particular his restoration of that artist's 'Hundred Guilder print' (see 30). LL

238a Caricature published by H. Humphrey, 16 November 1807
Engraving. 323 × 277mm
BM PD (D. George 10791)

238b Preparatory drawing for above of Captain William Baillie
Pen, ink and wash on paper squared for transfer. 220 × 175mm
V&A Dyce Bequest 767

239 Rosa Corder: faker of Rossetti and Fuseli

One of the most recondite caricatures in Max Beerbohm's profound satirical survey of the Pre-Raphaelite movement, *Rossetti and his Circle*, is labelled MR – AND MISS – NERVOUSLY PERPETUATING THE TOUCH OF A VANISHED HAND (a). It shows an empty studio in which a besmocked young woman stands at an easel producing a careful copy of one of Rossetti's intense small watercolour portraits of the head of his voluptuous model Fanny Cornforth. By the door stands the figure of a man nervously listening for the sound of approaching

239a

240 Forgeries by Major Byron (d. 1882), 'Romantic' fantasist

'Major Byron', who declared his full name to be George Gordon De Luna Byron (and was also known as 'Monsieur Memoir'), claimed to be Lord Byron's natural son. He maintained that his mother was a Spanish lady, the Countess De Luna, who contracted a secret marriage with Byron which was invalid by the laws of both England and Spain. The title 'Major' derived, he boasted, from his time in the service of the East India Company. He forged a large number of Byron, Shelley and Keats letters, partly to draw attention to his supposed origin and partly to make money. The two forged letters here (a,b) have been treated to artificially 'age' the paper. Major Byron himself composed most of the texts, which were frequently rather weak and clumsy in content, but he also used material already in print, which led to his detection in 1852. However, because they were boldly written, without a trace of shakiness, these fakes at first deceived even the authors' own publishers. The British Library possesses a considerable collection of his forgeries, presented in 1853 by William White, a bookseller who was duped by Major Byron into buying them. SB

240a Forged letter of Lord Byron, dated 13 February 1817, at Venice, to 'Madame la Baronne de Stael', at Geneva, by Major Byron
BL Add. MS 19377, ff. 20v–21

240b Forged letter of Percy Bysshe Shelley, dated 4 December 1816, at Bath, to his father-in-law William Godwin, by Major Byron
BL Add. MS 19377, ff. 117v–118

240c Forgery by Major Byron of a poem ascribed by him to John Keats but in fact by Samuel Laman Blanchard, who published it under the title *Hidden Joys.*
BL Add. MS 44919, ff. 75, 76

_Has lent me to behold the hearts of things,
And touched mine ear with pow'r; thus,
far or nigh.
Minute or mighty, fixed a flut with wings,
Delight, from many a mimic life coveal sh,
Peeps sparkling, and, in tones familiar sings._

J. Keats.

76

_along with an ivory-tipp'd cane. Carlo our
Neighbour Mrs Brawne's dog and it meet some-
times. Lappy thinks Carlo a devil of a fellow
and so do his Mistress. Well they may – he
would sweep 'em all down at a run; all for
the Joke of it. I shall desire him to peruse
the fable of the Boys and the frogs: though he
prefers the tongues and the Bones. You shall
hear from me again the day after tomorrow_

_Your affectionate Brother
John Keats_

240c
240d

240d Genuine letter of John Keats, sent from Keats's sick-room in Hampstead on 9 February 1820 to his sister Fanny.
BL Ashley MS 4870, ff. 1ᵛ–2

241 Alexander Howland Smith's 'Burns' forgeries

Robert Burns was an immensely popular poet, greatly admired by his contemporaries and followers, and so it is not surprising that he found his own forger. 'Antique' Smith, as he came to be known, was sent to prison for a year in 1893 for forging large numbers of letters by Burns, Sir Walter Scott and other famous figures. Most of these were written on the wrong kind of paper, some of which was torn from old books, and were also folded and sealed incorrectly. An important prosecution witness at the trial was George F. Warner, then Assistant Keeper of Manuscripts at the British Museum, who had closely inspected the documents in question and concluded that they were all forgeries. In Smith's fakes the letter 'i' is usually dotted far to the right, a feature of his

natural hand; Burns dotted his 'i' neatly above the stem of the letter. After his release from prison, Smith had no scruples about admitting that he was the author of these letters, or 'facsimiles' as he called them. SB

241a Inscription by Robert Burns _To John Mailand_ [a mistake for Maitland] _Esqᵉ_ forged by Howland Smith, dated January 1794. This is in a printed copy of Bishop Benjamin Hoadly's _Plain Account of the Nature and End of the Sacrament_ (1735).
BL Add. MS 43787, f. i

241b Forged letter of Robert Burns, addressed to 'John Maitland Esqᵉ Dumfries' and dated 17 January 1794. This was written to accompany the supposed gift of 241a.
BL Add. MS 43798, f. 73

242 Two facsimiles of the Caxton type

The pen and ink facsimiles of leaves from printed books made in all innocence by the three John Harrises count among the technically most skilful imitations of old originals made in the nineteeth century. Moses Harris (_fl._ 1766–85), the famous botanical

artist, was the father of the first, whose son, John Harris II, (?1791–1873), was the most famous. A desire to 'perfect' old books lacking leaves dominated nineteenth-century bibliophily and produced a ready market; Harris worked long and late, eventually going blind in 1857. A sale of his work was held for his benefit at Sotheby's on 22 August that year, and he lived on, almost destitute but supported by donations from his clients, for another sixteen years.

Normally a typeset original can easily be distinguished from a pen and ink facsimile by the impression which the type leaves in the paper. Typeset facsimiles do not suffer from this defect. In 1855 the type founder Vincent Figgins had a copy of Caxton's second type cut which can barely be distinguished from the original, especially when printed on old paper. This was used for a facsimile of Caxton's _Game and Playe of the chesse_ in 1855 (b) and later for _The boke of St Albans_; it too was used to perfect books with missing leaves.

The ironic possibilities of fraud are

242a

books through the press' which he put at the service of the Browning and Shelley Societies. In 1886 he became acquainted with T. J. Wise, a self-made businessman and like himself a keen collector of 'modern' authors. Wise and Forman were both well aware of the new strong American urge to collect books by famous authors, including the moderns. They were also aware of the naivety of the market and its remoteness from real expertise. It seems likely that Wise, the businessman, saw the commercial (and criminal) possibilities in Forman's taste for facsimile printing.

Prudently, Wise and Forman restricted themselves to the more obscure (and thus hitherto 'unknown' and 'rare') minor works of major authors. Pamphlets, purporting to be privately printed for their authors' own use and therefore not commercially available, began to emerge from 1888 with surprising frequency. They began with Swinburne's *Cleopatra*, quickly followed by other ephemeral poems by Elizabeth Barrett Browning and George Eliot. William Morris, Ruskin, Rossetti, Thackeray, Dickens, Robert Browning, Matthew Arnold and, eventually, Tennyson and R. L. Stevenson were all subjected to this fraud. One or two, Swinburne and Morris in particular, were shown these suppositious works, but, while denying any knowledge of them, did not condemn them as forgeries.

By far the largest and most famous of the Wise–Forman forgeries was the famous 'Reading Sonnets', an edition of Elizabeth Barrett Browning's *Sonnets from the Portuguese* supposedly printed at Reading in 1847 under the eye of the Brownings' confidante, Mary Russell Mitford. This edition was printed at the height of the forgers' career (*c.* 1888–1901), probably in 1893 or 1894. Unlike the others, it was never leaked onto the market through the sale rooms, but the 'romantic' story of its discovery was leaked through the gullible Edmund Gosse. It commanded a huge price when sold privately to American collectors, and it remained expensive

suggested by the fact that Harris's facsimile (a) was reproduced by the British Museum as genuine for many years, despite Harris's microscopic signature in the lower line. For many years this mistake distorted the dating of Caxton's later work, which depends on progressive damage to the line. NB

242a *Doctrinal of Sapience*
Harris's pen and ink facsimile
BL IB 55129

242b *Game and Playe of the chesse*
Figgins's typeset facsimile
BL C. 10. b. 1

243 Wise and Forman's fictitious editions of modern authors

Thomas James Wise (1859–1937) and Harry Buxton-Forman (1842–1917) carried the criminal possibilities of facsimile printing (see 242) to their logical extreme, and added their own, original form of forgery: the invention of books that could, even should, have existed, but never did. The plausibility of their choice of forgeries and the impossibility of comparing them with 'known' originals brought them a success which they enjoyed longer than most forgers.

Forman's interest in print went back to his friendship with William Morris and his finicky concern with 'seeing

and 'rare' until well after the death of Forman, its probable architect.

Both he and Wise must have profited considerably from their activities. They stopped manufacture (though not sale) before the market was flooded, but Wise disposed of the residue of their stock about 1912 to an ex-employee turned bookseller, Herbert Gorfin. It was Gorfin's evidence, belatedly given, that was conclusive when Wise was finally exposed in 1934 by two young booksellers, John Carter and Graham Pollard. Both had come independently to suspect the mass of 'modern' pamphlets which seemed to share a family resemblance. Together they constructed a web of proof based on well-backed forensic evidence, chemical analysis of the paper, anachronistic use of types (the famous 'Clay's Long Primer No. 3' of the *Sonnets*), the non-existence of purported printers or of presentation copies. This was published as *An Enquiry into the Nature of Certain Nineteenth Century Pamphlets*, a deliberate echo of Malone (see 160). They stopped short of accusing Wise (who died without admitting guilt three years later), but the inference was obvious. Their work was at once recognised as a classic of detection (in an age of classic detective stories); so it remains, and that is perhaps the best memorial to Wise and Forman. NB

Elizabeth Barrett Browning, *Sonnets from the Portuguese*
BL Ashley 4715

New fields to conquer

By the late nineteenth century European history had been thoroughly explored and exploited. Pioneering collectors in search of a new frontier, ambitious academics seeking a new subject and dealers needing a new source of supply had to turn elsewhere. Prehistory and archaeology provided a partial answer, turning objects that were in no sense art into collectable items, and so too did the whole range of non-European cultures.

Some of these, in the Middle East and India for example, had long-standing links with the European market. For others the arrival of collectors, often in the wake of European colonisers, created entirely new markets. In these the definition of a fake can become complicated (see 33), since buyers and sellers did not always share the same concept of authenticity. Here, too, the interruption of the craft tradition that marks a break in the history of faking in Europe is absent; the production of fakes may require only the adoption of existing skills, rather than the painstaking revival or simulation of dead ones.

244 Replicas and forgeries of prehistoric flints

In the late nineteenth century new ideas about human physical and cultural evolution encouraged a fashion for collecting flint implements. While savants renounced the purchase of stone artefacts because the practice encouraged fraud, craftsmen skilled in the production of stone tools or 'knapping' found a ready market for their products among enthusiasts wanting to complete sets of different types of artefacts. Some flint knappers, like William Spalding, produced and sold replicas. Museums, geologists and archaeologists showed considerable interest in the work of such knappers, as their demonstrations provided valuable insights into the technology of the past. Unfortunately, many were also duped by less scrupulous knappers who, like Edward Simpson alias 'Flint Jack', were willing to pass off their products as genuine antiquities. Replicas are still made for research and demonstration purposes (see 290) and, alas, there is still a ready market to encourage forgeries. JC(PRB)

244a Replica of a laurel leaf point made by William Spalding
H 112mm
BM PRB P1945. 2–3. 26

244b Forged 'Bronze Age' barbed and tanged arrowhead, made by Edward 'Flint Jack' Simpson
H 35mm
BM PRB P1956. 12–5. 2

Faking Persian Pottery
245–6

245 Persian jars

Forgeries of Islamic pottery were circulating very soon after it first began to be collected in Europe. 245a is, in fact, an original piece of the thirteenth century, and the Victoria and Albert Museum bought it as such in 1875 and paid a handsome price (£30. 12s. 6d.). Yet it was doubted before it had been in the Museum a year. A note dated December 1876 in the Museum register reads:

Mr Caspar Clarke lately returned from Persia says that about a dozen jars of this design were made in Persia about 30 years ago for a French gentleman, and that he knows the man who made the moulds. He believes this specimen to be one of the dozen.

This created sufficient uncertainty to consign the piece to the Museum stores. It did not, however, prevent the Museum a few years later from acquiring as genuine, for £25. 10s., one such forgery (b), which now clearly can be seen as based on the earlier acquisition. OW

245a 13th-century fritware jar, with turquoise glaze. H 650mm
V&A 2433–1876
245b 19th-century fake. H 394mm
V&A 673–1884

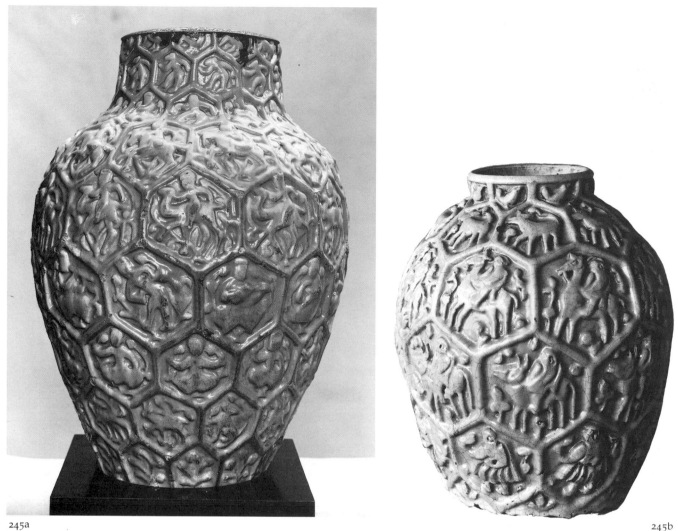

245a

245b

246 Persian bowls

The genuine bowl (a) was illustrated in 1947 by Arthur Lane in his *Early Islamic Pottery*, a book that quickly became the standard reference work. The forger, working some time in the 1960s, has clearly copied the design (b) from the small black-and-white photograph in the book. The decorative vocabulary is not well understood: the scale and proportions of the motifs are awry and the drawing is feeble, fiddly and aimless compared to the taut precision of the original. Forgeries of pieces with much simpler designs can be alarmingly deceptive, but more elaborate work gives many more chances for the forger to display a lack of authentic period style. ow

246a Early 13th-century fritware bowl, with underglaze painting. D 203mm
V&A C. 80–1918

246b Fake, imitating 246a, c. 1960.
D 255mm
V&A C. 179–1984

247 'Turkish 17th-century' carpet

This carpet was bought by the Victoria and Albert Museum in 1932 as a Turkish carpet dating from the later seventeenth century. The price was low enough to attract the Museum but not so low as to arouse any suspicions. The carpet is well woven with pleasant colours and in a technique consistent with four other carpets (in Berlin, Vienna, Florence and Konya) with similar patterns, all dating from the seventeenth century. Although not

recorded in the Register, there was a tradition that it had come from the Schwarzenburg Collection dispersed after the First World War. No questions were raised until 1962, when Nessim Cohen, an American dealer formerly resident in Cairo, wrote to the Museum that he believed the carpet to be a fake. It later emerged that the dealer from whom the carpet had been bought, F. P. Perlefter, had had a bad reputation in the trade and had, indeed, boasted of having sold a fake to the Museum. It was then suggested that the carpet had been woven in Hungary and sent to Cairo to be artificially aged.

A careful examination of the carpet by Mrs May Beattie suggested that the weaver may have been Tuduk, a noted producer of seventeenth-century

247

carpets. Three narrow stripes of red wool in the warp, and thus integral to the carpet, worried her. When CIBA Clayton analysed a sample of the dye it was found it to be a fusion of chrysophenine, and brilliant purpurine 10 B, discovered in 1885 and 1867 respectively (*CIBA Review*, 1966, no. 3, Chromatography, pp. 27–8).

Subsequently it was noticed that while there was appropriate wear on the front of the carpet, the back remained bumpy and springy. The wear on the front implied that the carpet had, at least, been laid upon a table, the normal use for such a carpet in Europe in the seventeenth century, but had this been so the back of the carpet should have shown slightly flattened knots. They were, however, rounded. It now seems likely that the carpet was woven in Hungary about 1930–2, shortly before its purchase. NR

L 2946mm; W 1702mm
V&A T.130–1933
LITERATURE A. F. Kendrick & C. E. C. Tattersall, *Handwoven Carpets, Oriental and European*, 2 vols, 1922, p. 46a

248 Imitations of Mughal painting

Several albums of painting and calligraphy are known to have been assembled for the Mughal Emperor Shah Jahan (r. 1628–58), incorporating miniatures done for him and his father Jahangir (r. 1605–27) and earlier panels of calligraphy, all mounted in decorative borders. None of these imperial albums survives in its original form, with the exception of one compiled by Shah Jahan's son Dara Shukoh, which is now in the India Office Library. Individual album pages are scattered through many collections, although three later assemblages, known as the Minto, Kevorkian and Wantage albums after their more recent owners, give an idea of the composition of the original volumes. The Minto album (split between the Victoria and Albert Museum and the Chester Beatty Library, Dublin) contains only original paintings, whereas the Kevorkian and Wantage albums (now mostly in the Metropolitan Museum and the

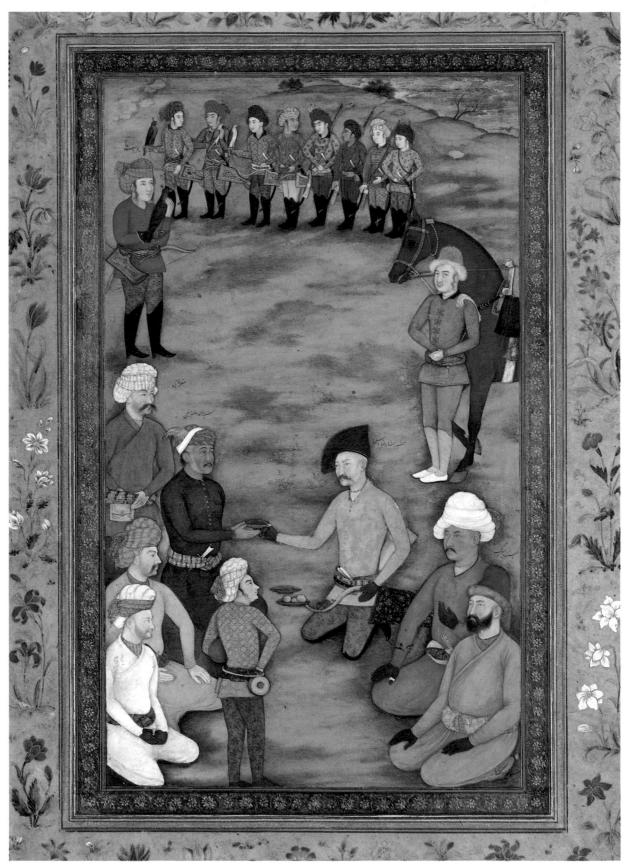

248b

Victoria and Albert Museum) have been adulterated by the inclusion of the early-nineteenth-century copies of paintings in the other albums.

Precisely when this restructuring of the royal albums took place is not known, but the imperial library had suffered losses ever since the invasion of Nadir Shah in 1737, when much of the imperial treasury was looted. The shrewd businessman who organised their removal must also have acquired Jahangir's seal, since it often appears on the copies from this source.

The painting by Bishndas (a) of Shah 'Abbas (r. 1588–1629) receiving the Mughal ambassador is a genuine page from a now dispersed album. Bishndas was one of the Emperor Jahangir's most valued artists, noted especially for portraiture, and he was sent to Persia with Khan 'Alam to record events and, in particular, to bring back likenesses of the Shah. Several versions of this meeting exist, both by Bishndas and by later artists, but 248b, though skilfully painted, is typical of the fakes in the Wantage and Kevorkian albums. Their most distinctive feature, easily recognisable also in the painting of cranes (d), is an indistinct, fuzzy effect which is probably derived from European steel-engraving techniques in which fine stippling is used for shading. This stippled technique contrasts with the traditional Mughal miniature-painting method of building up thin layers of paint to give opacity and depth to the colours. In the fake paintings faces are given a rounder, softer appearance than in the originals, a style very much in evidence in paintings of the Delhi school of the nineteenth century.

An unusual feature of 248b is that the reverse has been copied as accurately as the main painting. It bears three couplets by the poet Hafiz, inscribed on the original by the sixteenth-century calligrapher Mir 'Ali of Herat, whose work can be found scattered throughout the Mughal albums. While it is less easy to distinguish the genuine sixteenth-century calligraphy from its nineteenth-century copy, the decoration which surrounds it is noticeably less competent in the later version.

The seventeenth-century drawing of cranes (c) can be attributed to another of Jahangir's favourite court artists, Ustad Mansur, whose speciality was natural history paintings. This drawing, which encapsulates in very few lines the elegance and vitality of the cranes, was obviously intended as a sketch for a painting. The whereabouts of Mansur's finished painting is not known today, but the nineteenth-century copy (d) must surely be a very close likeness. The attribution to *Ustad Mansur Jahangir Shahi* has also been copied on to the fake painting. RC

248a Bishndas, *Shah 'Abbas I of Iran and the Mughal ambassador Khan 'Alam, c. 1620*
Private Collection

248b *Shah 'Abbas I of Iran and the Mughal ambassador Khan 'Alam*
Painted in Delhi, c. 1800
V&A IM. 42–1925

248c Attributed to Mansur, *Sketch of two cranes, c. 1615*
V&A IS. 219–1951

248d *Two cranes*
Painted in Delhi, c. 1800
V&A IM. 122–1921

LITERATURE B. Robinson, 'Shah 'Abbas and the Mughal Ambassador Khan 'Alam: the pictorial record', *Burlington Magazine* (February 1972); R. Crill, 'A Lost Mughal Miniature Rediscovered', *V&A Album 4* (1985); S. C. Welch *et al.*, *The Emperor's Album*, New York 1988

249 Islam Akhun: forger of 'ancient' Khotanese books

Islam Akhun, a Khotanese treasure-seeker, did brisk business in manuscript and printed documents sold in the 1890s to British and Russian collectors caught up in the excitement surrounding the rediscovery of lost civilisations along the route of the Chinese Silk Road. The 'unknown characters' on some manuscripts excited considerable scholarly attention: Dr A. F. R. Hoernle, the Indologist and philologist, spent years deciphering them. The suspicions of Sir Aurel Stein were aroused by the oddity of the script and of the bindings, which were unlike any he himself had excavated at numerous sites along the Silk Road, and he extracted a full confession from Islam Akhun during a 'semi-antiquarian, semi-judicial inquiry' in 1901.

The volume included here is blockprinted on contemporary Khotanese paper, which had been dyed and then smoked to impart a suitably ancient hue, and subsequently sprinkled with sand to give the impression of having been dug out of the desert. The crude, non-Chinese binding did not alert Macartney, the British Consul at Kashgar who purchased this and other books from Akhun. Indeed, Stein noted that many of Islam Akhun's forged books were later bound in fine morocco and placed in European libraries. EMCK

210 × 155mm
BL Or 13873 no. 20
LITERATURE M. A. Stein, *Ancient Khotan*, Oxford 1907, pp. 507–14

250 Moche-style vessels from Peru

Since quite early in the nineteenth century the manufacture of objects purporting to be of pre-Hispanic date – including the so-called 'portrait' vessels, which perhaps represent heroes or rulers of ancient Peru – has been common in Peru. In recent times the use of genuinely ancient pottery vessels, remodelled and painted to turn them into more elaborate specimens, has caused considerable confusion: thermoluminescence dating often appear to support the authenticity of the piece. However, in the nineteenth century more common types of forgery depended rather upon the use of original pre-Hispanic moulds which are often found in the graves of potters. From these it was possible for the forgers to produce numbers of pottery vessels in perfect style.

In many early examples little attempt was made to reproduce either the clay or surface finish correctly. Rather, the surface was 'aged' by making it appear black and dirty, and by adding to it fragments of genuine pre-Hispanic textile, abundantly available from mummy-wrappings preserved by the dry climate of coastal Peru. Since pottery vessels are equally abundant in these graves, it is perhaps puzzling that they should have been forged. However, genuine examples are often broken and require

250b,a,c

considerable restoration, which then has to be concealed. Demand for Moche pottery vessels remains high, and recent forgeries are of great sophistication.

250a Moche 'portrait' vessel, *c.* AD 400–600
245 × 145mm
BM ETH 1947. Am16. 13

250b Fake portrait vessel
250 × 130mm
BM ETH 1909. 12–7. 7

250c Fake portrait vessel
110 × 200mm
BM ETH 1909. 12–7. 8

251 Aztec-style obsidian masks from Mexico

The Mexican archaeologist Leopoldo Batrés, writing on the subject of fake pre-Hispanic antiquities in 1910, said that there were so many high-quality falsified objects made of obsidian by that time that 'sometimes only a very expert eye can distinguish the fake'.

251a

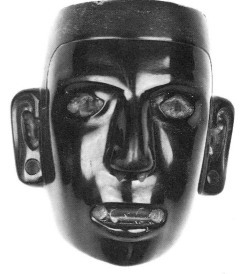

251b

Obsidian, a volcanic 'glass', is not a difficult material to work and supplies of it are abundant in Mexico. In pre-Hispanic central Mexico it was the most important material for the manufacture of the tools of daily life – flaked blades, chipped points and scrapers – as well as weapons, mirrors, vessels and small carvings and ornaments. Objects made of obsidian are commonly offered for sale as antiquities in present-day Mexico, and forgeries in this material have continued in production from the nineteenth century onwards.

The late Gordon Ekholm, one of the foremost experts in the detection of Mesoamerican forgeries, has warned that all large objects of obsidian, especially masks, must be considered suspect. It is, indeed, hard to think of any large obsidian mask among the known body of antiquities from Mexico that is generally accepted as genuine. Masks are, however, among the most sought-after categories of object with collectors.

The two examples included here are almost certainly nineteenth- or early-twentieth-century fakes. The back of 251a, representing the Mexican rain-god Tlaloc, has been left as a polished wedge-shaped cut, a feature not consistent with the usual practice of pre-Hispanic lapidaries; the mask of a man (b) resembles others illustrated by Batrés. Many such objects are to be found in European and North American collections. Batrés wrote that the Mexican National Museum had the 'richest collection of fake obsidian objects that exists in the world'. The techniques of their production, using petroleum and emery, are described by him and, as he concludes, many of the falsifications are 'marvels of art' in their workmanship.

251a The rain-god Tlaloc
H 130; W 180mm
BM ETH 1928. 10–2. 213

251b Face of a man
H 145; W 140mm
BM ETH 1907. 6–8. 1

LITERATURE L. Bartrés, *Antiguedades Mejicanas Falsificadas: Falsificacion y Falsificadores*, Mexico D.F. 1910; G. F. Ekholm, 'The problem of Fakes in Pre-Columbian Art', *Curator* VII/I (1964) pp. 19–32

252 Fake Peruvian mummy mask

The practice of decorating mummy packs or bundles with masks of textile, wood or metal was common in pre-Hispanic Peru. These masks are among the most sought-after antiquities from the region, especially those executed in silver and gold. Since demand outstrips the supply of genuine examples, such masks have been falsified with varying degrees of elaboration since at least the nineteenth century.

It is sometimes difficult to decide

253a,b

whether the cruder examples are fake or merely late and possibly even of post-Conquest date: indigenous burial practices did not immediately cease following the Spanish Conquest. Many of the faked masks are decorated with fragments of genuine pre-Hispanic textiles, feathers and so on from ancient burials to make them appear more authentic.

As information becomes available concerning pre-Hispanic metallurgy and the composition of alloys produced by ancient metalsmiths, science is better able to distinguish the

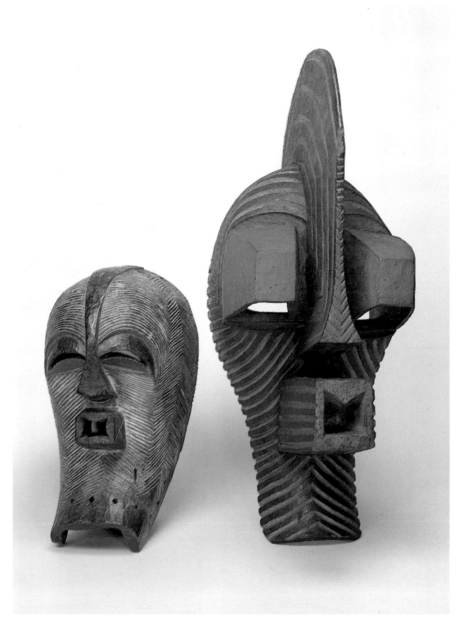

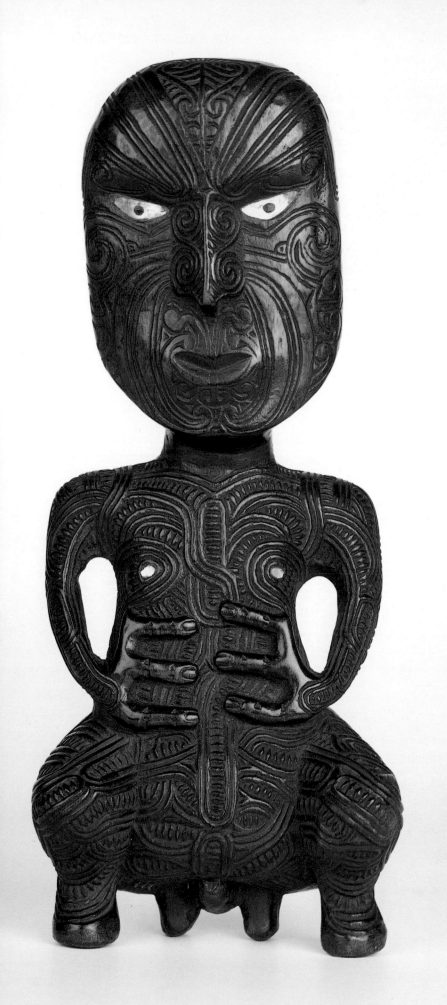

genuine from the fake. The type and depth of corrosion can also be studied and is sometimes revealing. However, such work is usually only carried out upon the finer and more important objects.

This mask has not been examined scientifically, but the fragments of pre-Hispanic textile fixed to it have clearly been specially cut; a layer of textile has been glued to the entire inner surface. This, along with the overall style of the object, strongly indicates that it has been made within the last 150 years or so.

Metal mask, purportedly from a mummy pack, Trujillo(?), Peru
H 269mm
BM ETH 1932. 11–10. 1

253 Songye masks from Zaire

The large mask (b), with its tall crest and exaggerated features, is of a type said to have been developed by local carvers at the suggestion of a European trader. The unpainted surface and general lack of wear on this example, which was in the collections of the Wellcome Historical Medical Museum by the 1930s, suggests that it may be an early example made for sale.

In more recent times, however, the Songye themselves have reappropriated the exaggerated style of commercially produced masks and now carve them to perform as powerful male masks. The more restrained black and white mask (a) is in the older style, which continues to be used in Songye masking societies, where it is identified as a female mask type. BJM

253a Songye mask
390 × 200 × 180mm
BM ETH 1956. Af27. 273. Mrs Webster Plass
253b Version made for sale
610 × 250 × 370mm
BM ETH 1954. Af23. Q232960. Wellcome Historical Medical Museum

254 Asante wooden fertility dolls (*akuaba*)

Dolls of this form were used by the Asante principally to treat infertility in women. A doll of the sex of the required child was made and treated

255

as if it were the child of the afflicted woman. In matrilineal Asante it was female children who were most urgently required and so male dolls are rare. The form of execution of the carving and its patina suggest that the male doll (b) will have been made for sale to tourists rather than for traditional uses. NFB

254a Genuine female *akuaba*
335 × 125mm
BM ETH Wellcome 85728. Donated by the Trustees of the Wellcome Historical Medical Museum.

254b Male *akuaba*
470 × 220mm
BM ETH Wellcome 137291. Donated by the Trustees of the Wellcome Historical Medical Museum

255 Free-standing 'Maori' figure

This sculpture was made, probably about 1910, by James Edward Little (1876–1953) of Taunton, Somerset. The features which enable it to be identified as a probable fake include the dark staining of the wood, the peculiar juxtaposition of motifs, the carving of the broad spiral grooves done in the style favoured by Little, and the use of the scrotum as a support.

Little was a furniture restorer who supplemented his income by dealing in authentic ethnographic artefacts and, eventually, by faking them, specialising in Polynesian, and particularly Maori, objects. He made several similar free-standing figures, one of which, bought in 1910 by a New Zealand collector, W. H. Skinner, is now in the National Museum of New Zealand in Wellington. Little's business, which he operated worldwide by mail order, flourished for nearly twenty years. His activities were first discovered in 1910 by the collector-dealer William Oldman after Little had made and sold a pair of Marquesan stilt steps (Watt 1982). Little's fakes still appear occasionally in sales even today. DCS/RW

H 280mm
BM ETH 1927. 1–7. 1. Presented by Miss Hirst
LITERATURE R. J. Watt, 'James Edward Little's Forged Marquesan Stilt Steps', *Records of the National Museum of New Zealand* 2, no. 7 (1982), pp. 49–63

256a,b

256 Maori nephrite clubs

Genuine Maori nephrite clubs, of the type known as *mere pounamu* (a), were and still are highly prized family heirlooms. This example, said to have belonged to Te Puna, Chief of Waikato, was presented to Sir George Grey, Governor of New Zealand, during his first tour of duty in that country in the mid-nineteenth century.

The other *mere* (b) is probably one of a large number of 'Maori' curios made by Germany's Oberstein and Idar lapidaries during the late nineteenth and early twentieth centuries. They were usually made and sold as copies, but some, commissioned by English and New Zealand dealers, were deceitfully passed off as authentic Maori artefacts. A combination of features makes this object very different from genuine specimens. The very dark, almost black nephrite was rarely used by the Maori. The regularity of the wheel-cut butt ridges and the parallel-sided hole for the suspension loop indicate not only the use of European tools but the precision of a lapidary employing them, for although the Maori began to use European tools to fashion their nephrite artefacts fairly early in the nineteenth century, the clubs they made still had a hand-crafted appearance. Finally, the shape of the club – squat, with a minimal hand-grip – is totally unlike the long elegant from of a genuine *mere*. DCS/RW

256a Genuine
L 378mm
BM ETH 1854. 12–29. 5. Presented by Sir George Grey

256b Fake
L 317mm
BM ETH Q81. Oc.1380

7

Faking in the 20th century

The parallel decline of copying as a discipline for aspirant artists and of a whole range of traditional crafts has greatly reduced the talent available for faking antiques and works of art. Combined with ever stricter attitudes towards restoration, this has gradually narrowed down the grey area in which imitation and repair shade into deception. It is almost impossible to ascertain whether a seventeenth-century imitation of Giorgione is a fake. For the nineteenth century the task becomes slightly easier, particularly where there is deliberate damage, artificial ageing or a misleading inscription, but the possibility that even the most deceptive of fakes started life as an innocent copy cannot be discounted. By the middle of the twentieth century this was no longer the case. Few innocent copies were being made, and then they were executed in pigments unknown before the nineteenth century. The motives behind a fake are given away by the battery of tricks used to fool the expert.

Society's attitude towards faking has at the same time become harsher. When Vasari described the successful deceptions practised by artists like Michelangelo and Tommaso della Porta, it was with admiration at their ability to rival the work of the ancients. When Pistrucci revealed to Payne Knight that he had cut the Flora cameo (152), or Bastianini (208) claimed paternity of the Benivieni bust, it was to show what skilled artists they were. And the response was to deny their claim or salute their achievement, not to punish them.

When Van Meegeren (258), who had been led into faking Vermeers by the desire to prove his own worth as an artist, confessed, he was sentenced to prison. Worse still, no one took seriously his claim to have established his credentials as an artist by deceiving the art establishment. This was not because that establishment had declined in prestige – quite the contrary – but because the by now exclusive emphasis on talent as the hallmark of worth in an artist debarred from esteem those whose claim rested on technical proficiency and imitative ability. Not that either were particularly impressive in the case of Van Meegeren, or the more recently famous Elmyr de Hory and Tom Keating (259). Their fame rests more on the prestige of the artists whose work they imitated than any talent of their own. Name, indeed, is everything; the 'Bernard Leach' pots (264) would not have been worth anything without the BL stamp that purported to identify them as the work of a great man.

But the fame of the new generation of art forgers has also been due to the mixture of reverence and resentment aroused by the arcane language of connoisseurship used by the guardians of high art, and the

dim light and luxurious surroundings in which the objects in their care are displayed for worship. When Graham Ovenden and Howard Grey briefly interrupted the promotion of Victorian photography to the status of great art by creating 'nineteenth-century' prints (265) they were put on trial, but the jury acquitted them.

Fascinating though recent fakes are, they are becoming as peripheral to the history of faking as the production of religious relics during the Renaissance. It is not that present expertise is such that successful faking is a thing of the past: the maker of the porphry head (262) fooled not only the British Museum but also the Louvre and the Metropolitan. The twentieth century is, however, the great age not of the art fake, but of the commercial counterfeit. The faking of luxury goods has, of course, gone on since at least the early eighteenth century (see 226), and the fakes and imitations of Cartier and Rolex watches, Louis Vuitton luggage, Chanel perfume, Moët and Chandon champagne and Scotch whisky shown here continue that tradition. But they also extend it; the growth in the market for luxury goods, combined with the breakdown of personal relations between suppliers and customers, has opened up enormus new markets for such fakes.

Counterfeiting has also spread from luxury goods to encompass almost any commodity sold under a well-known trademark or protected by a patent, that is – in a technologically progressive and increasingly brand-conscious society – almost anything under the sun. In 1987 it was estimated that 10,000–15,000 counterfeit Apple computers were sold per month in the USA. In 1983 a million fake contraceptive pills were distributed. It has even been suggested that the failure of the Carter administration's bid to rescue American hostages from Iran was due to fake helicopter parts (Foundation Cartier, *Vraiment Faux*, June–September 1988).

In all, counterfeiting accounts for as much as 5% of work production or 100 billion dollars worth of goods a year. And the ever more rigorous protection of trademarks and patents cannot check the growth of illicit activity provoked by the ever greater profits awaiting those who breach them. In the Third World counterfeiting may represent the first ring on the ladder that leads to development; in Europe and America it is a growth area for organised crime. Either way, the fakes most characteristic of the late twentieth century are those that promise the instant status conferred by a famous name or the corrupt profit to be gained by substituting an inferior product for the real thing. An apt comment on our times?

257 The 'Maestro del Ricciolo's' forgeries of Old Master drawings

Of the many fakes currently on the art market, those by the perpetrator of these examples are by far the most numerous, and it is probable that he is still active today. Any collector of Old Master drawings will be familiar with his productions, mostly drawn imitations of the eighteenth-century Venetians Antonio Canaletto (1697–1768) and Francesco Guardi (1712–93).

These fakes are invariably drawn on old paper, often with a prominent watermark. Because the surface of that paper has been impaired by age, the modern ink lines often bleed at the edges and slightly through the paper. Spurious and indecipherable inscriptions in a tidy hand are also frequently found. Most are drawings of Venice.

In a recent Italian newspaper article (*La Stampa*, 12 August 1987) Mario Spagnol speculated briefly on the faker's activity. Christened by collectors and dealers the 'Maestro del Ricciolo' (Master of the Curl), from the ornamental flourishes reminiscent of Francesco Guardi found in his work, he is thought by some to be 'an Englishman resident in Italy, by others a Roman, who with tireless creativity has for some time infested the market with fakes . . .'

In few other areas has fraud been as successful as in Old Master drawings. Indeed, the way that the reputation of the works of the great masters has been undermined, at great profit, by forgeries has both fascinated and amused. J. T. Smith, a former Keeper of the Department of Prints and Drawings at the British Museum, recounted in his *Nollekens and his Times* (1828) the following amusing tale of a distinguished late eighteenth-century drawings collector: 'John Barnard, Esq., nicknamed Jacky Barnard, who was very fond of showing his collection of Italian drawings, expressed surprise that Mr Nollekens did not pay sufficient attention to them. "Yes, I do", replied he; "but I saw many of them at Jenkins's at Rome, while the man was making

257a

them for my friend Crone, the artist, one of your agents".' NT

257a A Venetian view
Pen and brown wash. 197 × 276mm
BM PD 1988. 1–30. 4

257b A view through trees
Pen and brown ink with brown wash.
334 × 237mm
BM PD 1988. 1–30. 28. Presented by Mr & Mrs Cuéllar

258 Van Meegeren's fake 'Vermeers'

Born in 1889, Henricus Antonius van Meegeren was destined, despite his exceptionally mediocre talents as an artist, to achieve an infamous form of success and recognition for his 'artistic' creations. Having studied drawing under Bartus Korteling at Deventer High School, and at Delft Technical College, Van Meegeren learnt the techniques necessary for forging Old Masters from the dealer-restorer Theo van Wijngaarden. He had probably embarked on his career as a forger by 1923, when a *Laughing Cavalier*, supposedly by Frans Hals and reportedly coming from an English collection, was authenticated by the renowned Dutch art historian Hofstede de Groot. The firm Frederik Muller bought the painting for 50,000 florins, but then a few months later initiated a court proceeding on the grounds that the picture was a fake. A distinguished panel of experts appointed by the court declared the picture to be modern but de Groot, still believing it genuine, bought the painting, thereby bringing the affair to an end.

During the next decade Van Meegeren pursued his career both as an artist and as a budding forger, and by 1935 he had made considerable technical progress. His most distinguished contribution to the forger's art was his inspired idea of using a medium made from phenolformaldehyde resin dissolved in benzene or turpentine. According to his son, Van Meegeren first ground his pigments in oil of lilacs and then mixed them with his medium. When baked the resultant paint film exhibited all the surface characteristics of genuine seventeenth-century Dutch pictures. After four trial forgeries in the new medium (now in the collection of the Rijksmuseum, Amsterdam), Van Meegeren embarked upon a project which was to become his greatest achievement as a forger. He possessed a copy of a book published in 1936 by Dr D. Hannema, Director of the Boymans Museum in Rotterdam, and Dr A. F. E. van Schendel, later Director of the Rijksmuseum, entitled *North and South Netherlandish Painting in the 17th Century*. In it much emphasis was

237

258a

placed on the 'non-Dutch' qualities of early Vermeers like *Christ in the House of Martha and Mary*, *c.* 1654–5 (Edinburgh), *Diana and Her Companions*, *c.* 1655–6 (The Hague), and *The Procuress*, 1656 (Dresden). All three pictures have a large format. One is religious, another mythological, and both the *Christ in the House of Martha and Mary* and *The Procuress* clearly show the influence of Utrecht Caravaggesque painters such as Henrick ter Brugghen and Dirck van Baburen. It was reasonable to assume that others might also exist and Van Meegeren decided to supply one.

In 1936–7 he worked on his 'masterpiece', *Christ at Emmaus*. It was painted on a genuine seventeenth-century canvas which still had its original stretcher, something which is very rare. The composition on the original canvas, *The Raising of Lazarus*, was removed, retaining only the ground layer with its *craquelure*. Both the canvas and stretcher were cut down, and a piece of the original canvas was kept by Van Meegeren as proof that he had executed the forgery. Using his phenolformaldehyde medium, Van Meegeren painted the picture which, when completed, was baked at 105°C for two hours. The results were remarkable, and after giving the picture a few extra ageing treatments he was ready to present it to the world.

Through an intermediary Van Meegeren arranged for a famous Dutch art historian, Dr Abraham Bredius, to see the painting. An elaborate story explaining the picture's provenance had been fabricated which guaranteed the 'owner's' anonymity.

Bredius had discovered *Christ in the House of Martha and Mary* in the Coats Collection at Skelton Castle, Scotland, and was convinced that other Biblical compositions by Vermeer must exist. After examining the painting for two days Bredius authenticated it as a Vermeer 'of the highest art, the highest beauty'.

It was decided to postpone serious efforts to sell until Bredius's article on the painting appeared in the November 1937 issue of the *Burlington Magazine*. However, one of Duveen's agents was allowed to see the *Emmaus*. He cabled his employer and ended his message with an unequivocal opinion: 'Picture rotten fake'. This perceptive judgement became generally known and did little to encourage potential buyers. However, after the picture had been placed on display in the gallery of D. A. Hoogendijk, a highly important Dutch dealer in Old Masters, it was purchased for the Boymans Museum with the assistance of the Rembrandt Society, Bredius himself and a number of private donors.

Until the picture was exposed as a fake after the Second World War most of the leading art historians in Holland accepted the *Christ at Emmaus* as genuine. Dr Schmidt Degener, Director of the Rijksmuseum, was so eager to secure the painting for his institution that he was prepared to offer Vermeer's *Love Letter* and Pieter de Hooch's *Woman with Child in a Pantry* on permanent loan from the Rijksmuseum in exchange for the *Emmaus*.

During the war years a steady stream of 'Vermeers', all with religious subjects, came onto the Dutch market and were sold to eminent collectors. Much to Van Meegeren's chagrin, Reichsmarschall Hermann Goering succeeded in buying *Christ and the Adultress* in 1942. Perhaps the most remarkable transaction of all during the war was the purchase by the Dutch government in 1943 on behalf of the Rijksmuseum of *The Washing of Christ's Feet*, for 1,300,000 florins. That this was done on the advice of a committee composed of half a dozen famous art historians in the teeth of Van Regteren Altena's vigorously

258b

expressed opinion that the canvas was a fake must have provided immense pleasure to Van Meegeren, who nursed a life-long hatred of the art establishment and its high priests.

After the end of the German Occupation of The Netherlands in 1945 Van Meegeren was arrested on the charge of having collaborated with the enemy. The sale of *Christ and the Adultress* to Goering, which had been of great concern to Van Meegeren, had proved his undoing. Confronted as he now was with the serious charge of collaboration, Van Meegeren confessed to having forged the *Adultress*, and all the other 'Vermeers'. A furore resulted and the charges of collaboration were replaced by those of fraud. The extent of the embarrassment caused by Van Meegeren can be imagined, since the affair involved the nation's leading art historians, museum directors and curators, restorers and technical experts, and some of the most prominent dealers and wealthiest private collectors.

A commission of experts was appointed, headed by Professor Dr P. B. Coremans, Director of the Institut Royale du Patrimoine Artistique in Belgium, and concluded in March 1947 that the *Christ at Emmaus* and all the other 'Vermeers' which had appeared with astonishing rapidity between 1939 and 1943 were fakes painted by Van Meegeren. On 12 November 1947 Van Meegeren, who had become a national hero of sorts, was sentenced to one year's imprisonment, but he died before serving it, on 29 December 1947.

Christ and the Adulteress (a), sold to Goering in 1942, exhibits most of the stylistic trademarks typical of Van Meegeren, and not of Vermeer. Among the most conspicuous characteristics are heavy-lidded eyes with racoon-like shadowing, overly fleshy lips and noses, square-tipped wooden-looking fingers, and fragile, tiny wrists. The bag-like garments hung over the figures do not even succeed in disguising the faker's lack of ability in achieving correct anatomical structure and volume. The adultress no more has an arm that do most of the figures in Van Meegeren's

other 'Vermeers'. The facial types in his religious 'Vermeers' express three basic emotions: simpering goodness, anaemic holiness and swarthy roguery. In the *Christ and the Adultress* Jesus looks somewhat healthier than in most Van Meegerens, but a blood transfusion would do no harm. Clearly inspired by sixteenth-century Venetian paintings, the overall composition is not at all Dutch. The device of partially showing a view through a small wedge of a window or door is typical of both Giorgione and Titian. Goering's purchase of this picture confirms one's faith in poetic justice.

The *Lady and Gentleman at a Spinet* is a traditional 'Vermeer' and was probably painted about 1935–6, when Van Meegeren produced a few such pastiches. Unlike his other 'Vermeer' pastiches, this one found its way into the private collection of Dr Fritz Mannheimer, a prominent Amsterdam banker. The composition has been made up from bits and pieces borrowed from various Vermeers, including *Interior with an Artist Painting a Model* (Vienna), *A Young Woman seated at a Virginal* and *A Young Woman standing at a Virginal* (both National Gallery, London) and *Interior with a Gentleman and a Young Woman with a Wineglass* (Berlin–Dahlem). What is striking in Van Meegeren's *Lady and Gentleman at a Spinet* is that he was more successful in creating an anatomically correct woman than a man. Stripped of his cloak and clothes the cavalier would demonstrate a frightening case of anorexia nervosa.

Had Van Meegeren been a better artist he might never have felt the urge to fake; or he might just have succeeded in producing some 'Vermeers' which would have fooled more people longer than the ones he created. MKT

258a *Christ and the Adultress*, 1942
Oil on canvas. 900 × 1000mm
Rijksdienst Beeldende Kunst, The Hague; inv. nr. NK 3394. Ex collection Hermann Goering

258b *Lady and Gentleman at a Spinet*
Oil on canvas. 650 × 530mm
Rijksdienst Beeldende Kunst, The Hague; inv. nr. NK 3255. Ex collection Dr Fritz Mannheimer, Amsterdam

LITERATURE Lord Kilbracken, *Van Meegeren*, London 1967; D. Hannema, *Flitsen uit mijn leven als verzamelaar en museumdirecteur*, Rotterdam 1973

259 Tom Keating, *A barn at Shoreham*

Tom Keating, probably the most prolific and versatile art forger to be exposed in Britain this century, was born in London in 1917. He showed talent for painting at school, and from an early age considered it his true vocation, but his parents' poverty compelled him to start work at fourteen. His wartime experiences in the Royal Navy shattered his nerves, and he was invalided out in 1944. In 1950 a grant enabled him to study at an art college for two years, but he failed his diploma examination, and could not get the art teaching job he had hoped for. For the next few years he restored pictures on the shady fringes of the London art market, learning a great deal about painting techniques in the process. He later turned to outright forgery as a protest, by his own account, against the exploitation of artists by dealers. He later claimed that during the next twenty odd years he produced some two thousand fakes of about a hundred different artists, including Samuel Palmer, for whose work he always felt a particular affinity.

In about 1965 he settled in Norfolk with a former pupil, Jane Kelly. They cleaned and restored pictures, with Keating doing some faking as a sideline; the Palmers he forged at this time, which Kelly sold, ultimately led to his exposure.

The uncovering of Keating's forgeries began in March 1976, when Geraldine Norman, Art Sales correspondent of *The Times*, decided to investigate the subject of art fakes. She had been alerted to a number of suspect Samuel Palmers which had appeared on the market since 1969 and was also given the name of Jane Kelly as the vendor of some of them. Her article on thirteen suspect Palmers, naming Jane Kelly as the source of five of them, appeared in *The Times* on 16 July. She then learned of Kelly's relationship with Keating; she soon

259

discovered where Keating lived and went to interview him. She wrote another article (10 August), suggesting that he had forged not only the suspect Palmers but works by other artists. Subsequently she and her husband persuaded Keating to write his life story, which was published as *The Fake's Progress* the following year.

Finally on 27 August Keating made a general confession of his forgeries at a press conference. His revelations caused a sensation in the country and consternation in the London art market. Keating himself became and remained a popular hero. He was arrested in 1977, but all charges were later dropped because of his poor health. He won a television award for a series of lectures on great artists and their techniques, and was about to give another when, in February 1984, he died. A posthumous sale of his work fetched £274,000 – about seven

times the estimate.

The picture shown here was probably painted early in 1965, when Keating was laid up after a fall. In *The Fake's Progress* he recalled:

'I got my drawing board and a pile of pristine paper together and began to draw very rapidly in the style of the guv'nor, banging in a couple of sheep here, a shepherd there, the moon, trees and Shoreham church. Sometimes I put in the hallowed figure of Christ, sometimes a barn and sometimes a three-arched rustic bridge. I used water-colour, sepia ink, wax and varnish and all the other materials that Palmer would've used himself – except, of course, that mine were of the synthetic modern variety.

I gave some of them to the kids who'd been so kind to me while I was laid up with my back. I think they flogged a few in local junk shops, but I like to think they kept one or two and still have them on their walls now that they're grown up. I rarely bothered to frame them, I just handed out slips of

paper with Palmer drawings on them. I gave them to all kinds of people, like the gasman who came to read the meter, casual acquaintances and complete strangers and I even sent them to my family and friends as Christmas cards – I expect they chucked them in the dustbin on Twelfth night'.

This drawing was sold at Bonham's by Jane Kelly, where, together with another drawing, it fetched £30. The purchaser, believing that he had 'discovered' a Samuel Palmer took it to Colnaghi's, the Bond Street dealers who purchased it for £200, agreeing to share any further profit. Mr Edward Croft-Murray, at the British Museum, endorsed the attribution and it was on his advice that the Cecil Higgins Art Gallery bought it from Colnaghi's for £2,500 as a Samuel Palmer. It was only after Keating's exposure in 1976 that scientific examination demonstrated · that the paper and the principal

260 (*back*); 264 (*front left*); 266 (*right*)

colours were modern, and Geraldine Norman discovered that its composition was derived from Palmer's *The Shearers* (foreground) and *Landscape with a barn. Shoreham.* JBG

Sepia mixed with gum, and heightened with white, on paper. 262 × 372mm
Trustees of the Cecil Higgins Art Gallery
LITERATURE G. Norman, *The Tom Keating Catalogue*, London 1977, p. 26

260 After David Hockney (b. 1937), *Colourful head-dress with colourful nose*

This is an exact copy of an original drawing by David Hockney executed in 1963. The authentic composition was sold for £4,000 in 1980 and the forgery appeared on the market the following year. During the ensuing investigation David Hockney wrote 'This is not my work, New York, 24th March, 1981. D.H.' across the copy and his dealer was recorded as saying that it was the first known forgery of Hockney's work to have emerged. FC

Pencil, pen and ink and coloured crayons. 628 × 520mm
Metropolitan Police Museum

261 Abstract composition after Vasily Kandinsky (1866–1944)

This watercolour is signed with the monogram of the Russian-born artist Kandinsky and dated '25' (1925). The forger, however, has not produced an exact copy of an original composition, neither has he succeeded in an accurate imitation of Kandinsky's work of the mid-1920s, when he was one of the leading teachers at the Bauhaus in Germany. The effect is merely that of a generalised impression of Kandinsky's style which approximates to his famous series of 'Improvisations' of 1913–14. FC

Watercolour. 325 × 360mm
Private Collection
Illustrated on p. 234

262 Porphyry head of a Tetrarch, formerly identified as Constantius I (AD 293–306)

Within a few years of the British Museum's purchase of this head persistent rumours were circulating in Rome that it was a forgery, the first of

four manufactured there by the same forger. At the same time a number of scholars were expressing doubts about its authenticity, mainly on stylistic grounds. The very flattened features, especially in the side view, led Dr Dietrich von Bothmer of the Metropolitan Museum in New York to suggest that it had been made from a fragment of a porphyry column. He also suggested that some of the damage to the face had been both deliberately inflicted and deliberately limited in extent, in order to give a spurious appearance of antiquity without detracting too much from the market value of the head.

Studies in the technique of Roman portrait sculpture, including work in porphyry, carried out by Dr Amanda Claridge of the British School at Rome, cast further doubt on the head. Examination of tool marks under various degrees of magnification suggested that the head had been worked in a manner incompatible with Roman techniques. Close examination of the damaged areas also showed identical traces of the tool that had been used. In one place the fragments thus removed had even been re-attached with a modern adhesive.

The evidence, therefore, points to a fairly recent origin in Rome, about 1970. The porphyry itself was doubtless quarried in the Roman period, originally for use as a column. BFC

H 430mm
BM GR 1974. 12–13. 1
LITERATURE B. F. Cook, in *The Burlington Magazine* 126 (January 1984), pp. 19–20

263 Imitations of 18th-century porcelain by post-war fakers

263b, which was apparently sold as genuine around 1950, was identified as a fake by A. J. Kiddell of Sotheby's in the late 1960s. It is a copy of a Chelsea squirrel dating from about 1746 (a) and is reputed to have been made by a faker working in London.

A husband-and-wife team (now deceased) working in Torquay, Devon, were responsible for the 'chalky' figures, such as 263d. This piece imitates a rare figure of the so-called Girl in a Swing group made

at an unknown factory, probably in London, in the mid-eighteenth century. Pieces from this factory (c), whose output was probably small, have been sought after by collectors from the 1930s onwards.

Compared to the originals, both fakes are heavy and clumsily modelled; the colours on the girl (d) are especially harsh and sticky. Much uncertainty surrounds the precise origins of these recent fakes, as their makers were never prosecuted. AD

263a Genuine Chelsea squirrel, *c.* 1745
H 136mm
BM MLA Porcelain Catalogue II.7
263b Imitation of 263a
H 172m
Sotheby's 'Black Museum'
263c Girl dancing: genuine 18th-century figure
H 143mm
BM MLA 1938, 3–14, 90. Bequeathed by Wallace Elliot
263d Imitation of 263c
H 136mm
BM MLA OA10580. Presented as a study item by Dr J. Ainslie, 1953

264 'Bernard Leach' pottery

Produced in 1980 by William Boardman and Vincent Mason, two prisoners in Fetherstone Prison, Wolverhampton, during pottery classes held there, each of these examples bears the impressed seal mark of the Leach Pottery, St Ives, Cornwall and the monogram of Bernard Leach (1887–1979). These and other pieces were taken by an associate to leading auction houses, including Christie's (b: lot 43, 15 July 1980), Sotheby's Belgravia (a), Phillips, Bonhams and Lawrence of Crewkerne, where they were accepted as genuine, despite the clumsy forms and unconvincing decoration. Within three months of the first release onto the market they were recognised as fakes by Mr Richard Dennis, and both men were subsequently successfully prosecuted. It is rare that fakers of ceramics have been brought to book in this way. AD

264a Stoneware eleven-sided bowl
H 118mm
Metropolitan Police Museum

262

263c,d,b

264b Vase
H 243mm
Metropolitan Police Museum
264c Vase
H 204mm
Metropolitan Police Museum

265 Howard Grey and Graham Ovenden's fake 'Victorian' photos

These photographs played starring roles in two separate hoaxes. The print of a young girl (c) is based on a photograph taken in 1974 during a session arranged by the London advertising photographer Howard Grey. Grey dressed the eleven-year-old professional model Johanna Sheffield in Victorian clothes and photographed her – and other models – in order to include some novel pictures in his portfolio. He handed a set of modern black and white prints from the session to the painter Graham Ovenden, a well-known collector of Victorian photographs.

According to an article in *The Sunday*

Times (18 November 1978), seven prints from Grey's session were transformed by Ovenden into pastiches of Victorian original photographs, namely salted paper prints – a delicately toned, matt, often bluish process used in the 1840s and 1850s. Unknown to Grey, Ovenden lent the prints to a National Portrait Gallery exhibition entitled *The Camera and Dr Barnardo* in the summer of 1974, telling officials at the gallery that these works were by a newly discovered photographer named Francis Hetling who took photographs of 'poor Victorian street children in the north of England' (*The Sunday Times*, 19 November 1978). The titles which Ovenden gave them purported to be from Hetling's diaries, which he claimed to have seen. Some visitors to that exhibition recognised the model and others identified them as 'wrong': the lighting and tonality were unconvincing, and the faces looked 'modern'. However, Ovenden had also shown these prints to a friend and business associate, the dealer Eric Sommer, saying that a large trunk of

paper negatives and prints was still in the possession of the Hetling family, who wanted to publish them (*The Daily Telegraph*, 29 October 1980). Later, *The Telegraph* reported, Sommer paid Ovenden £600 for ten of them, and a further nine were sold to a Washington dealer for £540. 'Hetling' photographs were offered to Colnaghi & Co., the Bond Street dealers, for an important selling exhibition of photographs in 1976, but the cataloguer, Miss Valerie Lloyd, refused to include them without 'further evidence of the photographer's existence, which never came. However, in 1980 a court case did.

Proceedings at the Old Bailey were entertainingly described by Richard Boston in *Quarto* for January/February 1981. John Mortimer, Ovenden's QC, argued that Ovenden had wanted to demonstrate that collectors and dealers in Victorian photography equate age with beauty. His final summing up for Ovenden's defence caused great merriment in court, and Graham Ovenden and Howard Grey

were acquitted of the charge of conspiracy to defraud.

The other two fake or pastiche photographs were commissioned from Howard Grey and an advertising agency art director by *The Connoisseur* magazine in 1981. The female model (a) was Isabelle Anscombe, author of an article published by the magazine in May 1981: 'Daylight Robbery? Exposing the shady side of "Victorian" photography'. The magazine commissioned the photographs to show that it would be possible to make new photographs indistinguishable in their physical properties from nineteenth-century originals, to test these on experts and thus to question the basis of the market in nineteenth-century photographs. A pleasant, middle-aged lady pretended at an 'opinions' session for the public at the Victoria and Albert Museum that she had found the photographs in her attic. They were artfully mixed up with genuine photographs of the 1860s and 1870s by Francis Frith & Co. The present writer – like others consulted – took the authenticity of the photographs for granted; they appeared on a brief examination to be amateur oddities of the 1850s. The hoax was reported in the press and on television. At the request of the Museum, Howard Grey subsequently presented one 'Hetling' print and also material showing, step by step, how he made the prints for *The Connoisseur*, together with an account of the procedure which he and the art director had researched together at the British Library. The starting point was a modern camera, a Rolleiflex SL66 with a telephoto lens, and slow Ilford film. Grey's text explains:

After selecting a suitable image, a moderately contrasted enlarged positive was made on thin Kodalith paper. This had to be the same size as the finished salt print. Subsequently a high contrast negative of this print was produced by contact and development in a contrast-gaining developer. This negative was made semi-transparent with varnish. To obtain a salt print, Whatman paper dating from the 1840s was immersed in a common salt solution and dried. In the darkroom, the paper was then evenly coated – using a brush – with a

265a

solution of silver nitrate and ammonia, then dried. This rendered the paper light sensitive.

In a printing frame, the light sensitive paper was brought into contact with the paper negative and exposed to a quartz halogen light source, similar to intense sunlight, until a dense magenta/brown positive was produced. This salt print was then washed in distilled water, fixed in ordinary 'hypo' solution, washed again and dried with slight heat.

Since the print had not been toned for permanence at that stage, it was possible to 'antique' the image with photographic bleach and vegetable dye using careful brushwork.

The print was then mounted onto a page from an old photographic album with an arrowroot paste. The initials were made with pen and sepia ink and were the art director's own initials.

These photographs were made with ingenuity, but, while no one closely involved with photographs would minimise the difficulties of recognising fakes – calotype photographs of the 1840s can look freshly printed – they depended for their success to a great extent on a confidence trick. MHB

265a Howard Grey, untitled photograph of a seated woman holding hazel twigs

Salted paper print from film negative, 1981. Signed in ink on mount *G. M. W.* V&A Ph.310–1981. Given by the photographer 1981

265b Howard Grey, untitled photograph of foliage
Salted paper print from film negative, 1981
V&A Ph.313–1981. Given by the photographer 1981

265c Photograph by Howard Grey, printed by Graham Ovenden, untitled photograph of a young girl
Salted paper print from a film negative, 1974. In pencil on reverse: PHOTOGRAPH BY HOWARD GREY PRINTED BY G. S. OVENDEN V&A Ph.314–1981. Given by Howard Grey 1981

266 Modern commercial counterfeits

A range of commercial counterfeits are included. A number of them are deceptive imitations of well-known brands of luxury goods, like Chanel No. 5 perfume, Rolex and Cartier watches, Louis Vuitton luggage, Johnnie Walker Black Label whisky and Gordon's gin. Others are counterfeits of industrial components – less glamorous but potentially more dangerous and equally widespread.

The art and craft of faking: copying, embellishing and transforming

To create an accurate reproduction with a convincing aura of age, or to make a plated metal object that looks solid, requires a whole range of skills in addition to those usually possessed by the craftsman. Some of the more common methods used to produce copies for both legitimate and clandestine purposes are described below, together with a brief historical survey of plating and patination techniques. The range of techniques is as wide and sometimes as bizarre as the objects themselves. As well as creating new objects made to look old, the faker's art includes the transformation of the badly damaged or mundane into pristine works of the greatest rarity.

Making a copy

The choice of method used by the craftsman is often dictated by the purpose for which the copy is intended: to record, to teach or to deceive. Clearly a copy using the original just as an inspiration need not pay the same attention to technical detail or evidence of age that a fake must. Different methods have different strengths. Thus a hand-made copy employing traditional methods may have all the right technical details but be artistically inept; conversely, an electrotype or cast gives a perfect reproduction of the form of an object but both the materials and methods of construction are totally different.

The best results can sometimes be obtained from the same methods that were used to create the originals. Thus, for example, the ancient techniques of Greek vase painting are now fully understood, and some craftsmen are making and decorating vessels using the original technology and achieving the appearance of the originals, if not their grace (267). Coins, until quite recently, were generally struck between dies or stamped in a hand press and counterfeiters often went to the trouble of cutting their own dies (268), or even constructing ingenious engines, such as the rocker press (269).

Casting

Perhaps the easiest and oldest method of making a copy is to take a

267 An ancient Greek vase and a modern forgery

The genuine vase (a) is an Athenian black-figure lekythos of the sixth century BC, but the other (b) was made recently using methods perfected by the ancient Greeks and subsequently lost, but rediscovered through careful research. The areas which were to appear black were painted separately using a thick thixotropic mixture of illite clay – very similar in principle to modern non-drip paint. In the kiln the pots were first fired in an oxidising atmosphere which made all the surfaces orange; then the air supply was reduced, turning all the surface black and 'setting' the surface of areas covered with the thixotropic paint. Oxidising conditions were then restored and the unpainted areas turned orange again but the painted areas, now sealed, could not be reoxidised and remained black. PC

267a Genuine lekythos
H 142mm
BM GR 1864. 10–7. 180

267b Fake
H 143mm
BM GR 1973. 6–12. 1. Given by
Mrs M. Guido

267b,a

Fig. 8a

Fig. 8b

plaster cast. From this negative a positive can be cast in plaster, ceramic or metal. Since antiquity copies in bronze have been produced from original works in other materials by the technique of lost-wax casting. This involves pouring wax into the mould to make a replica which will be used in the final casting. For example, a large bronze head (once in the Getty Collection) was accepted as an original work of the Hellenistic period, until its striking similarity to a marble carving in the Naples Museum was noticed. Not only do details of the hair match exactly, but even the crack in the marble running down the left cheek has been reproduced faithfully in bronze (fig. 8).

With minor fakes, such as those undertaken for the tourist trade, the faker often avoids the trouble of a plaster cast and just makes a rough copy, often garbling the poorly understood details. In such cases copies are easy to spot (271, 272). Many counterfeit coins are cast (273), but the forgeries lack the sharp detail of the original struck coins and are not difficult to detect.

Cast replicas of major works of sculpture and of architectural details have been produced quite legitimately for centuries and collections of casts have occupied a considerable area of major museums. Museums

Fig. 8 The large bronze head (a), formerly in the Getty Collection, is a modern, faithful copy of a Hellenistic marble carving (b), now in the Naples Museum.

268

268 Coin dies and counterfeit

The dies were cut by a forger to strike counterfeit half-crowns of Charles I (1603–49).

D 48mm, 66mm (dies); D 35mm (coin)
BM CM Dies 356, 359

269 Spanish rocker press

This crude coining press of the 'rocker' or 'sway' type dates from the late sixteenth or early seventeenth century, when the rocker method of striking coins had a brief vogue. Blanks were inserted between a pair of dies with curved faces which were rocked against each other to impress the coins. The method had many drawbacks, including the need to allow for distortion during striking by producing oval dies, and it showed itself unsuitable for large-scale coin production. It was, however, very convenient for smaller-scale work by a single person, and hence for the production of siege coinages and, as was probably the case with this example, for use by counterfeiters. BJC

H 300mm
BM CM
LITERATURE J. Cribb (ed.), *Money: from*

Cowrie Shells to Credit Cards, London 1986, p. 100; D. R. Cooper, *The Art and Craft of Coinmaking*, London 1988, pp. 72–4; E. Besley, 'Rotary coining in England', in M. M. Archibald and M. R. Cowell, *Metallurgy in Numismatics* III (forthcoming)

270 Pieces of scissel from counterfeit Richmond farthing tokens of Charles I, *c.* 1625–34

The early seventeenth century saw the first large-scale issuing of officially recognised token money in England, and large numbers of counterfeit copper tokens circulated in the first part of Charles's reign. By striking at or below the minimum permitted weight the forgers could maximise their profits. Most of these forgeries were produced by the same method as the official tokens, being stamped on a strip of copper drawn through engraved cylinders. The scissel was left as waste after the tokens had been cut out. BJC

BM CM E 5020. Presented by J. P. T. Musson
LITERATURE C. W. Peck, *English Copper, Tin and Bronze coins in the British Museum 1558–1958*, London 1960, pp. 31–4, 45–6

271 Kongo figures from Zaire

The wood figure (a) has had removed from its abdomen a block of magical

269

materials but is otherwise a genuine example of a type of Kongo wood sculpture. It (or a closely similar example) has, however, served as a model for the creation of a cast from which metal versions, such as 271b have been produced. The reproductions would seem to have been made in Europe for trade in Africa, or even possibly for sale in Europe itself, brass or bronze being, to certain tastes, a 'nobler' material than wood. BJM

271a Wood. H 230mm
BM ETH 1969. Af30. 1
271b Brass. H 225mm
BM ETH 1954. Af23. 1687. Wellcome Historical Medical Museum

272 Forged *shabti*-figure and its mould

One of the most familiar items of ancient Egyptian funerary equipment was the *shabti*-figure, a small mummiform statuette intended to act as a substitute for its owner should he or she be summoned to perform any arduous manual labour in the Underworld. *Shabtis* were made in a wide variety of materials including stone, wood, faience (glazed composition), pottery and metal. The better-quality specimens are inscribed with the hieroglyphic text of the 'shabti formula', a magical spell by which the figures were to be brought to life in the Underworld.

Because of their attractive appearance and their modest size *shabtis* have always been among the most popular souvenirs brought home by tourists in Egypt. As early as the 1830s Egyptians were exploiting this demand by producing fake *shabtis* in large numbers. These are mostly made of Nile mud, cast in moulds, and occasionally contain a weight to convey the impression that they are made of stone. Few forged *shabtis* deceive the expert, since the stylistic details are rarely accurate and the inscriptions are usually nonsensical.

The *shabti* made from this mould, which dates from the late nineteenth or early twentieth century, exhibits several of the characteristic hallmarks of a forgery: incorrect proportions, unintelligible text and misunderstood

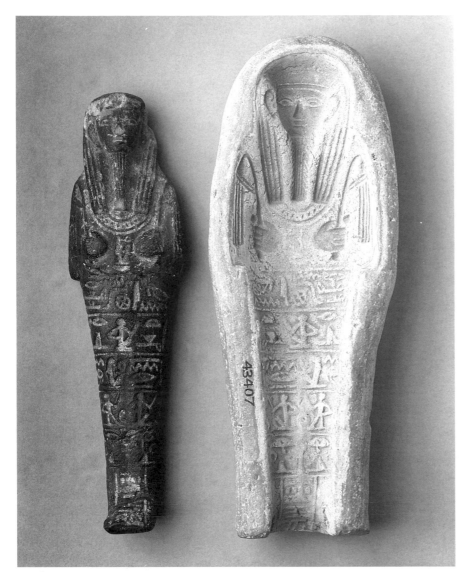

272a,b

These terracotta moulds, found in
1988 outside the walls of the Roman
city of London, were used to make
counterfeit Roman coins in about
AD 250.

273a Coin mould of Severus Alexander
(AD 222–35)
D 24mm
Museum of London

273b Coin mould of Julia Mamaea, mother
of Severus Alexander
D 25mm
Museum of London

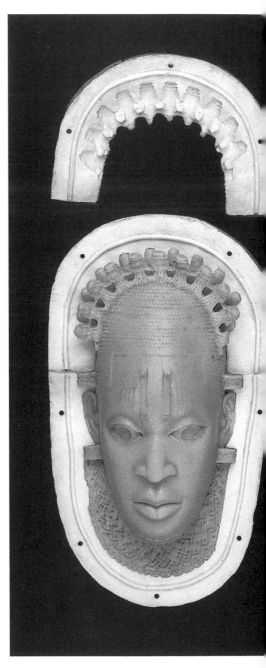

attributes (the hoes held in the hands
of genuine *shabtis* have here been
incorrectly interpreted as
flail-sceptres). Moreover, the lack of
detail on the sides and back and the
longitudinal score-marks (probably
caused by the smoothing of the
surface with a knife blade) are typical
features of the modern fake. JT

272a *Shabti*
BM EA F24
272b Mould
L 195mm
BM EA 43407
LITERATURE T. G. Wakeling, *Forged Egyptian
Antiquities*, London 1912, p. 47, pl. VI, 4

273: coin and mould

274b

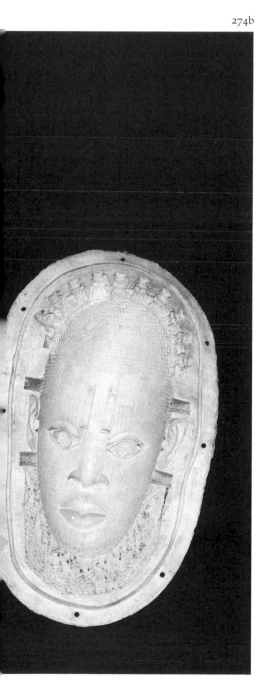

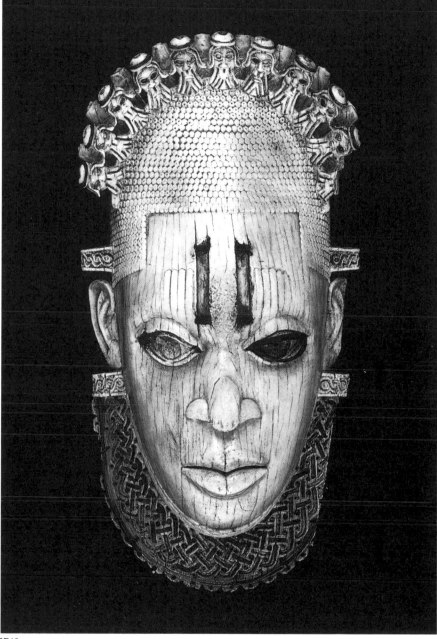

274a

274 Ivory pectoral of the Oba of
Benin and a resin cast

The original sixteenth-century ivory
has been used to make a mould, from
which a replica has been cast in resin.

274a Benin ivory
H 250mm
BM ETH 1910. 5–13, 1

274b Resin replica in plaster mould, with
two of the five sections removed

still make replicas of artefacts for other institutions. At the British Museum modern replication follows the old methods, but now moulds of plaster, gelatine, guttapercha or, more latterly, PVC have largely been replaced by silicon rubber cold-setting flexible moulds (274; see also 24).

The moulds are assembled from a number of separate sections, as it must be possible to pull the mould away freely, and the skill of the moulder lies partly in designing the mould to have as few components as possible. The usual material for casting replicas is either synthetic resin or plaster of Paris. Large objects may be cast in several parts by applying layers of plaster or resin to the separate pieces of the mould. These are then joined to produce a hollow replica, with a considerable saving in both weight and cost. The replicas are colour-matched to the original by the use of tinted resin/plaster for casting and by hand-colouring afterwards.

Pointing

This is a technique whereby precise point locations are taken all over the original, stopping just short of the surface. These are transferred as drilled holes onto the block of stone from which the copy is to be carved, until it resembles a sponge rather than a sculpture. When the pointing is complete the sculptor, or more likely an assistant, has merely to chip away the stone down to the ends of the drilled points; the sculpture then needs only the removal of a final layer of stone and polishing. The technique has frequently been claimed as ancient but there is no real evidence for this either in ancient literature or on surviving sculpture. Pointing probably developed in Italy in the seventeenth and eighteenth centuries and in the nineteenth century popular sculptors such as Canova had many assistants in their workshops, assiduously copying into stone from the master's plaster models, or from ancient sculpture for customers who preferred the antique (see p. 50).

Electrotyping

Another method of making an exact copy of an object, developed in the nineteenth century, is electrotyping. The method is still used today in preference to casting when every surface detail of the original is to be transferred. The process can best be described by following through the production of an electrotype of a typical object, in this case a gilded silver dish from the Carthage Treasure (275a).

Silicone rubber moulds are taken from the original, and the contact surface is made conductive by rubbing on powdered silver (275b). Electrodes are attached and the mould is placed in an electrolytic plating bath from which copper is deposited onto the conducting face of the mould. When a sufficient thickness of copper has been deposited, after some hours, the mould sections are removed (275c). Surplus copper is removed from the section edges and they are backed with soft solder to give weight (275d). The sections are then assembled and electroplated. The areas to be left ungilded are then lacquered (275e) and selective gilding applied (275f).

Electrotypes have been widely made as exact copies of metalwork for

275 Silver bowl from the Carthage Treasure, illustrating the process of electrotyping

The gilded silver dish (a) dates from the fourth century AD. A gilded and silver-plated replica (b-f) has been made by the process of electrotyping.

D 136mm
BM MLA Dalton Early Christian Antiquities Catalogue no. 358

275a

275d

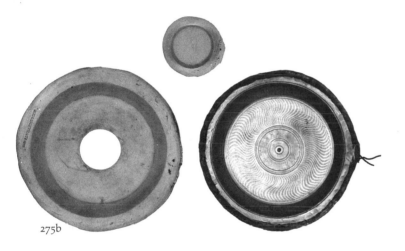

275b

275e

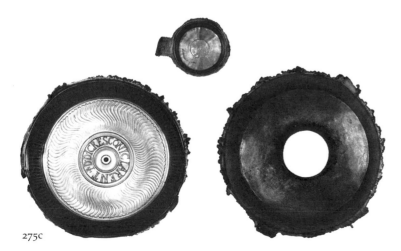

275c

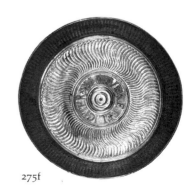

275f

276 Fragments of a sword sheath from the so-called Raab Treasure, found near Komáron, Hungary

The remains of this fifth- or sixth-century sword sheath were sold in 1891, when they comprised the chape and several binding strips. However, when offered for sale again in the 1980s three additional binding strips were present. On close inspection four were seen to be exactly identical, even down to the marks of wear and tear and accidental damage. The three strips on the left are electrotype copies of the original to their right.

L 122mm
BM MLA 1987, 3–8, 1 & 2

277a Forged noble of Henry VI

This contemporary forgery of a noble minted in 1422–7 is one of only two counterfeits in the hoard of gold coins and jewellery found at Fishpool in Nottinghamshire. A thin sheet of gold was wrapped around a silver core and then struck. Burial over the centuries has caused most of the silver to corrode away, leaving just the gold shell.

D 35mm
BM CM 1968. 4–12. 131
Illustrated on p. 256

277b Forged crown of Charles II

This contemporary counterfeit originally had a layer of silver foil, which has now disappeared, but was held to the copper core by many silver rivets. The labour involved in making this forgery must have been considerable.

D 37mm
BM CM 1954. 12–2. 2
Illustrated on p. 256

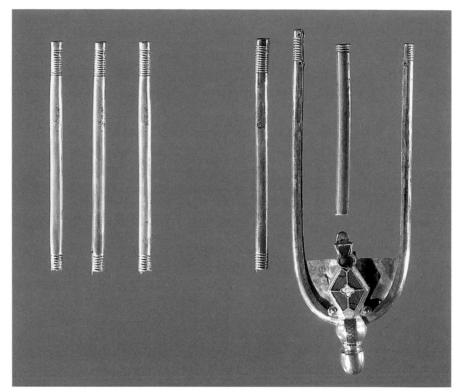

276

academic and display purposes, but only rarely for deception (276), as the method of construction and the materials are so different from the original.

Surface treatments to deceive and delight

Plating

From the earliest times base metals have been covered with more expensive materials. As with copying itself, the motives have been mixed – innocent improvement as well as deception. At the simplest level a foil of the precious metal is wrapped around the base metal, as in the forged noble from the Fishpool hoard (277a). This cannot have been very convincing, and sometimes the forgers experimented with quite extraordinary methods, as with the counterfeit crown of Charles II (277b).

Another problem for those counterfeiting gold coins is that gold is much denser than most other metals, and thus a gold-plated forgery is very perceptibly light. Even lead is less dense than gold and is anyway so soft and difficult to gild that it could not imitate a gold coin. Just occasionally economic conditions have come to the aid of the counterfeiter. For example, in the nineteenth century the output of platinum exceeded demand, and its price fell substantially below that of silver. Platinum was first discovered in the Spanish colonies in South America and was used in some countries for coinage, notably in Spain itself (though mostly only for patterns) and Russia, which also had

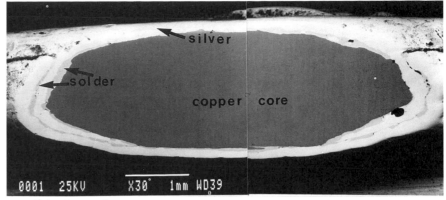

279: photomicrograph

277c Counterfeit sovereign of Victoria, 1869

Gilded platinum. D 22mm
BM CM 1906. 11–3. 3814. Given by F. Parkes Weber

278 Silver-plated cups, 1st century AD

A thin silver foil has been soldered to the brass body metal of the stand using a lead-based low melting point soft solder.

H 22mm
BM GR 1889. 10–19. 2,3; 1890. 9–23.12
(Catalogue of Silver Plate 173, 4 & 5)

279 Contemporary silver-plated forgery of an ancient Greek coin of the city of Byzantium, c. 400 BC

The copper base of this forgery shows through the silver plating where the edge has been polished. The accompanying photomicrograph of this area shows the light silver foil firmly bonded to the copper substrate by a copper-silver hard solder. Where the silver foil overlaps on the left hand side some of this solder can be seen.

D 17.5mm
BM CM BMC 9

280 Minoan dagger

This bronze dagger has silver-plated copper rivets. Metallographic examination showed that the silver foil was fused to the copper, either with a hard copper-silver solder or, more probably, by fusion welding. This is the earliest example of the technique more commonly known nowadays as Sheffield Plating.

L 270mm
Museum of Archaeology and Anthropology, Cambridge, 1925–832

substantial deposits of the metal. Spain was the source of a large proportion of nineteenth-century platinum counterfeits. As it is similar in weight to gold and of high striking quality, it was very useful to counterfeiters, who merely needed to gild their platinum copies of current gold coins (277c). Interestingly, platinum today has about twice the value of gold.

The usual method of silver plating in antiquity was to solder silver foil to the surface, using either a soft solder with a low melting point (278) or, for a firmer, more durable bond, a hard solder with a high melting point (279). Alternatively a bond could be formed by heating the silver foil whilst in close contact with the copper base metal, a process known as fusion welding (280). In the eighteenth century, when it was re-discovered by Thomas Bolsover, this process came to be known as Sheffield Plating. Sheffield Plate enjoyed great popularity for the next century and is now avidly collected. Deception was rare but in the early days some pieces were passed off as solid silver and were given stamped marks very similar to the hallmarks on genuine silver items (281). The problem was so serious that Parliament banned false marks on plated items in 1773; but the practice of adding a row of stamped marks on silver-plated items continued well into the age of electroplate.

The alchemists and arsenic plating

Related to the processes of gilding were the techniques used by alchemists to change at least the outward appearance of metals, if not their fundamental nature. How much they really believed in their transmutations of base into precious metal in a literal sense is not certain, but where the chemical processes can be followed in the alchemic literature they seem to have been capable of producing a golden surface coloration with materials such as calcium polysulphides (rotten eggs) or a silvery alloy by treatment with arsenic salts.

Contemporary manuals for craftsmen gave very similar recipes and there seems little doubt that the intention was to deceive. One such recipe, from the Mappae Clavicula (eighth to ninth century AD) reads:

Melt together 4 parts of copper, 1 part of silver, and add 4 parts of unburnt orpiment [arsenic sulphide], and when you have heated it, let cool and put in a pan – coat the pan with potters clay – and roast it, until it becomes a cherry red; take it out and melt it, and you will find silver.

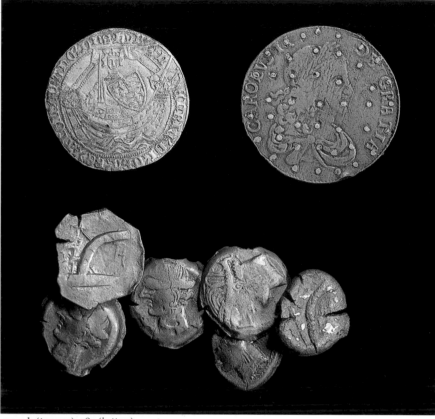

277a,b (*top row*); 282 (*bottom*)

281 Silver-plated cup and cover

This standing cup and cover was probably made in the 1760s. It is of Sheffield Plate, which is of very similar appearance to solid silver, especially if as here it carries marks not dissimilar to real assay or hallmarks.

H 200mm
V&A M. 199–1920

282 Carthaginian coins

These coins are part of a hoard dating from the time of the Libyan revolt in the third century BC. They contain between 5% and 12% of arsenic in the copper overall, but this is concentrated to about 20% at the surface, giving a silvery appearance to the coins. It is not certain whether these were intended to deceive, or merely to appear silvery.

BM CM 1987. 9–13. 1 to 67

283 Dollars of George III, 1804

The fake coin (a) has been mercury silvered, while the genuine piece (b) is made from solid silver.

D 40mm
BM CM E5067 (a), E4081 (b)

284 Chinese gilt-bronze bears

The substantial figure (a) was believed to date from the Chinese Han dynasty, about 200 BC. If genuine the bear would have been mercury gilded, and even after two thousand years some traces of mercury should still have persisted in the gold, but in fact the gilding contained none. It also has many small blisters that are characteristic of electroplating on a poorly prepared surface. This and the false patina suggest the bear is recent.

Genuine Han dynasty bear figures were small, and were usually used as feet for lacquer or bronze vessels (b).

284a 20th century
H 172mm
BM OA 1947. 7–12. 382. Oppenheim Bequest
284b Han dynasty, 2nd–1st century BC
H 55mm
BM OA 1947. 7–12. 378. Oppenheim Bequest

This would have produced an alloy rich in arsenic which would have tended to concentrate at the surface making it appear very silvery. Alternatively, the surface could have been covered with a paste of arsenic salts and charcoal dust and reduced *in situ* with a blowpipe to give a silvery surface.

Although numerous descriptions of arsenic treatments survive in alchemic works from China to Rome very few actual arsenic-plated objects have yet been identified. However, a hoard of bronze coins from Carthage (282) has recently been found and these have a high arsenic content. They must once have looked very silvery, and even now are still grey.

Mercury amalgam plating

Mercury forms amalgams with a number of metals and this property was appreciated and utilised in both China and the classical world over two thousand years ago. The technique continued in use almost up to the present day. Filings of the precious metal were mixed with mercury to form the amalgam, graphically described in the nineteenth century manuals as 'butter of mercury'. This was spread on the base metal, and the mercury was removed by gently heating to its boiling point (357°C), leaving the precious metal adhering firmly to the body metal.

Mercury gilding, also known as fire-gilding or parcel-gilding, gives a very durable plating and was much used by both legitimate craftsmen

and forgers. Mercury silvering was less common, at least in the West, but was popular with coin forgers in recent centuries (283).

Electroplating

From the late eighteenth century scientists and inventors endeavoured to perfect an electroplating technique which would give a stable, firmly adhering, smooth plated layer. In 1840 the Elkington brothers in Birmingham discovered that metals in a cyanide solution could be

284a

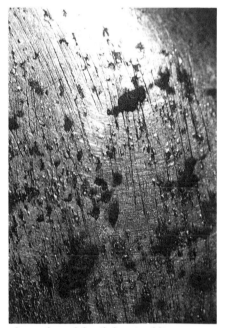

284a: enlarged detail showing blisters characteristic of electroplating on poorly prepared surface

284b

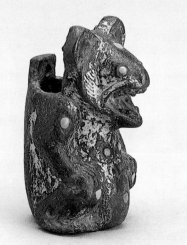

285 Chinese sleeve weight

This bronze weight, possibly dating to about AD 1600, has been made in the style of more than a thousand years earlier. An imitation patina has been applied by placing fragments of mineral malachite onto the bronze.

L 68mm
BM OA 1984. 4–8. 8

286 Roman bronzes: genuine and false patinas

The hand (a) is a genuine Roman bronze of the first century AD, but was repatinated by the great collector Richard Payne Knight in the early nineteenth century to give it the black appearance he and other early collectors were convinced it had originally possessed. The statuette of Athena Isis Tyche (b) is of the second century AD and is of similar composition but it retains its natural patination.

286a Repatinated symbolic hand
L 146mm
BM GR 1824. 4–41. 1 (Catalogue of Bronzes 875)

286b Naturally patinated statuette
H 140mm
BM GR 1920. 2–18. 1

286a,b

successfully electroplated onto copper, and this process rapidly superseded all other forms of gilding or silvering. Forgers often use electroplating on objects in imitation of earlier plating techniques, but careful examination can often reveal tell-tale marks and imperfections typical of electroplating (284). However, there is always the possibility in such cases that a genuine item may have been replated.

Patination

Most materials deteriorate and corrode with age, especially if buried in the ground. Many decay away completely, and metals, glass and even stone and ceramics slowly corrode at the surface. This surface corrosion is known as patination, and is often a strong indication that the object has been buried, or at least neglected for a very considerable time. The production of a convincing patina has therefore been of great interest to those engaged in faking or restoration.

Metals often corrode to give a very pleasing patina, which is usually made up of a mixture of oxides and carbonates with some chlorides,

287 Patinated bowl

The patina on this bowl has been produced by treating with a mixture of chemicals soaked through sawdust. It is one of a range of attractive finishes developed in the 1970s by Michael Rowe and Richard Hughes whilst at Camberwell School of Arts and Crafts, London.

D 180mm
Private Collection

288 *Shakudō* sword guard (*tsuba*)

The superb dark patination on this genuine nineteenth-century Japanese *tsuba* is a good example of *shakudō* work. It has been inlaid with other metals to give a very pleasing polychrome effect.

62 × 49mm
BM JA 3432

289 Repatinated Etruscan incense-burner

This bronze incense-burner is a genuine Etruscan antiquity, but the patination is completely false. It contains lead and copper carbonates developed *in situ* on the heavily leaded bronze by treatment with chemicals. The patina is visually quite satisfactory but it is very loose, revealing clean metal beneath. The piece was acquired by the British Museum in the nineteenth century from the famous dealer and jeweller Alessandro Castellani of Rome (see also 1, 151f, 172). As well as producing superb jewellery in the 'archaeological style', Castellani's workshop also carried out extensive restorations and improvements of antiquities and was not above producing complete fakes. It is possible that when this piece was first discovered the patina was roughly removed, thereby greatly reducing its value. Castellani gave it a completely new patina to restore its value before attempting to sell it. PC

H 544mm
BM GR 1873. 8–20. 211 (Catalogue of Bronzes 780)

sulphides and sulphates. The familiar green patination which forms on copper alloys is usually the hydroxy-carbonate, malachite, or if formed in salty conditions the chloride, atacamite. Patina has been appreciated as an important element in the value and aesthetic appreciation of bronzes since the Renaissance in Europe and much earlier in China. The Chinese already had a highly developed sense of history and antiquarian interest over two thousand years ago, and bronzes dug up from burials of the Shang period (*c.* 1700–*c.* 1050 BC) and other Bronze Age cultures were greatly admired and collected. These bronzes were of course patinated during many centuries of burial, and imitations made in the Song (AD 1137–1279) and Ming (AD 1368–1644) dynasties often had a synthetic patination applied to them. These are amongst the earliest examples of false patina, although the intent was probably to decorate or imitate rather than to deceive (285).

The classical world also held the artistic achievement of their forebears in high esteem, and the Romans, for example, collected earlier Greek bronzes and also produced new work in deliberately archaic style. However, there is no evidence to suggest that they either appreciated the patina that some of the old pieces recovered from the ground must have possessed or attempted to replicate it on the new pieces inspired by the old. Contemporary Greek and Roman wall-paintings of scenes that include statuary invariably show them as being flesh- or bronze-coloured, never green or black. This suggests that the Romans preferred their bronzes clean, and indeed a number of contemporary contracts for cleaning and polishing statuary in public places survive. Additional evidence comes from the surviving statues themselves,

289: detail of foot

290 Modern flint axe

This is a modern copy of a Palaeolithic handaxe specially made for this exhibition by P. Harding out of flint from Brandon in Suffolk near the prehistoric flint mines of Grime's Graves. Part of the axe has been artificially patinated using strong alkali to simulate the appearance it would have acquired during thousands of years of burial in chalky soil. The upper part has been left unpatinated to show the contrast.

L 140mm

where a good deal of polychrome detail was often added. Thus the lips and nipples were often of red copper inlaid into the golden bronze of the rest of the statue. This colour contrast would only have been apparent if the metal was kept polished.

Collectors from the Renaissance onwards were, however, firmly of the opinion that the bronzes were originally patinated, and indeed some passages in the works of Pliny and Pausanias do specify certain alloys as taking on or absorbing colour, suggesting some form of deliberate patination. Later collectors came to believe that not only were antique bronzes regularly patinated, but that this patina was black. How this belief came about is not clear now, but may be attributed to a chance comment by Pliny in the *Natural History* concerning the treatment of bronzes with bitumen. Some bronzes, especially those with a high tin content such as mirrors, did sometimes come out of the ground with a fine black patina, but to the disappointment of the antiquarians most did not. Some collectors were not above scraping off the genuine natural patina acquired over the centuries and replacing it with the patina they felt it *ought* to have had (286). When carrying out authenticity tests on suspect bronzes the patina is carefully studied and the possible repatination of an otherwise genuine piece is yet another factor to be taken into account.

In the nineteenth century an enormous number of chemical treatments and recipes were devised to produce patinations of every hue and texture. Many of the treatments involved the salts of antimony and arsenic applied to the surface in some moderately corrosive medium. The results were, and indeed often still are, very attractive. However, in this century interest declined and many of the recipes have been lost. The range of colours and textures was much restricted, and 'bronzed' or 'antique' finishes have normally been produced in this century with solutions containing copper salts and ammonium chloride or potassium sulphide. Very recently there has been a revival of interest in Europe and America in chemical patination (287).

In the Far East there is a continuing tradition of producing patinas on copper alloys known as *shakudō* (288). These alloys, of copper with small amounts of gold and silver, are treated with solutions of metal salts in organic acids derived from fruit such as the bitter plum. They were much admired in nineteenth-century Europe, and scientists and artists carried out experiments trying to replicate these effects.

The patination described so far was applied purely for decorative effect or to enhance an antiquity. However, patinas are also applied to bronzes to deceive, to make a modern fake appear ancient or to disguise a repair or addition. Fortunately, for curators at least, to create a convincing patina is not easy. Basically there are two approaches: the faker can either attack the surface with chemicals to produce a patina (289), or he can attach ground-up minerals of correct colour and texture to the surface. With both methods it is difficult to get the patina to adhere as firmly as it would have done if it had developed slowly over the centuries, and the false patina can usually be detected scientifically.

False patinas are usually associated with metalwork, especially bronzes, but other materials have also been treated to create the appearance of great age. For example, in the late nineteenth century there was a vogue for collecting prehistoric flint implements, and good

specimens could command high prices. This, naturally enough, led to the production of fake implements for sale. The work involved not only flaking the tools, but also patinating them. Where the flints had lain in a chalk alkaline soil they developed a milky white or brown patina, and it was discovered that boiling the flint in strong caustic soda solution rapidly gave the desired effect (290). A brown patina was produced by the addition of some rusty nails to the caustic soda solution.

Fake antique silver

From early times gold and silver objects were tested and marked with a control stamp to guarantee the purity of the metal. The assaying and stamping of silver objects with a hallmark has been carried on for centuries by the Goldsmiths' Company at their Hall in London and at other regional centres in Britain. In the past fakers would make items of base silver and give them false marks. In modern times, however, antique silver has a value far in excess of the metal value, and fakers have copied the old marks, not to pass off base metal as silver, but to suggest that a modern copy is an antique.

There are three principal methods open to the faker. He can attempt to imitate genuine punches. Of course, the resulting mark must not look too fresh, so it will be heavily buffed, or the punch itself will be made with rather rounded edges to produce a 'softer' impression. The Goldsmiths' Company keep impressions of all the punches used in the past, and are continually examining the hallmarks on genuine pieces, so that it would be very difficult for a hallmark made from a fake punch to escape notice.

An alternative is to cut genuine hallmarks from worn-out or badly damaged antiques and insert them into freshly made pieces. It can be difficult to disguise the join, but this can sometimes be done by making the decoration follow the line of the join (294).

A third method is to convert worn-out silver into something more valuable, whilst retaining the marks, sometimes producing superb anachronisms (293), or to convert a relatively common item, such as an eighteenth-century spoon, into a much rarer and more expensive fork. The latter is a fairly common transformation as the hallmark is on the shank and not damaged. An easy method is to cut off the bowl of the spoon and replace it with a set of prongs for the fork, but the soldered joint is difficult to conceal (292). A more sophisticated job can be done by first hammering the bowl of the spoon flat and then turning up the edges to form a rectangular tray. Additional silver is poured in and the filled tray is then beaten to the correct profile. The prongs are cut out, filed and polished. The hallmarks are preserved, and there is no soldered join, but even so the transformation can be detected by scientific examination at the Goldsmiths' Laboratories.

In the late nineteenth century there was a spate of fake antique silver produced in Britain, and the Goldsmiths' Company acted firmly to control the problem. A particularly notorious case was uncovered in 1898 when the shop of Reuben Lyon was raided and hundreds of pieces bearing fake hallmarks were found. Further enquiries over many months eventually led to the discovery of their maker, Charles

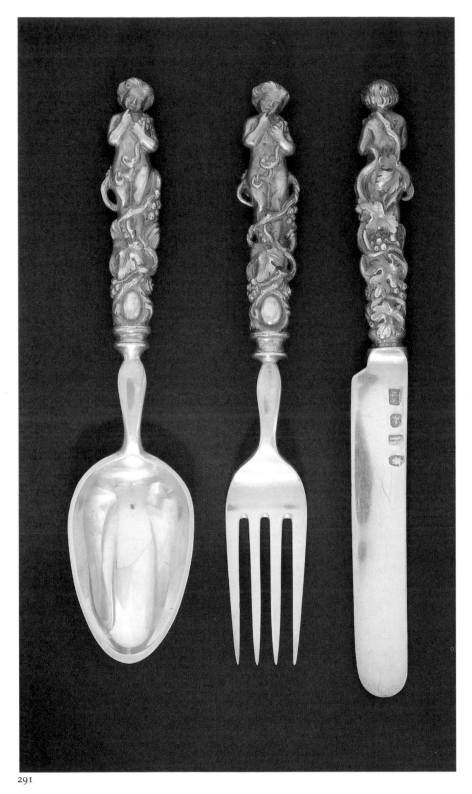

291 Silver knife, fork and spoon set with fake punch marks

This set was made by Charles Twinam in the 1890s bearing false hallmarks for London 1783 (the date letter is the 'h', third letter along). It was recognised and acquired by the Goldsmiths' Company in the 1950s when it appeared on the market.

L 196mm (knife), 180mm (fork), 180mm (spoon)
Goldsmiths' Company, cat. no. 187

292 Transforming spoons into forks

The single fork (a), apparently dating from 1777, is made up of the hallmarked shank of a spoon soldered to a much later fork end. The soldered lap joint is rather crudely executed and clearly visible.

A more sophisticated method of turning spoons into the more collectable forks is represented by the six-piece set (b).

292a Single fork,
L 177mm
Goldsmiths' Company, cat. no. 147

292b Spoons into forks: set of 6
Goldsmiths' Company

291

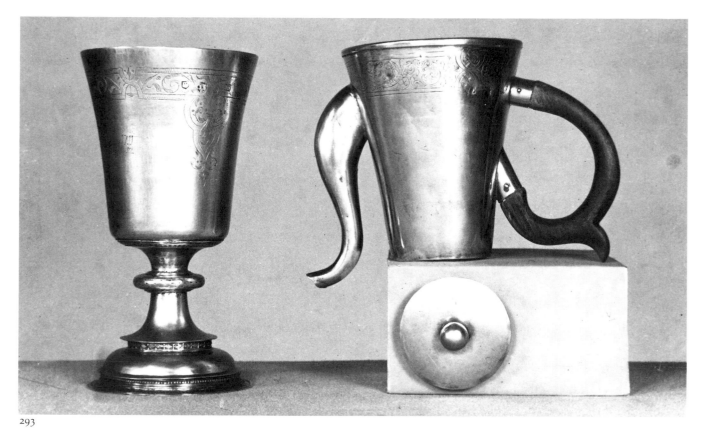

293

293 From chalice to coffee pot

This 'coffee pot' has been made out of the inverted bowl of a late medieval chalice. It retains its perfectly genuine hallmarks for the early sixteenth century, predating the use of coffee in Britain by well over a century.

H 160mm
Goldsmiths' Company, cat. no. 56

294 Fake '18th-century' silver ewer with genuine hallmarks

This ewer is a very Victorian copy of an eighteenth-century piece, but carries the perfectly genuine hallmarks of London for 1765. Close examination reveals these have been cut from another piece and soldered in. The decoration has been designed to cover and disguise the join.

H 200mm
Goldsmiths' Company, cat. no. 22

Twinam, and hundreds more fakes were found at his home and workshop in Holloway, together with the fake punches he had used to produce the hallmarks. Although many hundreds of pieces were seized and melted down, many more had already been sold and still regularly surface on the market even now (291).

Copying prints

The most direct way of copying a print is simply to draw it free-hand (296b), although tremendous skill and patience is required to produce a convincing result. Very occasionally the faker took the trouble actually to reproduce the plate, so that a whole faked edition could be printed. If he worked from an engraving rather than the original plate, then he would have to engrave the image in reverse, possibly using a mirror (297).

The introduction of photography in the mid-nineteenth century opened up a whole range of interesting possibilities, both for legitimate copies for illustrations in books and for fakes. In some instances a photograph was itself passed off as an original, but in general the distinctive surface of the photographic print gave it away. Processes such as photogravure (27) could be much more difficult for the unwary to detect, especially if the print was mounted behind glass. Prints made by high-quality photomechanical processes can be made more convincing by being printed on old paper with the appropriate ageing techniques (298).

295 Martin Schongauer (*c.* 1450–91), *The Virgin and Child with a parrot*, early 1470s: a deceptive restoration

The British Museum has since the eighteenth century owned the unique impression of the first state of this print, with the engraving not yet complete. It was therefore natural that it should wish to acquire an impression of the much commoner second state when one came up for auction in 1891 (a). Unfortunately, after the sale someone spotted that the bottom 8mm of the print had been cut off and replaced by a facsimile drawn in pen and ink. As chance would have it, the Museum was able to purchase a perfect impression of the same state four years later (b). AVG

Two impressions of the second state.
159 × 155mm

295a Restored
BM PD 1891. 10–15. 11

295b Complete
BM PD 1895. 9–15. 256. Malcolm Collection

LITERATURE M. Lehrs, *Geschichte und Kritischer Katalog des . . . Kupferstichs im XV. Jahrhundert. V Martin Schongauer und seine Schule*, Vienna 1926, pp. 188–90

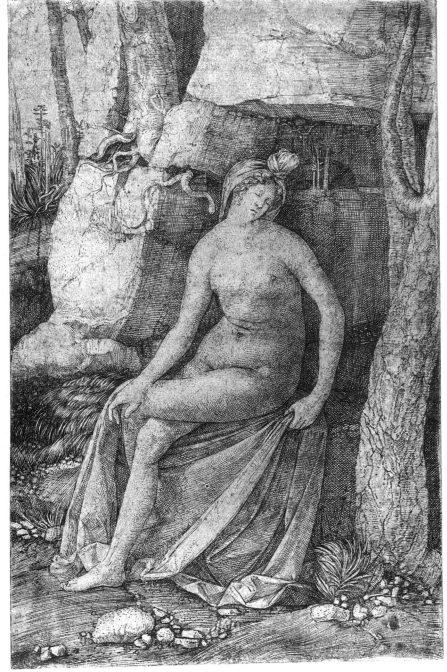

296a

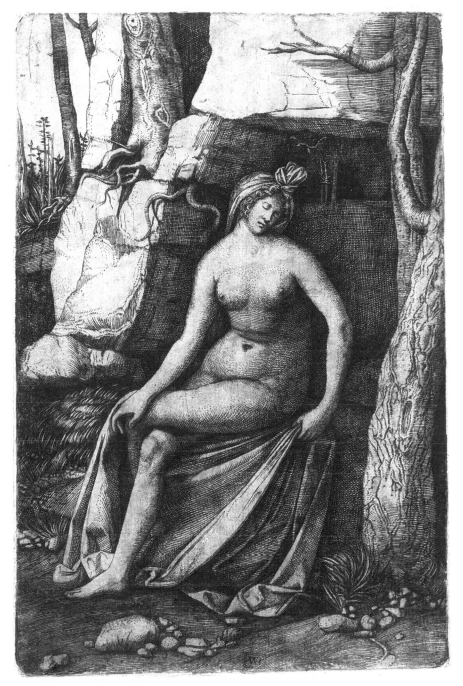

296b

296 Jacopo de' Barbari (*c.* 1460/70 – before 1516), *'Cleopatra'*: an original engraving and a hand-drawn copy

The British Museum acquired in 1854 one of the seven known impressions of Barbari's engraving *'Cleopatra'* (perhaps *c.* 1510), so called because the root of the tree by the head of the female figure looks very much like an asp. This impression is weak and faintly printed, so that when another impression of the print described as 'splendid' turned up at the sale of the collection of Luigi Angiolini of Milan in 1895 (b) Colnaghi's were commissioned by the Museum to purchase it, which they did for 72 marks – a suspiciously low price, since another Barbari print in the same sale fetched 660 marks.

Comparison with the genuine print already in the collection showed the lines to be thick and coarse, not like the precise silvery lines that one would expect from a Barbari engraving, and it was registered as a 'fine early copy, or possibly the original plate reworked'.

It was not until Hind compiled his great corpus of early Italian engraving that the truth was revealed, and the register further annotated: 'a pen and ink fabrication'. That it was intended to deceive is shown by the initials WB at the bottom centre, which purport to be the mark of some collector. F. Lugt (*Les Marques de Collections*, Amsterdam 1921, no. 2605) records it only as an 'unidentified mark found on prints of the XV and XVI centuries'. The truth must be that it is an invented mark used by the same faker on a number of his products, thus almost becoming his trademark. AVG

296a de' Barbari, *'Cleopatra'*
Engraving. 179 × 117mm
BM PD 1854. 6–28. 127

296b Pen and ink copy
BM PD 1895. 6–17. 52

LITERATURE A. M. Hind, *Early Italian Engraving* II, London 1948, p. 157, no. 27

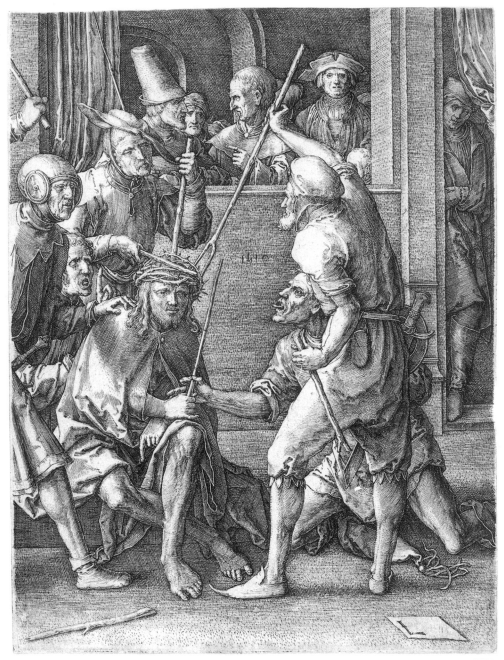

297a

297 Lucas van Leyden, *The Mocking of Christ*: original engraving and copy

Lucas van Leyden (1494–1533) was one of the greatest masters of engraving in the Netherlands, and his work was copied from an early date. Some of the copies are so astonishingly good that detection is extremely difficult. These two impressions of the *Mocking of Christ* (1519) are virtually identical, and it is only by minute comparison of details that we can be sure that we are dealing with two different plates. For example, in the mouth of the man standing at the left there is an extra horizontal line in the copy (b) that makes it appear that his tongue is sticking out. The watermark of the paper shows that it was made very soon after Lucas's original. It is unlikely to be a replica by Lucas, for why should he take such trouble to imitate himself? But as a copy it is an astounding

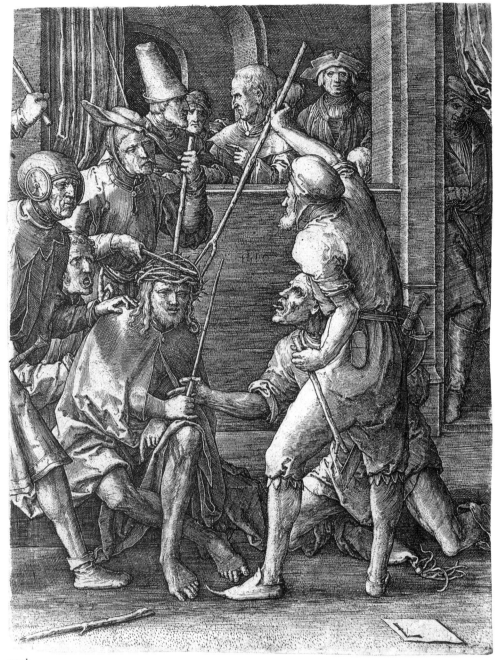

297b

achievement; the plate must have been engraved free-hand in the opposite direction to the print from which it was copied (since the image reverses when printed). It was only identified in the late 1960s by John Rowlands, the present Keeper of the Department of Prints and Drawings. AVG

297a Original
Engraving. 170 × 128mm
BM PD K.k 6–93

297b Copy
BM PD 1958. 7–12. 108

LITERATURE E. S. Jacobowitz & S. L. Stepanek, *The prints of Lucas van Leyden and his contemporaries*, Washington 1983, especially p. 211

298a

298b

298 Urs Graf's *Standard-Bearers* and line-block reproductions

The first pair of prints (a) come from a very rare series of sixteen showing the standard-bearers of the different cantons in the Swiss Confederacy, made by Urs Graf (*c.* 1485–1527/8) in 1521. No complete series survives, and most of the prints are known in only three or four impressions. The series has always been famous and sought after because of its unusual technique: instead of cutting away the background so that the lines stand in relief to print black (the usual woodcut procedure), Graf has here cut the lines directly into the block so that the design stands out as white against black.

The second pair (b) are modern facsimiles made by the photo-mechanical line-block process, by which a relief printing surface is produced from a photographic negative made from an original impression. This has been the standard process of making reproductions of relief prints since the late nineteenth century. What makes these two examples unusual is the care that has been taken to disguise their origins. Both have been printed onto genuine early sixteenth-century paper, and the faker has added very convincing stain marks as well as spots of glue in the corners to give the impression that the prints have been extracted from an old album. If the originals had been less rare the imposture might well have remained undiscovered, but close examination revealed the truth: the metal line-block surface has produced a uniform blackness in the background but the originals show the grain of the wood from which they were printed. AVG

298a Urs Graf, *The Standard-Bearers of Friburg and Basel*, 1521
White-line woodcuts. 190 × 108mm (approx.)
BM PD 1924. 6–17. 21; 1845. 8–9. 1730

298b After Urs Graf, *The Standard-Bearers of Zurich and Bern*
Line-block reproductions
BM PD 1970. 7–13. 4 & 5. Presented by August Laube

LITERATURE J. K. Rowlands (compiler), *Hollstein's German Engravings. Etchings and Woodcuts. XI Urs Graf.* Amsterdam 1977, pp. 55–63

299 'Rembrandt', *Self-portrait with the artist's mother*

The 'Rembrandt' *Self-portrait with his mother* (e) is a falsification, made by skilfully joining sheets from two etchings: *Self-portrait with Saskia* (a,b) and *The artist's mother with her hand on her chest* (c,d). The image of Saskia has been replaced with that of Rembrandt's mother. Sections of the plate of the latter were masked before printing in order to erase the dark background. The forgery may have been done by Claude-Henri Watelet, who owned and republished these and other etched plates by Rembrandt in the eighteenth century. Six 'impressions' of the forgery are recorded. MRK

299a,b Rembrandt, *Self-portrait with Saskia*
Etching. 104 × 95mm

a 2nd state
BM PD 1973. U. 883. Cracherode Collection

b 3rd state
BM PD 1843. 6–7. 12

299c,d Rembrandt, *The artist's mother with her hand on her chest*
Etching. 94 × 66mm

c 1st state
BM PD 1843. 6–7. 216

d 2nd state
BM PD 1973. U. 782. Cracherode Collection

299e Fake: *Self-portrait with the artist's mother*
BM PD 1973. U. 884

299b

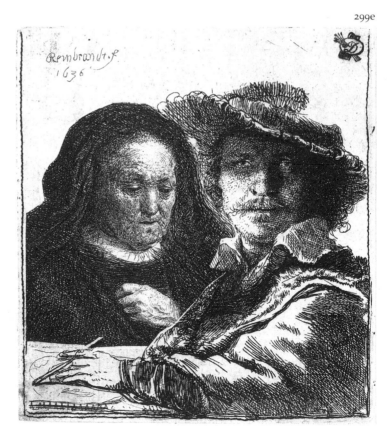

299e

Restoration and transformation

Badly damaged or inferior objects can have their value very considerably increased by suitable treatment. The degree of restoration that should be carried out on an object is today a very contentious issue. Legitimate restoration of the kind that would be carried out in a museum strives to achieve a balance whereby the new work is clearly distinct from the original, whilst giving the overall impression of how the piece must originally have appeared. On the other hand, fraudulent resoration (300) seeks to hide any damage that exists.

Various techniques can be used to transform an object, to turn the anonymous into the famous, and the everyday into the rare. Thus a depiction of an anonymous or minor personage may be altered to resemble someone of historic importance, such as a king (302), or changed to suit the taste of collectors (301). PC

300 Egyptian statuette of a man with a statue of Osiris

This sculpture was part of the collection formed by Sigmund Freud. The group is iconographically highly unusual: examination revealed why. By ordinary light the group appears intact but radiography shows extensive damage, with large areas missing and made up with plaster. Osiris' head, which has been fixed to the body by a metal dowel, does not belong to the group at all.

H 300mm
Freud Museum, LDFRD 3132

301 Portrait head of 'Nero'

This head, worked to fit into a statue, was purchased by Charles Townley in London in 1778 from another English collector, Lyde Browne, who had acquired it in 1775 at the sale of the collection of Dr Anthony Askew. Askew is said to have brought the head to London from Greece in 1740.

Within the British Museum the head has had a chequered existence. Condemned as a forgery, it was passed from Greek and Roman to British and Medieval Antiquities. In 1967 it was returned, its reputation heightened by association with the other antiquities brought from Greece by Askew, which are of undoubted authenticity. Moreover, it is difficult to imagine a workshop of forgers active in Athens before 1740.

However, the head is clearly not a contemporary portrait of Nero (AD 54–68). The crude cutting of the eyes and fringe are untypical of Roman work in first-century Greece. The features bear little relation to the two surviving representations in stone of

300

300: radiograph

301

the coin portrait of AD 64, on which the head is based.

If it is not entirely an eighteenth-century creation, the head may have been substantially recut to attract collectors. A possible motive may have been collectors' enthusiasm for Nero, one of the subjects of Suetonius' biographies *The Twelve Caesars*, and the lack of surviving ancient portraits of him. Hadrian was excluded from the biographies, and the head of Nero may have been recut from one of this emperor, of which many examples have survived in Greece. The original must have been wreathed, to judge by the exaggerated height of Nero's fringe and the depth of hair at the nape of his neck. Though wreaths were not generally a feature of his coiffure, a head of Hadrian from an over-life-sized cuirassed statue with oak wreath, now in Chania Museum (Crete), gives some notion of the possible original form of this portrait.

Fine-grained micaceous marble, probably Pentelic. H 425mm
BM GR 1805. 7–3. 246 (Catalogue of Greek Sculpture 1887)
LITERATURE M. Wegner, *Hadrian*, Berlin 1956, p. 95 and pl. 24 (portrait in Chania); M. Bergmann-Zankers, '''Damnatio Memoriae''; umgearbeitete Nero- und Domitiansporträt', *Jahrbuch des Deutschen Archäologischen Instituts* 96 (1981), pp. 317–412, esp. figs 9–10, pp. 328–9 (surviving stone portraits of Nero); B. F. Cook, *The Townley Marbles*, London 1985, p. 27

302 Portrait of Edward VI of England (1537–53)

Although at first glance a convincing portrait, the sitter's awkward stance and the general woodenness of the execution give grounds for suspicion. In addition, when the picture is viewed in raking light it is possible to discern on either side of the king's legs the outlines of a rounded skirt that emerges ghost-like from the dark background.

Examination by x-radiography reveals the presence of a young girl concealed beneath the image of the king. She holds a carnation or pink, traditionally the symbol of a betrothal portrait. Details of her costume

suggest a date between 1610 and the early 1620s. A Netherlandish provenance has been proposed for this painting.

The artist has employed great economy of means in adopting the earlier portrait to that of the boy king. The girl's hair-line has been extended to give a high forehead but otherwise the contours of the lace, hands and sleeves have been followed quite closely. The carnation has been converted into a tasselled dagger. The boy's costume probably derives from a

sixteenth-century portrait and although correct in most respects lacks accuracy in certain details.

The stiffness apparent in this portrait corresponds to the more schematic and hierarchical images associated with English portraiture in the seventeenth century, and the way in which the artist has applied nodules of paint in high relief is a characteristic feature of English painting at this time. PY

Oil on panel. 1111mm × 635mm
V&A F.47. Forster Bequest

302: radiograph

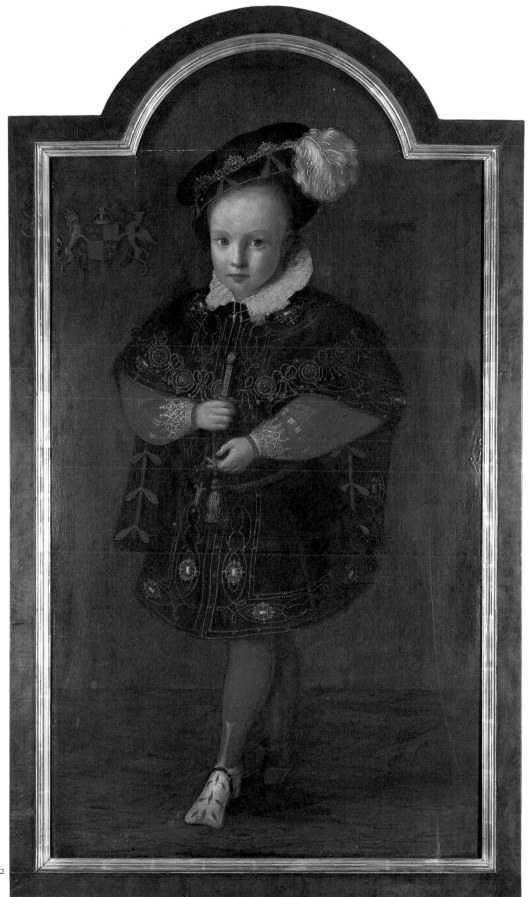

302

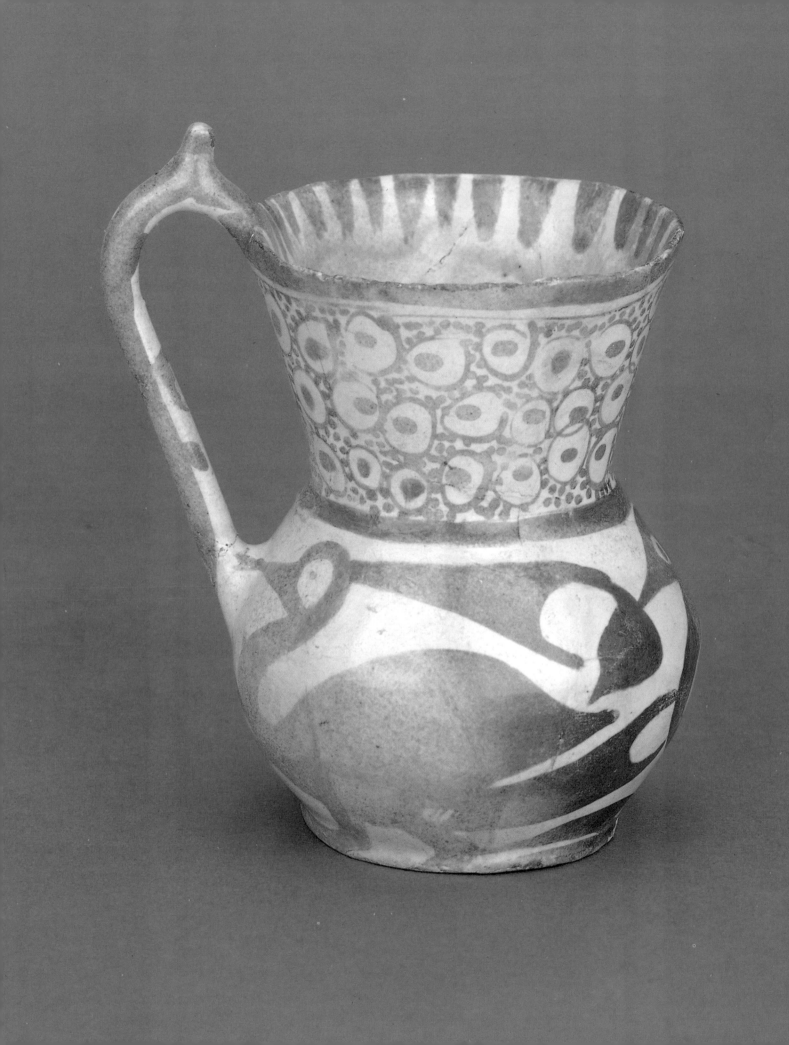

9

The scientific detection of fakes and forgeries

Scientific and technical examination, using a wide variety of approaches and techniques, can unmask fakes and restorations in much the same way that forensic methods are used in criminal investigations. The problems posed in authenticity investigations are often more complex and subtle than simply: is it fake or genuine? The questions are rather: how much is genuine, and how much is recent restoration and embellishment? Is the piece made up of unassociated

307

307: radiograph

THE SCIENTIFIC DETECTION OF FAKES AND FORGERIES

pieces? The value of the whole is considerably greater than the sum of the parts, as far as the antiquities market is concerned. The investigator must also keep in mind the many reasons for producing copies, discussed in earlier chapters.

Thus, in order to be effective the scientific investigator relies heavily on co-operation and interaction with the art historian to establish the correct approach to the investigation, as well as to define the specific problems. It is, for example, of no real help to pronounce an object such as the Egyptian oyster shell pendant (306) genuine when the real interest of the piece is the authenticity of its inscription.

There are two main approaches to the scientific detection of fakes: studying the materials and methods of construction to ascertain if these are commensurate with the apparent age of the object, and, secondly, looking for evidence of age, such as the formation of a patina on glass or metals, or more fundamental processes such as radiocarbon decay in organic material or the build-up of thermoluminescence in some crystalline materials. These dating methods, together with dendro-chronology, can sometimes go beyond an indication of age and give an actual date, as for example with the Turin Shroud (317). Thus a wide variety of scientific methods and techniques, combined with a broad knowledge of early technology and experience in how materials be-have, can uncover a wealth of information about the history of the objects under investigation. However, problems and pitfalls abound; even established dating techniques must be applied with caution. For example, mammoth ivory of Pleistocene date from the perma-frost of Siberia was widely used up to the last century as a source of ivory; dating the ivory would be of little help here.

Despite the apparently bewildering array of apparatus and methods, probably the most potent tool remains the human eye, aided by a good binocular microscope at one end and an informed brain at the other!

Visual examination: microscopy, ultra violet and x-radiography

Visual examination aided by magnification, or by ultra-violet or x-rays, can often show how an object was made (303, 304), and suggest something of its history since manufacture – even when these have been carefully disguised.

An important area of authentication is to ascertain whether the suspect object was made using the appropriate technology. For example, since medieval times wire has been made by drawing out a rod of metal through progressively smaller holes in a drawplate. But in earlier times wire was made by a variety of methods, including tightly twisting a thin strip of metal to produce a hollow tube rather like a drinking straw, or by twisting a thin, square-section rod and then rolling this to a circular section (block-twisting). Wires produced by these two methods are quite unlike modern drawn wire, which has scratches running along its length from being pulled through the drawplates (305c): the twisted wires have long helical seams (305a,b).

Later embellishments can also sometimes be spotted visually where the wrong technique has been used. For example, metal surfaces can be

303 Imitator of Pieter Brueghel, *A Religious procession*

This painting is taken from a detail of a composition by Brueghel, of which there are two versions: *Kermesse Flamande* (Musées Royals des Beaux Arts, Brussels) and *Kermesse with theatre and procession* (Fitzwilliam Museum, Cambridge). There are also several versions and variants of the same detail, mostly copies made in the seventeenth century.

The x-radiograph reveals an unusually unblemished image, and the densities suggest the use of appropriate pigments. Micro-chemical analysis has shown, however, that the green is chromic oxide, a pigment not in general use until the mid-nineteenth century.

When purchased in 1923 by Lord Lee the painting was probably no more than a few years old, and in order to stimulate the appearance of age, the forger, unable to induce a convincing pattern of naturally occurring cracks in the paint, was obliged to paint them, meticulously, on top of the composition. By now the resinous varnish layer has itself begun to degrade and fracture, lending the painting a genuine if superficial aura of age. RBG

Oil on panel. 276 × 441mm
Courtauld Institute of Art, University of London

304 Imitator of Nicholas Hilliard, *John and Frances Croker*

Until recently ascribed to Nicholas Hilliard with a putative date of 1580–5, these miniatures are probably by George Perfect Harding, about 1840. They are pastiches rather than copies; *Frances Croker* (a) is derived in part from a painting attributed to Gower (now in the Victoria and Albert Museum, w.1–1931), but with considerable alterations to the costume and jewels. No source is known for *John Croker* (b).

Although superficially convincing, their nineteenth-century origin is betrayed by anachronistic techniques. The features are painted transparently directly on the parchment rather than on the invariable sixteenth-century

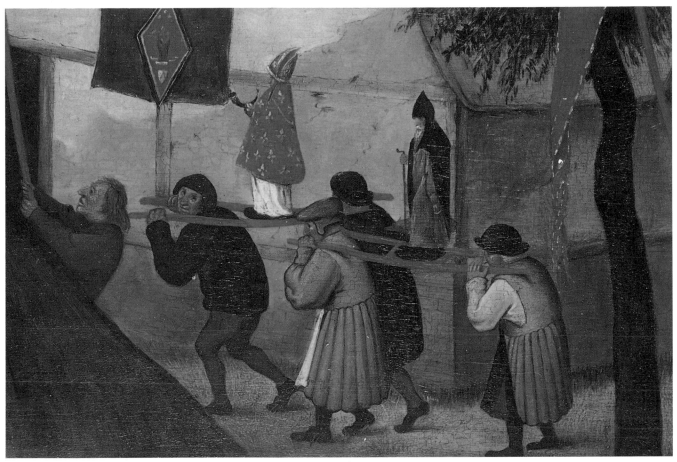

303

303: enlarged detail of sleeve of bearer on right, showing hand-painted and natural cracks

decorated in a number of ways, such as engraving (where a steel engraving tool is pushed along to remove a sliver of metal), or chasing (where the tracer, a tool rather like a blunt chisel, is tapped into the metal to create the design). The graver needs to be of a very hard and strong metal, and so engraving did not develop until iron or steel tools were available. Thus examples of engraving purporting to be earlier than the Iron Age should be treated with suspicion (306).

X-rays penetrate solid materials which are opaque to light, so that with an x-ray one can see details of construction or repairs deep inside an object, even when they are carefully disguised beneath make-up or false patinas (307–8). With modern apparatus it is possible to view the x-ray image instantaneously and continuously whilst moving the object. This enables a much more thorough examination to be carried out than by the traditional single plane photographic method.

Ultra-violet radiation can be useful for detecting a false patina. Under ultra-violet radiation certain organic chemicals fluoresce and give out visible light. Many binding agents or glues have this property, so that if a false patina made up of ground-up minerals has been stuck in place then it can be revealed in this way (308). False patinas can also be induced by chemical treatment of the metal, but the patinas which are visually similar to natural patinas tend to be of minerals which do not occur naturally. These can be identified by x-ray diffraction analysis.

'carnation' ground, and the painting of the jewels and other details demonstrate a similar ignorance of Hilliard's methods. With the exception of the backgrounds, the pigments are ground to a regular consistency and richly gummed, unlike Hilliard's selectively ground, matt paints, and are almost certainly proprietary cake watercolours, available from the 1790s. The parchment was coated with gum before painting, a distinctively late technique.

It is likely that these miniatures are deliberate fakes made for the antiquarian market in the 1840s, when Harding, who had been a well-known miniaturist, illustrator and copyist, was in financial difficulty. JM

Painted on parchment stuck to pasteboard. (a) 50 × 41mm; (b) 48 × 38mm
V&A P.139–1910. Salting Bequest
LITERATURE H. W. Sass, *Notes and Queries*, 1, 3rd series (10 May 1862), pp. 375–6; G. Reynolds, *Nicholas Hilliard and Isaac Oliver*, London 1947, no. 24; E. Auerbach, *Nicholas Hilliard*, 1961, pp. 88, 90, 195; R. Strong, *Nicholas Hilliard*, London 1975, p. 29

305a Swedish gold bead, 1st century AD

Magnification on the scanning electron microscope has shown this bead to be genuine: it can clearly be seen that some of the wire has been made by twisting a thin strip of metal, one of the techniques of producing wire before the medieval period.

BM MLA 1921, 11–1, 46

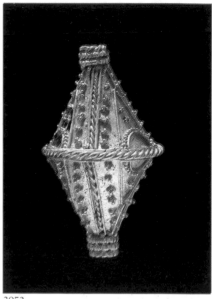

305a

305a: detail enlarged on a scanning electron microscope

305b: detail enlarged on a scanning electron microscope

305b Roman chain from New Grange, Co. Meath, Ireland

When magnified on the scanning electron microscope this can be seen as a good example of block-twisted wire, with numerous helical seams.

BM PRB 1884. 5–20. 4

305c Gold bangle said to be from Roman Egypt

The scanning electron microscope clearly shows striations typical of modern drawn wire.

D 75mm
BM EA 1901. 3–9. 19

306 Egyptian gold shell pendant

The pendant is probably ancient. However, its interest lies in the rather crudely engraved cartouche, purporting to be of the 12th dynasty (early second millennium BC). Microscopic examination clearly shows that the lines were created by engraving, a technique not in use at this date. Thus the inscription cannot be of the date ascribed to it. This view is reinforced by the crispness of the engraved line compared to the rest of the pendant, also suggesting the cartouche is much more recent.

H 50mm
BM EA 65281

305c: detail enlarged on a scanning electron microscope

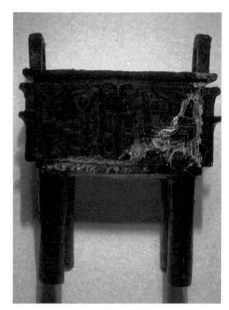

308: under ultra-violet radiation the false patina fluoresces

307 Islamic jug

This small jug, with its stylised peacock decoration, dates from the ninth century AD. Viewed by ordinary light it appears to have a few small cracks, but x-rays reveal that it is very extensively damaged, with large areas, especially around the rim, completely missing and made up in plaster.

H 117mm
BM OA 1952. 2–14. 1
Illustrated on pp. 274–5

308 Chinese bronze vessel (*fang ding*)

This bronze vessel of the eleventh century BC appears undamaged by ordinary light, but x-rays reveal extensive damage that has been repaired by soldering. The very light areas joining the cracks are lead solder. These rather clumsy and unsightly repairs were carefully disguised by the liberal application of a false patina; this contains an organic binder which flouresces under ultra-violet radiation, revealing the extent of the repatination.

H 222mm
BM OA 1973. 7–26. 4

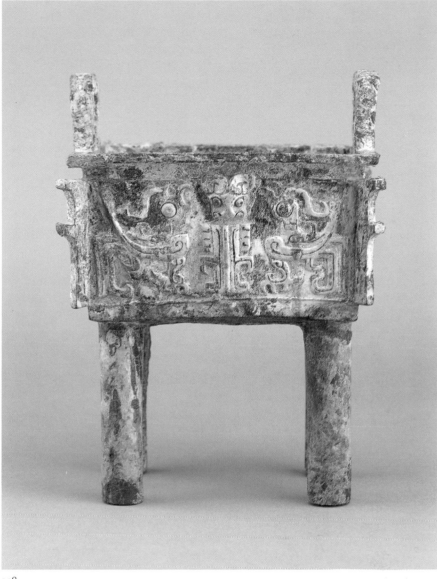

308

308: the radiograph reveals extensive damage, repaired with solder

Analysis

Composition is an important consideration in the authentication of an object. The composition of the alloy, ceramic or glass from which the object is made, and also the trace elements which can be diagnostic of a particular process or source of a material, can reveal much about the object's history. A wide range of analytical techniques are used, depending on the information required.

Energy dispersive x-ray fluorescence (XRF) is a popular analytical technique which has the double advantage of being non-destructive (i.e., it does not require a sample to be removed from the object) and of providing an instantaneous analysis of a wide range of materials, such as metals, stone, glass and ceramics. The object to be analysed is simply placed before the x-ray source and a qualitative analysis (which elements are present) is completed in a matter of moments (309). The method can also be used for quantitative analysis (how much of each element is present), but for this the surface of the object has to be carefully ground and polished (311, 312).

If a more precise analysis is required a drilling or core is usually preferred as giving a more representative sample. The dissolved sample can be analysed by techniques such as atomic absorption spectrometry (AAS) or inductively coupled plasma arc spectrometry (ICP), which give an accurate and precise analysis of a wide range of elements down to and including minor traces (310).

309 'Etruscan' statuettes of banqueters

One of these two figures (a) is an authentic Etruscan piece of the sixth century BC: XRF analysis showed it to contain copper with some tin and a little lead, typical of early Etruscan bronzes. The other statuette (b) is of copper with some zinc, i.e. a brass. Brass was not used by the Etruscans at this period and this strongly supports the art historical evidence that the piece, although not unattractive, is a relatively recent copy.

309a Genuine bronze
L 330mm
BM GR 1831. 12–1. 1
309b Fake
L 330mm
BM GR 1918. 1–1. 113

309a (*back*), b (*front*)

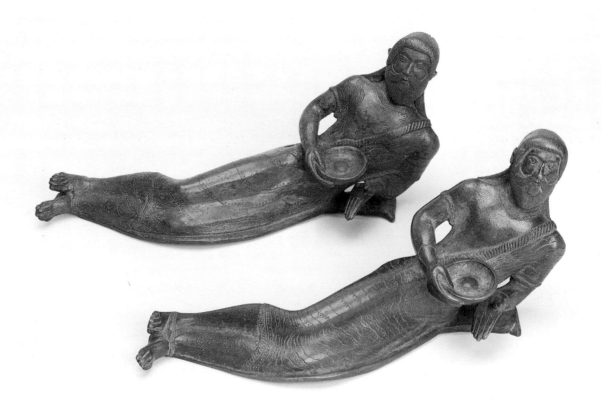

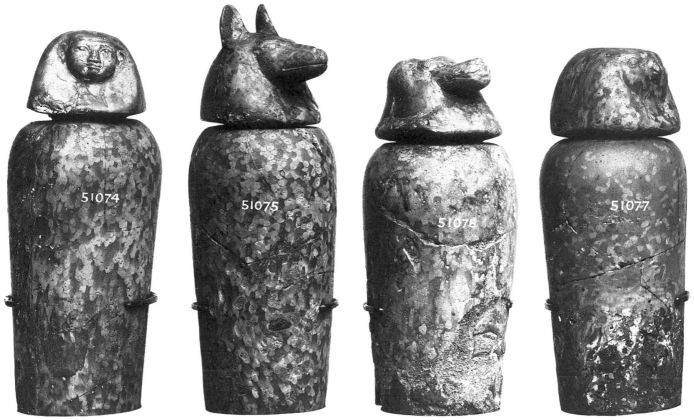

311

310 Fake Roman coin (*aes grave*)

Early brass was made by mixing copper with zinc ore and heating in a closed crucible; the resulting alloy had a zinc content which did not exceed 28%. In Europe it was only after metallic zinc began to be made in the eighteenth century that it was possible to achieve any composition for brass merely by adjusting the relative quantities of copper and zinc. Thus this *aes*, with 30% of zinc, although purporting to be Roman of the third century BC, is likely to be modern.

D 95mm
BM CM 1978. 12–23. 1

311 'Ancient Egyptian' blue glass canopic jars

These jars resemble superficially specimens of the New Kingdom (1567–1085 BC), but they are unusual for several reasons. The use of glass for their manufacture rather than stone, pottery or wood is highly irregular. They are also much smaller than most genuine New Kingdom jars, and the internal cavities are hardly large enough to accommodate

Sometimes it is necessary to analyse very small areas or to analyse all over a specific area (313). This can be done by using micro-analytical and digital mapping facilities linked to a scanning electron microscope (SEM).

The analysis of the trace and minor element content in man-made and natural materials can often provide useful information in authentication studies. Modern methods of production and refining are very different from those used in antiquity. Thus, for example, many metals, notably silver, are much purer than in antiquity (314), but much post-medieval glass has many more metal ions than previously.

Some elements or minerals can identify the area from which the material was found; the knowledge that a particular source was not utilised in antiquity can provide decisive evidence against the authenticity of an object made of material from that source. Identification of the minerals present by x-ray diffraction and petrological examination, coupled with compositional analysis, can frequently reveal the provenance of the raw materials of an object and, in turn, its authenticity (315).

Modern scientific techniques of mass spectrometry provide a powerful tool in provenance and authentication studies. Many elements occur naturally with two or more atomic weights. Thus, for example, an oxygen atom with the atomic weight 16 is chemically the same as the rather rarer oxygen atom with the atomic weight 18. These two forms are known as isotopes of oxygen. The ratios of the stable isotopes in a natural material are normally determined by the local geological conditions prevailing at its formation. Some elements have unstable isotopes; in other words, they decay radioactively. In these cases the

the packages of mummified entrails which such receptacles were designed to contain. The inner surfaces show no traces of ever having been used. Analysis has revealed several suggestive facts about the composition of the glass. Quantitative x-ray fluorescence analysis shows that it contains 22% lead oxide, an exceptionally high proportion for ancient blue glass. The aluminium content is also high and the amount of soda low. Most telling of all is the very high proportion of arsenic present (approximately 1%); this level is unparalleled, and no authenticated examples of glass with such a high level of arsenic are known before the end of the medieval period. It is therefore almost certain that the jars are the work of a modern forger. JT

H 163–185mm
BM EA 51074–7

312 Blue glass scarab

The authenticity of the inscription on this large scarab of King Sheshonq III (c. 825–773 BC) has been questioned on the grounds that the inscription is clumsily executed and that its undersurface is markedly convex – a common characteristic of forged scarabs made in the nineteenth century AD. These circumstances alone are insufficient to identify the scarab as a forgery, but scientific analysis has considerably strengthened the suspicion. Analysis of the glass has revealed a very high lime content (15% CaO), while the amount of soda present is exceptionally low (3% Na_2O). In ancient Egyptian glass the amount of CaO is rarely above 10% and hardly ever exceeds 12%, whereas the proportion of soda is normally in excess of 12%. JT

L 98mm
BM EA 64203
LITERATURE J. D. Cooney, *Catalogue of Egyptian Antiquities in the British Museum. IV: Glass*, London 1976, no. 165

313 'Lombardic' gold brooch

This brooch belongs to a group of gold jewellery purporting to date from the seventh century AD (see 182). However, micro-analysis shows that the solder is modern: the false colour digital map shows cadmium concentrated all over the soldered area on the brooch, but cadmium is a constituent of modern gold solders. There have been claims recently that cadmium can occur in ancient solders; however, so far it has not been found in the solder of any piece from excavation or from any other unimpeachable source, and its presence may be taken as evidence that the solder at least, if not the whole object, is modern. PC

D 57mm
BM MLA 1930, 11–6, 1
Brooch illustrated with 182 on p. 175

313: false colour digital map

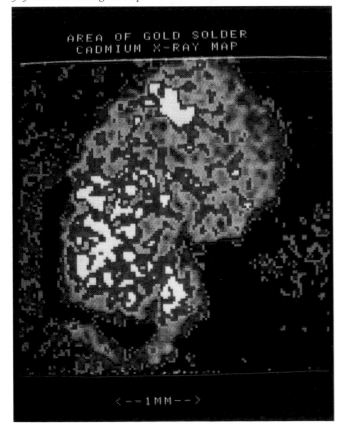

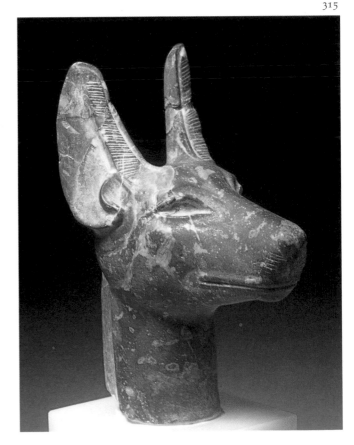

315

314 'Roman' silver ingot

This silver ingot purports to be late Roman, but Roman silver invariably contains traces of gold, whereas this ingot contains none.

L 113mm
BM GR 1979. 9–11.1

age of the deposit will also affect the proportion of such isotopes present in the material.

In classical antiquity marble was quarried from various sites in Greece and Asia Minor, and at Carrara in Italy, and it was widely exported. White marbles were particularly prized, but they have little to distinguish them visually from one another, and are chemically very pure. However, in marble (a calcium carbonate) the stable isotope ratios of carbon and oxygen (i.e. the ratio of ^{13}C to ^{12}C and of ^{18}O to ^{16}O) can vary with source. In principle once the quarries have been characterised, marble used in sculpture can be provenanced (316). If an object is believed to have been restored or added to in the recent past the stable isotope ratios can also demonstrate whether more than one type of marble is present. PC/SGEB

316

315 'Ancient Egyptian' lapis lazuli jackal or dog's head

This lapis lazuli head has been reconstructed from fragments and restored in places with beeswax. It was presumably intended as a representation of the god Anubis.

The object displays a number of stylistic peculiarities which suggest that it is a forgery: for example, the very short snout and the deep, squat face. The ears are not positioned symmetrically and are anatomically inaccurate. X-ray diffraction analysis of the lapis lazuli has now revealed the presence of a calcium silicate, wollastonite. This mineral is not present in the lapis from Badakshan, Afghanistan, which is thought to have been used in Egypt, but is a characteristic impurity of lapis from Lake Baikal, Siberia, a deposit which was not exploited until the nineteenth century AD. In view of this the modern origin of the head becomes a virtual certainty. JT

H 92mm
BM EA 64075

316 Relief with three pairs of captive Amazons

This panel was recomposed from fragments of a longer panel with eight Amazons, which decorated the lid of a sarcophagus of the mid-second century AD. The relief came to the British Museum from the collection of Charles Townley, who had acquired it in Rome in 1774 from the dealer Thomas Jenkins. Its earlier history is complex, but it is known that in the sixteenth century the lid-panel was in the collection of Guglielmo della Porta (d. 1577), when the first four Amazons were drawn by Giovannantonio Dosio.

It has been suggested that della Porta fabricated the end of the panel, to the right of a straight joint which runs through the relief beside the fourth Amazon, where Dosio's drawing stops. However, Smith in his catalogue of 1904 observed only minor restorations. The contrasting opinions were tested by stable carbon and oxygen isotopic analysis of powdered marble from the left, centre and right

of the panel. The results showed that all parts of the panel were most probably cut from one slab of marble, originating from Carrara (Tuscany). The results therefore support Smith's view that the right end is largely ancient. Della Porta apparently joined the seventh and eighth Amazons to the first four. The fate of the fifth and sixth figures, which appear in a drawing of about 1500, is unknown. SW

Carrara marble. H 304mm; L 1884mm
BM GR 1805. 7–3. 135 (Catalogue of Roman Sarcophagi 14)
LITERATURE A. H. Smith, *A Catalogue of Sculpture in the Department of Greek and Roman Antiquities* III, London 1904, pp. 304–5, no. 2299; P. P. Bober & R. O. Rubinstein, *Renaissance artists and antique sculpture*, London 1986, pp. 178–9, no. 142

Scientific dating methods for detecting fakes

Radiocarbon

Carbon is a fundamental constituent of all living matter. It has three naturally occurring isotopes, the least abundant of which is also unstable and therefore radioactive – hence the name 'radiocarbon' for this isotope which, because of its scientific designation (^{14}C), is also called 'carbon fourteen'. The really unusual characteristic of ^{14}C, however, is that it is continually being formed in the upper atmosphere. Atoms of ^{14}C combine with oxygen to form carbon dioxide, which mixes throughout the atmosphere, dissolves in the oceans and, via the photosynthesis process and the food chain, enters all plant and animal life. If the production rate is constant, there is a dynamic equilibrium between formation and decay, and therefore a constant ^{14}C concentration in the atmosphere and in all living organisms.

When a plant or animal dies, it ceases to take in radiocarbon, and the level begins to fall at a rate determined by the radioactive decay law. This law relates the number of atoms left after a period of time has elapsed to the initial or equilibrium number: with each period of 5730 years the number of atoms remaining is halved.

In principle, therefore, if the number of atoms of radiocarbon remaining and the initial number can be evaluated by experiment, then the time elapsed since death can be determined. For a bone excavated on an archaeological site this can provide an estimate of the age of the context in which the bone was found. However, for wood this may not be the case, since radiocarbon dates the time at which individual tree rings were formed, and this might be several hundred years before the tree itself was felled and even longer before the wood was used.

In general, it is organic materials that can be dated by radiocarbon. In Britain the most commonly preserved sample types are bone and charcoal, but on some sites or in other areas of the world a different suite of materials might remain, preserved perhaps by charring, waterlogging or by particularly arid conditions.

One of the main assumptions of radiocarbon dating is a constant rate of ^{14}C production. However, it is known that variations in the earth's geomagnetic field and in sunspot activity have affected production in a rather unpredictable way in the past. This means that radiocarbon results need to be calibrated to convert them to calendar ages. This is done using a calibration curve, the accurate calendar axis of which is produced by dendrochronologically dated tree rings that are then radiocarbon dated to provide the radiocarbon axis.

The amount of radiocarbon in a sample can be measured in two ways, either by waiting until it decays and counting the beta particles produced in a gas proportional or liquid scintillation counter, or by separating and counting the actual number of radiocarbon atoms using an accelerator mass spectrometer (AMS). The traditional methods of gas proportional or liquid scintillation counting required large samples, but the newer AMS technique needs much smaller samples (typically a few tens of milligrammes rather than grammes) and is therefore of greater use in the dating of objects.

The advent of small sample radiocarbon dating has meant that

317 The Turin Shroud

This linen cloth, some 4.25m in length, bears the shadowy image of the front and back of a man who appears to have been scourged and crucified, and is therefore believed to have been Christ's burial shroud. Its history is known with certainty back to about AD 1350, when it was in the possession of the de Charny family in France. Even then it appears to have caused something of a religious furore, being declared by some to be a fake and by others to be the true Shroud. In 1898 the first ever photography of the Shroud revealed that when seen in negative the image is strikingly life-like. This discovery and subsequent medical findings fuelled suggestions that the cloth could conceivably be genuine.

A fragment of the cloth was recently removed for radiocarbon dating, and samples measuring only a few square centimetres (equivalent to about 50mg) were apportioned to three accelerator laboratories in Oxford, Zurich and Tucson, Arizona. The British Museum was asked to participate in the certification of the sampling and the statistical analysis of the results. The calibrated radiocarbon result, published in the journal *Nature* in 1989, was AD 1260–1390, which corresponds well with the Shroud's first appearance in France. However, until it can be properly established how this striking image came into being, the mystery remains incompletely resolved. SGEB

Photograph kindly supplied by the British Society for the Turin Shroud

318

318 Panel painting of King Edward IV (1422–83)

This portrait of Edward IV is in the style of the period; in particular, he is portrayed with his fingers on the frame, whereas the later style was for the subject to be fingering a ring. Dendrochronology, however, shows the last tree ring of the panel to have been formed in 1498, and thus that the portrait was executed after Edward's death by an artist faithful to the earlier tradition. SGEB

320 × 200mm
Society of Antiquaries

319 The 'Haçilar' ceramics

During the 1950s excavations at the prehistoric site of Haçilar in south-western Turkey uncovered a previously unknown type of pottery. This high-quality painted and burnished ware was remarkable both for its beauty and for its very early date in the sixth millennium BC. Pottery of this type began to appear on the antiquities market during the following decade and was eagerly acquired by collectors. Gradually scholars began to suspect that genuine objects were being joined by vessels and figurines of doubtful authenticity.

The examination of 'Haçilar' pottery was the first application of the newly developed technique of TL testing. A

objects it is now possible to date that would previously have sustained an unacceptable amount of damage if conventional radiocarbon had been used. One such is the Turin Shroud (317). SGEB

Dendrochronology

The origins of dendrochronology lie in climate studies, rather than in a need for a dating method. Particularly in temperate climates, where there is a contrast between the seasons, trees grow by the addition of an annual ring. The growth region is a thin band of cells, called the cambium, lying between the bark and the sapwood. Division of these cells adds new bark to the outer side of the cambium and new sapwood to the inside. For some species the width of each ring depends on prevailing climatic conditions, such as temperature and rainfall. Counting backwards from the cambium layer gives the age of a particular ring, and its relative thickness indicates whether in that year the growing season in the locality was good or poor. The trees of the same species growing in the same locality should have similar temporal patterns of ring widths, which are uniquely defined, like a signature, by their common history. This forms the basis of cross-dating: being able to associate, on the basis of duplication of pattern, a tree ring sequence of unknown age with one of known age.

Chronologies, or 'master curves', are established by cross-dating, starting with living trees, or timbers where the year of felling and the 'zero age' ring is the present, and then by using large felled timbers with patterns sufficiently overlapping the existing chronology to be certain of a unique match and to allow the extension of the time-scale. A dendrochronological curve will only apply to the climatic region and genus of the trees used to produce it. Several long chronologies now exist for different species of tree and different localities – for example, over eight thousand years for the bristlecone pine (*Pinus aristata*) in California, and more than seven thousand years for oak (*Quercus* sp.) in Ireland. Not all types of wood are suitable for this dating technique, but fortunately many of the species most commonly used as building materials, such as oak in Britain, can be used. Dendrochronology has been of major importance in producing calibration values for radiocarbon dates, but its direct use as a dating technique is limited. Large numbers of rings (typically in excess of 100) are needed to ensure a unique fit of an unknown timber onto a master curve, and extra allowances must be made for the loss of sapwood, for trimming of planks or seasoning before use. Where viable, however, it can be very accurate, not only to year but, on occasion, to season of felling.

Panel paintings present one major area for the application of this technique. If the date of felling of the tree can be determined and shown to post-date the death of the artist, clearly the painting is a fake. Interestingly, dendrochronology can also demonstrate when panels are taken from the same tree because of the close similarity of the ring patterns. The study of panel paintings has given some interesting insights into the vogue for portrait painting. Many 'portraits' of the English kings, for example, have been shown to have been 'retrospectively' executed (318). Dendrochronology has been able categorically to prove what was already suspected stylistically. SGEB

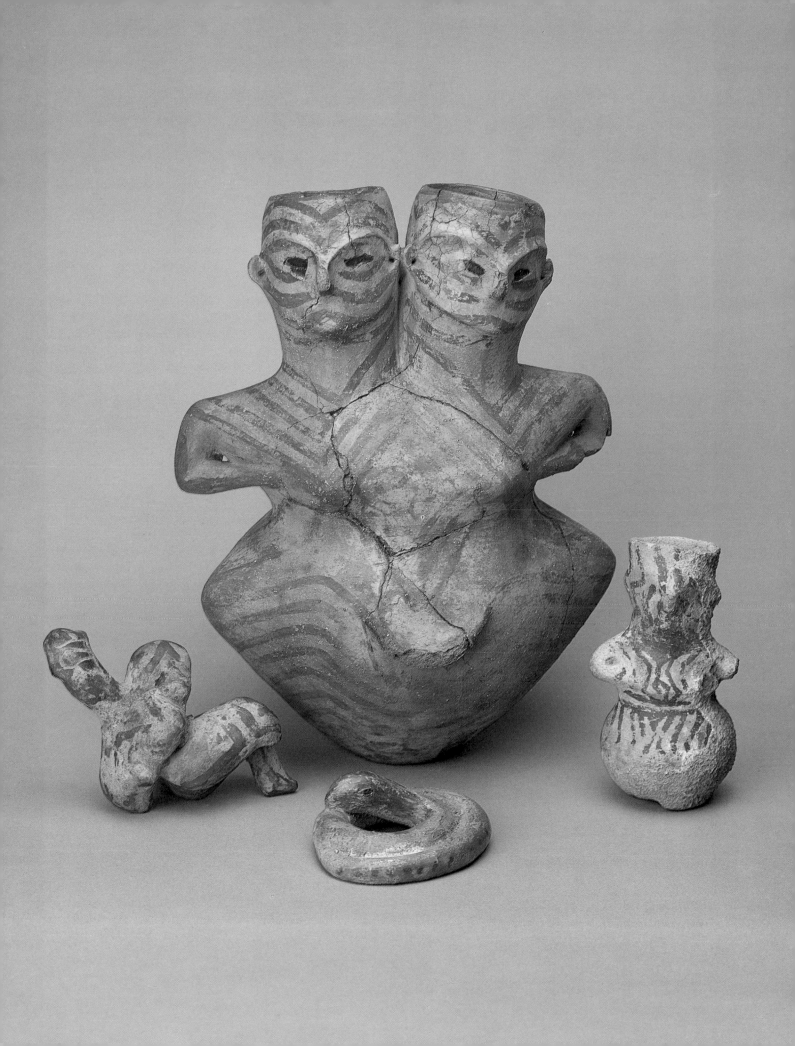

large number of objects were examined, including pieces from official excavations; 48 out of the 66 objects tested were shown to have been made in recent times.

319a Genuine anthropomorphic vessel, 6th millennium BC
H 115mm
BM WAA 134707

319b Fake 'Haçilar' double-headed vessel
H 270mm
BM WAA 134686

319c Fake 'Haçilar' figurine
135 × 75mm
BM WAA 134376

319d Fake 'Haçilar' snake
87.5 × 70mm
BM WAA 134631

320 Zapotec-style pottery vessels

Zapotec culture flourished in Oaxaca in southern Mexico between about AD 200 and 800. It produced distinctive pottery vessels in human or zoomorphic form, which are now found in large numbers in many collections throughout the world. Many Zapotec pottery vessels, however, have long been suspected of being forgeries. The recent testing of the British Museum's entire collection using thermoluminescence has confirmed that most of the vessels thought to be modern are indeed fakes.

That so many museum curators have been deceived by these fakes is less surprising when seen in the context of both the style itself and the history of archaeology in Oaxaca. Relatively little was really known of Zapotec culture until the excavations at the Monte Alban and other sites in the 1930s. Except for the earliest styles, Zapotec pottery was largely mould-made and decorated with applied decorative motifs often cut from flat sheets of clay and easily copied. The use of genuine pre-Hispanic moulds has also caused confusion. One of the vessels included here (c) would attract suspicion because the form itself is not within the canon of Zapotec work. However, the animal figures which decorate the body of the vessel are from a genuine figurine mould and therefore in perfect Zapotec style.

There is good evidence that a

Thermoluminescence

The thermoluminescence (TL) phenomenon is a property of crystalline materials that have been exposed to ionising radiation. If such crystals are subsequently heated they can emit the light termed thermoluminescence. This light is additional to the incandescence produced by heat alone. Quartz and feldspars, for example, which are typically found in pottery, are minerals that produce TL.

The ionising radiation is mostly alpha, beta and gamma from the decay of small amounts of uranium, thorium and potassium, naturally occurring in both the sample itself and in the burial environment. When ionising radiations pass through matter, they produce free electrons that can become trapped at lattice defects in the crystals. Depending on the nature of the defect (trap), the electrons can remain trapped at ambient temperature for long periods of time – millions of years in some cases. If heat is applied, however, sufficient energy is given to the electrons to release them and, if they find another type of defect called a luminescence centre, the light known as TL is emitted. Temperatures above about 350°C will release the stable electrons, i.e. those which are unlikely to have been affected by ambient temperature. During firing sufficiently high temperatures would have been reached to release all of the electrons trapped over geological time, thus 'resetting the TL clock' and leaving the traps empty to begin accumulating electrons again.

When a sample is heated in the laboratory a glow curve is obtained, this is a plot of the TL emission with temperature. The glow curve obtained on first heating an archaeological sample such as pottery is known as the natural TL. In simple terms, the natural TL emitted above about 350°C is proportional to three factors. The first is the rate at which radiation has been received. This depends on the radioactivity levels in the pottery and its burial soil, but for given concentrations (measurable, for example, by analysis) is constant with time due to the long half-lives of these radioactive elements. The second factor is the effective TL sensitivity of the sample to radiation, i.e. how much TL the crystals produce for a given amount of radiation. This can be measured in the laboratory using calibrated alpha and beta radiation sources to induce so-called 'artificial' TL. The third factor is the age of the pottery or, to be more precise, the time elapsed since the pottery was last fully heated to a temperature of about 400°C or more. In principle therefore, if the natural TL can be measured along with the first two factors, the age of the pottery can be determined.

By about 1970 earlier research had firmly established TL as an archaeological dating method for ceramics. Since then research has continued, refining the technique and demonstrating its applicability to a range of other materials such as burnt stones, stalagamitic calcite and sediments. Along with the development of pottery dating, the authenticity testing of ceramic objects became feasible. However, authenticity testing differs from TL dating in two major ways. Firstly, the sample size available is normally small (about 30mg) so as to avoid damage to the object. Secondly, the environment of the object for the majority of its lifetime is unknown, and hence its contribution to the total radiation received cannot be measured. From dating studies, however, it is known that this contribution is not normally dominant, and a

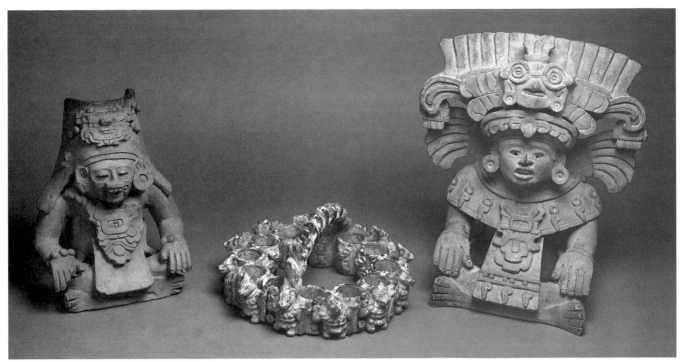

320a,c,b

flourishing trade in false antiquities existed at the turn of the century, and its products filtered through to the United States and Europe. In the 1920s and 1930s a large percentage of the so-called ancient material which would have been familiar to interested persons was the product of this well-established manufacture.

320a Zapotec figure of a deity
370 × 320 × 200mm
BM ETH 1849. 6–27. 20

320b Fake seated figure of a deity
H 400mm
BM ETH 1946 Am. 16–7

320c Fake 'basket' with rodents
D 355mm
BM ETH 1940 Am2. 43

likely range of values can be assumed. This is normally adequate to distinguish recently made objects – fakes – from those genuinely manufactured in antiquity. In addition to pottery, the core material from bronzes can also be TL tested, since this is normally a ceramic material that has been fired to a sufficiently high temperature to 'zero the TL clock'.

The power of the method in authenticity testing was dramatically proven in testing a group of spectacular ceramics (319) purporting to come from Haçilar, Turkey. Doubts about the authenticity of these ceramics were confirmed at the Research Laboratory for Archaeology and the History of Art in Oxford, where the new technique was being developed. No longer did evidence of authenticity have to rely solely on stylistic criteria that can be unreliable.

The British Museum established its own TL laboratory in the early 1970s and has thus been able to test not only objects offered for purchase, but collections acquired prior to the development of TL. One such collection is that of Zapotec ceramics (320). SGEB

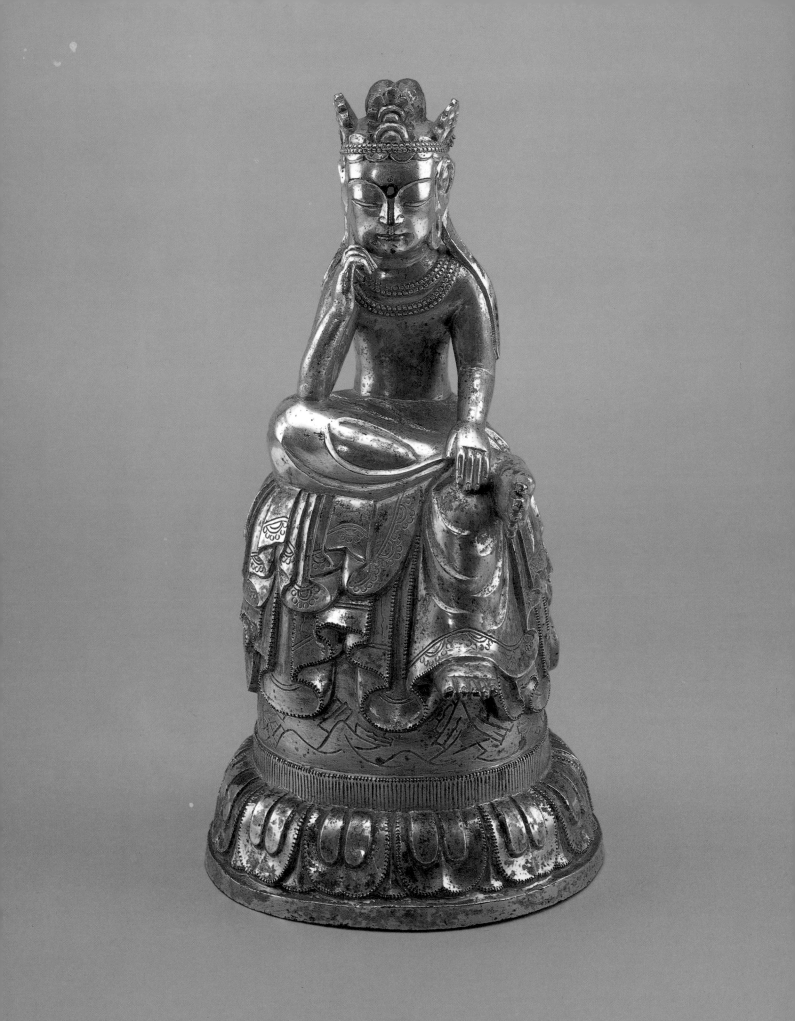

10
The limits of expertise

It would be misleading to end with the comforting impression that scientific advance and scholarly expertise can solve all problems. Every object in this concluding section has been the subject of intense debate. Some, like the warrior god from Gezzine (321) and the 'Blau monuments' (322), were once thought fake and are now believed genuine. Others, like the Egyptian limestone figure (323), would be condemned if they appeared on the market, but are known to be genuine because discovered in a properly conducted excavation.

The majority, however, are still in limbo. Many cannot be dated: stone, for example, does not undergo any datable transformation when carved or chiselled and the techniques used on it may remain unchanged for centuries. As a result the suspicion that falls on stone objects lacking a clear cultural context, like the Grime's Graves 'goddess' (325), the Great Zimbabwe soapstone figure (330), the crystal skull (328) and the bearded man (327), cannot at present be dissipated.

Even where there is evidence it may be contradicted by stylistic or iconographic analysis (332, 333), and in some cases it may prove to be itself unreliable or misinterpreted. The composition of the ink used for the Vinland Map (329) was once thought to be definitely modern. Now it is known that ink of this type is, after all, compatible with a medieval date. The artefacts found in Glozel, in central France, in the 1920s (334), which had by the 1930s been dismissed by almost all archaeologists as obvious fakes, were found to be 2,000 years old when TL tested in the 1970s. Now it is thought that these tests were themselves invalid and that a medieval date is to be preferred.

Such cases demonstrate that certainty remains elusive, and happily so, for it is the mystery surrounding them that lends these objects half their magic.

321 Warrior god, from Gezzine, Lebanon, *c*. 2000 BC

This figure, acquired in 1957, is one of a group of figures known to come from the Lebanon. After examination, however, the Museum's Research Laboratory concluded that it was a modern fake on the grounds that its surface seemed to have been artificially roughened, that the edges of the front ribs of the corset were unworn and almost razor sharp, that the patination was thin and scant and that the metal almost pure copper. Both the then Keeper of Western Asiatic Antiquities at the British Museum, Dr Richard Barnett, and Henri Seyrig, a French scholar who had published a group of these figures in 1953, were convinced that it was genuine, and pointed out that a similar piece, which had been in the Cabinet des Médailles, Paris, since the mid-eighteenth century, was also made of nearly pure copper. Nevertheless, the Research Laboratory persisted, after a second examination, in concluding that the object was probably false.

Barnett was deeply concerned by

321

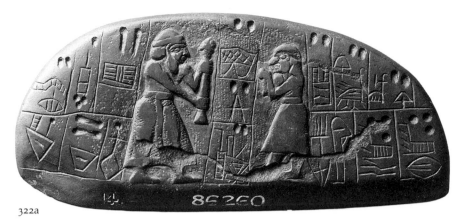

322a

this conflict between scientific and academic opinion. It was therefore with some pleasure that he was able, ten years later, to report that a new examination by the Research Laboratory had concluded that 'the balance of scientific evidence must therefore now be considered as being no longer incompatible with the age assigned on stylistic grounds'.

What had changed in the interim? The results of the 1968 examination simply confirmed the previous ones. But the second of the earlier reports had concluded that 'if objects of known provenance and great age could be examined which were made of similar oxygen-free high purity copper . . . it is possible that the situation would be altered', and this is exactly what had now occurred.

This affair is a reminder that inferences drawn from scientific analysis, like those drawn from historical or archaeological analysis, are only as reliable as the evidence on which they are based. The Research Laboratory had concluded – reasonably but wrongly – that pure copper was not likely to have been used in the second millennium BC. Where the evidence for declaring an object a fake depends on contextual evidence such errors can never be entirely ruled out. CNM

Copper. 255 × 72mm
BM WAA 135034

322 The 'Blau monuments'

When these stone objects were presented to the British Museum in 1899 nothing like them was known and they were dismissed as 'two forgeries purporting to be Babylonian inscriptions'. As late as 1922 the Museum Guide hinted that there might be doubts as to their authenticity, but subsequent excavations in southern Mesopotamia have produced parallels which show them to be genuine early Sumerian objects with a date of around 2900 BC and among the earliest examples of the developing cuneiform script, still mainly pictographic. The two pieces appear to belong together and, as far as they can be read, seem to be a legal document recording the sale of a field and the details of the transaction.

Their provenance is unknown, and they are called after an earlier owner, a Dr A. Blau, who lived for some time in southern Mesopotamia. CNM

Phyllite or slaty schist. 160 × 75mm (a); 180 × 42mm (b)
BM WAA 86260, 86261
LITERATURE M. E. L. Mallowan, *Early Mesopotamia and Iran*, London 1965, pp. 65–7

323 Egyptian limestone figure

The identification of a sculpture as a forgery often depends on the observation of some minor inconsistency of iconography or technique in an otherwise convincing piece. Where an artefact as a whole fails to fit preconceived notions of the traditions of ancient art there is a strong temptation to condemn it as a forgery. This piece illustrates the dangers of such a dismissive attitude. The hopelessly incorrect bodily

proportions, together with the gross style of execution, suggest the work of the most inept forger, yet the statue has a reliable pedigree, having been obtained at Abydos by Henry Salt in the early nineteenth century. It entered the British Museum at the sale of the Salt Collection in 1835. Significantly, the pose and costume of the figure conform to standard types of the Old Kingdom and, apart from the crudeness of the workmanship, there is no reason to doubt that it dates from the 6th Dynasty (c. 2300 BC) – a reminder that besides the craftsmen who produced the renowned masterpieces of Egyptian sculpture, there were many other practitioners whose talents were much more modest. JT

H 432mm
BM EA 2296

324 Egyptian serpentine statuette with gold head-dress

This unusual statuette, apparently representing the god Osiris, was acquired in 1909 and purports to come from Tell Basta in the Egyptian Delta. It has been the subject of speculation for many years, and even after extensive scientific examination including TL on presumed material which proved equivocal, its authenticity remains uncertain.

It consists of a seated mummiform figure of mottled green stone, probably serpentine, to which have been added a face mask, crown and uraeus of gold, and a wig (now incomplete) of gold inlaid with lapis lazuli. When the statue was acquired it had a fine gold chain bearing a pendant in the form of the goddess Maat. The statue itself, which is uninscribed, is stylistically peculiar and difficult to date, although it cannot be proved to be a forgery. The facial features show some affinities with royal portraits of the 25th Dynasty (c. 747–656 BC), but it is difficult to find a convincing parallel among statues of divinities dating from this period.

Even stranger are the gold accoutrements, the presence of which on a stone figure of this type is in itself highly unorthodox. Scientific analysis

323

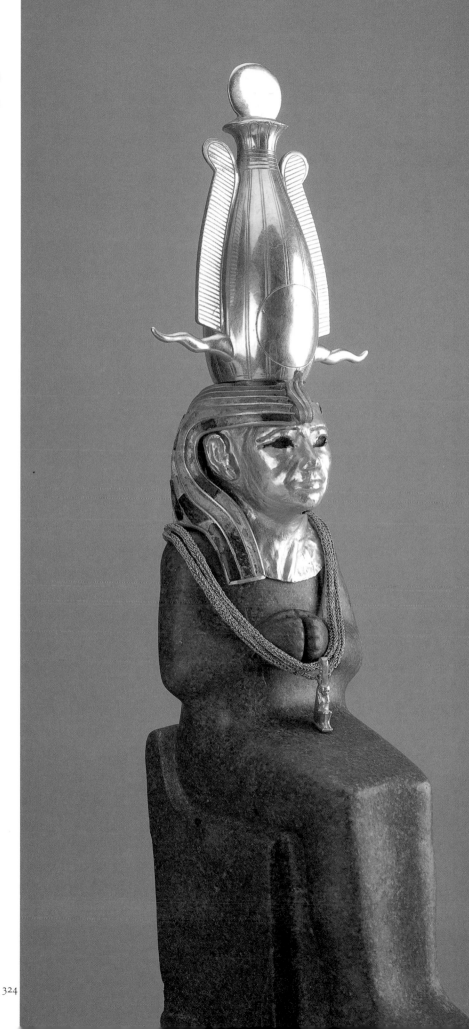

has demonstrated that the gold is ancient, but that the various components were made at different times – a finding which accords well with their somewhat incongruous appearance. The necklace and pendant are probably not part of the original ensemble. The mask, however, was clearly moulded over the face of the statue and, like the wig, must have been intended specifically for this piece. If these items were not made in antiquity they must be considered the work of an expert forger, for the wig in particular displays technical virtuosity of a high order. The most suspect component, on both iconographical and technical grounds, is the crown. Though made of ancient gold, its exceptionally high polish and the lack of tool marks on its surface suggest the use of a high-speed buffing tool, while the rim shows signs of having been machine-made.

 Although no firm conclusion regarding the figure's authenticity is possible, it has clearly undergone alteration. Traces of copper on the

325a,b

back of the head may indicate that it originally wore a head-dress of copper or bronze. At what date the present accessories were added is unknown, but the crown at least seems to be a modern reworking, and this raises the suspicion that the other components may also be of recent manufacture. If so, it is remarkable that so much precious metal was expended on the enhancement of a not particularly distinguished piece of sculpture. JT

H 282mm
BM EA 48994–48998
LITERATURE E. A. Wallis Budge, *Egyptian Sculptures in the British Museum*, London 1914, pp. 19–20, pl. XLII

325 Goddess and phallus from Grime's Graves

These two objects were found by A. L. Armstrong during his excavations at Grime's Graves in the late 1930s. The first to be discovered was the goddess (a), upright on a pedestal of flat chalk slabs near an original platform of closely packed blocks of mined flint, the apex of which pointed to the figure. On this were several antler picks and at its base a small, well-made chalk cup. Nearby were the chalk phallus (b) and three natural flint nodules, arranged, according to Armstrong, 'in the form of a phallus'.

The lack of any close parallels from other Neolithic sites has led some to doubt the authenticity of these pieces.

Indeed, it was rumoured at the time of discovery that they had been planted in order to fool Armstrong. It is unlikely that their status will finally be settled until similar objects are found elsewhere, or someone writes their memoirs.

325a Female figurine
H 102mm
BM PRB C356
325b Phallus
97 × 68mm
BM PRB C357

326 Problematic ancient coins

Since the sixteenth century much time and energy has been spent on the question of whether certain coins are ancient or whether they are modern forgeries. This is not just a question of antiquarian curiosity, since our attitude to some historical or economic matter can often depend on whether or not we accept a particular coin. Within the last thirty years, for instance, a hundred-page book has appeared arguing that the Roman Emperor Augustus was panicked by the minting of a particular coin type into degrading and humiliating the Roman moneyers and into moving his principal mint from Rome to Gaul; alas, the coin on which it is based is a forgery.

Not all cases are, however, so clear. For example, the Romans made their first gold coins in about 217 BC to meet

the enormous expenses incurred in their war against the Carthaginian Hannibal. These coins were made in different denominations, two of which are certainly genuine (a); however there is also a third (b) which adds to the obverse design the letters xxx, denoting 30 (asses). The coin is known from only four specimens, and opinions about its authenticity have oscillated for more than a hundred years. If genuine, the coin gives the earliest definite evidence for the denominations and development of the Roman monetary system; if false, we can disregard the convolutions necessary to make sense of it. In this case judgement depends on stylistic comparison with the other genuine denominations.

In the early Imperial period a number of very rare sestertii were minted for minor members of the Imperial family. Two such cases concern the family of Claudius (r. AD 41–54). Claudius undoubtedly minted small bronze coins (c) in honour of his elder brother Germanicus, but are the larger sestertii (d) which depict him also genuine? If so, this would be the only instance at this time of the same designs being used on different bronze denominations. The British Museum's specimen looks very plausible; the style is identical to that on the smaller pieces and the patina looks convincing, although we know that patinas have been artificially induced since the sixteenth century.

There are also some sestertii depicting Claudius' son Britannicus (e). If genuine, these would be the only coins minted at Rome depicting him, and this would be of some considerable historical interest, since otherwise coins were made at this time only for Claudius' stepson and eventual heir, the later Emperor Nero. There is also an obvious motive for forging them, as we can tell from the reaction at Rome in 1773, when the first specimen turned up, and the enormous price which was then paid for it. Again the case is unproven: all the rare specimens look suspiciously similar, and they are all worn, making judgements about their fabric difficult. The figure of Mars on the reverse is most uncharacteristic of coin design in

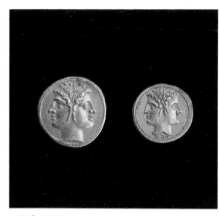

326a,b

AD 50, but can be paralleled thirty years later. To get round this difficulty it has, rather implausibly, been proposed that the coins were actually minted by the Roman Emperor Titus (AD 79–81), the boyhood friend of Britannicus. Another line of thought points out that there is some (rather ambivalent) evidence that such coins come from Bulgaria, and it has been envisaged that a subsidiary Roman mint in the province of Thrace might have been responsible for the coins' production. AB

326a,b Roman gold coin, *c.* 217 BC, and similar piece inscribed xxx
BM CM *BMC* Roman Republic 75, R11243

326c,d As and sesteritius of Germanicus, *c.* AD 45
BM CM *BMC* Claudius 217, 214

326e Sestertius of Britannicus, *c.* AD 50(?)
BM CM *BMC* Claudius 226 = Titus 306

327 Seated figure: Hellenistic sculpture or modern fake?

This Moses-like figure is one of a group of statues acquired by the British Museum in 1908, said to have been found by workers building the railway to Mecca in a tower near Maʿan in southern Jordan. At the time they were accepted as genuine, if unusual 'Hellenistic' pieces dating from the third to first centuries BC.

It is now thought that the Greek inscription above the right shoulder is modern and that the figure itself shows knowledge of Renaissance and baroque European sculpture. For these reasons this statue is now generally considered to be a fake. In

327

328

the absence of any scientific process by which such stone statues can be dated, or of definite evidence that there was a modern workshop producing stone carving of this quality in the area of northern Jordan/southern Syria from which this black basalt comes, an element of doubt remains. CNM

Black basalt. 406 × 240mm
BM WAA 102604

328 Rock-crystal skull

Although of spectacular appearance and representing considerable craftsmanship, the origins of this large carving of a skull in rock-crystal are most uncertain. Purchased from Tiffany of New York in the late 1890s,

the skull had passed through many hands and was said by G. F. Kunz in 1890 to have originally been brought from Mexico by a Spanish officer 'sometime before the French occupation of Mexico'. Past speculation has suggested that the skull is in fact of Far Eastern origin, but at the time of its entry into the collections of the British Museum it had generally come to be accepted as being from pre-Hispanic Mexico. Attempts to verify this on technological grounds have not proved successful. Although the stylisation of the features of the skull is in general accord with other examples accepted as genuine Aztec or Mixtec carvings, the overall appearance does

not present an obvious example of Aztec or any other Mesoamerican art style. When last examined by the British Museum Research Laboratory the conclusion was that some of the incised lines forming the teeth seemed more likely to have been cut with a jeweller's wheel than to have been produced by the techniques available to Aztec lapidaries.

The best suggestion as to the origin of the rock-crystal itself is that it is Brazilian, and this makes a pre-Hispanic date for the skull unlikely, even if it does come from Mesoamerica. Sources of rock-crystal are known in Mesoamerica, and it is also possible that pre-Hispanic craftsmen had access to rock-crystal

traded from North America, but there is no archaeological evidence of trade with South America, and the Brazilian sources have apparently been exploited only in recent times.

It has further been suggested that the British Museum skull may be an example of colonial Mexican art, perhaps for use in a Spanish-American church or cathedral. In this case it is assumed that the work would have been produced by a native Amerindian, influenced by European style and taste. There is indeed a most interesting example of a Mexican rock-crystal skull incorporated into a crucifix by a European craftsman, but this is clearly of pre-Hispanic date and style.

Other speculations as to the origins and possible use of the crystal skull are legion. The question remains open.

H 210mm
BM ETH 1898–1
LITERATURE G. F. Kunz, *Gems and Precious Stones of North America*, New York 1890

329 The Vinland Map: genuine document or modern forgery?

The acquisition of the Vinland Map, purporting to date from about 1440, was announced with great fanfare on the eve of Columbus Day, 10 October 1965, by Yale University in New Haven, Connecticut. The map includes, on its western edge, an area labelled *Vinlandia Insula*. This was not just the earliest depiction of any part of the New World on any map; more importantly, it pre-dated Columbus' epochal discovery. From the outset the map generated much heated discussion. A team of notable experts, including R. A. Skelton, at that time Superintendent of the Map Room in

the British Museum, and George Painter, then Assistant Keeper of Incunabula in the British Museum, attested to its veracity. Other scholars were concerned by what they saw as errors in Latin grammatical construction, the appearance of the ink, the extraordinarily accurate shape of Greenland, and the entire absence of provenance before the map surfaced in a hotel room in Switzerland in 1957. Even a symposium on the map hosted by the Smithsonian Institution in Washington DC in November 1966 failed to reach a consensus.

In 1972 microscopic samples of ink from various sections of the map were taken for analysis by McCrone Associates in Chicago, who performed a number of sensitive tests on the samples (polarised light microscopy, x-ray and electron diffraction, and scanning and transmission electron

329

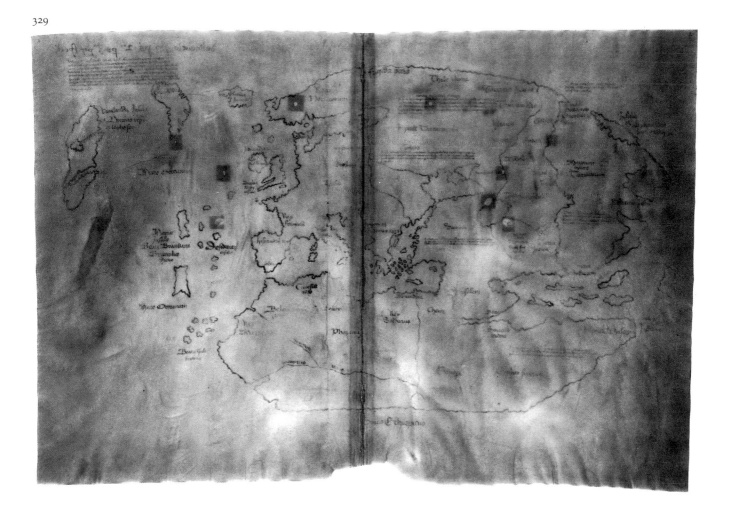

microscopy). Their report to Yale University, issued in January 1974 stated that they had found titanium dioxide in the ink, in a form (anatase) not commercially available until the early 1920s; the map was therefore a forgery.

The story does not end there, however, as the map still had its supporters. By 1984 newer analytical techniques were available, and in the autumn of that year the Vinland Map was taken to the University of California, Davis, for proton induced x-ray analysis. This form of analysis is non-destructive and non-invasive, and so could be applied to a larger area of the map area than had been covered by the McCrone Report. The Davis Report, published in *Analytical Chemistry* (15 March 1987) took issue with the McCrone Report. It showed 5,000 times less titanium dioxide than McCrone reported, and stated that the presence of the mineral was too small to be responsible for the colour of the ink. The Davis Report was careful, however, not to make any claim for the validity of the map based on their findings, simply stating 'while our work argues strongly against the specific McCrone Associates proof that the Map is fraudulent, we do not claim therefore that the Map is authentic. Such a judgement must be based on all available evidence, cartographic and historical as well as compositional'.

McCrone responded with an article in *Analytical Chemistry* (15 May 1988) standing by his original analysis. There the matter rests. The Map is still awaiting future palaeographic/historic/scientific testing before it can be unequivocally categorised as genuine or false. BMCC

278 × 410mm
Yale University Library

330 Soapstone figure from Zimbabwe

This is one of three well-carved soapstone figures in a closely similar style which have been associated with the site of Great Zimbabwe, the most impressive of a series of related historical settlements in southern Africa. They recall a set of very much larger soapstone columns, some surmounted by carvings of birds. These were only discovered and documented in the last century, but are of greater antiquity. This example (and others similar) are, however, unique in their smaller scale, unabraded surfaces and well-defined anthropomorphic features. All lack any firm documentation. There is, therefore, a possibility that they are not from Great Zimbabwe, as the British Museum's acquisition details written down from the vendor in the 1920s suggest, and they may have been carved in imitation of the soapstone columns at the site specifically for sale. BJM

H 412mm
BM ETH 1923. 6–20. 1

331 Aztec-style stone masks of the deity Xipe Totec

These two stone masks, known throughout the scholarly world, rank among the most renowned objects thought to be of Aztec date.

They represent the deity Xipe Totec, who was celebrated in ceremonies which involved the wearing of the flayed skin of a human victim. The outer surface of the masks represents the skin flayed from the face; on one of them (a) the mouth of the living celebrant is shown protruding through the mouthpart of the skin. On the inner surface of each mask is carved a full-figure representation, presumed to be of Xipe Totec. These frontally presented figures differ only in that the pose is adapted to the available space. Each has four arms, one holding a rattle-spear, one a shield, a third carrying an inverted skull (probably representing a container for incense), and the fourth held across the breast with drapery covering the forearm.

In a recent article Esther Pasztory has drawn attention to a number of puzzling features of this iconography. For example, there are no multiple-armed deities in the Aztec or other Mesoamerican pantheons. If these figures represent Xipe Totec, then two of the arms should have empty hands, since they would represent the empty

330

331a,b

hands of the flayed skin. Frontal figures in relief are rare in Aztec sculpture, and the presentation of the figures, apparently in dancing postures, is highly unusual. The form of their head-dresses is unique, and it is difficult to find parallels for the folded drapery. Furthermore, although relief carvings on the reverse sides and bases of Aztec sculptures are frequent, they rarely represent the same personage as shown on the front or top. The round ear-plugs shown on the fronts of the masks are also unusual in Xipe sculptures, and the slight central parting of the hair is thought to be unparalleled in Aztec sculpture.

Her conclusion is that: 'The Xipe masks may be genuine, idiosyncratic works' or 'made in the middle of the

nineteenth century by a carver who was familiar with Aztec art in the Mexican Museum but who did not fully understand Aztec iconography'.

The former hypothesis is supported by the discovery of many idiosyncratic pieces during the excavations for the metro and of the Aztec Great Temple site in Mexico City. There is also the lack of any identifiable model for the masks, and the difference in quality between these pieces (and another similar mask in the Musée de l'Homme, Paris) and other known fakes.

331a D 220mm
BM ETH 1902. 11–14. 11
331b D 220mm
BM ETH 1956. Am. x. 6

332 Figure of the Bodhisattva Maitreya in the style of the 7th century

This figure was long considered to be one of the few early Japanese bronzes outside its country of origin. It has been scientifically examined a number of times by the British Museum's Research Laboratory, and on technical evidence alone would appear to be genuine. However, this is an instance where stylistic and scientific evidence are apparently in conflict, for a recent art historical examination throws considerable doubt upon its origin.

The scientific evidence
The figure is a lost-wax casting with minor amounts of arsenic, bismuth, tin and antimony, with the arsenic content rising to about 3% at the

333

and thus it is possible that the metal is a mixture of copper and such an alloy.

The gilding of the piece is also puzzling. The lower layers contain mercury, which is indicative of the traditional fire-gilding process, but the upper layers are of much purer gold, although this is apparently also overlain in places by a thin layer of copper. The surface gilding has many blisters, typical of electroplating on a poorly prepared surface. A possible explanation is that the original mercury gilding had become worn and was electroplated, and that some putative salts of copper which had formed on the surface were electromechanically converted back into copper in some conservation treatment. This, of course, would seem to imply that the figure was of some considerable age. Another tenable explanation could be that the piece is the creation of a craftsman at the beginning of this century who was anxious to imitate the traditional metal and gilding methods, and who gave the figure an artificial patination to increase the appearance of age. The overall appearance of this could have been displeasing to an early owner of the piece, who might have had it electrogilded and the corrosion treated electrochemically.

These possibilities are all very speculative. What is certain is that the piece is very close in composition and technology to a genuine piece, and if it is indeed modern, then it is one of the most technically correct fakes yet encountered by the British Museum's scientists. PC

The stylistic evidence

Several features of the bronze differ from those of genuine pieces in Japan. For example, there is no provision behind the head for the fixture of a nimbus, whereas all known genuine pieces do have such a fitting. The fingers of the right hand are cast bent over, whereas in all known genuine pieces the forefinger, at least, is extended and the fingertips touch or almost touch the cheek. There is far more gold on the surface than on genuine old pieces, but it is inconceivable that an object of such supposed age and importance could

surface. The composition is very similar to genuine early bronze pieces of the same style, but very different from the alloys of bronze or brass that one would have expected from a modern piece. This is an unusual metal and would have been very difficult to cast, hence the numerous blow-holes and the considerable thickness of the casting. However, copper was still produced by traditional methods in Japan right up to the beginning of the twentieth century, and the product was often highly impure and similar to the piece in question. Arsenical copper was, and still is, also used in the decorative *shakudō* and other patinated alloys,

have been regilded in Japan. The engraved landscape around the lotus pedestal and the engraved decoration on the garment are similar to the decoration on pieces in the Hōryūji temple near Nara, but there are significant differences, especially in the landscape, which lacks vigour, and in the folds of the garments, which are ungainly. The misunderstanding of the drapery is perhaps the most telling piece of stylistic evidence, especially in view of the Hōryūji figures.

One of the problems in using scientific examination alone to judge whether the piece is genuine or not is that Japanese metalworking traditions are known to have continued from the distant past to the present day. The electroplating seems, however, to be very damaging to its credibility, and from a stylistic stand-point the differences from known genuine pieces cannot be readily explained. The figure is known to have been in this country since the 1920s, but objects in the Hōryūji temple were copied by traditional craftsmen at this time using traditional materials (see 8). On the whole, therefore, it is probable that this bronze Bodhisattva was made in the early twentieth century. VH

H 310mm
BM JA 1963. 2–14. 1
Illustrated on p. 290

333 Avalokiteshvara and consort

Javanese art has, from the nineteenth century, been extensively copied and forged. Some forgers' work between the Wars has been praised by the distinguished authority, A. J. Bernet Kempers. Work in museums has continued to be copied by generations of craftsmen.

While under Indian influence, Javanese or Indo-Javanese culture fell into a Central Javanese (seventh to tenth centuries) and an East Javanese period (tenth to sixteenth centuries), according to the centres of political power and artistic activity, and many small metal images were made. The example here has been questioned most recently by Miss Pauline Lunsingh Scheurleer of the

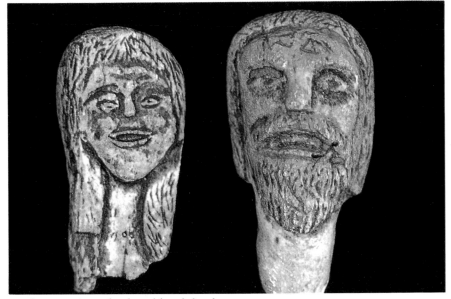

334: bone-carvings of male and female heads

Rijksmuseum, Amsterdam, who draws attention to its mixture of Central and East Javanese forms (personal communication). Thus, while the detachable base seems of about the early tenth century, the elongation of the bodies recalls the figures associated with the famous Nganjuk mandala (late tenth to early eleventh century). The haloes appear consistent with the latter date but the perplexing jewellery is closer to Central Java, while the belts at the tops of the lower garment 'are not Indo-Javanese at all'. The combination of the well-known Buddhist deity Avalokiteshvara with Shri, the goddess of fortune, has not been found in published iconographic sources, but occurs nevertheless in one other example, convincingly ancient and quite different.

To Miss Lunsingh Scheurleer's observations may be added other suspect features: the clumsy and waistless elongation of the bodies, the flat execution of the ornaments which, by the later Javanese period, show more marked relief, even on very abraded bronzes, and the unusual form of head-dress of both deities: the type, rare on Avalokiteshvara, is apparently unrecorded for Shri.

A recent examination by the British Museum Research Laboratory showed that the composition of the alloy from which it is made is similar to that of undisputed pieces of the twelfth to fifteenth centuries and that, though heavily cleaned, it bears a small residue of corrosion products which are thought to have formed slowly. The scientific evidence therefore favours the antiquity of the group. WZ

Bronze. H 165mm
BM OA 1963. 7–10. 1
LITERATURE A. J. Bernet Kempers, *Ancient Indonesian Art*, Cambridge, Mass., 1959, p. 52; P. Lunsingh Scheurleer & M. J. Klokke, *Ancient Indonesian Bronzes*, Leiden etc., 1988, p. XI and nos 51–3

334 The mysterious discoveries at Glozel

For over half a century the mystery of findings made at the hamlet of Glozel in the Auverne region of France has continued to baffle archaeologists and scientists alike. The facts can be briefly stated.

In March 1924 the seventeen-year-old Emile Fradin was working in his grandfather's fields, when the cow drawing his plough stumbled into an oval-shaped hole. When cleared, the hole was found to be about two and a half metres long with a paved base, and had stones set about its edge. In it were a few pots, some tablets, and bricks and lumps of glass. A thin glass-like layer could be seen on some of the bricks.

334: terracotta tablet

334: terracotta model of hermaphrodite sexual organs

It seems the cow had fallen into a medieval glass kiln; indeed, there are records of quite a few such kilns in the region. At the time, however, the Fradins were convinced that they had discovered a grave, and from henceforth called the field 'Le Champ des Morts' (Field of the Dead). Unfortunately, this 'tomb' was cleared the very same night.

Eventually news of the find reached Dr Morlet, a surgeon from nearby Vichy and an amateur archaeologist. Fascinated, he bought from the Fradins the rights to excavate and publish finds from the field in Glozel. Almost at once Emile Fradin and Dr Morlet began to excavate and rapidly brought to light a large number of amazing objects. There was a huge range of pottery, unlike any which had been reported before: face urns, hermaphrodite figures, handprints embedded in clay, bobbins, lamps. Most exciting of all were clay tablets, inscribed with a mysterious script containing not only the letters of the modern alphabet, but also many extra symbols, in all some 133 different letters. Moreover, there were also pieces of pebble and bones which were carved with images of animals, some of which had been extinct for thousands of years. In all, some 5,000 objects have been discovered.

From the style of the pebble- and bone-carvings, Dr Morlet concluded that the site was probably around 10,000 years old and so argued that the script was the most ancient known in the world. Archaeological opinion about the discoveries was divided. Among the supporters of Morlet was one of France's leading archaeologists, Salomon Reinach. Opposing him was a large anti-Glozellian group, which expressed grave doubts as to the authenticity of the material. Credibility was strained by the apparent uniqueness of the objects, and by the mixture of styles, such as the Magdelanian pebble engravings, similar to those found at Les Eyzies, and the tablets, with their mysterious script which had no precedent in Europe and was attributed to ancient Phoenician writing. There was also the very wide diversity of the clay objects, none of which resembled excavated material from any other site. The finds, which had apparently survived thousands of years of burial in a damp site, were in a remarkably good state of preservation and yet when some were tested they were found to be easily dissolved in water.

In 1927 the International Anthropological Congress sent a commission of archaeologists down to Vichy to examine the site. After conducting excavations of its own, the Commission finally concluded that there was nothing of any great age at Glozel. However, in 1928 Reinach and others organised a new commission. It excavated at Glozel for three days in April 1928, finding several objects, including a clay tablet, all in undisturbed soil. It concluded that all finds in Glozel were authentic, mainly because objects surrounded by roots could not have been placed in the soil recently.

The controversy eventually died down, and by the time war broke out Glozel was all but forgotten. The second phase of investigations at Glozel came much later, with conclusions which are no less puzzling and complex. By 1974 the technique of thermoluminescence (TL) was well established for determining the age of ancient pottery. In a paper in *Antiquity* by Hugh McKerrell (National Museum of Antiquities of Scotland), Vagn Mehdahl (Danish Atomic Energy Commission) and Henri François and Guy Portal (Centre d'Etudes Nucléaire at Fontenay-aux-Roses), dates were given for a wide range of Glozel material, varying from 700 BC to AD 100. The datings suggested by the TL tests were confirmed from preliminary radiocarbon dating of bone collagen.

At the Archaeometry and Archaeological Prospection Symposium held at Oxford in 1975 three papers were presented on aspects of Glozel. The archaeological objections to the site were summarised by Professor Colin Renfrew:

1. The finds . . . are without

significant parallels elsewhere, either in the same region or outside it.

2. The assemblage of finds, which is firmly dated by TL, contains no single object typical of the very well-documented cultures of that region . . .

3. The assemblage shows . . . chronological inconsistencies which . . . are difficult to reconcile with the authenticity of all the objects.

Criticism of the precise techniques used in the TL measurements was expressed by Professor Martin Aitken and Joan Huxtable, from the Research Laboratory for Archaeology and the History of Art at Oxford University. They felt that larger uncertainties should bracket the date range, since none of the material was scientifically excavated, and so information on the burial conditions was lost. Aitken and Huxtable also reported the dating of an unprovenced fragment, finding dates of AD 1200 and AD 1350 using two different TL techniques.

This paper, from the laboratory which pioneered the method, delicately expressed for the first time the question: 'Is it not possible that, in this particular instance, there is something mysteriously wrong with thermoluminescence?' The original measurements were subjected to further checks, but McKerrell et al. stood firm by their original dating, suggesting that the Oxford sample might be a brick from the medieval glass kiln.

To add to the mystery, in 1976 Barbetti published a paper on the archaeomagnetic analyses of six 'Glozellian' ceramic artefacts. Archaeomagnetic techniques determine the strength of the magnetic field in which ceramics were allowed to cool after firing and, since the geomagnetic field strength at any given location has generally varied in the past, the method can give an indication of the periods in which the ceramics could have been made – or definitely exclude certain periods. He concluded that two of the inscribed tablets, one dated by McKerrell et al. and the other by Aitken and Huxtable, could not have been fired between about 1500 BC and AD 1500. In 1977

another thirteen dates were announced by McKerrell et al., this time with a range of 349 BC to AD 174. It appeared that scientific dating was as varied as the objects themselves, and that the scientific debates were no less heated than the archaeological ones had been some half a century before.

In 1983 yet another excavation was proposed some 500 metres from the original Glozel excavations where some time previously 'Glozellian' objects had been found. The digs were carried out under conditions of stringent security. Rather little was found on this occasion – a few pieces of stone, which included a polished axe and others inscribed with animal figures and 'Glozellian' script, plus a little pottery. However, the 'Glozellian' faction found confirmation in these finds of the presence of a Neolithic civilisation in the region.

It is easy to scoff at the scientific measurements made on these objects, especially the TL dating. Yet TL has been used with considerable success for twenty years in testing the authenticity of many thousands of pieces from virtually every part of the world. And there can be no doubt that most of the pottery does not appear to be of modern origin, even if it might not be as old as the original 'pro-Glozellians' had suggested.

It is with the hope that the thermoluminescence discrepancies can be untangled that work has started on the investigation of the thermoluminescence of Glozel. One of the conditions is that nothing can be published until 1991, when the work will appear in a French journal. All that can be said at this stage is that it has been possible to identify problems caused by the peculiar geology of the region and that there is some modification of the original dating. A dating sequence which is archaeologically more plausible has emerged.

But the site remains an amazing mixture and an enigma, losing nothing of its appeal. There are still surprises in store at Glozel. DS

335 The Berlin Flora: a wax bust once attributed to Leonardo

In 1909 Wilhelm von Bode acquired a wax bust, known as 'Flora' (a), and published it as a work by Leonardo da Vinci. Soon afterwards the London *Times* reported that the bust had really been made in 1846 by the English wax-modeller Richard Cockle Lucas. So began the 'Flora controversy' which has raged intermittently ever since, and which has still not been settled. A recently published pamphlet by Hans Ost (1984) claims to put an end to this academic quarrel, but it actually offers no new findings.

Stylistic evaluations of the piece have been so extremely contradictory that it has not so far been possible to reach a concensus on this basis. Peter Metz saw in the bust 'the highest perfection of plastic expression and a vivacity of the elements which together form a full and rich unity of calm, classical lucidity and harmony', while Gustav Pauli found nothing in the Flora bust but a Victorian style suggestive of porcelain figures. Hans Ost regrets the absence of an inner, overall idea; the combination of numerous prototypes makes the work appear of dubious quality.

This discrepancy of opinion is no doubt primarily due to the ruinous state of the bust, which provokes highly subjective stylistic evaluations. The numerous wax analyses of early and more recent date are also curiously contradictory. We are, therefore, for the time being unable to make specific conclusions on the basis of stylistic evaluation or scientific analyses as to its date even, let alone its attribution to either Leonardo or Lucas.

The inaccessibility of the documents regarding its acquisition and subsequent events (in East Berlin) makes it impossible for the Sculpture Department of the Staatliche Museen Preussischer Kulturbesitz in West Berlin to attempt a fundamental unravelling of the controversy. These documents include a photograph album of works by Lucas, among which is a photograph of the Flora bust which has been marked by Lucas himself, not as his own work, but as

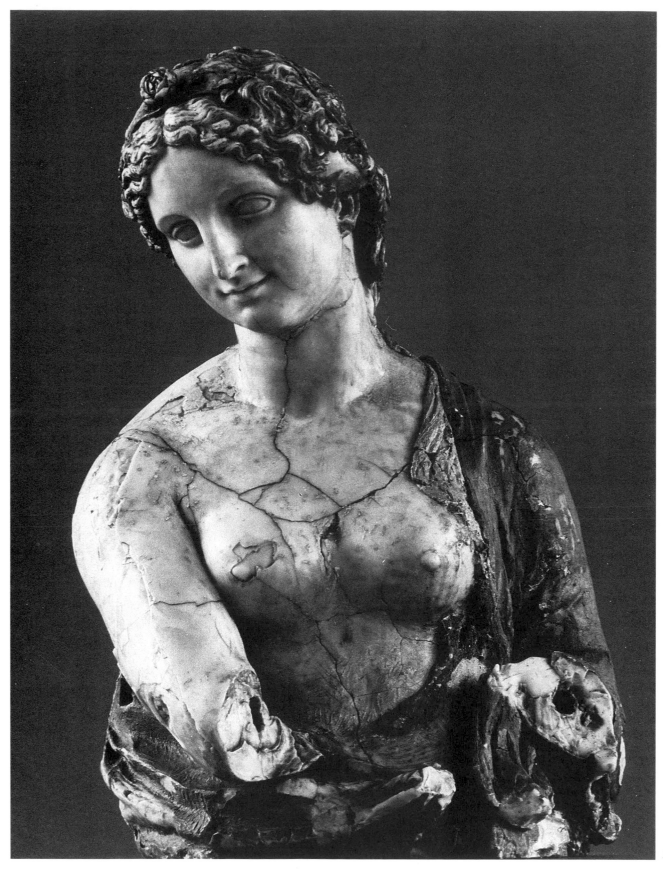

335a

that of Leonardo. However, an investigation of certain aspects of the manufacture and technique – so far apparently not introduced into the discussion – do seem to offer new criteria for forming an opinion.

The controversy began with a statement made by Albrecht Dürer Lucas under oath on 14 May 1910 that the bust was the work of his father, Richard Cockle Lucas (see also 129). A. D. Lucas's statement said that in 1846 an art dealer named Buchanan sent an oil painting then attributed to Leonardo (b) to Lucas senior with a view to having the subject copied in wax. Lucas junior claimed to have helped his father with setting up the clay model and making the plaster mould. He then assisted with the casting, rotating and swinging of the mould to ensure the correct distribution of the wax. However, a careful consideration of the technical problems of casting the Flora bust strongly contradicts some of Lucas's assertions. The weight of a plaster mould large enough to cast a bust of this size would have been at least 150kg – a considerable burden for Lucas and son to have manoeuvred apparently without other assistance. Furthermore, as the bust was cast in sixteen layers, the effort – repeated at each casting – would have been enormous. Why would Lucas senior have chosen this very labour-intensive method? Why not, as was customary, cast the bust in one or two layers? The creator of the bust was evidently compelled to deal economically with his material (whether it consisted exclusively of spermaceti or was mixed with beeswax), but we know from the son that his father had a sufficient quantity of cheap candle scraps at his disposal. He could therefore have spared himself so much labour.

Lucas junior had nothing to say about the finishing of the bust after the casting, except that he claimed to have helped his father paint the hair and the flowers. The latter are now no longer present but can be seen in Lucas's wax representation of the bust as he remembered it at the time of the controversy in 1910 (fig. 9). However, the brown paint on the hair was actually clearly applied to a surface

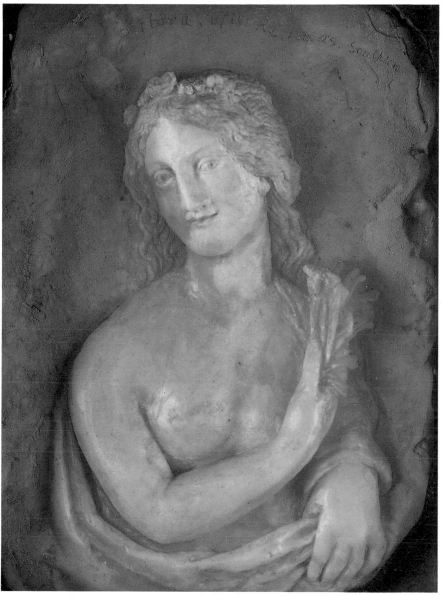

Fig. 9 Flora, after R. C. Lucas, modelled in wax by his son A. D. Lucas in 1910. Lent by Mr A. Hinton

already finished with a spoon chisel, so the sculpture cannot have been freshly cast.

He further declared that his father was in the habit of filling up his casts with 'odd materials'. This is a curious assertion; packing a new wax casting in this way is technically absurd and, as far as we are aware, not known from any work attributed to Lucas with certainty. But the bust, which today is accessible from below, is in fact crammed with all sorts of material held together by a resinous, brittle paste which must have been poured in while hot. The packing included scraps of newspaper, unprinted paper (including a letter in English dated 184?), remnants of material, large lumps of clay, pressed in while still soft, and even a wooden stick inserted horizontally. The use of the clay and the stick to stabilise a newly cast bust makes no sense technically. In fact, it would have the opposite effect, leading to the formation of cracks.

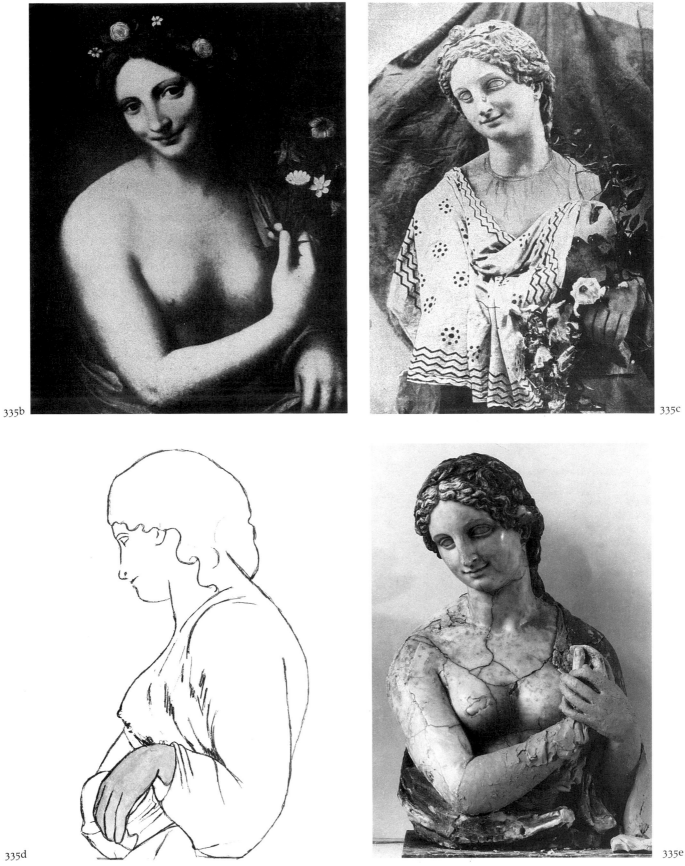

335b

335c

335d

335e

Such a working method makes sense only if the intention was to stabilise a bust which was beginning to fall to pieces, by cementing the fragments together. This supposition is strengthened by the fact that the paste has penetrated cracks, intermediate spaces and flaws in the outer wall.

Much attention has been focused on a studio photograph of about 1860 (c), showing the bust partially veiled. The print dates from the early days of photography, and many details are blurred or retouched and therefore difficult to interpret. That the drape shown fastened at the neck was added later by retouching is not in doubt. The question of why this was done has several possible answers. Some explain these drapes as a result of prudery, that Lucas was embarrassed at exhibiting a photograph of the naked beauty he had himself just manufactured, but this is not a very convincing explanation. It is remarkable that he also covered the whole of the right lower arm and parts of the hand with cloth and foliage and left only the upper part of the hand with the fingers free – exactly that part of the sculpture that was present at the acquisition as a fragment. It is highly probable that the arm was hidden because it was missing, as it is today. The most obvious explanation is that the drapes served to hide the damage and cracks already present at the time.

Discussion about the left hand on the photograph has also been heated. To some it has appeared as a human hand, the presence of which exposed the photograph as a studio joke. Others have found in the position of the hand an added similarity to the oil painting, thereby strengthening the thesis that Flora was a copy by Lucas of the picture. The photograph allows no unequivocal interpretation on this question either. In its present state the bust has lost both hands and the right lower arm; the exact original positions of the hands are therefore unknown. But disagreements regarding the composition of the arms and hands were previously solved by reference to the 'Leonardo'.

A modern photograph of the Flora can, if taken from the same angle and with the same lens and enlargement,

be superimposed over that of 1860, making it possible to correlate the positions of both hands on Lucas's photograph exactly with the bust as it is today. The result shows that the left hand is situated at the exact elevation of the arm, but hanging down. The still existing lower left arm is, however, pointing upwards at an angle of approximately 40°C, making it impossible for the hand to be hanging down at the angle shown. If the photograph shows the original hand as adapted by Lucas, the lower arm would be at least 8cm too short: it would have been anatomically completely deformed (d). The right hand, too, is wrongly placed on the photograph. Even today there are still traces on the right side above the left breast where something had been attached, but instead the 1860 photograph shows the hand protruding further towards the left shoulder, in imitation of the 'Leonardo'.

It is tempting to conjecture that both hands were originally placed together at the same elevation over the left breast. Of course, it is no longer possible to reconstruct exactly how the hands were arranged, but the general position of the arms can be deduced from the overall composition and from individual details, so that considerable differences between the bust and the 'Leonardo' painting become evident (e). Thus the photograph by Lucas is exposed as a collage aimed at making the bust resemble the 'Leonardo'.

In summary, the Flora bust was not made as a three-dimensional copy after the 'Leonardo' painting by Lucas. All of the observations above confirm that it came to Lucas's workshop as a damaged fragment for restoration. The painting was evidently intended to serve as the basis for the reconstruction of missing parts. Lucas strengthened the bust from the inside by the use of the most varied materials and in a few places touched up the surface (the signs of plaster repairs to the surface are evident in the 1860 photograph). It is possible that his son, then aged eighteen, assisted him. If the photograph of the bust was made as late as 1860, the restoration must have been postponed for some

years, as it was clearly still in a damaged state at that time. Surface cracks were touched up, and missing parts disguised by a scarf; the left hand was made to look like the painting in an organically impossible way (by the use of a live human hand).

On this basis it seems impossible to us that the process can have taken place in the way described by A. D. Lucas, but we are far from wishing to impute any conscious falsification of facts to him: sixty-three years had passed when he made his statement. The Flora bust already had a history when it arrived at the studio of Richard Cockle Lucas as a partly damaged piece. When it was actually made, whether in the sixteenth, eighteenth or early nineteenth century, will continue to be a subject of thought and controversy. AK/PB

335a Photograph of the Flora bust, 1988 Staatliche Museen Deutscher Kulturbesitz, W. Berlin

335b Photograph of an oil painting attributed to Leonardo da Vinci Private Collection

335c Studio photograph by R. C. Lucas, c. 1860

335d Reconstruction of the position of the left hand according to the photograph by Lucas (A. Kratz)

335e Reconstruction of the positions of both hands according to anatomical facts (A. Kratz)

LITERATURE E. J. Pyke, A biographical dictionary of wax modellers, Oxford 1973, s.v. Lucas; H. Ost, Falsche Frauen (False Women), Cologne 1984 (includes the most important literature)

Further reading

ANDRÉN, A., *Deeds and Misdeeds in classical Art and Antiquities*, Partille 1986

ARIES, ROBERT, *Les Faux dans la Peinture et l'Expertise Scientifique*, Monaco 1965

ARNAU, FRANK (H. SCHMITT), *Three Thousand Years of Deception*, London 1961

ASHMOLE, B., *Forgeries of Ancient Sculpture in marble: creation and detection*, Oxford 1961

BACKHOUSE, JANET, 'A Victorian Connoisseur and his Manuscripts', *British Museum Quarterly* XXXII (1967–8), pp. 76–92

BACKHOUSE, JANET, 'The "Spanish Forger",' *British Museum Quarterly* XXXIII (1968–9), pp. 65–71

BAILEY, D. M., 'Roman Lamps: Reproductions and Forgeries', *Museums Journal* LX (May 1960), pp. 39–46

BARKER, N., *A sequel to an enquiry into the nature of certain nineteenth century pamphlets by John Carter and Graham Pollard*, London 1983

BARTRÉS, L., *Antiguedades Mejicanas Falsificadas*, Mexico 1910

BAYARD, E., *L'art de reconnaître les fraudes*, Paris 1914

BLOCH, P., 'Original-Kopie-Fälschung', *Jahrbuch Preussischer Kulturbesitz* XVI (1979), pp. 41–72

BOTHMER, DIETRICH VON, & NOBLE, JOSEPH V., *An Inquiry into the Forgery of the Etruscan Terracotta Warriors in the Metropolitan Museum of Art*, New York 1961

BOYD, SUSAN, & VIKAN, GARY, *Questions of Authenticity among the arts of Byzantium*, exhibition catalogue, Dumbarton Oaks, Washington 1981

BROAD, W., & WADE, N., *Betrayers of the truth*, Oxford 1985

CARTER, J., *An enquiry in to the nature of certain nineteenth century pamphlets*, London 1983

CESCINSKY, H., *The gentle art of faking furniture*, London 1931

CLERMONT-GANNEAU, C., *Les Fraudes Archéologiques en Palestine*, Paris 1885

COLE, SONYA, *Counterfeit*, London 1955

COSTELLO, PETER, *The Magic Zoo*, London 1979

Counterfeits, Imitations and Copies of Works of Art, exhibition catalogue, Burlington Fine Arts Club, London 1924

COURAJOD, L., 'L'imitation et la contrefaçon des objets d'art antiques', *Gazette des Beaux-Arts* XXIV (1886), pp. 188–201, 312–30

DRESSEL, H., 'Pirro Ligorio als Münzfälscher', *Zeitschrift für Numismatik*, 1899

DUTTON, DENIS, *The Forger's Art*, Berkeley 1983

ECO, UMBERTO, *Faith in Fakes*, London 1986

ELLIOT, WALLACE, 'Reproductions and Fakes of English Eighteenth-Century Ceramics', *English Ceramic Circle* II, no. 7 (1939), pp. 67–81

EUDEL, PAUL, *Le Truquage*, Paris 1884

EUDEL, PAUL, *Trucs et Truquers*, Paris 1907

Fakes and Forgeries from collections in Israel, exhibition catalogue, Eretz Israel Museum, Tel Aviv 1989

Fälschung und Forschung, exhibition catalogue, Museum Folkwang, Essen 1976/77

FARRER, J. A., *Literary Forgeries*, London 1907

FENBY, J., *Piracy and the public*, London 1983

FERRETI, M., 'Falsi e tradizione artistica', in *Storia dell'arte Italiana III.3. Conservazione, falso, restauro*, Turin 1981, pp. 115–95

FLEMING, S. J., *Authenticity in Art*, London 1975

FORESI, A., *Tour de Babel*, Paris and Florence 1868

Forgeries and Deceptive copies, exhibition catalogue, British Museum, London 1961

FREL, J., 'Imitations of Ancient Sculpture in Malibu', *The J. Paul Getty Museum Journal* IX (1981), pp. 69–82

FRIEDLAENDER, MAX, *Genuine and Counterfeit: Experiences of a Connoisseur*, New York 1930

FURTWÄNGLER, A., *Neuere Fälschungen von Antiken*, Berlin 1899

FU SHEN, 'Chang Dai-chien's The Three Worthies of Wu and His Practice of Forging Ancient Art', *Orientations* (September 1989), pp. 56–72

GANZEL, D., *Fortune and men's eyes*, Oxford 1982

GRIERSON, PHILIP, 'Some modern forgeries of Carolingian coins', *Centennial publication of the American Numismatic Society*, New York 1958, pp. 303–15

GRIERSON, PHILIP, & BLACKBURN, MARK, *Medieval European Coinage*, Cambridge 1986, pp. 332–8

HALL, E. T., 'The Courtrai chest from New College, Oxford, re-examined', *Antiquity* LXI (1987), pp. 104–7

HAMILTON, CHARLES, *Great forgers and famous fakes*, New York 1980

HASKELL, FRANCIS, & PENNY, NICHOLAS, *Taste and the Antique*, London 1981

HAZEN, A. T., *Bibliography of the Strawberry Hill Press*, New Haven 1942

HILL, G. F., *Becker the counterfeiter*, London 1925

HOWARD, S., *Bartolomeo Cavaceppi*, Chicago 1980

ISNARD, GUY, *Faux et Imitations dans l'Art*, Paris 1959, 1960

JAHN, MELVIN E., & WOOLF, DANIEL J., *The lying stones of Dr J. B. A. Beringer*, Berkeley 1963

JEPPSON, LAWRENCE, *Fabulous Frauds*, London 1971

JONI, J. F., *The Affairs of a Painter*, London 1936

KEATING, TOM, & NORMAN, GERALDINE AND FRANK, *The Fake's Progress*, London 1977

KENYON, NICHOLAS (ed.), *Authenticity and Early Music*, Oxford 1988

KINNS, P., *The Caprara Forgeries*, London 1984

Kunst og Kunstforfalskning, exhibition catalogue, Kunstmuseum, Aarhus 1989

KURZ, OTTO, *Fakes*, New York 1967

LAWRENCE, L. A., 'Forgery in relation to numismatics', *British Numismatic Journal* 1905–7: II (1905), pp. 397–409; III (1906), pp. 281–90; IV (1907) pp. 311–16

LOWENTHAL, DAVID, *The past is a foreign country*, Cambridge 1985

LUSETTI, WALTER, *Alceo Dossena, scultore*, Rome 1955

MACLAGAN, SIR ERIC, 'Ivoires faux, fabriqués à Milan au début du XIXe Siècle', *Aréthuse* I (1923), pp. 41–3

MAILFERT, ANDRÉ, *Au Pays des Antiquaires*, Paris 1935

MENDAX, FRITZ (pseud.), *Art Fakes and Forgeries*, London 1955

MILLS, J. F., *The genuine article*, London 1979

NEUBURGER, ALBERT, *Echt oder Fälschung*, Leipzig 1924

NOBILI, R., *The Gentle Art of Faking*, London 1922

ORVELL, MILES, *The Real Thing: Imitation and Authenticity in American Culture 1880–1940*, Chapel Hill, North Carolina, 1989

OST, H., *Falsche Frauen*, Cologne 1984

PANOFSKY, ERWIN, 'Kopie oder Fälschung?', *Zeitschrift für bildende Kunst* 1927–8

PHILLIPS, DAVID, *Don't Trust the Label*, exhibition catalogue, Arts Council, London 1986–7

PICÓN, CARLOS A., *Bartolomeo Cavaceppi*, exhibition catalogue, Clarendon Galleries, London 1983

POPE-HENNESSY, J., *The study and criticism of Italian Sculpture*, New York 1980

The Real, the Fake and the Masterpiece, exhibition catalogue, Asia Society Galleries, New York 1988

SACHS II, SAMUEL, *Fakes and Forgeries*, exhibition catalogue, Minneapolis Institute of Art, Minneapolis 1973.

SAVAGE, GEORGE, *Forgeries, fakes and reproductions*, London 1976

SCHULLER, SEPP, *Forgers, Dealers, Experts*, London 1960

SESTINI, *Supra i moderni falsificatori di medaglie greche antiche nei tre metalli*, Florence 1826

SIMPSON, COLIN, *The Artful Partners: the secret association of Bernard Berenson and Joseph Duveen*, London 1988

SMITH, JOHN THOMAS, *Nollekens and his times*, London 1828

SOX, DAVID, *Unmasking the Forger*, London 1987

STOCKING JR, G. W., *Objects and Others*, Madison, Wisconsin, 1985

TAIT, HUGH, 'The Girdle-Prayerbook or "Tablett" . . .', *Jewellery Studies* 2 (1985), pp. 29–58

THEATÈS, O., 'Les grandes mystifications artistiques. Terres cuites fausses' *Le Musée* V (1908), pp. 171–82

TIETZE, HANS, *Genuine and False: Copies, Imitations, Forgeries*, London 1948

TOUT, T. F., *Mediaeval Forgers and Forgeries*, London 1920

True or False?, exhibition catalogue, Corning Museum of Glass, New York 1953

TÜRR, K., *Fälschungen antiker Plastik seit 1800*, Berlin 1984

Vals of Echt?, exhibition catalogue, Stedlijk Museum, Amsterdam 1953

VAYSON DE PRADENNE, A., *Les Fraudes en Archéologie Préhistorique*, Paris 1932

Vervalsingen van Egyptische kunst, exhibition catalogue, Musées Royaux d'Art et d'Histoire, Brussels 1984

Vraiment faux, exhibition catalogue, Fondation Cartier, Jouy-en-Josas 1988

Vrai ou faux? Copier, imitator, falsifier, exhibition catalogue, Bibliothèque Nationale, Paris 1988

WALKER, RAINFORTH A., *How to Detect Beardsley Forgeries*, Bedford 1950

WATSON, OLIVER, 'Fakes and forgeries of Islamic pottery', *V&A Album* 4 (1985), pp. 39–46

WEST, W. J., *Truth Betrayed*, London 1987

WIENER, J. S., *The Piltdown Forgery*, London 1955 (reprinted 1980)

For further references see:
REISNER, R. G., *Fakes and Forgeries in the Fine Arts: A Bibliography*, New York 1950

Index

INDEX